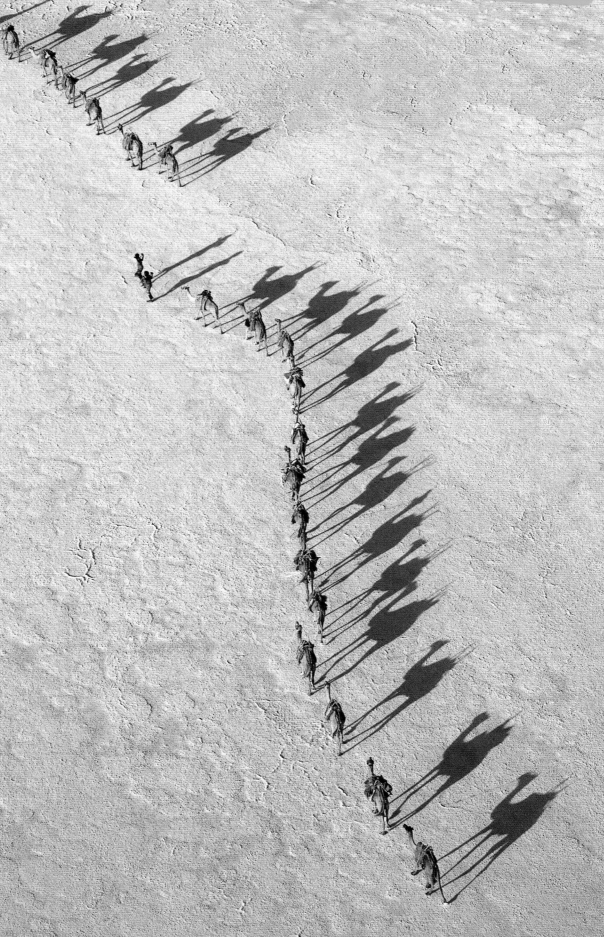

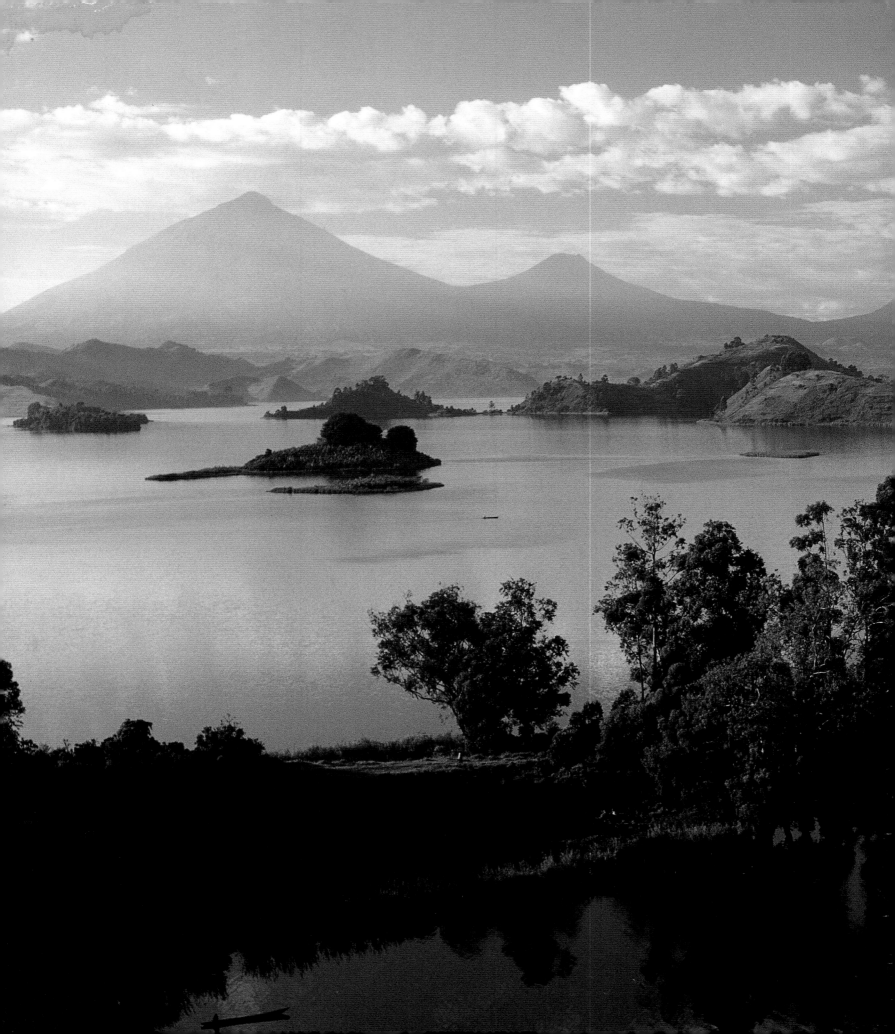

AFRICA'S GREAT RIFT VALLEY

Photographs and text by

NIGEL PAVITT

HARRY N. ABRAMS, INC., PUBLISHERS

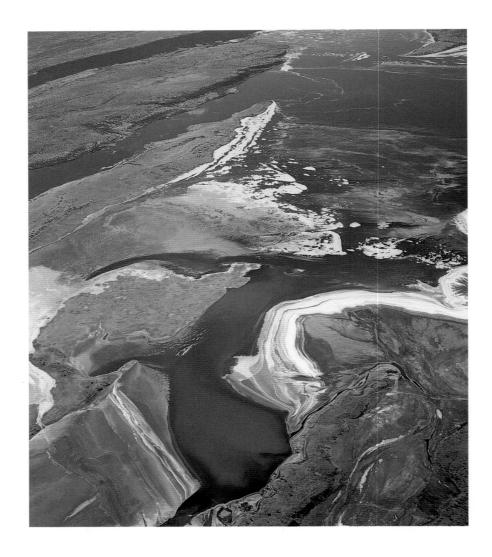

PAGE 1: *An Afar camel caravan crosses the salt flats of Lake Assal, Djibouti, as shadows lengthen in the late afternoon sun.*

PAGES 2–3: *With the backdrop of five Virunga Volcancoes, Lake Mutanda is one of the most attractive small lakes of the entire Rift system.*

ABOVE: *White soda encrusts the mud flats of Lake Natron, a closed basin alkaline lake situated in an inhospitable, low-lying region of Northern Tanzania*

EDITOR: Robert Morton
DESIGNER: Lindgren/Fuller Design, Inc.

Published in 2001 by Harry N. Abrams, Incorporated, New York

Printed and bound in Hong Kong
10 9 8 7 6 5 4 3 2 1

Editor's Note: Correctly given, the country name of Malawi is spelled with a circumflex over the letter "w." In English-language dictionaries, however, this is not the case. For the convenience of readers, the English form is followed.

Library of Congress Cataloging-in-Publication Data
Pavitt, Nigel.
 Africa's Great Rift Valley / Nigel Pavitt.
 p. cm.
 ISBN 0–8109–0602–3
 I. Title: Great Rift Valley. II. Title.

DT365.19 .P38 2001
967.6—dc21

2001022727

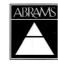
Harry N. Abrams
100 Fifth Avenue
New York, N.Y. 10011
www.abramsbooks.com

Contents

Genesis: Formation & Evolution

The Great Rift Valley of eastern Africa is the largest, longest, and most conspicuous feature of its kind on earth. It stretches for nearly 3,500 miles from the Afar Depression in the Horn of Africa to the mouth of the Zambezi River in Mozambique. The Rift Valley landscape ranges from searing salt flats lying more than 500 feet below sea level to snow-capped mountains towering 16,763 feet. Astronauts call it the most significant physical detail of the world visible from outer space.

An extraordinarily rich fauna inhabits the Rift Valley. There are greater concentrations of wild animals on its grasslands than in any area of similar size elsewhere on earth. Unique species of the Rift include the rarest large primate in the world, the mountain gorilla, which roams the mist-shrouded forests of the Virunga volcanoes in central Africa, and a diminutive fish that thrives in alkaline springs too hot to touch.

An equally immense variety of flora cloaks the Rift Valley, adapting to variations in altitude, temperature, and rainfall. Species embrace highly specialized forms that live in the Afro-alpine zone above 12,000 feet and tiny plants that lie dormant for years in the desert wastes of the valley floor. In the space of a few weeks after a rare rainstorm, these ephemerals flower, set their seeds, and then wither until the next rain, when they will germinate again.

Across the Rift Valley's varied landscape the people are just as diverse. They belong to a multitude of different tribal cultures, each with its own distinctive traditions and lifestyles: haughty Afar nomads tend their herds in the harsh Danakil Depression of northeast Ethiopia; diminutive pygmies, Africa's ancient inhabitants, hunt in the dense, damp Semliki Forest of western Uganda; stocky Bantu-speaking farmers cultivate the rich volcanic soil of the Western Rift; and lanky Maasai warriors graze their cattle on the East African savanna. No tribe presently living in the Rift Valley is better known than the pastoral Maasai. These much-admired people are intensely proud of their age-old customs in a sea of change.

Rift Formation

Unlike valleys carved out by rivers descending to the sea, rift valleys are formed over tens of millions of years by faulting within the Earth's crust, often accompanied by intense volcanic activity. In the faulting process, large slabs of rock slide past each other horizontally or vertically, releasing strain energy in the form of earthquakes.

An extensive network of caves and tunnels honeycombs the extinct volcano at Suswa, Kenya. They were formed when lava continued to flow underground long after the exposed upper crust had cooled and solidified.

During the Cenozoic era, the era of recent life, dating back sixty-five million years and characterized by the evolution of mammals, Eastern Africa was deluged under molten lava and thick beds of explosive rock. The size of the area buried under volcanic material, the vast bulk and variety of that material, and the prolonged duration of the eruptions, make East Africa one of the world's most notable volcanic regions. Although early episodes of volcanic activity predate the formation of the Rift, the role volcanism played later should not be underestimated. It has sculpted and enriched the magnificent scenery of eastern and central Africa, renowned for imposing escarpments, some of them relatively old and weathered, others still fresh, sharp, and steep. Outflows of basaltic lava in Ethiopia lie several thousand feet thick and add as much as 6,500 feet to the height of the landscape along the margins of the Rift. Without lava, there would be no Ethiopian Plateau or Central Kenya Highlands. Without composite volcanic cones made largely of lava, there would be no Mounts Kilimanjaro or Kenya, the two highest mountains in Africa. Without faulting, there would be no Rwenzori Mountains, the fabled Mountains of the Moon. Instead of being blessed with temperate upland regions of fertile soil and high rainfall, there would be featureless low-lying plateaus with poor soil and low rainfall. By chance, these changes to landform, climate, and vegetation combined to stimulate human evolution.

Looking back briefly to an early stage in the development of this planet promotes understanding of the geological processes that led to the formation of the Great Rift Valley. Two hundred million years ago, the world consisted of one supercontinent called Pangea, which gradually separated to create the Tethys Sea. One component of Pangea was known as Laurasia, the other Gondwana. The southern continents in existence today began to form when Gondwana's underlying plate split,

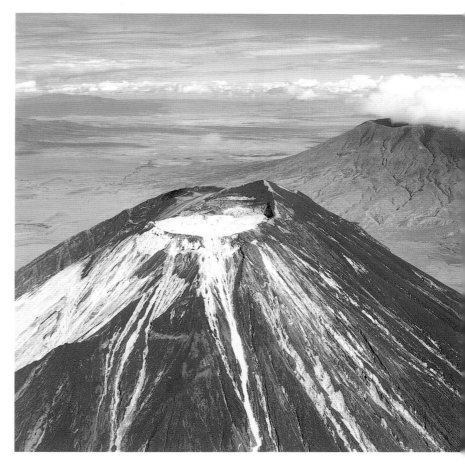

Ol doinyo Lengai, an active volcano in northern Tanzania, displays recent discharges of rare carbonatite lavas, which turn white on exposure to air. The extinct volcano, Kerimasi, stands behind and to the right of Lengai.

and the landmass began to break up 135 million years ago. Africa became the largest fragment, and is now the second largest continent with 22 percent of the earth's land surface.

The earth's crust and part of its upper mantle are made up of a mosaic of large and small tectonic plates, separated from one another by mobile zones of relative weakness called plate boundaries. Together, they constitute a rigid lithosphere that floats on partly molten rock. Over the aeons, the plates—and by extension modern continental landforms—have moved considerable distances, driven by forces that are not yet fully understood in a

process called continental drift. The African Plate, for instance, has shifted through 60 degrees of latitude and rotated 15 degrees counter-clockwise in 300 million years. Sophisticated measuring devices show very slight movement continuing to this day. Most of the seismic and volcanic activity on Earth concentrates along the boundaries where plates interact by diverging, converging, or slipping past one another.

The activity of these plates not only affects landforms but also the planet's undersea configuration. Huge mid-oceanic ridges are formed along divergent plate boundaries where hot volcanic material flows out and shallow earthquakes are commonplace. Running beside the crests of those ridges are deep underwater rift valleys that vary in width between a quarter and one and a quarter miles and rise almost two miles above the seabed. Until recently, the only evidence of these features was the volcanic islands that pierce the ocean surfaces, such as Iceland in the North Atlantic. But scientists now have the technology to trace them through topographic, magnetic, gravitational, and seismic studies. In doing so, they have established that an almost continuous rift, associated with the crests of the world's mid-oceanic ridges, runs for a distance of 37,000 miles around the globe. Africa's Rift links with this system at the Afar Triple Junction.

Triple junctions are not unusual in the world's jigsaw of tectonic plates. Where they occur, two arms of the junction commonly develop fully while the third remains undeveloped as a "failed" arm. Africa has two triple junctions. Both are places of continental rupture and both have an arm that never developed. After separating for tens of millions of years, South America finally broke away from Africa more than 100 million years ago along two developed arms of the ancient triple junction in the Niger Delta off the West African Coast. Its "failed" third arm, the Benue Trough, runs inland through the Niger Basin, but is buried deep underground and cannot be seen.

Across the continent, on the East African Coast, Arabia split from Africa around thirty million years ago at the Afar Triple Junction, which lies just off Djibouti and Eritrea. There, the converging oceanic rifts of the Red Sea and the Gulf of Aden make up the junction's developed arms and the Great Rift Valley forms its "failed" third arm. Not an oceanic boundary, this arm will never likely develop to a stage when all the land in the Horn of Africa east of the Rift breaks away from the rest of the continent and drifts away. Nevertheless, the Rift still evolves.

Though subsidence has contributed to the exceptional depth of the floor of the African Rift, the sheer walls of some sections are principally the outcome of faulting. In fact, the floor rests below sea level in only three places—the Afar Depression and the beds of Lakes Malawi and Tanganyika. True scale experiments conducted in the late 1930s by a pioneering German geologist at the University of Bonn, Hans Cloos, showed that the widths of Rift Valleys are usually the same order of thickness as the continental crust upon which they lie. This significant relationship determines the important role uplifting plays, for if a small portion of land between parallel fault lines lags behind the surface of the adjoining plateaus during a gradual doming of the earth's upper mantle, a rift valley forms.

The development of Africa's Great Rift system did not take place simultaneously, nor did it happen overnight. It began 25 million years ago with pronounced activity 6 and 2.5 million years ago. The extraordinary fissure tended to follow the continent's north-south axis of maximum doming where stress on the earth's crust had been greatest. Fault lines appeared, and, in time, magma welled through tensional fissures or cracks in places weakened by faulting. For almost 18 million years, protracted periods of massive volcanism

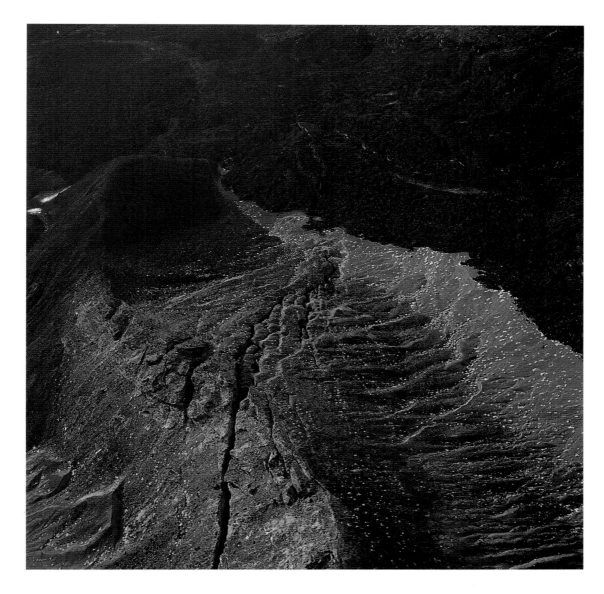

A little distance offshore the coast of Djibouti, the northern extent of Africa's Great Rift Valley abuts a triple junction where the oceanic rifts of the Red Sea and the Gulf of Aden converge. In this infertile region of unstable geology, the Rift widens perceptibly each year.

were interspersed with equally long periods of inactivity. Simultaneously, over the same time span, the interrelated forces of doming, faulting, and subsidence began to thrust, twist, crumple, and buckle the earth's crust until it acquired the shape and form of today's unique valley system. Its most recent phases of development brought about the uplifting of the Western Rift, which changed the entire drainage pattern of Africa's Great Lakes region.

East African volcanism now exists in a quiescent phase that may last several hundred thousand years. Large fissure eruptions ceased pouring out great thicknesses of lava and ignimbrites about 1.7 million years ago, but many of the big volcanoes situated in the Rift trough were active for another million years or more. The most recent lava flows from Longonot, an unmistakable cone near Kenya's Lake Naivasha, are only five thousand years old. Volcanoes

are still active in three centers—the Afar Depression of Ethiopia, the Lake Natron region of northern Tanzania, and the Virunga Mountains of Uganda, Rwanda, and the Democratic Republic of Congo. Other volcanoes are dormant but not dead; somber-looking and foreboding, they tower above the valley floor. Yet others are dead and unlikely to erupt again. Mount Kenya, the largest in this category, was formed as a result of the geological forces that shaped the Rift but lies outside its system.

Discovery and Early Exploration of the Rift Valley

Two thousand years ago, Greek philosophers and explorers intent on solving the mysteries of the unexplored African continent and the source of the Nile were intrigued that the river overflowed each year from June to mid-September during Egypt's hot, dry summer. They sought a logical explanation. The greatest of all ancient Greek geographers was Claudius Ptolmemaeus, better known as Ptolemy, who lived in Alexandria between 127 and 145 AD. He rejected the absurd notion of previous geographers that the Nile rose in the vicinity of the Indian Ocean, if not from the ocean itself. He placed its source some distance south of the equator among the rivers and lakes of a mysterious, snow-clad range known as the Mountains of the Moon. Ptolemy drew on an accumulation of knowledge for his shrewd deductions and not the firsthand accounts of travelers, since merchants trading along the East African coast seem not to have ventured far inland. One account that must have attracted his special interest was *Periplûs of the Erythrêan Sea*, written by an anonymous Greek navigator or merchant living in Alexandria around 60 AD. It is generally considered to be the best early record of commerce from the Red Sea to East Africa and India.

Fernandez de Encisco, a Spanish writer of the sixteenth century, made a voyage to the East African port of Mombasa in the early years of that century, where he obtained information from native caravans regarding the topography of the interior. In his *Suma de Geographia* published in 1519 he tells us that "west of this port stands the Ethiopian Mount Olympus, which is exceedingly high, and beyond it are the Mountains of the Moon, in which are the sources of the Nile." He must have taken the latter name from Ptolemy's map. Over the next three hundred years, the "Ethiopian Mount Olympus" appears and disappears according to the whims of earth scientists and cartographers who were mostly desk-bound and based their knowledge on analyzing the reports and descriptions of others.

In 1845, the Reverend Johann Ludwig Krapf, a German Protestant missionary, founded the first inland mission in East Africa at a time when the exploration of the interior of East and Central Africa had barely begun, and the existence of the Rift Valley was unknown. Early travelers had little interest in geological matters. They were missionaries like Krapf spreading the word of God, explorers bent on finding the source of the Nile, men sponsored by their governments with an overtly colonial agenda, adventurers seeking their fortune, or sportsmen hunting big game.

One man who contributed much to Europe's understanding of African geography in the nineteenth century was an Englishman named W. Desborough Cooley, but he damaged his reputation by discrediting an account of equatorial snow made by the Reverend Johann Rebmann,

Towering above the margins of the Western Rift are the 16,000-foot-high snow-capped Rwenzori Mountains, shown on the maps of ancient Greek geographers almost 2,000 years ago as the Mountains of the Moon.

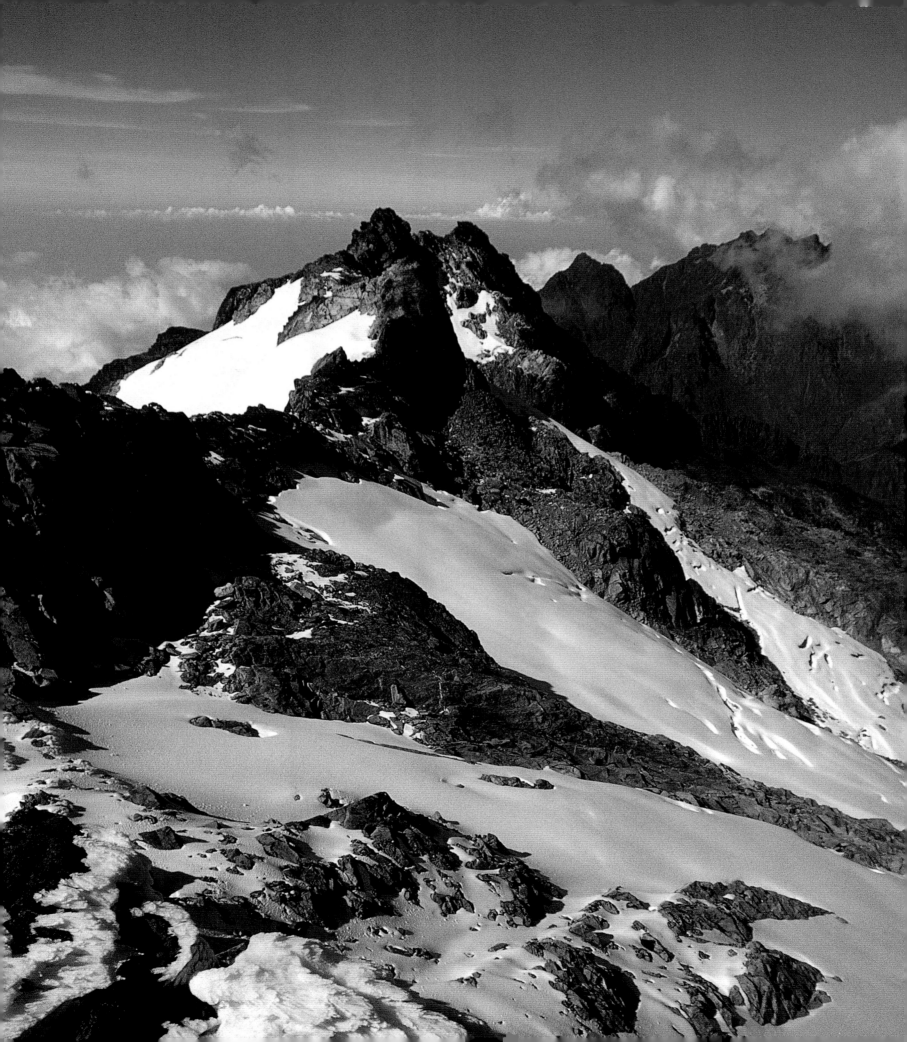

a colleague of Krapf. Rebmann sighted Mount Kilimanjaro in 1848 but his down-to-earth report—the first definite confirmation of the existence of Africa's highest mountain—was dismissed presumptuously by Cooley as "a most delightful mental recognition, not supported by the evidence of the senses." Cooley was sure the description of a snowcap was of a purely visionary nature. He must have disbelieved the narratives of classical geographers too.

When Baron von der Decken, a German explorer, attempted to climb Kilimanjaro in August 1861, he was driven back by bad weather. On his second attempt a year later, he reached an altitude of 14,000 feet before heavy snow forced him back again. "The ground lay white all round us," he wrote. "Surely the obstinate Cooley will now be satisfied!" But Cooley was not persuaded. "So the Baron says it snowed during the night—in December with the sun standing vertically overhead!" exclaimed Cooley. "The Baron is to be congratulated on the opportuneness of the storm. But it is easier to believe in the misrepresentations of man than in such an unheard-of eccentricity on the part of nature. This description of a snowstorm at the equator during the hottest season of the year, and at an elevation of only 13,000 feet, is too obviously a traveler's tale invented to support Krapf's marvelous story of a mountain 12,500 feet high covered with perpetual snow."

Ten years after this controversy ended, Rebmann and another missionary colleague, Jakob Erhardt, produced a map of the interior, mainly for missionary use, by collating their sketchy information with the firsthand accounts of Arab and Swahili-led caravans penetrating the little known interior. However, these merchants had no interest in geography and no knowledge of scientific instruments. Their stories were not always accurate either, for they were inclined to relate what they thought the missionaries would like to hear, rather than hard facts. Nevertheless, the missionaries' map, featuring an enormous lake shaped like a giant slug and bigger than the Caspian Sea, excited those who believed they might find there the source of the Nile. The Royal Geographical Society promptly dispatched an expedition to explore the region. Though it failed in its quest to discover the Nile's source, the detailed account of the journey was of great value to a prominent Viennese geologist by the name of Eduard Suess.

Professor Suess was the first to suggest that the system of valleys and lakes that crossed Arabia and Africa was a unique, continuous trough. He had read avidly all the reports of travelers and explorers to the region and, with remarkable insight for a man who had never set foot in Africa, adduced from them a far greater significance than the writers themselves could ever have guessed. In an illuminating paper of 1891 entitled *Die Brücke des Ost-Afrika*, Suess summarized all the existing knowledge of the geology and structural geography between Syria and Lake Malawi to proffer a theory of interconnected earth movements. The account of Count Samuel Teleki's harrowing journey to Lake Turkana was of special importance for it provided him with the vital clue to a continuous chain of Rift Valley lakes. Suess coined the word *graben* (grave) to describe the trough in which all these lakes lay, a word used to this day by geologists to describe a trough or valley formed when a block of land subsides between two almost parallel fault lines. His only mistake was to surmise that the formation had taken shape in too short a geological time frame.

Professor John Gregory was the man who really put Africa's Great Rift Valley on world maps. After studying geology at London University, he took a keen interest in Africa and the work undertaken by Suess. In late 1892 he seized the opportunity to accompany an expedition into Somali country in the hope of reaching an unexplored section of the Rift at the northern end of Lake Turkana, then known as Lake Rudolf. But the expedition was doomed from the outset because it lacked sound leadership

and organization. It foundered on the banks of the Juba River where the men turned back in disarray. Gregory returned to the coast and promptly left for Mombasa, thankful to get away. At least, he had learned some valuable lessons from the mistakes of others, which was to help him mount his own expedition to Lake Baringo for the purpose of proving Suess's theory empirically.

The expedition was a shoestring affair because Gregory was short of funds. Experienced travelers warned him not to cross Maasailand with fewer than seventy men, but he could afford to hire no more than forty—and he succeeded brilliantly, with the loss of only one porter through illness. His first sighting of the Rift Valley at the Kikuyu Escarpment, just northwest of modern Nairobi, was a dream come true. "We stopped there, lost in admiration of the beauty and in wonder at the character of this valley, until the donkeys threw their loads and bolted down the path." Whenever his little caravan reached uninhabited country, Gregory wandered off alone to collect rocks and plants, climb mountains, or examine the geological structure of volcanoes and cliffs. He always wore a jacket with large side pockets into which he stuffed rock samples, and his men, amused by this quirk, nicknamed him *Mpokwa*—Swahili for a person with bulging pockets.

Gregory's plan to stop for a few days at Naivasha and examine the Mau Escarpment was thwarted by belligerent Maasai warriors who demanded extortionate payments and nearly forced him back. After they made a failed night raid on his camp, he moved quickly on to Lake Baringo, where he studied the rock structure of the escarpments for a while. This change of plan was fortuitous. Overlooking Lake Baringo are the rugged Tugen Hills, a huge fault block standing in the middle of the Rift. Outstanding accumulations of lavas and sediments are exposed along the hills' eastern slopes, revealing the geological sequences of more than ten million years. The oldest fossil sites lie

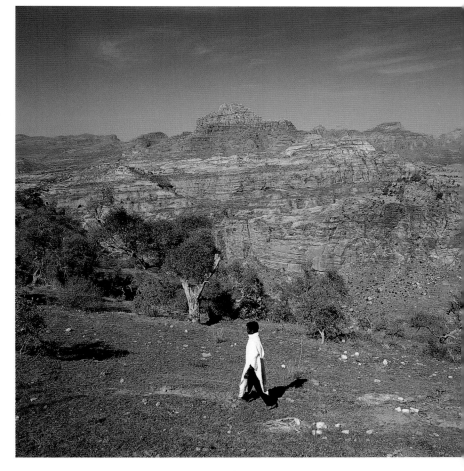

The Gheralta Mountains rise 8,000 feet in Tigray Province, northern Ethiopia.

close to the top of the hills, where scientists continue to make exciting finds. By comparing similarities in the strata of the Tugen Hills to other scarps, Gregory was able to prove to his own satisfaction that earth movements caused by faulting, not erosion, had formed the magnificent valley through which he had trekked all the way from the Kikuyu escarpment to Lake Baringo. His name for it, "The Great Rift Valley," has been used ever since to describe the entire African Rift system. In recognition of

OVERLEAF: *Kerimasi volcano in Northern Tanzania manifests the region's violent past. Ash from this and other dormant volcanoes formed a hardpan beneath the friable soil, which tree roots find almost impossible to penetrate.*

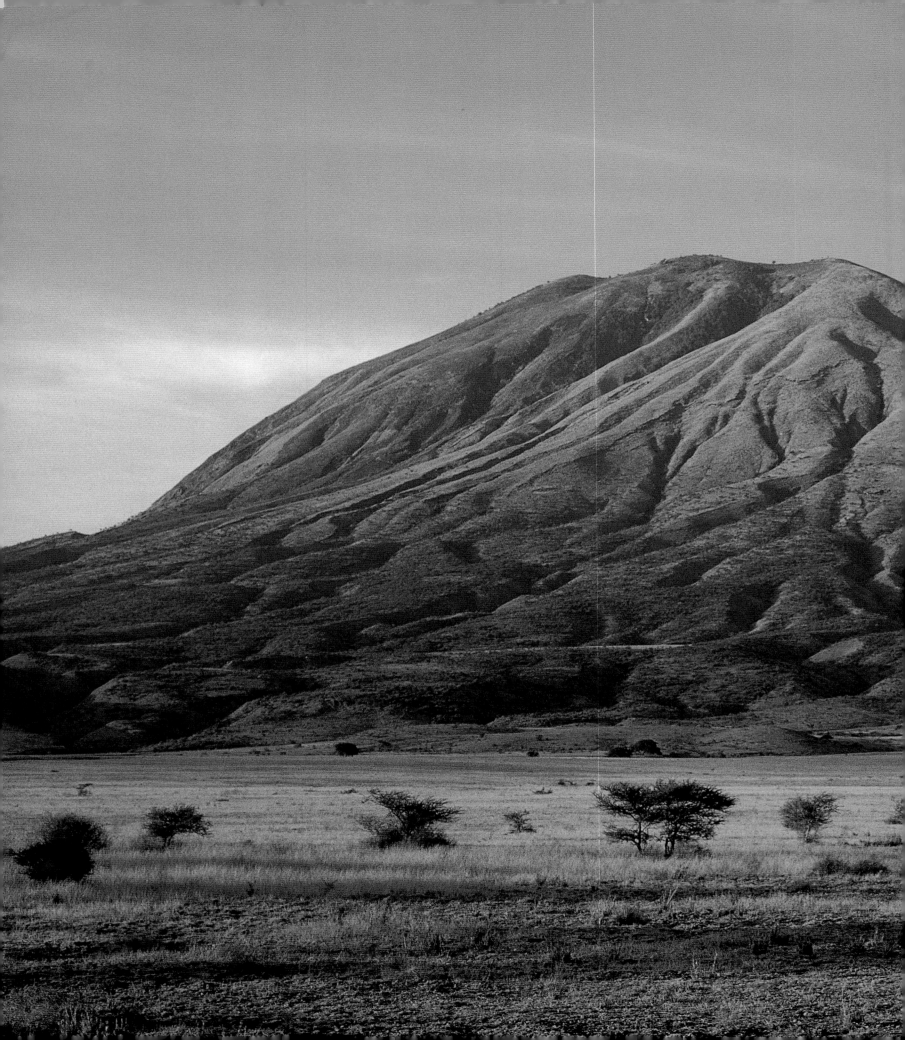

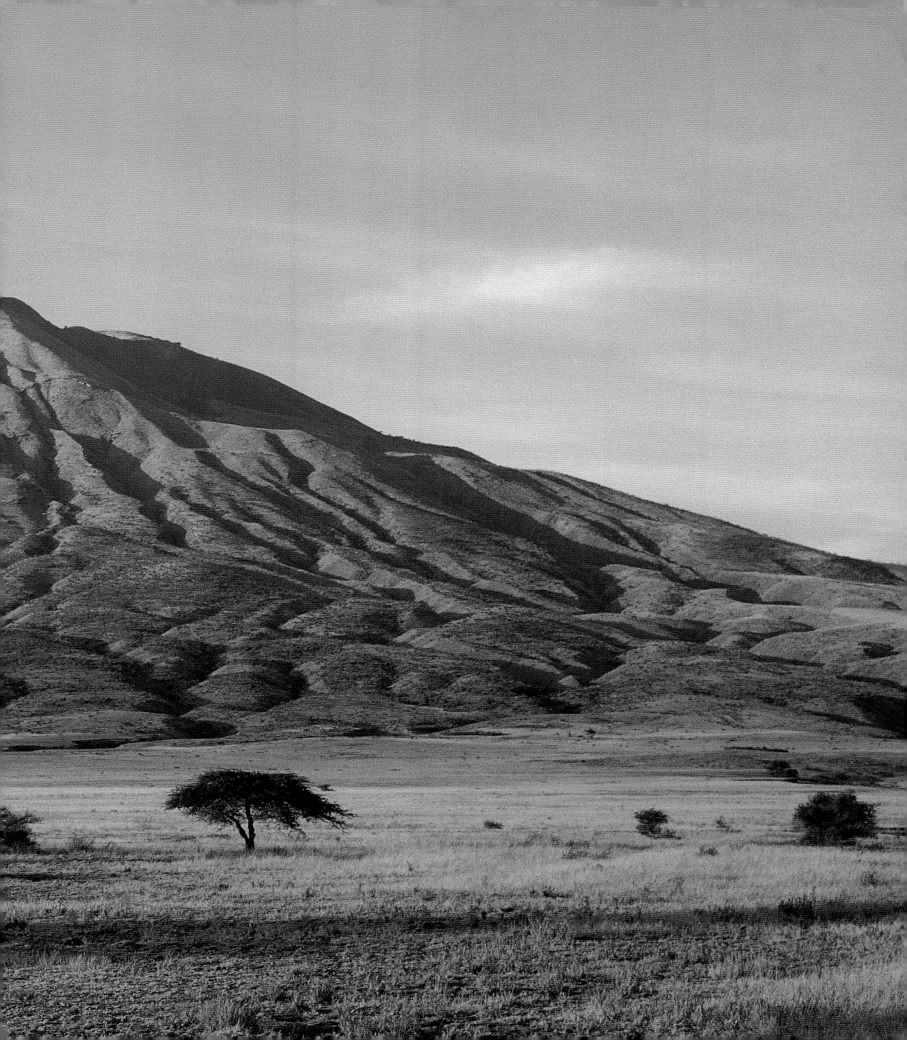

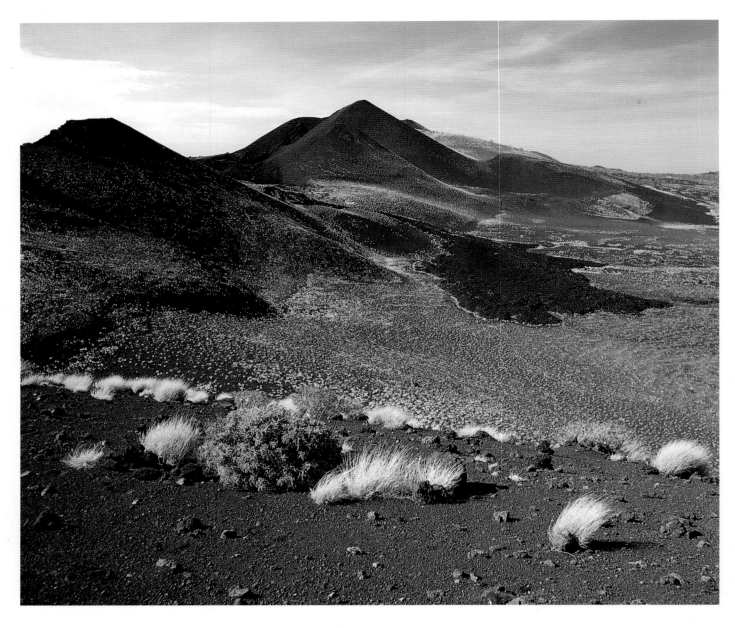

Scarcely anything grows in the sun-scorched, windswept volcanic soil of South Island, in Lake Turkana, northern Kenya.

his pioneering work, the dramatic portion of the Rift from northern Tanzania to central Kenya bears his name.

Evolution

Over the aeons, the world has experienced many major shifts of climate and vegetation. About eighteen million years ago, sea levels were much higher than they are today and temperatures were more extreme; the earth was warm and wet, which encouraged the growth of luxuriant vegetation and dense tropical rainforests in Africa. Three million years later, the climate became cool and dry. Sea levels decreased, and the African rainforests receded. This change led to the growth of woodlands and more open plains. There seems to be a correlation between these

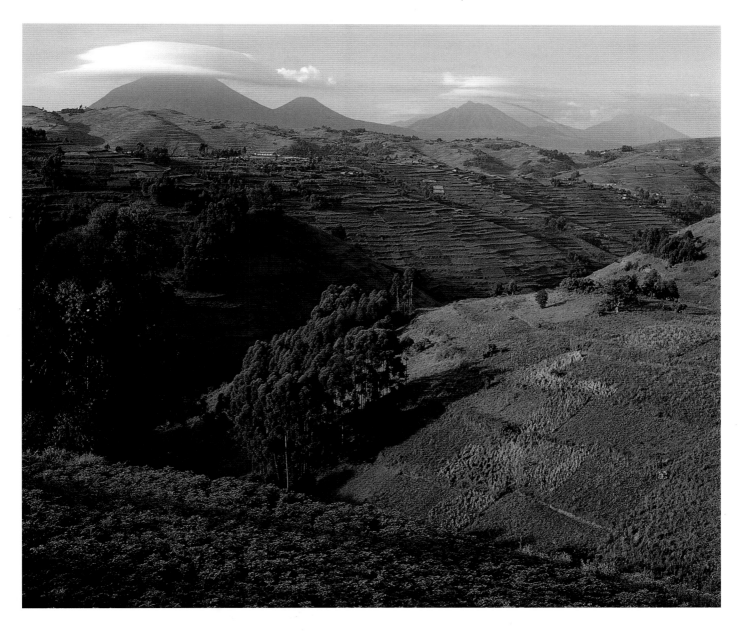

Abundant rain and rich volcanic soil combine to make the land in southwest Uganda exceedingly fertile.

events and the geographic upheavals associated with the formation of the Rift Valley at that time. Perhaps vast clouds of volcanic ash released into the atmosphere blotted out the sun and triggered a climatic change. Whatever the reason, a pattern of repeated swings from wet to dry and back again combined with a changing landscape to stimulate evolution of all kinds.

For a species to split into two or more different species, geographic isolation and long periods of separation are necessary. Geographic isolation can occur in many ways, not only as islands in a sea. Deserts, lakes, rivers, mountains, and remnant forest "islands" hemmed in by a "sea" of grass can also create geographic isolation. Speciation occurs when the genes in a small isolated population of living organisms

come to be unrepresentative of the entire gene pool. Genetic divergence can result in changes to the anatomical structure, size, color, and habits of a species as well as its inability to breed with other species, especially the one from which it evolved. Cichlid fish offer a fine example.

Cichlids are a large family of small brightly colored freshwater fish, popular for aquariums. The majority of them come from the lakes of Africa's Great Rift Valley. For two million years until 12,000 years ago, a series of dramatic climatic and temperature changes led to long periods of drought and falling water levels in the southern Rift lakes. Groups of cichlids became isolated in lagoons and rock pools, eventually diverging to become separate species. When water levels rose, they came into contact with other populations again, but genetic divergence prevented them from interbreeding. Closely related species cannot coexist for long without finding ways to differ from one another, because both are likely to seek the same food sources. Thus, the newcomers had to find ecological niches to fill—places in the food chain—or die out. The cichlids successfully managed to divide the available aquatic resources and flourished. There are now more than 430 cichlid species in Lake Malawi, for example, with the number still rising. Most of them are endemic, and all have found a niche—rock scrapers, plant scrapers, sand-digging insect eaters, scale eaters, leaf choppers, rock-probing insect eaters, and so on. The list is endless. Lake Tanganyika has another 200 endemic species, which are likewise extremely diverse. Combined, they represent well over half the world's cichlid population, which in all probability originated from a single ancestral species.

In the animal kingdom, the genus *Tragelaphus* (from the Greek *tragos*, a goat and *elaphos*, a deer) provides a good example of adaptive radiation—the evolutionary splitting of a single lineage into a number of distinct species. Once

again, geographic isolation and unlimited time are the essential prerequisites. Sometimes known as the bushbuck tribe, the *Tragelaphini* are medium- to large-sized African antelopes with spiral horns and may have originated from a single Asiatic ancestral immigrant over fifteen million years ago. Africa and Eurasia were joined at that time, allowing an influx of species to take place.

There are nine *Tragelaphini* species, all living in close proximity to the African Rift system. They can be divided conveniently into four groups by their habits and habitat, which possibly gives a clue as to how they separated and why speciation occurred tens of thousands of years ago. Fossil remains dating from the mid- to late-Pleistocene epoch have been found for all but two of them. The fossils point to only slight evolutionary change, with horns now less upright than they were in prehistoric times.

The nonterritorial, forest-dwelling species of *Tragelaphini* number four: the bushbuck, bongo, nyala, and mountain nyala. All have large rounded ears, tails with bushy white undersides, and a color range from light tan to dark liver-brown with whitish markings. They rely on concealment to avoid predators and tend to browse at night. The bongo, biggest and most colorful of all forest antelopes, is the shyest. The mountain nyala, rarest of the four, lives at high altitude in the Bale Mountain massif of Ethiopia, where small groups may also be seen in more open country.

The other *Tragelaphini* species are not forest dwellers. The sitatunga looks rather like a big bushbuck except for its oily, water-repellent shaggy coat. It has long, splayed hooves with flexible pads of skin, allowing it to walk with ease in soft mud. The evolution of such characteristics never evolves without good cause. Most aquatic of all antelopes, the sitatunga frequents papyrus swamps and permanent marshes, where it feeds on swamp vegetation in water up to its shoulders. To avoid detection, it may

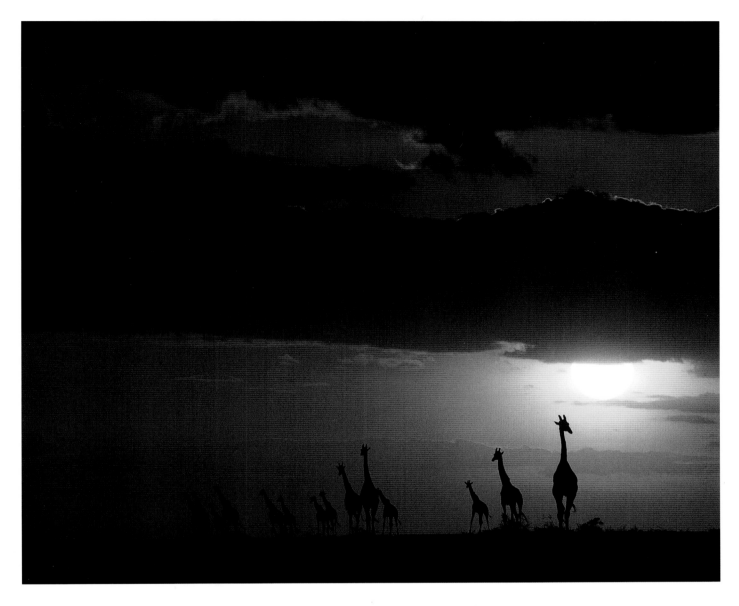

At certain times of the year, the treeless Serengeti Plains support the greatest concentrations of wild animals left on earth today.

hide by submerging itself almost totally. Despite this subterfuge, men hunting with packs of dogs persecuted it mercilessly in the twentieth century.

The greater and lesser kudus inhabit broken bush country. The greater kudu ranges widely, although many pastoral peoples covet the magnificent spiral horns of adult males for use as a kind of trumpet on ceremonial occasions and to call warriors to arms. The lesser kudu

frequents a much smaller arid zone of eastern Africa from Ethiopia down to southern Tanzania.

Last among the *Tragelaphini* are two species of eland, massive ox-like antelopes with dewlaps like those of Brahman bulls. Elands live in forested margins beside the wide expanses of the African plains, and though rather slow and seemingly cumbersome they can maintain a trotting pace for hours and are great jumpers. Several

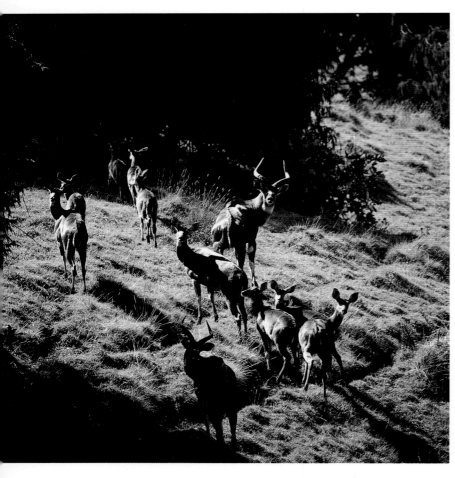

The Bale Mountains are home to the rare mountain nyala, a now-endangered species that was unknown to science until 1910. Well adapted to temperature extremes, the mountain nyala survives in isolated pockets above 9,000 feet.

attempts have been made to farm elands commercially for the superior quality of their meat and their ability to thrive in marginal lands. They have the advantage of being browsers as well as grazers and have the body mechanism to cope well in waterless regions. But the species lack several important characteristics necessary for successful domestication and will never be a substitute for cattle without recourse to genetic engineering.

With the possible exception of the African wild ass, which was domesticated either in North Africa or the Near East six thousand years ago, no large mammal native to Africa

has ever been domesticated by man. Notwithstanding Africa's biodiversity this phenomenon may not be as strange as it seems, for animals in Africa coevolved with protohuman and early human species over millions of years and thus had ample time to develop a sense of fear as the hunting skills of our ancestors steadily improved. In other parts of the world, animals evolved in the absence of predators, including humans, and had no fear. That mistaken trust led to the demise of many wild species.

Among African species that have never been fully domesticated, although they are farmed extensively, is the ostrich, the world's largest bird and a familiar sight of the African plains. Over millions of years in geographic isolation, the African ostrich adapted to its changing environment by developing tremendously powerful legs capable of running at high speed and kicking a marauding predator to death.

Ostriches are classed as ratites, a rather obscure late nineteenth-century name for an interesting group of flightless birds, which all have useless little wings. Smaller ratites also live in other parts of the world, but man has been responsible for exterminating the most vulnerable ones, including the elephant birds of Madagascar and all thirteen species of moa from New Zealand. Scientists are reasonably sure that ratites were flightless from the earliest times of their existence because none of them had a large breastbone or sternum where the powerful wing muscles necessary for flight would normally attach.

Humanity's Evolution

Much of the best fossil evidence of human evolution has been recovered from sites in Africa's Great Rift Valley, the most probable setting for the genesis of mankind. The most important paleoanthropological sites of the Rift include the Awash Valley and Hadar in the Afar region of Ethiopia, the Turkana Basin extending over much of

northwest Kenya and southwest Ethiopia, and Olduvai Gorge in northern Tanzania.

Human evolution can be traced back to a link with early apes by analyzing the evolutionary development of the skull. A good example of what might have been a candidate for human ancestry is *Proconsul*, a tailless, fruit-eating primate about the size of a female baboon. It emerged from a large assembly of arboreal primates living exclusively in Africa during the early Miocene epoch, about twenty million years ago. One of the early apes that migrated to Asia deviated around thirteen million years ago to give rise to the modern orangutan. Orangutans, however, are not man's closest relative, but a lineage remaining in Africa is thought to have progressed steadily toward modern African apes and humanity.

No one knows for sure what put its members on this evolutionary path, but the majority view holds that gorillas probably deviated from the phylogenetic tree about nine million years ago and chimpanzees between six to four million years ago with five million the most likely time frame. Modern chimps and bonobos—a chimp with a rounder cranium and less pronounced brow ridges and muzzle—share 98.4 percent of similarities in genetic composition to the human species and unquestionably are man's closest living relatives.

The potential for any species to multiply depends on natural habitat, especially food. As resources diminish and numbers increase, individuals have to exploit their surroundings more fully in order to survive and expand again. Eventually, competition forces some individuals to move to different environments where they may form new species given sufficient time and isolation. The first adaptation that distinguished early humans from apes was bipedal locomotion instead of locomotion on all fours. This seems to have been beneficial—freeing the forelimbs

for food gathering, tool using, or other functio[n] do not know the reason it occurred. Bipedalis[m] took place when more open savanna-type ve[g] replaced most of Africa's closed canopy forests toward the end of the Pliocene, an epoch that lasted from five to two million years ago. Until recently, scientists had linked bipedal adaptation to a much drier global climate, which was accentuated in eastern Africa by a massive phase of tectonic upheavals that shaped the Rift. These upheavals led to much drier conditions in the rain shadow east of the Rift. Though climatic fluctuations are sufficient to promote new species, evidence is now emerging to question whether the effects of climate and a change in habitat were the major causes of bipedalism.

Whatever the case, with their forelimbs freed, our earliest ancestors, the australopithecines (literally Southern Apes), began to travel greater distances in search of food and had the ability to carry it back to their secure abodes in the trees. They were still vulnerable to predators, however, and this problem persisted until they developed the art of making tools.

The oldest known secure evidence of divergence of the human lineage from African apes is *Australopithecus anamensis*, whose fossil remains were discovered in the Turkana Basin in 1994. Though *anamensis* had quite large canines and thicker dental enamel than apes, the discovery of a shinbone later that year showed that it was bipedal 4.1 million years ago. Another exciting discovery had been made a year earlier when *Ardipithecus ramidus* was found at Aramis in the Awash Valley of Ethiopia. It lived 300,000 years before *Australopithecus anamensis*, which might be close to the root of the family tree when African apes and humanity separated.

Among the most important discoveries that identify australopithecines with humanity are a remarkable trail of

fossil footprints at Laetoli, and the famous fossil remains of a nearly complete female skeleton from Hadar, called Lucy by her discoverer. Both are as interesting as they are important.

The Pliocene site at Laetoli in northern Tanzania was so named by local Maasai tribesmen after the magnificent red fireball lily, *Scadoxus multiflorus*, which grows there in profusion at the onset of rain each year. The Maasai identified the place as a potential fossil site to the pioneering paleoanthropologists, Louis and Mary Leakey, at the conclusion of a three-month research season at nearby Olduvai Gorge in 1935. Though other scientists had visited the site before them, the Leakeys were still able to collect a large number of exposed fossils. Mary Leakey returned there eventually in 1974, two years after her husband's death. In 1976, her painstaking research was rewarded when the hominid footprints of three individuals were discovered imprinted in tuff that had been ejected by Sadiman, a deeply eroded volcano standing nine miles east of the site. The excellent preservation of the imprints shows that they were made in moist ash, which hardened upon drying before being buried in ash layers from subsequent eruptions. They proved conclusively the presence of a hominid with an upright, striding bipedal gait between 3 and 3.6 million years ago.

Lucy's fossil remains were discovered in 1978 by an international team led by an American paleoanthropologist, Don Johanson. More complete than any other finds of a similar age, the skeleton stands out as the finest specimen of man's earliest ancestors yet located in the world. Classi-fied as *Australopithecus afarensis*, Lucy lived about three million years ago. A difference in body size between the sexes was common among the early australopithecines. As an adult, Lucy stood only three and a half feet tall; she had short legs relative to her trunk length. She still climbed

trees but was nevertheless an efficient walker, despite taking more steps than a modern human takes to cover the same distance. Lucy lived in a lush environment, however, and so had no need to walk far or fast. Her brain was no bigger than a chimpanzee's, and her dentition was distinctly apelike, featuring large canines. From a distance, she would have looked very similar to her more ancient relative, *Australopithecus anamensis*.

The earliest species of the human race evolved from the australopithecines between 2.5 and 2 million years ago in an evolutionary process that was confined to Africa. First on the world stage was *Homo habilis* (handy man), followed by *Homo ergaster* (workman), and then by *Homo erectus* (upright man). Until 1992, *Homo ergaster* and *Homo erectus* were classified as a single species. When it became evident that Africa's skulls were much older than the earliest Asian fossil remains discovered in China and Java—with the crania longer, higher, and more rounded at the back of the head—scientists decided to reclassify them as a separate species. The most significant discovery of *Homo ergaster* fossil remains, called Turkana Boy, date to 1.56 million years ago. Found on the west side of Lake Turkana in 1984, the skeleton is the most complete one of any early human ancestor. The boy died when he was about twelve years old and stood 5' 8" tall yet he only had a brain size equal to that of a modern one-year-old. He would, however, have reached six feet in height at maturity, which was taller than had been previously thought the case for archaic *Homo* species.

A crucial factor in the evolution of australopithecines to anatomically modern humans was their increased meat consumption, which was made possible by their use of stone tools, examples of which have been gathered at numerous sites. In time, meat eating altered the arrangement and shape of early hominids' teeth, and with that the shape of their skulls. A combination of manual dexterity

and an increased calorie intake eventually led to an enlargement of the brain. Since meat is rich in protein small quantities give great nutritional value, unlike most plant food, and so the continual quest for food became unnecessary. This left time for *Homo* to engage in other activities, which led to the rudimentary beginnings of human social behavior.

There are two opposing theories about the emergence of the human race: a multiregional theory and an Out of Africa one. Though support for the multiregional theory is dwindling, its proponents argue that *Homo sapiens* emerged from populations of *Homo erectus* in diverse parts of the Old World. They go on to suggest that *Homo erectus* (which largely disappeared from the fossil record 200,000 years ago) emerged from *Homo ergaster* outside Africa. In 1999, an exceptional fossil find of *Homo ergaster* at Dmanisi in the Republic of Georgia produced the oldest human fossils ever to have been found outside Africa. Two almost complete skulls not only lent support to the timing of the species' exodus to Eurasia about 1.8 million years ago but also showed an affinity that confirmed beyond doubt its African roots.

The Out of Africa theory offers the more probable sequence of events. Its proponents contend that *Homo sapiens* emerged in sub-Saharan Africa from an archaic *Homo* species, which in turn had emerged from *Homo ergaster* living in Africa about half a million years earlier. The fossil records of *Homo sapiens*, which appear to be much older in Africa than elsewhere in the world, reinforce this argument, for the appearance of anatomically modern humans seems to date back roughly 120,000 years. A fossil discovery at Kibish in the Omo River Delta, north of Lake Turkana, was a vital clue in establishing this likely date. The Out of Africa theorists now believe that these human ancestors began their migration into Eurasia

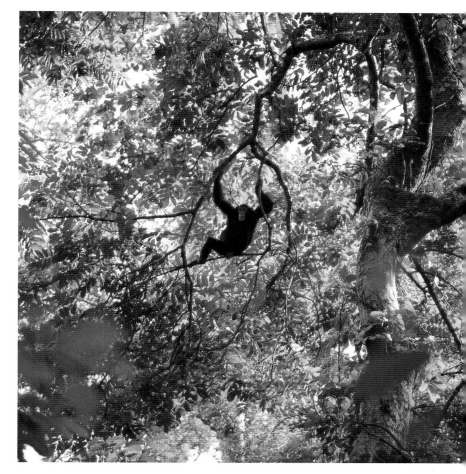

A chimpanzee swings in the high forest canopy of the Kyambura Gorge, western Uganda.

about 100,000 years ago, and that dispersal across the subtropical zone was rapid.

Ongoing research of the available variations of mitochondrial DNA (mtDNA) lends support to the Out of Africa hypothesis. Every life form has the same complicated double helix DNA, indicating that it originated from the same source. Mitochondrial DNA are the microscopic powerhouses that provide a cell's energy. They mutate faster than nucleus DNA and can only be inherited through the maternal line. Studies already show that mtDNA among the !Kung bushmen of southern Africa and the pygmies of tropical Africa exhibit greater diversity than elsewhere and are therefore more ancient. An

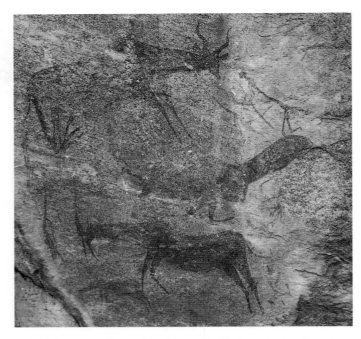

Rock shelters at Kolo, northern Tanzania display paintings by early hunter-gatherers that could be 7,000 years old.

African Mitochondrial Eve in the Biblical sense is hardly a reality, yet an analysis of mtDNA and the Y chromosome, which is only passed on through the male line, will enable genetic anthropologists who can gather sufficient data to establish past associations of peoples around the world. There will be some surprises as knowledge of the past is transformed. The well-known paleoanthropologist Dr. Richard Leakey has already highlighted one issue: "Africa was not *discovered* by Europeans; it created them!"

Homo sapiens sapiens (the earth's present human species) reached Eastern Europe at least 45,000 years ago and coexisted with Europe's hominid, the Neanderthal, for several thousand years. Though Neanderthals had larger bodies and brains than humans, these features might have been adaptations to retain body heat in glacial conditions. Unlike other species, Neanderthals coped well with cold. DNA tests carried out on a Neanderthal bone in 1997 finally laid to rest the long-running debate over their links

to our human ancestors: they were a separate species but not necessarily of lower intellect than humans or incapable of articulate language. They most probably evolved from *Homo ergaster* in Europe long after the first African exodus had taken place. The reason for them dying out 28,000 years ago remains unclear, but it might have been the result of competition with early humans who were technologically more advanced. Although they made stone tools, Neanderthals rarely carved bone implements and appeared not to understand art.

Human history in Africa began to accelerate about 50,000 years ago, evidence for which appears with the finding of more complex stone tools and ostrich eggshell adornments at Kenya's Rift Valley sites. Widely considered an important class of evidence for modern human behavior, the presence of ornamentation indicates increased social communication and solidarity. Among today's hunter-gatherer communities, for example, beads are a common gift. Over the next 10,000 years, the art of making more sophisticated tools and artifacts spread to different parts of the world as our hunter-gatherer ancestors sought food farther and farther afield. Perhaps their rapid colonization of far-flung places also had something to do with the development of speech, upon which human creativity depends so much.

Domestication of Plants and Animals

Global temperatures reached the glacial maximum during the final phase of the Ice Age 20,000 years ago when Africa was gripped in drought. Once the climate warmed again, abundant plant and animal life reappeared. Hunter-gatherers moved back into northern Europe and expanded elsewhere. A major advance for humanity was the domestication of plants and animals starting 12,000 to 10,000 years ago in the Fertile Crescent—that historic swath of land in the Middle East that encompasses parts of modern

Turkey, Syria, Iraq, Iran, Lebanon, Israel, Palestine, and Jordan. Until then, every human being on earth lived by hunting and gathering wild foods. The change in lifestyle was very gradual, initially being no more than an insurance against famine when the natural resources of a region dwindled as populations grew. It could be argued that the origin of the modern world is rooted in the Middle East.

The Fertile Crescent was blessed with a mild Mediterranean climate, and a bountiful plant and animal inventory suitable for domestication. Hunter-gatherers had long identified emmer wheat and barley as the most palatable and the most easily harvested of the wild grasses, and so cultivated them first. Everyone takes grass for granted, but the human race, not to mention domestic and wild animals, relies very heavily on it. Almost every important food crop today is grass: maize, wheat, barley, rye, millet, sorghum, rice, and teff.

Also native to Eurasia were 13 of the world's 14 big mammals, which were to prove suitable for domestication. Once people had realized their value, wild animals were rounded up, tamed, and protected as a first stage toward full domestication, which took more than five thousand years. The wild ancestor of cattle, the auroch (*Bos primigenius*), was an early candidate for domestication and marked another great milestone in human history, for cattle have fulfilled key agricultural, cultural, and religious roles in society ever since. The powerful black auroch, standing six feet tall at the shoulder, ranged over large tracts of the Old World until its disappearance 400 years ago, largely due to deforestation and indiscriminate hunting by man. It was a stunning extinction for its time, but pales to insignificance with the scale and rate of human destruction today.

Theories about the origins of modern cattle populations in Africa remain divided. The auroch is known to have roamed ancient North Africa several thousand years before domesticated cattle appeared during a dry climatic

phase about 9,000 to 8,000 years ago. A thousand years or so later, dated archaeological remains and artistic representations of humpless beasts in the Ahaggar Mountains of Southern Algeria identify the region's first cattle as taurine, akin to the European breed (*Bos taurus*). Although Africa's cattle may have been introduced from the Middle East, where taurine cattle had been selectively bred, more and more evidence now points to independent domestication.

Whereas agriculture preceded the domestication of wild animals in the Fertile Crescent, the reverse was the more likely scenario in Africa. Moreover, the African centers of cattle domestication and tropical crop development were geographically quite separate. Many burgeoning communities embraced pastoralism—gaining a livelihood from the care of livestock in semiarid lands—for economic, social, and cultural reasons well before agriculture became commonplace. Over the centuries, the process of selective cattle breeding produced African taurine breeds with

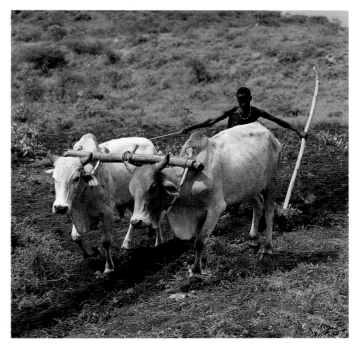

A young man tills the soil with yoked oxen near Konso, southwest Ethiopia. His primitive "plough" is a sharpened pole hewn from hardwood.

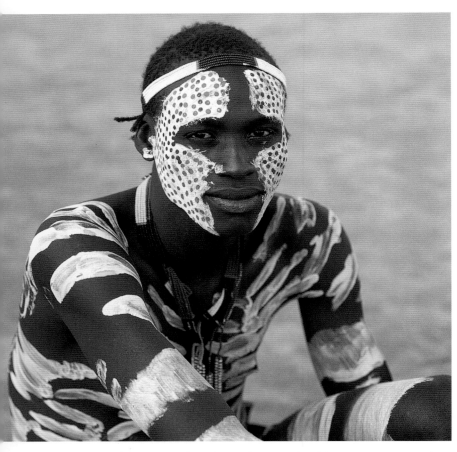

A young man from the small Karo tribe of the Omo River in south-west Ethiopia has decorated himself in preparation for a dance.

economically important traits. They adapted well to heat, drought, and poor quality feeds, while some became tolerant to endemic diseases, in particular trypanosomiasis borne by the tsetse fly. Only the African buffalo has complete resistance to this killer disease, but the N'Dama cattle breed of West Africa has near immunity: animals may get sick but invariably will recover. There is usually a price to pay for selective breeding: in the case of the African taurine, these characteristics have been achieved at the expense of productivity.

Driven by adverse climatic conditions 4,500 years ago, the pastoral communities began to migrate across the African continent along routes that remain largely unknown. Archeological and molecular studies of taurine cattle, however, point to several dispersal routes radiating from a possible center of origin in Upper Egypt. This research indicates that most groups set out in a westerly direction: only one moved south. The people of the southern movement followed the Nile to an ill-defined area somewhere near the border of southeast Sudan and southwest Ethiopia, where they are thought to have lived for untold generations before moving on again. From time immemorial, this region has been a melting pot of many diverse ethnic groups.

Large numbers of humped-backed or zebu cattle (*Bos indicus*) were brought into the Horn of Africa during the human invasions from Arabia in the seventh century BC. These cattle had originated from wild auroch populations in a region that now forms part of northern India and Pakistan, and had been separated from the Near East for upwards of 200,000 years. They soon proved popular for their greater resistance to drought and their heavier build. Since the tsetse fly is unknown in Asia, zebu cattle had no reason to develop adaptive genes, which was a drawback to their dispersal through the tsetse fly belt lying roughly 10 degrees of latitude either side of the equator across the entire breadth of the African continent. It was, therefore, an incredible stroke of good luck that they were introduced into the Horn of Africa, a mostly fly-free zone due to its dry climate and sparse vegetation.

By painstaking human selection, the pastoral communities of eastern Africa successfully crossbred taurine and zebu cattle to produce the hardy sanga breed. Despite the breed's susceptibility to trypanosomiasis, a coincidental change of climate gave people the opportunity to expand into sub-Saharan Africa. The semiarid region forming the transitional zone between the Sahara Desert and the humid savannas to the south was four to five degrees north of where it is now and contained several lakes. In an ensuing dry phase, the tsetse fly lacked the

moist soil and shady conditions so necessary for breeding and retreated south. This left large tracts of virgin land suitable for the nomadic herders of sanga cattle. In time, the acquisitive people discovered a north-south corridor running along the temperate margins of the Great Rift Valley, which became their gateway to the south. The colonization of southern Africa would have been impeded without the natural advantages of the Rift system.

Human Expansion

Africa presents a striking mosaic of people from five clearly defined racial groups. Its exceptional diversity arises from an equally diverse geography spanning the temperate zones of the northern and southern hemispheres. It has no written history except in those countries bordering the Mediterranean Sea and Ethiopia. This makes the task of tracing population movements difficult, the more so because humans have lived there far longer than anywhere else. A thousand languages are spoken in Africa, making up one quarter of the world's total. However, linguistic experts are able to categorize them into four main groups, or phyla. By combining aspects of language, culture, agriculture, and livestock, insight may be gained into a people's origins and movements. It just so happens that the peoples of the

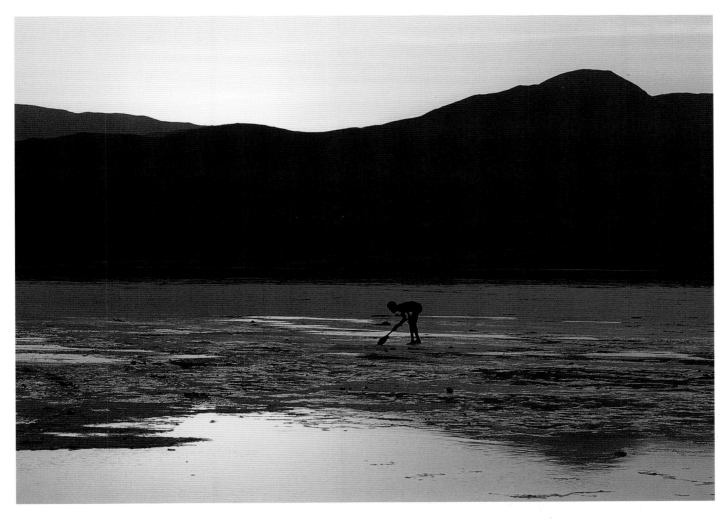

As the light fades on a blistering day, an Afar man digs salt from Lake Assal, Djibouti.
He will toil late into the night, and load his camels before dawn the following day.

Eastern Rift are harder to unravel. The population is the most ethnically mixed of the entire continent due to the ancient cultural diffusion that took place in southern Sudan.

In the same way as plant and animal domestication in the Fertile Crescent changed the lifestyle of the people there, a pattern emerged in Africa three to five thousand years later. Although the Sahara Desert was a major ecological barrier, adverse climatic conditions and a paucity of wild plants suitable for domestication caused the delay. Moreover, the continent had an exceptionally rich biodiversity, which made it unnecessary for the inhabitants to change their well-established hunter-gatherer lifestyles. The natural environment was measured only in terms of security: personal security and shelter, food and water security, and security from disease. The importance of soil and rainfall were yet to be understood.

By 5,000 BC sorghum, pearl millet, peanuts, cowpeas, and African rice had been domesticated in land south of the Sahara Desert, followed two thousand years later by yams and oil palm in tropical West Africa. About this time, the Ethiopian Highlands also became an important center of domestication with a small-grained cereal called teff (*Eragrostis abyssinica*), finger millet, coffee, and *ensete*, the false banana (*Ensete ventricosa*), all cultivated from wild plants. Meanwhile wheat and barley from the Fertile Crescent had reached Egypt and North Africa, but bananas and plantains native to Southeast Asia took much longer to arrive by sea at trading centers along the East African Coast. Bananas proved enormously popular, and more than any other crop, turned people into sedentary agriculturists, which triggered a population explosion. As hunter-gatherers, families could usually cope only with a single child unable to walk with the group because of the almost daily movement required to hunt. But there was no such concern in a home with permanent cultivation nearby. Populations increased tenfold.

The change from a traditional hunter-gatherer existence to agriculture was a long, drawn-out affair. At first, cultivation was of secondary importance and people moved frequently. The introduction of iron implements, however, quickly brought about food surpluses and population growth, which regularly outstripped the carrying capacity of the land. The sizes of cultivated fields then increased, and land clearances kept pace, but a combination of poor agricultural practices and an irreversible decline in the availability of wild foods still kept people on the move. Improvements in traditional weapons and hunting techniques further aggravated the problem, and large tracts of land were regularly abandoned when they became devoid of game. In consequence, tsetse flies changed their feeding habits from animals to humans, who contracted sleeping sickness for the first time. The long-standing maxim about evolution, which states that a species must adapt to changing conditions or face extinction, could never have been truer.

The Bantu are Africa's largest linguistic group and a classic example of people reacting to change. The many similarities in more than two hundred distinct languages of the Niger-Congo phylum have led experts to determine that all Bantu speakers originated from a single source, although they are now culturally and economically diverse. When their existing natural resources could no longer support a growing population some 5,000 years ago, Bantu peoples began to leave their homeland near the present-day common border of Nigeria and Cameroon in West Africa. Since the country to the north and west of them had been settled, they had to find a way around the vast tropical rainforest of the Congo, which loomed menacingly to their east.

One group, known as the Western Bantu branch, opted for a coastal route, which took them in a southerly

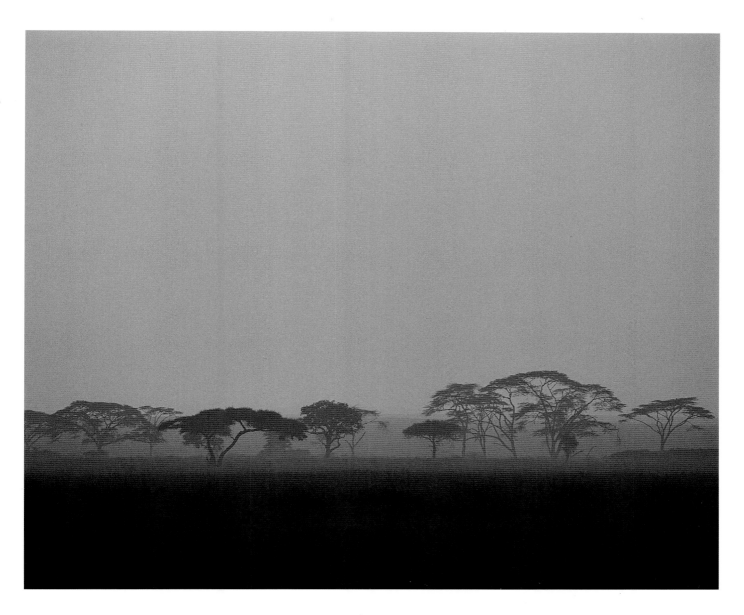

An early morning mist silhouetting acacia trees will soon evaporate beneath the rays of the rising sun to herald a scorching day in northern Tanzania.

direction along the South Atlantic coastline of West Africa. In the many hundreds of years of hardship they endured to clear the tropical rain forest, most of their livestock was lost to the tsetse fly. From time to time, they settled in stable communities in the multitude of fertile valleys carved in an east-west direction by rivers emerging from the tropical rain forest, which they fished to supplement the protein in their frugal diet. They also improved their agricultural skills by planting yams and cowpeas in the open spaces. The dense forests were left entirely to the pygmies whose lifestyles were so different from the newcomers that peace prevailed. Still, the present-day lack of pygmy languages suggests that the Bantu must have overwhelmed many scattered pygmy populations at that time.

Once the main body of the Western Bantu branch reached modern-day Angola, most people were forced to

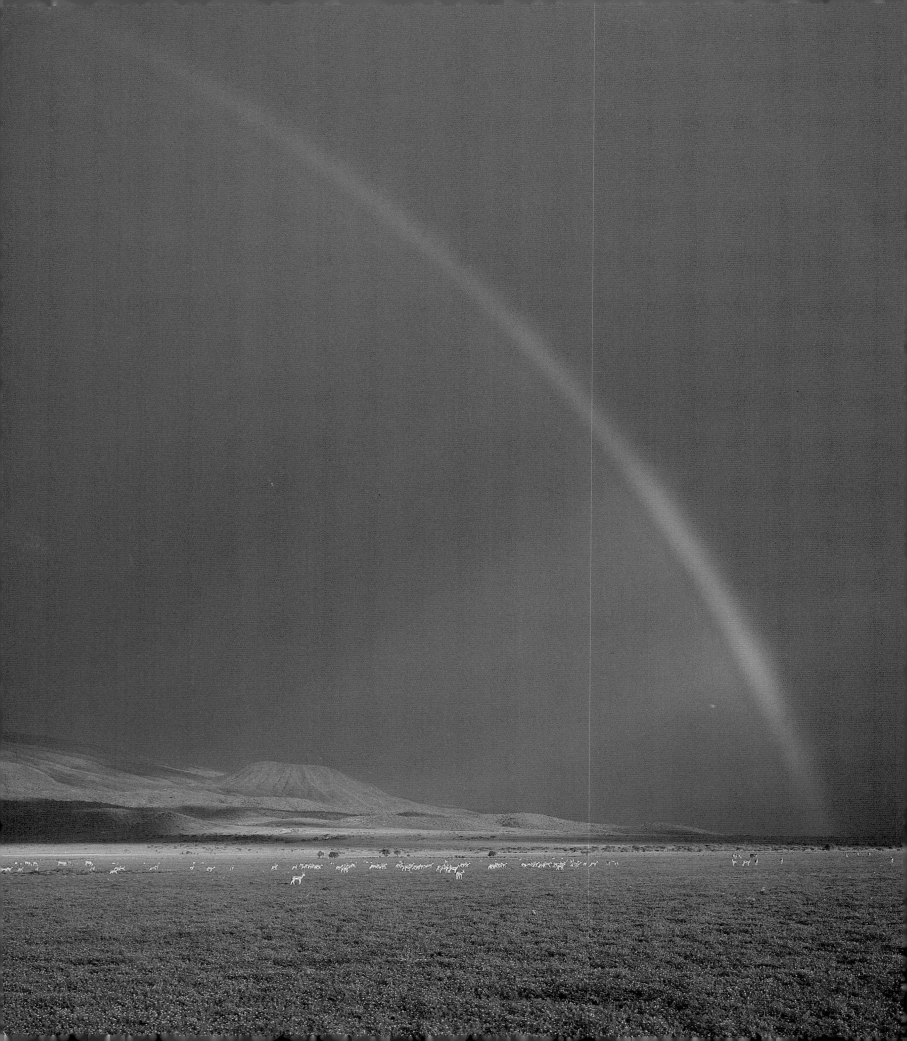

take up hunting and gathering again because the poor soil of the scattered woodlands was unsatisfactory for growing yams. This change put them in direct conflict with San Bushmen, who retreated south to places where the Bantu could not easily survive. While many Bantu family groups turned east toward Lake Malawi, others forged south into Namibia: the Xhosa reached the Great Fish River of Southwest Africa before unfavorable conditions brought them finally to a halt. The Dutch found them living there in 1652.

The Eastern Bantu branch was more fortunate. Its members set out in an easterly direction, skirting the northern margins of the tropical rainforest to reach the Great Lakes Region of central East Africa two thousand years later. Along the way, they acquired sorghum and millet from farmers living in the grassland savannas south of the Sahara and taurine cattle from herders of central Sudan. Being creative and inventive, they also learned to smelt iron while improving their skills as potters. It was a rewarding period by any standard. The imported banana plant was of major benefit to them. Quite how, when, and where it came into their possession is uncertain. Perhaps they found it growing in the Great Lakes region, where plantains have since become the staple food of most Bantu-speakers there. Only known for certain is that banana cultivation was widespread throughout East Africa in the first century AD, and that the region now has more varieties than elsewhere in the world.

The Bantu diaspora did not end on the fertile plains and valleys of the Great Lakes region. Instead, the pace quickened. Though some people did remain, whose descendants established the Kingdoms of Buganda, Bunyoro,

and Karagwe, others pushed east to the Kenya Coast. Others traveled south following the lakes of the Western Rift to link up near Lake Malawi with Bantu-speaking peoples of the Western Branch, with whom they no longer had a common tongue. During their long separation, the Western Bantu had only acquired bananas, not sorghum or millet, which their distant relatives now gave them. This is established beyond reasonable doubt because the Bantu words for sorghum and millet are of Eastern Bantu origin. The Western Bantu also had the opportunity to restock because the Eastern Bantu cleverly avoided the fly belt by driving their herds down a tsetse-free corridor along the high margins of the Rift.

By the close of the third century AD, Bantu domination of the entire African continent south of the equator was complete. The loosely knit bands of San Bushmen, whose territory had once extended north into East Africa, were no match for agriculturists wielding iron tools. They had to retreat, and there are two clues to the extent of their former territory. The first one is a fine display of rock art in shelters along the edge of the Maasai steppe near Kondoa in central Tanzania. The other one is the "click" language spoken by the Sandawe of the central Tanzanian Rift, who appear to have racial affinities with some Khoisan speakers of Southern Africa.

The Great Rift Valley has given the world the gift of humanity. It has also given the African continent a dramatic landscape of outstanding beauty and a natural world that has no equal. These and other aspects of this amazing valley, and some of the people living there, will be explored in the remaining sections of this book. .

Thomson's gazelles and other antelopes congregate to feed on new shoots when rain turns the parched grasslands to a verdant green.

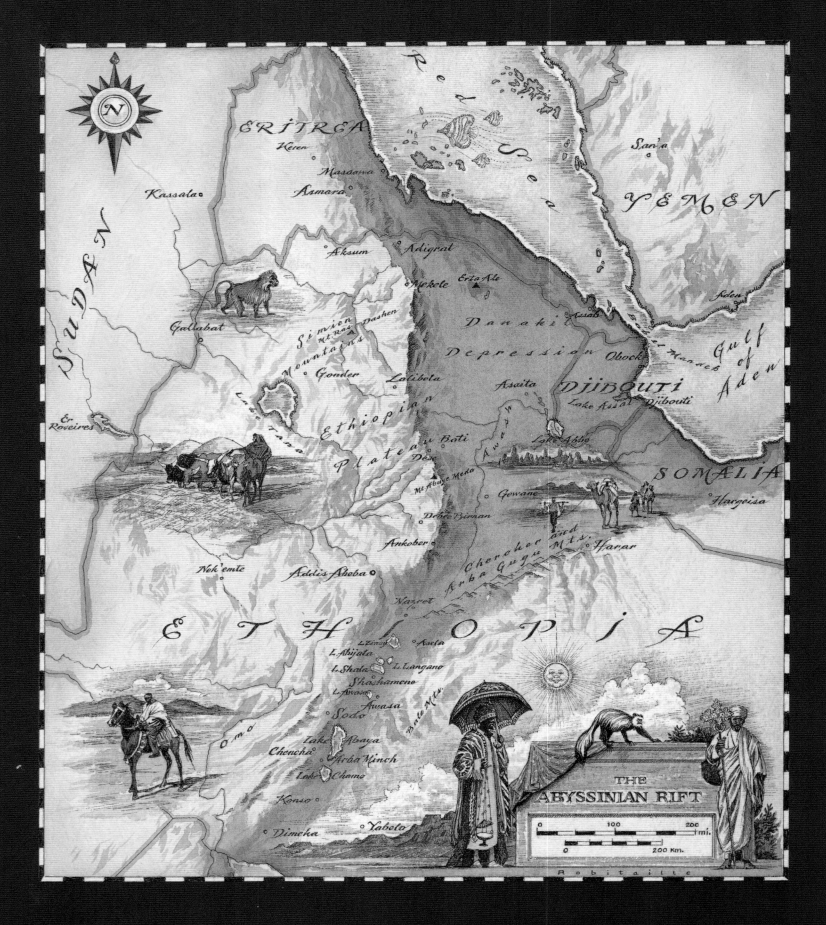

THE
ABYSSINIAN RIFT

| 0 | 100 | 200 |
| mi. |

| 0 | 200 Km. |

The Abyssinian Rift

The Great Rift Valley forms a trough of unrivalled grandeur running through the middle of Ethiopia from its northern extreme in Eritrea to its southern border with Kenya. It encompasses the tiny republic of Djibouti, situated at the mouth of the Gulf of Aden, and a narrow coastal strip of Somaliland. These countries of the Horn of Africa have within their boundaries every type of climate and terrain in a landscape of vast horizons and dramatic vistas.

The Ethiopian highlands constitute the largest volcanic massif in Africa with more than 50 percent of the continent's landmass above 6,000 feet. The massif dominates a region surrounded by a sea of arid plains and desert wastes. It was the heart of the ancient Ethiopian empire and the stage for all of its feudal history. Centuries ago, a journey to the emperor's court was a hazardous feat through the inhospitable land of nomadic tribesmen with a justified reputation for emasculating or murdering male strangers. Until the middle of the nineteenth century, mysterious Ethiopia was hidden from the outside world.

Twenty-five million years ago, low-lying parts of the Horn of Africa emerged from the sea, and Ethiopia's arched landmass rose like a giant blister 8,000 feet above the surrounding plains. The tension on the earth's crust was immense and something had to give way. Eventually, parallel cracks appeared along the axis of structural weakness, triggering massive volcanism. In the aftermath of this, faulting and down-warping began to shape the Great Rift Valley. In Tigre Province, west of Adigrat, the land rose 9,500 feet.

For millions of years, immense volumes of basalt lava flooded through fissures to layer the land with rock up to 7,000 feet thick. Some of the most striking accumulations of lava are along the scenic western scarp of Ethiopia's Rift system near Balchi, Debre Sina, and Ankober, where they lie 3,000 feet thick. Today, the land falls away with startling abruptness. The sheer walls of the awesome escarpment, often stepped and usually deeply eroded, were formed anew less than two million years ago when faulting and volcanic activity entered a new dynamic phase.

The Rift Valley developed long after the existence of these volcanic highlands because the trough separated the Chercher, Arba Gugu, and Bale Mountains from the highlands at their southeast corner. Faulting also divided the region into two plateaus, the Ethiopian to the west and the Somalian to the east. Huge, deeply eroded horsts—elongated fault blocks that have been raised above the level

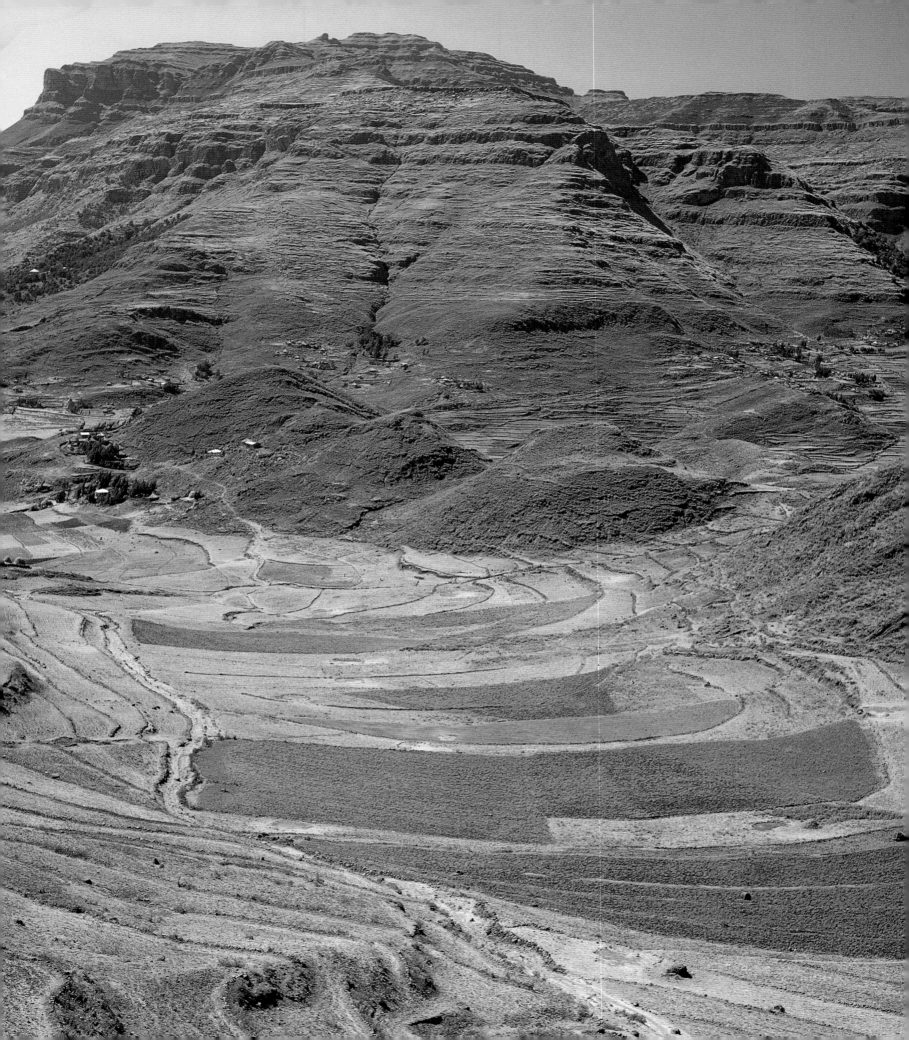

of surrounding land—are a feature of the east. In Ethiopia, they were elevated as a result of the tectonic movements that sculptured the Rift Valley but are not actually a part of the system itself. These extensive mountainous areas rise to 9,800 feet in Eritrea, and 6,500 feet elsewhere.

Over the millennia, erosion has sculpted the landscape in Ethiopia more than in any other part of the Rift system. The spectacular gorges and great ravines that make communications difficult were carved out of solid lava rock when little streams were mighty rivers in the Pleistocene epoch. Some of the dramatic scenery resembles America's Grand Canyon. Glaciation of the highest mountains also occurred during the last Ice Ages, but in the present climate the peaks are not high enough for permanent snow. Nevertheless, a history of climatic extremes, and the isolation of areas lying to the north and to the south of the Rift divide, have influenced Ethiopia's diverse flora and fauna.

The low-lying Danakil Depression of northeast Ethiopia makes a triangle with the Afar Desert to funnel the Rift system into eastern Africa. The region is conspicuously volcanic in origin with Erta Ale and other cones still active along the lines of crustal weakness within the Rift system. Lava rocks and ash are strewn everywhere and fields of hot yellow sulfur heave and spit like a witch's cauldron. Temperatures on the rocks reach 165 degrees F, making the place the most truly forbidding of the entire Rift system. Yet, four and a half million years ago this landscape was home to early man. Among many exciting discoveries unearthed by researchers in the Afar region in modern times was the fossilized skeleton of the world's earliest known hominid, *Ardipithecus ramidus*.

OPPOSITE: *Ethiopia is a land of vast horizons and dramatic scenery. Weathered mountains near Maichew exhibit layer upon layer of volcanic material, which built the Ethiopian Highlands into Africa's greatest plateau.*

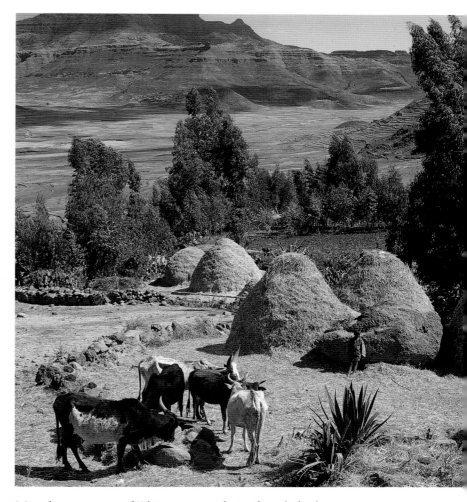

More than 90 percent of Ethiopians earn a living from the land, mainly as subsistence farmers. Stacks of unthreshed grain will keep a family and livestock fed during the dry season.

Today, in the wickedly hostile climate of the area, the Afar people lead a nomadic lifestyle tending stock in a semi-desert terrain containing forage good enough only for goats and camels, rarely cattle. Once known as the Danakil, the Afar have never given more than token allegiance to the central governments of Ethiopia and Djibouti. Proud, self-confident, and much feared by outsiders, they pledge loyalty to their sultans and adhere nominally to the Sunni branch of Islam.

Until the Awash River was harnessed for irrigation, low rainfall made cultivation impossible in the Danakil despite pockets of fertile soil. Residents of the Danakil,

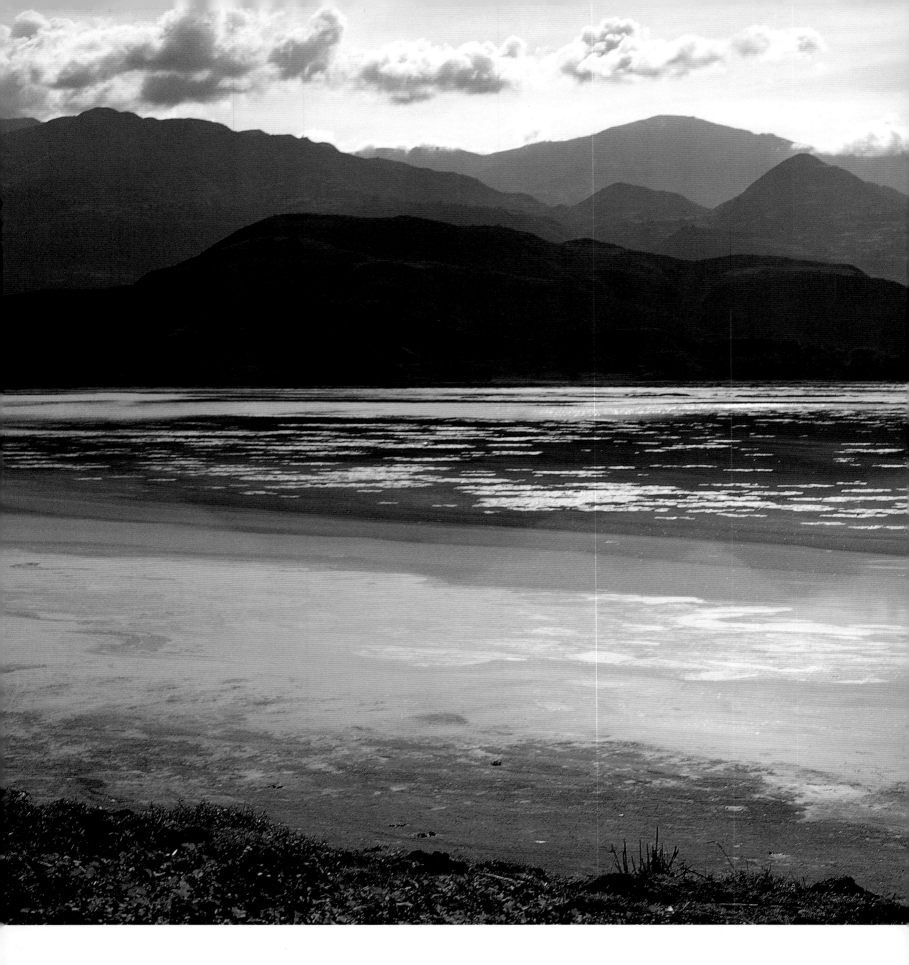

however, have always benefited from a ready demand outside the area for frankincense—an aromatic gum resin from the indigenous *Boswellia* tree—and salt, which lies in deposits 1,600 feet thick. Salt owes its origins there to the separation of a Red Sea gulf by a barrier of basaltic lava ten thousand years ago. The gradual evaporation of the trapped seawater ultimately produced a natural resource that man has mined for more than two thousand years in the northern plains, where the land drops 380 feet below sea level. Desert warriors toil in tremendous heat to hew blocks of raw salt into bars that have long been a standard form of currency in the region. Every bar travels to market on camels whose owners live ten days distant in Tigre province, a very different world, where the land rises more than 6,000 feet above the Rift's sweltering floor.

In stark contrast to the heat and dust of Afar country, a temperate climate atop the Western escarpment of the Rift permits the people, who are largely Christian, to work the land intensively using age-old farm implements. The rural scene seems almost biblical in its simplicity. Teff, the staple food of most Ethiopians is a small-grained cereal used to make *injera*, a fermented, bread-type pancake. Thin, round, and mildly sour tasting, *injera* is eaten with a highly spiced meat or vegetable dish called *wot*, which comes in many varieties. Teff stands as an example of Ethiopia's early success as a center of plant domestication, which did not happen by chance. The highland climate allowed people to live there unconstrained by the debilitating endemic diseases of lower altitudes such as bilharzia, malaria, and trypanosomiasis. By about the fifth century BC, Ethiopians were already irrigating their land and using ox-drawn ploughs to increase crop yields.

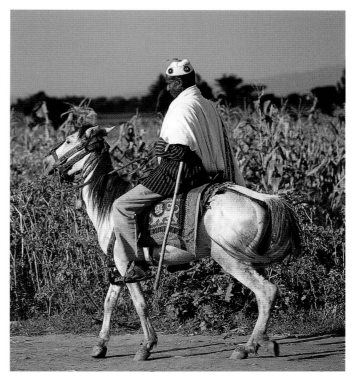

Hardy Abyssinian ponies are renowned for their stamina. The rider of the gaily-caparisoned pony above sits on a saddlecloth decorated with the imperial lion. Lions are associated with Ethiopia's last monarch, Emperor Haile Selassie, sometimes known as the Lion of Judah, because he kept tame lions at his palace.

Agriculture still forms the backbone of the Ethiopian economy, with 90 percent of the population earning a living from the land. Markets, therefore, are important commercial and social centers, for the people live in scattered rural communities and travel great distances each week to sell their surplus animals and farm produce. Highland farmers often ride to market on gaily-caparisoned ponies as sturdy mules carry the heavy loads. Those who live in the lowland regions load donkeys and camels and walk beside them for hours, oblivious to the scorching heat. Transactions in the marketplace rarely begin much before midday and continue well into the evening. Markets are lively, noisy,

Between Senbete and Kombolcha in the Ethiopian Highlands, the land rises spectacularly from the trough of the Rift Valley. The fertile soil between the scenic mountains is farmed intensively.

and colorful: pungent aromas of many different spices on sale pervade the fresh mountain air. Several large markets are sited on the very edge of the Rift Valley scarp where farmers barter with their nomadic neighbors.

The largest market outside Addis Abeba, Ethiopia's capital city, occurs at a small town called Bati where the population swells tenfold on market days. The Afar from the eastern lowlands sell cattle, camels, hides, fat, salt bars, and handicrafts; highland farmers of the prosperous Desse region sell vegetables, lentils, spices, herbs, tobacco, and coffee. Between these two groups—with their contrasting styles of dress, ornaments, and hair—are the traders from outside the region, who stock little stalls with a variety of inexpensive wares that include soap, cups, cloth, beads, trinkets, knives, batteries, and shoes.

A striking feature of the northern sector of the Great Rift Valley is the large number of closed basin lakes, some fresh

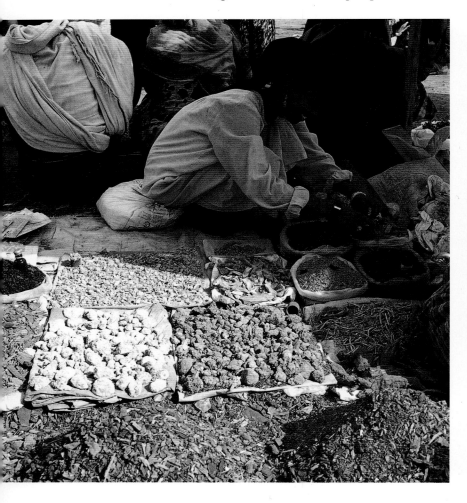

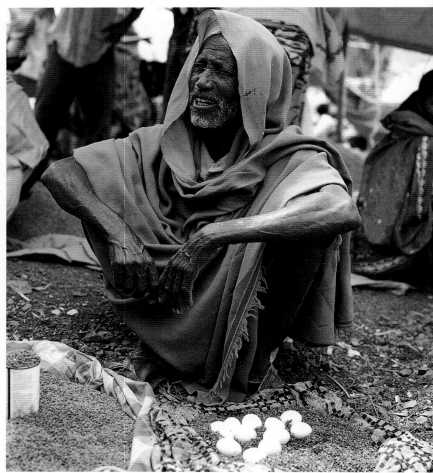

ABOVE, RIGHT, AND PAGES 42–45: *On top of the western scarp of the Abyssinian Rift, the town of Bati hosts the largest open-air market in Ethiopia. Nomads trek long distances there each week from the harsh low-lying deserts to barter with Amhara and Oromo farmers from the fertile highlands. All manner of produce and livestock are offered for sale, including (above) a variety of fragrant woods and frankincense, an aromatic resinous gum obtained from a species of the Boswellia tree, which thrives in the barren Horn of Africa.*

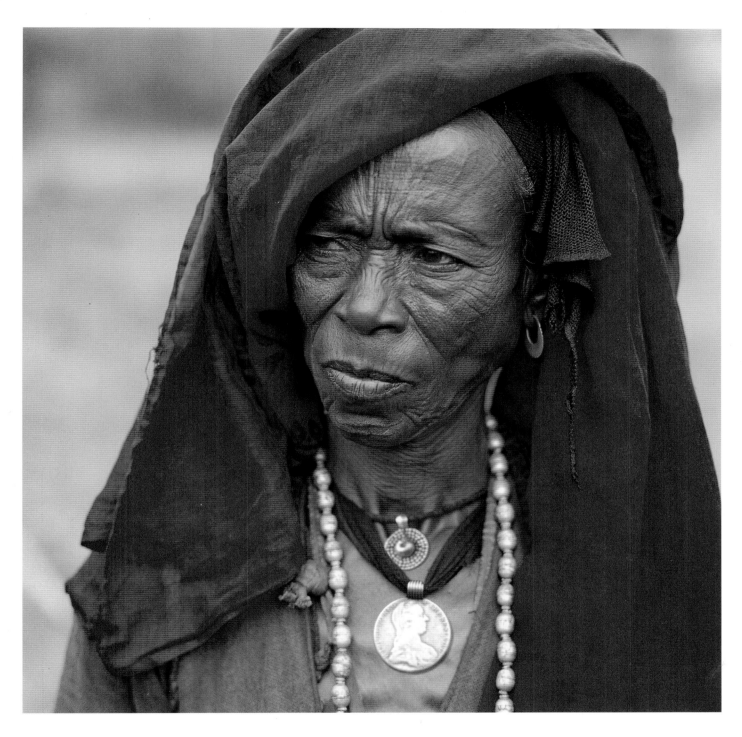

An Oromo woman wears around her neck an old Maria Theresa dollar, the Austrian
silver coin that was once the most common currency of the region.

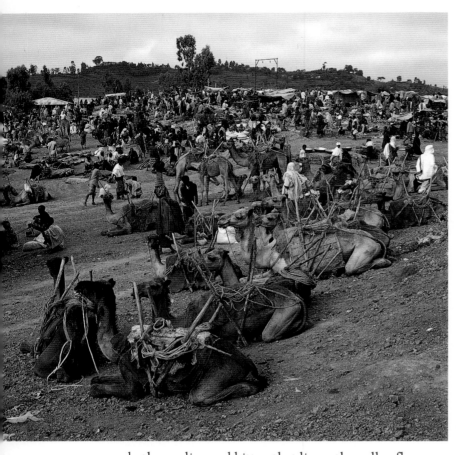

exploited by ancient and inefficient cultivation until erosion has become a formidable problem. From time immemorial, Ethiopia's soil has nourished the Nile Delta; thousands of tons are lost each year through the combined effects of deforestation and poor farming practices.

The direction of the Rift Valley in the far south of Ethiopia is unclear because the escarpments of the Western and Eastern Highlands do not bound its trough. Moreover, whole sections have been obscured by the complex earth movements and intense volcanic activity that took place after it had formed. The main arm passes close to the large seasonal lake of Chew Bahir (formerly known as Lake Stefanie) and links up with Lake Chamo, the southernmost of Ethiopia's long chain of permanent lakes. Another narrower arm follows the Omo River but peters out in the foothills of the Ethiopian Highlands, thus constituting a false arm.

In southwest Ethiopia, a remote, lawless area, armed tribesmen live largely untouched by the outside world. They have more affinity with the peoples of southern Sudan than with the rest of their country. It was the last region to be incorporated into Emperor Menelik II's feudal empire at the end of the nineteenth century, yet it remained exposed to the unscrupulous activities of slave traders for another fifty years.

Ethiopian History

Ethiopia has a history dating back two thousand years. In Africa, only Egypt has a more ancient civilization. The name Ethiopia derives from the Greek word for "burnt faces" and once applied to all the dark-skinned people living south of Egypt. The earliest historical records of Ethiopia describe a powerful kingdom at Aksum flourishing between the second and ninth centuries AD. As early as 700 BC, however, waves of people from Arabia had migrated to Africa, encouraged by merchants who spoke well of the climate and economic opportunities there. To

and others saline and bitter, that lie on the valley floor. During the dramatic climatic changes associated with the Great Ice Age of the Pleistocene epoch, Lakes Ziway, Langano, Abijata, and Shala became one enormous lake covering several thousand square miles. The shallow lakes of the Afar region, which border Ethiopia and Djibouti, are little more than saturated solutions of brine today. Even those fed by the mighty Awash River dissipate themselves in the fierce desert heat. The valley floor south of Addis Abeba rises irregularly to 6,000 feet at the watershed of Lake Ziway. Trending southwest from Ziway, a string of lakes—Langano, Abijata, Shala, Awasa, Abaya, and Chamo—lie amid prosperous farming country that is one of the most productive and settled parts of the Horn of Africa. The valley's fertility stems from an accumulation of sediments over hundreds of thousands of years. In contrast, the soil on the highlands has been woefully over-

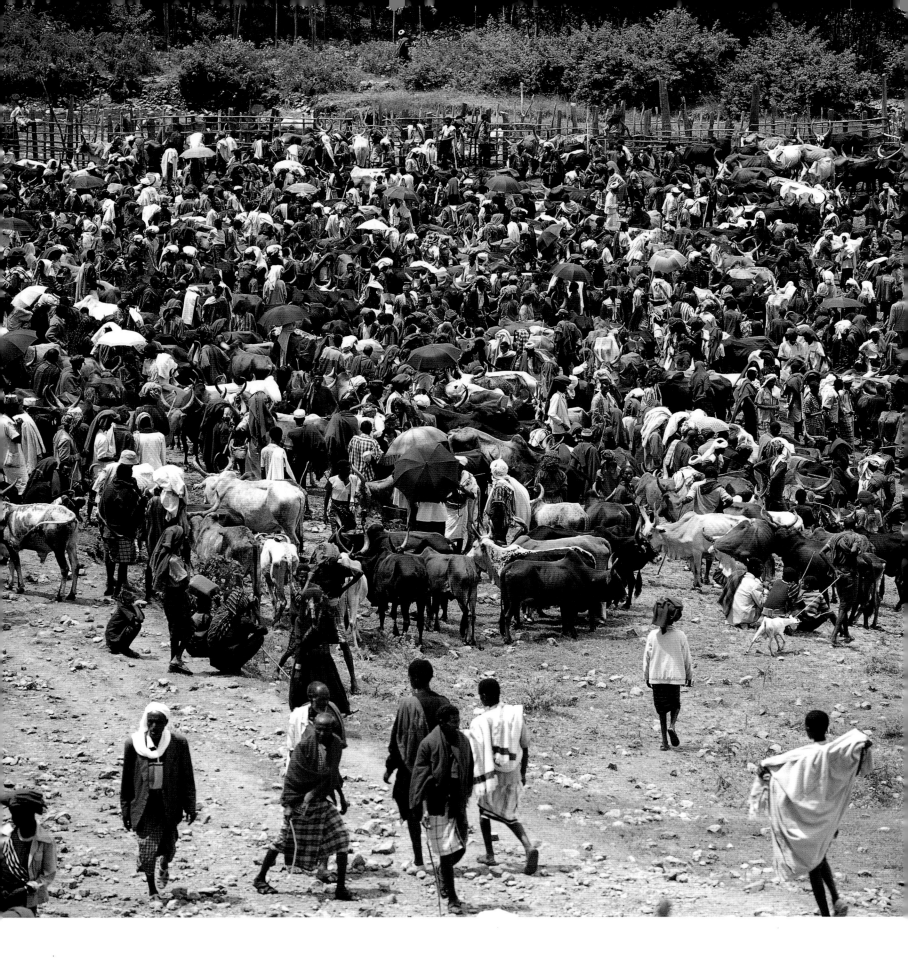

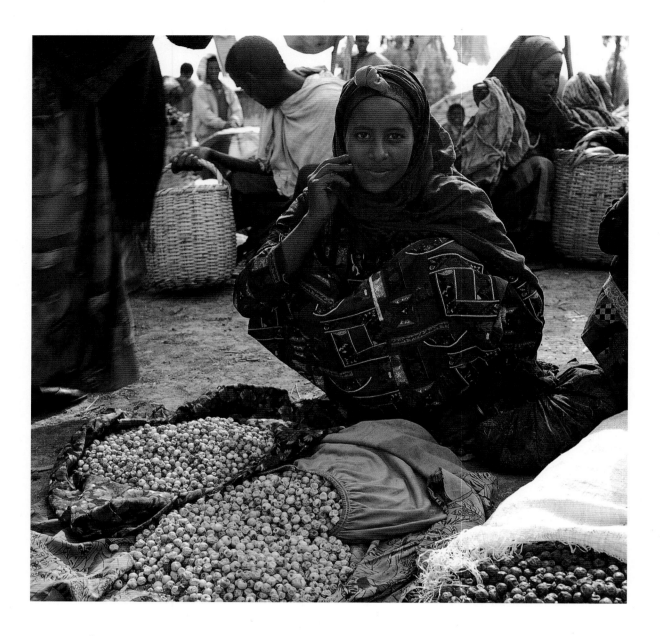

their new country, these immigrants brought their language, Ge'ez, with a unique alphabet, hump-backed zebu cattle, new crop varieties, and the art of building in stone.

The first coins in Africa—made of gold, silver, and bronze, and depicting the head of the ruling monarch on both sides—were struck at Aksum in the reign of King Endybis, around 270 AD. A century later, another monarch ordered 126 giant monoliths to be hewn from solid granite. The tallest measures over 100 feet, making it bigger than any seen in Egypt. Door and windowlike

shapes are carved on some of them, giving the appearance of slender multi-storied buildings. These extraordinary relics, along with the ruins of an ancient palace housing twenty-seven thrones wrought of stone, are potent reminders of Aksum's past glory.

At the height of its prosperity, Aksum was the greatest marketplace of northeastern Africa, with merchants traveling throughout the Red Sea region as far afield as Alexandria. Relations with Egypt were particularly cordial. Several cultural practices of the

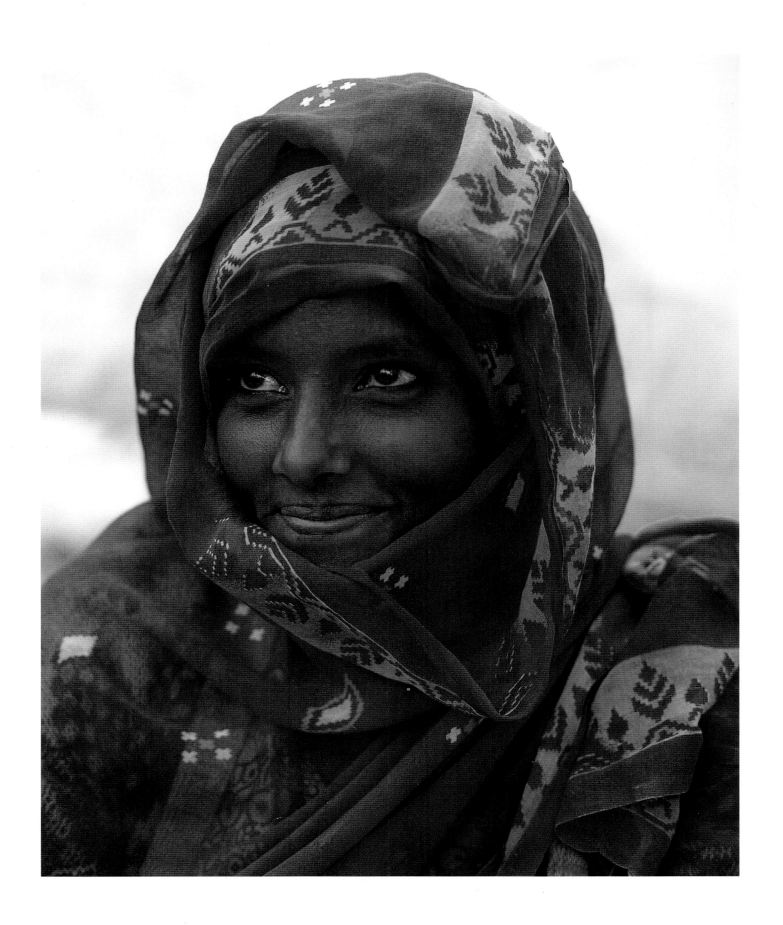

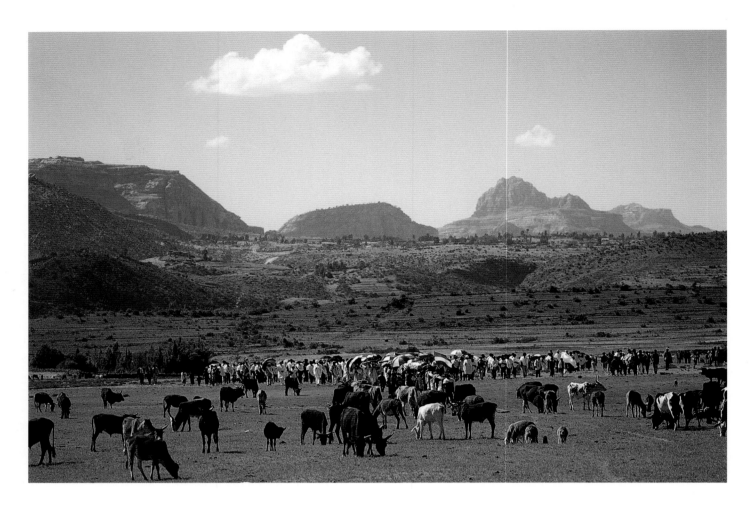

period survive in Ethiopia to this day, such as the burning of incense in the home, the use of eye cosmetics called kohl, and numbers of domestic ornaments and tools.

Though Aksum flourished before the advent of Christianity, it has long been regarded as the holy city of the Ethiopian Orthodox faith, giving Ethiopians a sense of spiritual pride. Added to this is an unshakeable belief that the Queen of Sheba was Makeda, Queen of Ethiopia, who was born about 1020 BC. While the Old Testament account of the Queen of Sheba's visit to King Solomon also dates back to the tenth century BC, Jewish and Islamic traditions portray her as the ruler of Saba in southwest Arabia. Unfortunately, no clear archaeological evidence has been found to support any of these claims. Ethiopians base theirs on a fourteenth century document entitled

Kebra Negast ("Glory of the Kings"). The script is in Ge'ez, the liturgical language of the Ethiopian Orthodox Church, which is comparable to Latin in the Roman Church. Ge'ez and Amharic (the official language of Ethiopia) are both Semitic in origin, although they are written from left to right unlike other Semitic scripts. Until the twentieth century, all Ethiopian bibles were laboriously hand-written in Ge'ez despite its eclipse as a vernacular. So the average person's knowledge of the scriptures was poor even if they were literate in their own tongue.

The *Kebra Negast* relates how Sheba arrived in Jerusalem at the head of a camel caravan bearing gifts of gold, jewels, and spices, returning home heavy with Solomon's child. The Israelite king lived up to his reputation as a great lover and clearly found time to entertain his

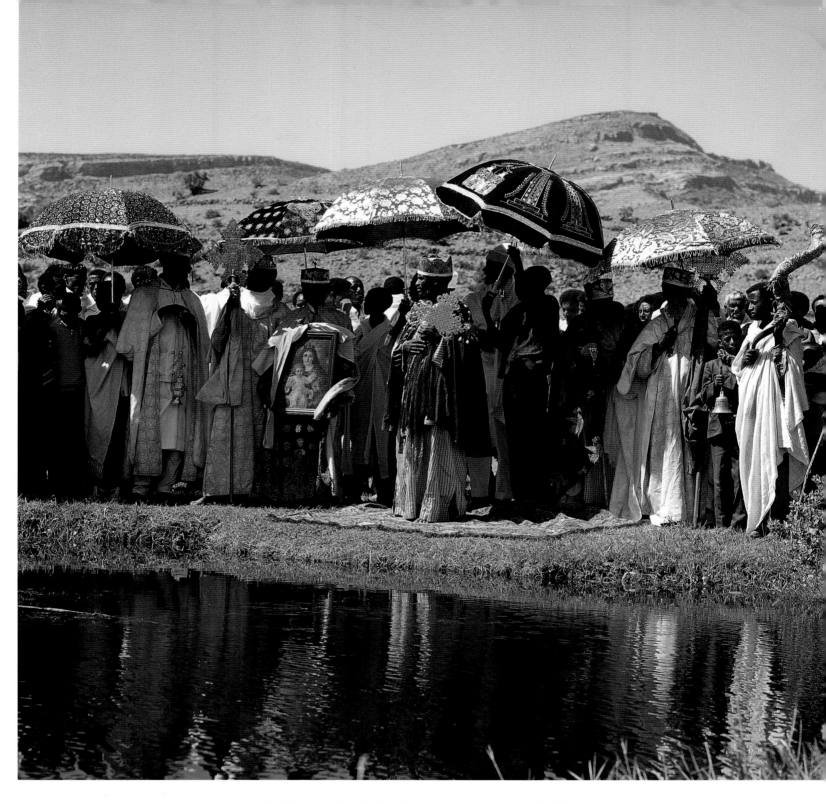

OPPOSITE AND ABOVE: *In Ethiopia, Africa's oldest Christian nation, more than half the population follows the Ethiopian Orthodox faith. Here, at Abraha Atsbeha in Tigray Province the faithful celebrate Timkat (Epiphany), the church's most important Holy Day. Priests carry shrouded replicas of the Ark of the Covenant on their heads. Wearing colorful vestments and carrying silk brocade umbrellas, large silver and bronze crosses, a picture of the Virgin Mary, and kudu horn trumpets, they lead their flock in a long procession to a river or lake symbolizing the Jordan River, where baptism takes place.*

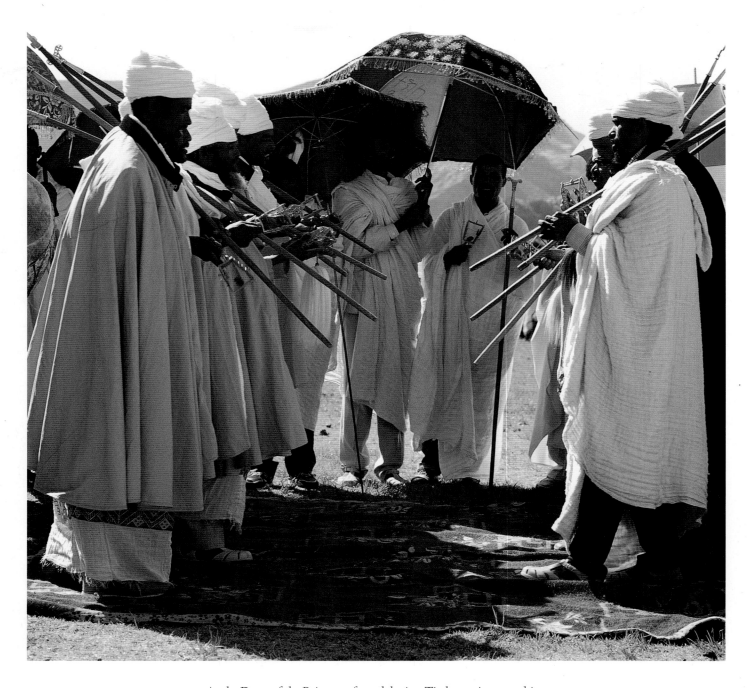

ABOVE: *At the Dance of the Priests performed during Timkat, priests stand in two rows facing one another and sway gently as they chant. In addition to the staffs on their shoulders, they carry* sistras, *musical instruments, possibly of Egyptian origin, which have been used in religious ceremonies since Old Testament times.*

OPPOSITE: *A priest stands on a narrow ledge outside the rock-hewn church of Abune Yemata, in the Gheralta Mountains near Guh. Carved into a cliff face with a sheer drop of 800 to 1,000 feet, the church is reached only by a hazardous ascent with tiny footholds and irregular hand grips.*

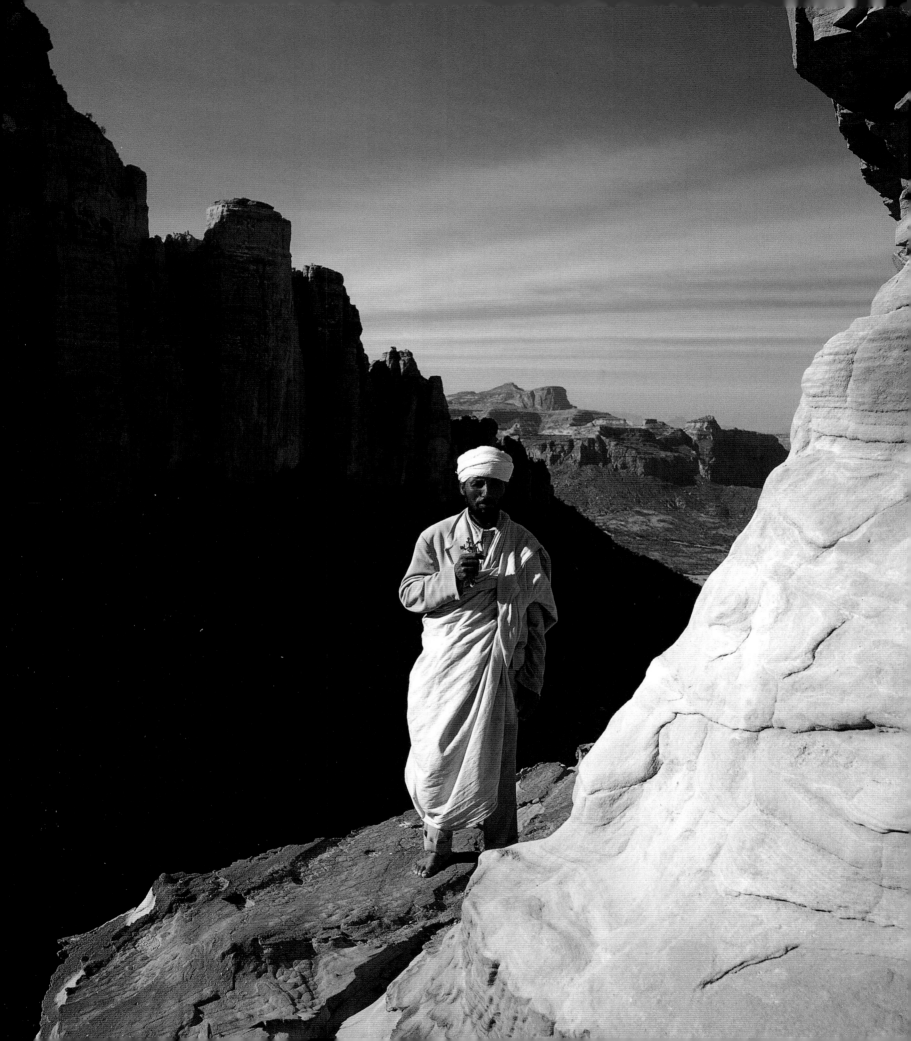

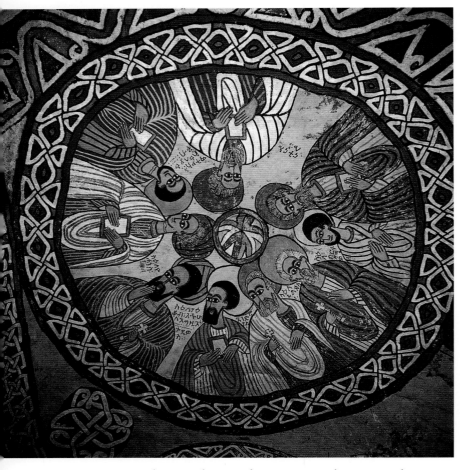

Frumentius' arrival in the country tells that he and his brother were philosophy students of Syrian descent who were traveling to Red Sea ports when bandits killed the master and crew of their vessel. Their lives were spared, however, and they were brought to Aksum, where Frumentius became tutor to the king's son. He later became a bishop of the Egyptian Monophysite Christian, or Coptic, Church and is honored as a saint in the Roman Catholic and Greek Orthodox churches, although somewhat surprisingly ignored by the Egyptian Coptic Church, which ordained him in the first place.

From the fourth century AD until 1950, the patriarch of Alexandria's Coptic Church appointed an Egyptian to be the *Abuna*, or archbishop, of the Ethiopian Orthodox Church. Not surprisingly, religious principles in Ethiopia followed those of Egypt. The Ethiopian Church believes in the single divine nature of Christ. This is fundamentally different from Western religious beliefs, which regard Christ as both human and divine. Other differences were to emerge later during the country's long isolation.

A significant contribution to the spread of Christianity in the ancient kingdom was made toward the end of the fifth century AD with the arrival of nine apostles from several different Mediterranean countries. They dispersed among the Tigray people to broadcast the word of God and build churches on pagan shrines. Ethiopian Christians regard this period of their country's history as the second evangelization. In time, the king extended his authority and spread Christian conversion to the southern Arabian peninsula. It was halted a century later, though, by a popular uprising of Yemenis backed by Persia. Hitherto, Ethiopia had enjoyed close ties with all the kingdoms of the Arabian peninsula because many of her citizens were of Afro-Asiatic blood.

The unexpected rise of Islam in the seventh century AD became a turning point from which the Aksumite kingdom

guest despite a harem of 700 wives and 300 concubines. Sheba's legendary son from the union, Menelik "the son of the wise man," became the founder of Ethiopia's imperial dynasty. Ethiopians believe that Menelik as a young man brought the Ark of the Covenant to Aksum after visiting his father in Jerusalem. Although the ark disappeared without a trace from inside the ancient tabernacle of the temple where Solomon had housed it, the Ethiopian Orthodox Church asserts that it is safe in an inner sanctuary of Aksum's St. Mary of Zion church. Only one monk is permitted to enter the shrine. When he dies, another guardian is chosen from the monasteries of northern Ethiopia.

The introduction of Christianity to Ethiopia in the middle of the fourth century AD is ascribed to Frumentius, who converted the Aksumite ruler, King Ezana. The legend of

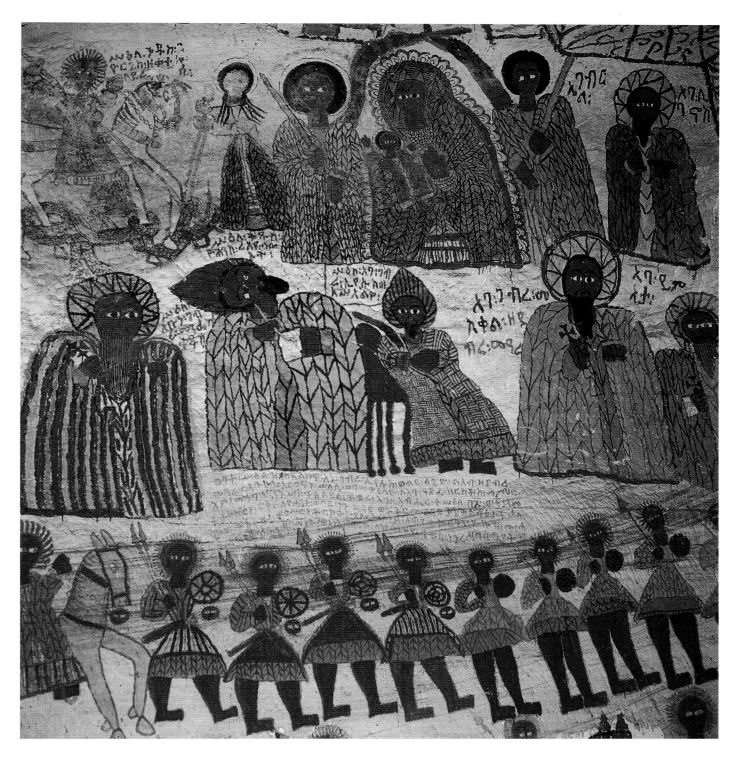

OPPOSITE: *The fifteenth-century mural on the domed ceiling of Abune Yemata church depicts the nine apostles who came to Ethiopia from the Mediterranean toward the end of the fifth century* AD.

ABOVE: *Elsewhere in the Gheralta Mountains, the rock-hewn church of Yohannes Maequddi houses richly-colored murals painted in a primitive style unique to this region.*

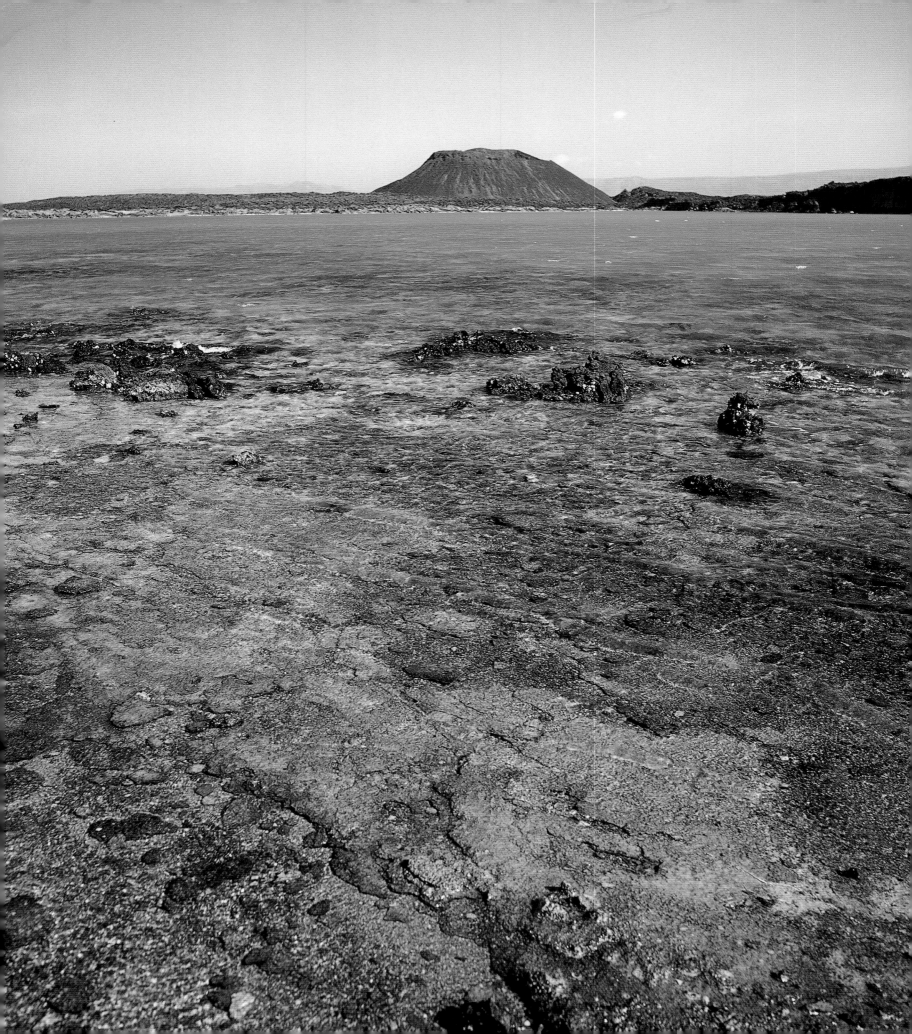

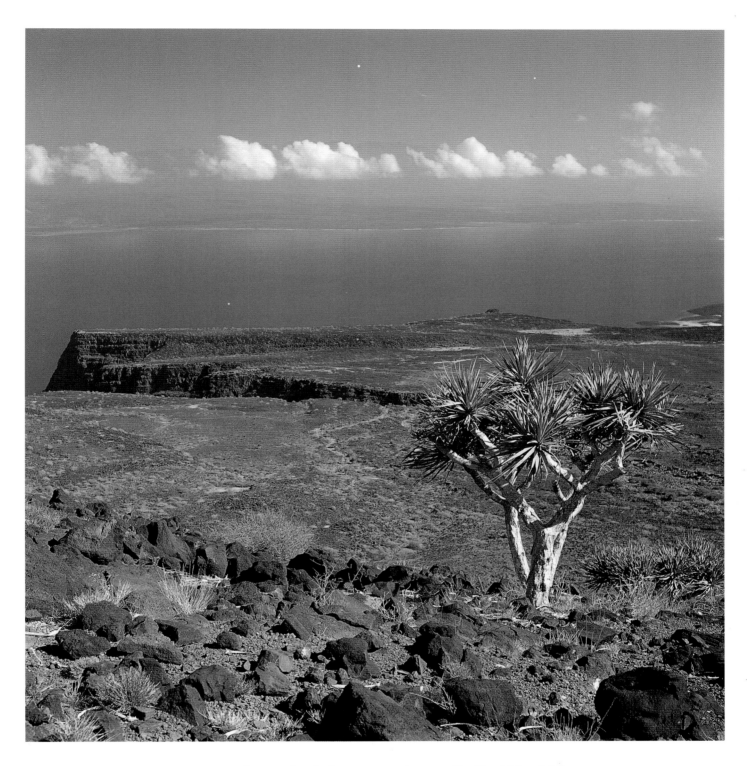

OPPOSITE: *A perfect cone-shaped volcano juts into the sea at Ghoubbet el Kharâb (The Devil's Throat), a region of high seismic activity in Djibouti.*

ABOVE: *A Dragon's Blood tree (Dracaena orbet) struggles to survive in the lava rock terrain of Djibouti where rainfall is low and temperatures at sea level regularly exceed 100 degrees F.*

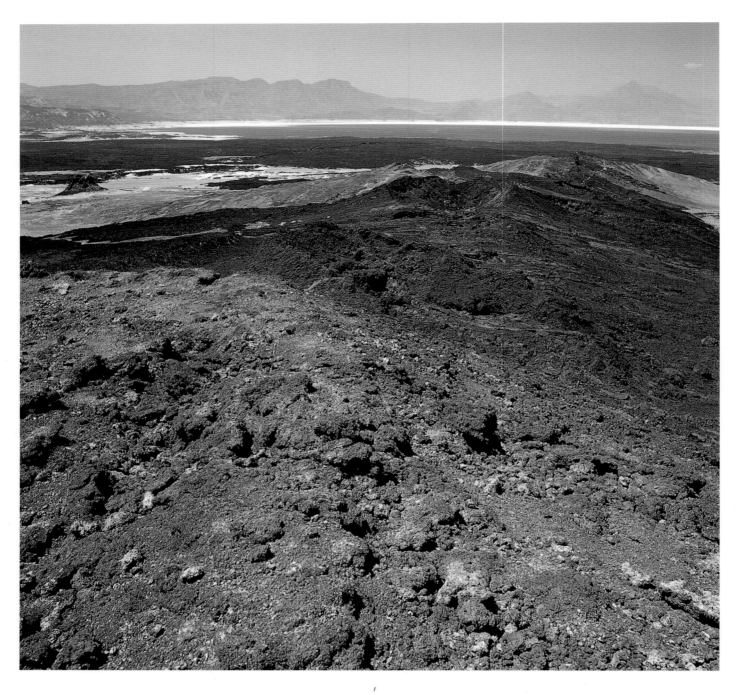

ABOVE: *Red volcanic debris from the explosion crater of Garrayto, which erupted in 1978, colors the foreground of a distant view of Lake Assal, Djibouti.*

OPPOSITE: *Pure salt crystallizes on the flats beside Lake Assal. The lowest place in Africa, it lies 509 feet below sea level. The lake's waters contain 348 grams of dissolved sodium chloride per liter—an astonishing concentration caused by constant evaporation in the scorching sun.*

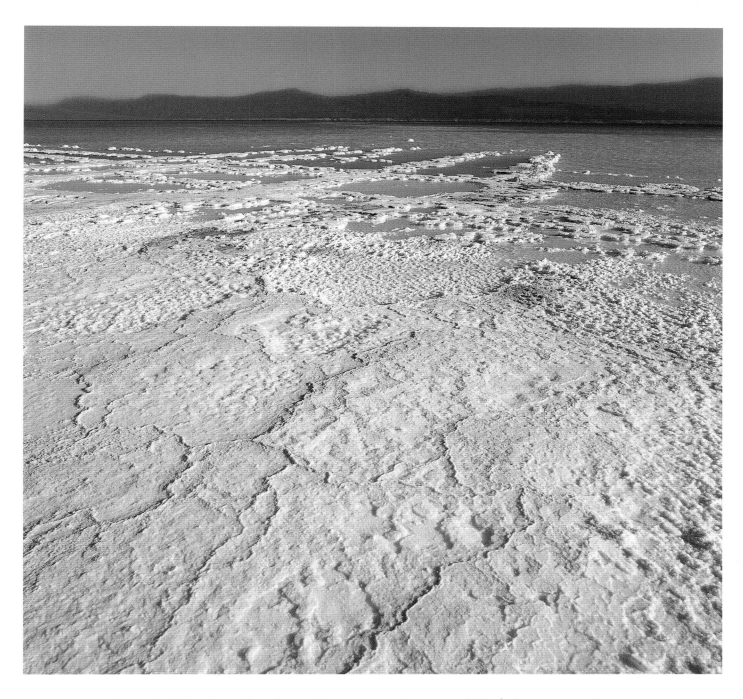

never recovered, yet it had already outlasted Jerusalem and Rome. Aksum was initially spared a direct onslaught by Muhammad's conquering armies, but Muslim sailors usurped control of the shipping lanes and quickly deprived Ethiopians of the lucrative Red Sea trade. This misfortune precipitated a rapid and irreversible economic decline resulting in Aksum's collapse because money was no longer available to finance a standing army or a government administration. A rebellion ensued and a tribal chieftainess, Gudit, and her followers—who included the Falashas, the black Jews of Ethiopia—destroyed much of the ancient city. (The rise of Christianity three centuries earlier had sealed the fate of Judaism in Aksum: Jews left for the relative security of Lake Tana and

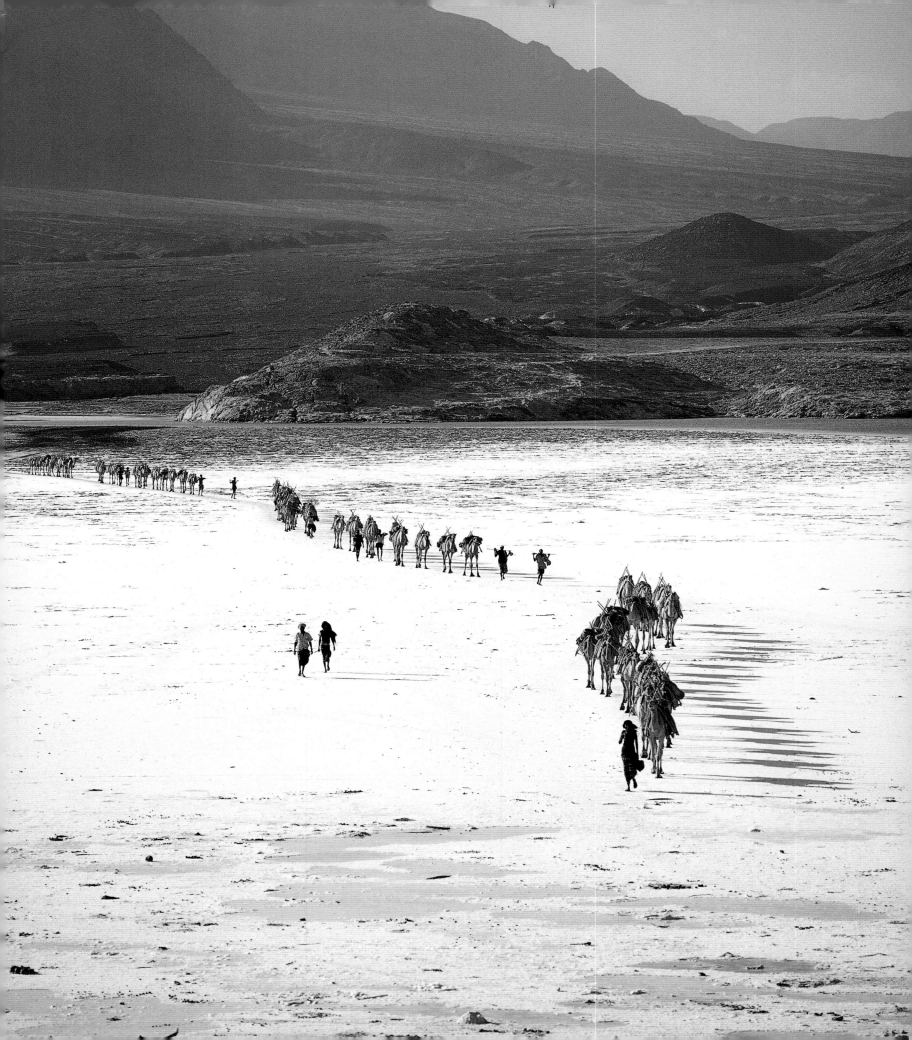

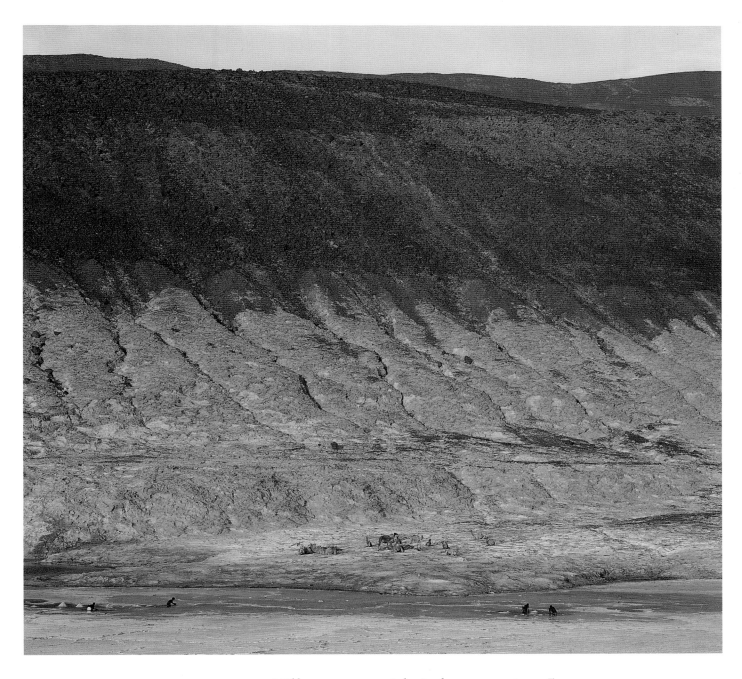

OPPOSITE AND ABOVE: *Midday temperatures at Lake Assal surpass 120 degrees F, restricting daytime activity. Afar camel caravans arrive late in the afternoon and men immediately set about collecting salt from deposits that are at least 190 feet thick. Each camel carries between four and ten thirty-pound sacks.*

OVERLEAF: *Lake Abbe, on the border of Djibouti and Ethiopia, is the last in a line of alkaline lakes in which the Awash River dissipates. The jagged pinnacles and spires at the lake were formed thousands of years ago when volcanic gases bubbled up through the bottom of an ancient lake that was 100 feet deeper than it is today. Minerals from the gases encrusted the soil they passed through, leaving behind these extraordinary creations when the waters receded.*

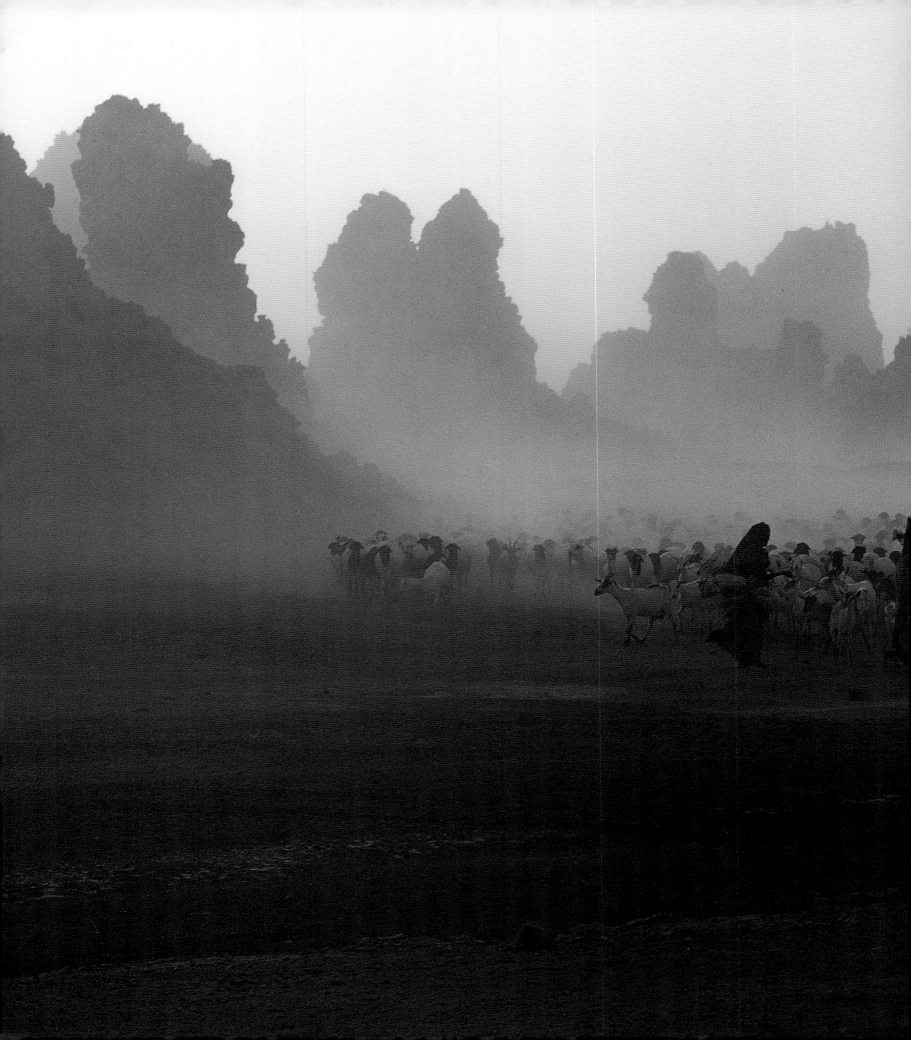

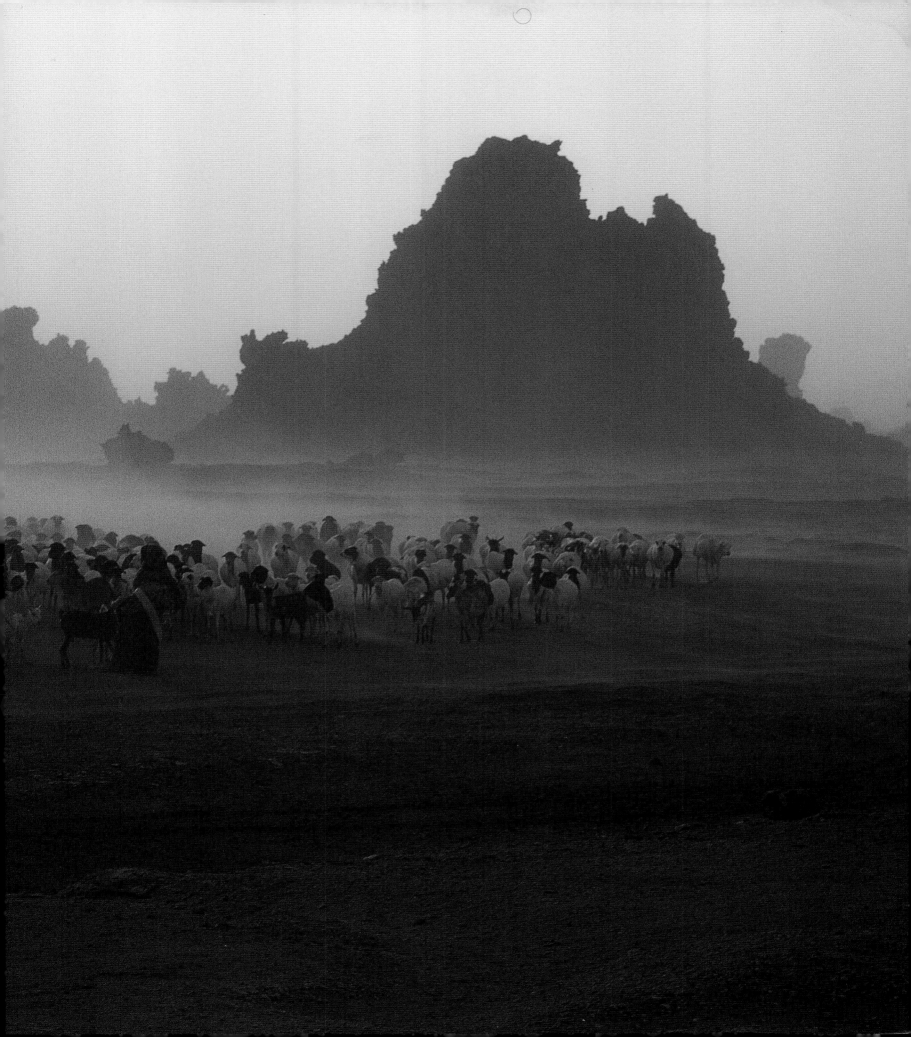

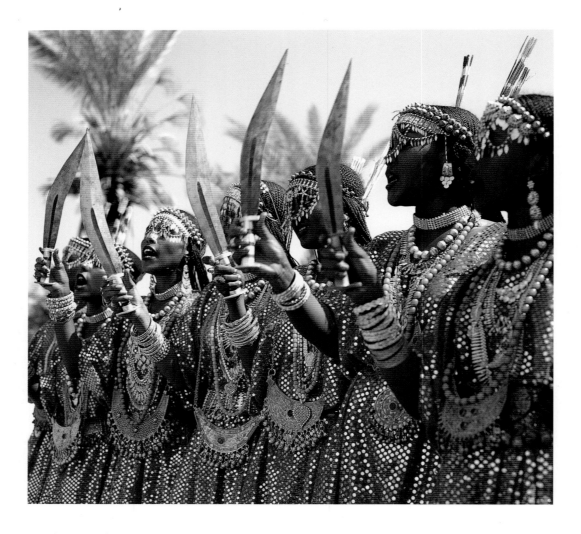

the Simien Mountains, south of Aksum, where they converted many to their faith. Their descendants call themselves Beta Israel. In the twentieth century, many Falasha Jews were brought to Israel, where they could practice their faith openly.)

For a thousand years, the Ethiopian highlands became a cloistered Christian stronghold whose links with the outside world were cut by the rising tide of Islam. Ethiopians, nevertheless, remained staunch to their faith against the invading Muslim armies and the machinations of Portuguese Jesuit priests wanting to convert them to Catholicism. Moreover, they built some outstanding churches hewn from solid rock while their clergy were inspired to develop a new brand of Christianity steeped in the past.

The principal adherents of the Ethiopian Orthodox faith today are the Amhara and Tigray peoples of the northern and central highlands, and almost two million

ABOVE: *During a dance, Muslims girls from the sultanate of Tadjoura, Djibouti display the curved daggers of their men.*

OPPOSITE: *Afar warriors carry large curved daggers, known as* jile, *strapped to their waists. Modern rifles have replaced the daggers as weapons but they are still worn by tradition.*

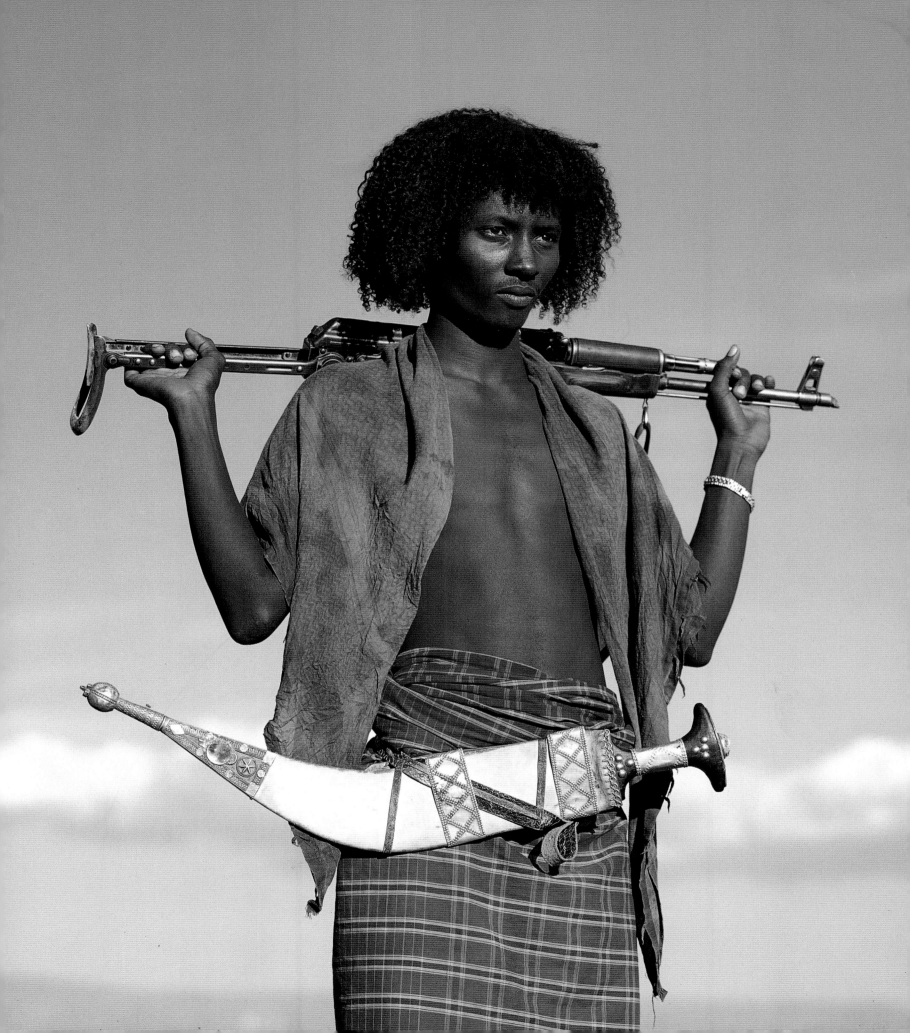

*The crystal clear hot springs at Filwoha (filwoha means 'hot water' in the Afar tongue)
in the Awash National Park are vivid manifestations of volcanism in the trough of the
Abyssinian Rift. Water rises from deep underground at about 96.8 degrees F.*

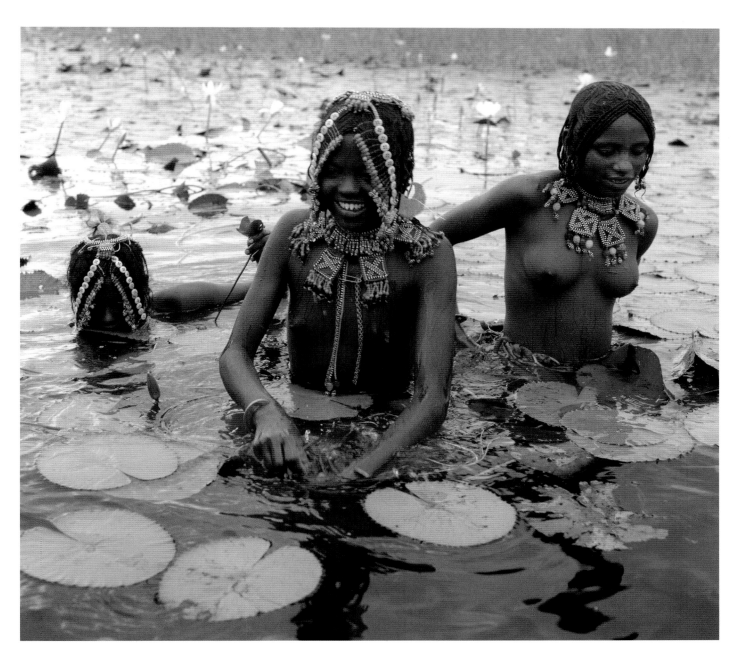

Afar girls harvest wild water lily bulbs in the marshlands of the Awash River. The bulbs are peeled, boiled, and eaten like potatoes, or dried and pounded for later use.

others in Eritrea. They believe that theirs is the only true religion. They revere the Old Testament, and a shrouded replica of the Ark of the Covenant, the *tabot*, replaces the altar in every church. Central to their religious beliefs is a special veneration of Saints Michael and George. They admit seven sacraments, pay homage to the Virgin Mary and other saints, and respect the resurrection, the last judgment, and other features of the Roman church. Prayer and fasting are regular, although fasting means abstinence from eating meat, milk, and eggs rather than total denial of food. Ethiopian Orthodox Christians observe the fasts of the Coptic Church and add a few Ethiopian feasts of

The western scarp of the Abyssinian Rift rises to 11,000 feet at Gooch Meda, where troops of Gelada baboons thrive in a climate that is more alpine than tropical. Found only in Ethiopia, the Gelada differs from true baboons in having nostrils some way from the tip of its muzzle. Sometimes called the "bleeding heart baboon" because of the naked, pink patch on its chest, the Gelada feeds mainly on grasses and poses no threat to local farmers. Males have long flowing manes and are twice the size of females.

their own. They follow a thirteen month calendar based on that of ancient Egypt, which has twelve months of thirty days each with five or six days extra between August and September, the beginning of the church year. This calendar was not changed in 1582 when Pope Gregory reformed the Julian calendar used by most of the Western world. Ethiopians continue to have thirteen months in a year and to be seven years behind the rest of the world.

From time to time over the centuries, the forces of Islam have invaded Ethiopia, but never conquered the country's mountain fastnesses. The man who came closest was Ahmed Ibn Ibrahim el Ghazi, nicknamed Ahmed Grañ "The left-handed," after he declared a *jihad*, a holy war, in 1528. Supported by Arab and Turk mercenaries, he led hordes of highly mobile Oromo horsemen, who were pagan in religion and savage in custom, on a rampage into the Christian highlands. Towns and villages were burnt, churches destroyed, treasures looted, and people put to the sword. The first Christian church in sub-Saharan Africa—the fourth century church of Saint Mary of Zion at Aksum—was razed to the ground. Only intervention by the King of Portugal, who feared that his country's interests in the Red Sea were imperiled, saved the Christian monarch. Portugal responded to an urgent appeal by dispatching 450 musketeers to fight the Muslim army. With Grañ's death in 1543, the fifteen-year war was brought to a close with immense structural and cultural damage to the nation.

Despite Portugal's invaluable help, attempts by Jesuit missionaries to exploit the goodwill of the people and convert them to Catholicism failed after an initial period of success. By 1628, Ethiopia had eleven Jesuit mission stations manned by fifteen priests. A learned Spanish member of their order, Pedro Páez, succeeded in converting Emperor Susenyos to the Roman faith. Most Ethiopians viewed his act as heretical. In the face of widespread revolt, Susenyos abdicated in favor of his son, Fasilidas, who promptly proscribed the Jesuits and reestablished links with the Egyptian Coptic Church in Alexandria.

OPPOSITE: *One of the most splendid views from the western scarp is at Debre Sina where the accumulated layers of basaltic lavas and tuffs lie 3,000 feet thick. The ancient divide between Muslim and Christian communities was this barrier wall of the Great Rift Valley.*

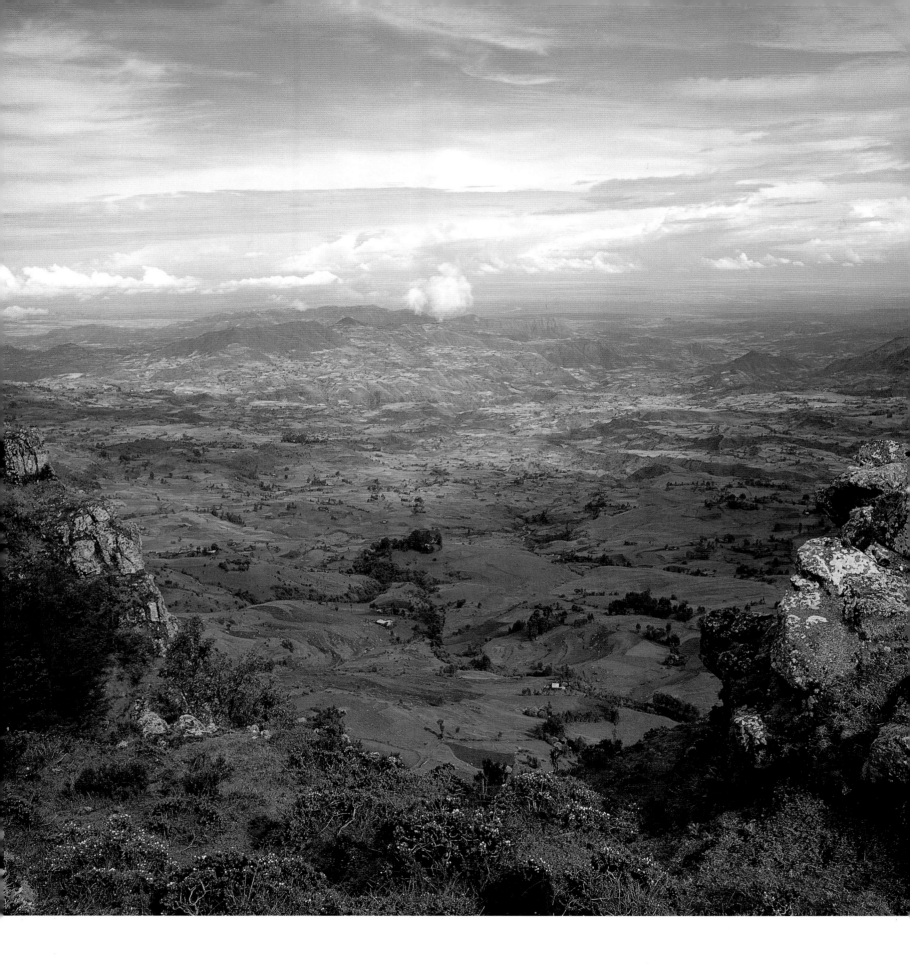

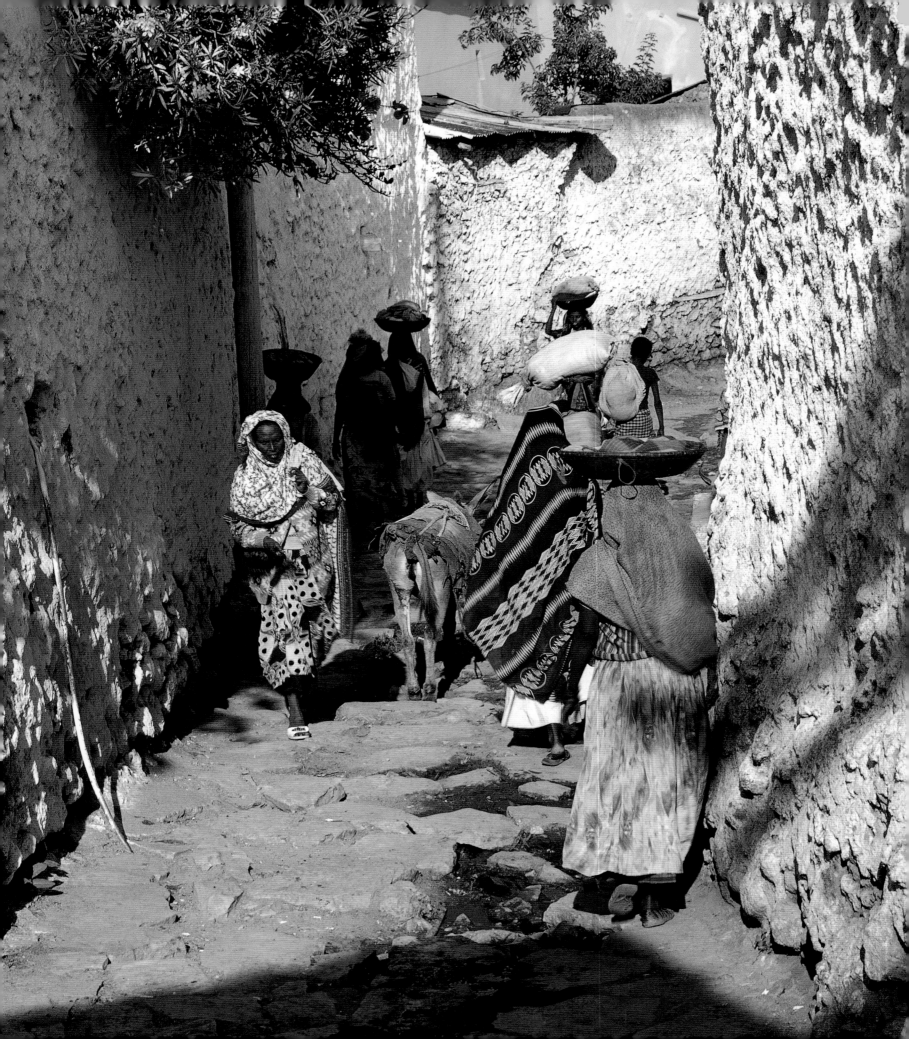

The seventeenth-century castles at Gondar are reminders of Portugal's brief influence in Ethiopian affairs.

Ethiopia's little-known, ill-mapped feudal kingdom came to world attention in 1864 when Emperor Theodore felt slighted by Queen Victoria's failure to reply to one of his letters seeking technical assistance and precipitated a crisis. He detained the British consul, Captain Charles Cameron, and later put him in chains. Other foreigners suffered the same fate when the emperor took to the bottle and his behavior became increasingly irrational. When negotiations for the captives' release failed, Britain ordered General Sir Robert Napier, the commander-in-chief of the Bombay army, to mount a punitive expedition. He reached Africa with a flotilla of 290 vessels on January 2, 1868 and dropped anchor off Zula, just south of modern-day Massawa. There, he prepared for the 350-mile march to Magdala, where the prisoners were incarcerated. Never before had modern military operations been undertaken in a country without roads, where the conditions for provisioning a large army were so unfavorable.

Stone and timber for the construction of piers at Zula had to be imported. Special vessels with condensing units, which turned seawater into drinking water, anchored offshore. Railway lines and steam engines were shipped from India. Elephants and mules were brought from the Punjab; donkeys, camels, and more mules were purchased from as far afield as Spain, Persia, Syria, Egypt, and Aden. To fill their needs, the expedition's agents were forced to buy the "sweepings" of the Eastern World. Only bullocks were obtainable locally, but the majority of those used in the campaign were draught animals brought in

A maze of narrow streets runs through the medieval walled city of Harar, which is regarded as sacred in the Muslim world. Once an independent city-state, Harar was incorporated into the Ethiopian Empire in 1887.

from Bombay. By the close of the campaign, a total of 40,000 transport animals had been landed in Ethiopia.

Troops, heavy equipment, weapons, ammunition, rations, and stores came from both England and India and a special minting of 500,000 Maria Theresa dollars was hurriedly shipped from Austria to fill Napier's munificent war chest. This large silver coin had long been the preferred currency of the region. India provided most of the muleteers

Unlike Muslims elsewhere, Harari women love bright colors, and are seen in public without face veils. Above, a Harari girl in wedding attire wears a silver Koran holder around her neck. Her beautifully embroidered silk dress can be turned inside out, where it is black, and worn at funerals. The finely woven basket on her head, known as agelgil, *is used for carrying* injera, *sour pancakes made from small-grained teff (*Eragrostis abyssinica*), a staple food of Ethiopia.*

LEFT, OPPOSITE: *The Dorze people live on top of the Rift escarpment to the west of Lake Abaya where the land rises to 9,000 feet. Bamboo grows luxuriantly at these altitudes (left) and is a valuable resource, owned and protected by individual farmers. The unique traditional Dorze home, constructed of bamboo stands about eighteen feet high (opposite), and is roofed with the sheaths of bamboo stems.*

BELOW: *Dorze men are accomplished weavers, making some of the finest cotton cloth in Ethiopia. The man relaxing outside his home at Chencha with a water-cooled pipe wears Dorze national dress made by himself.*

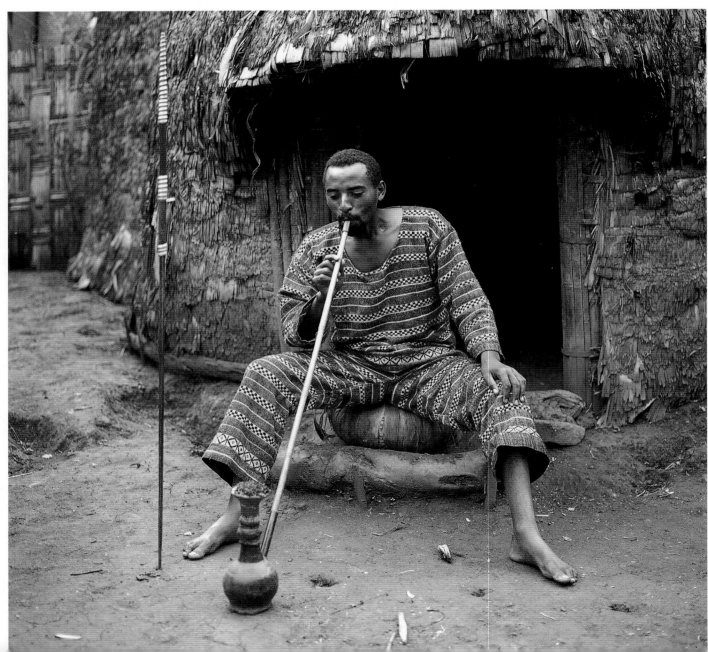

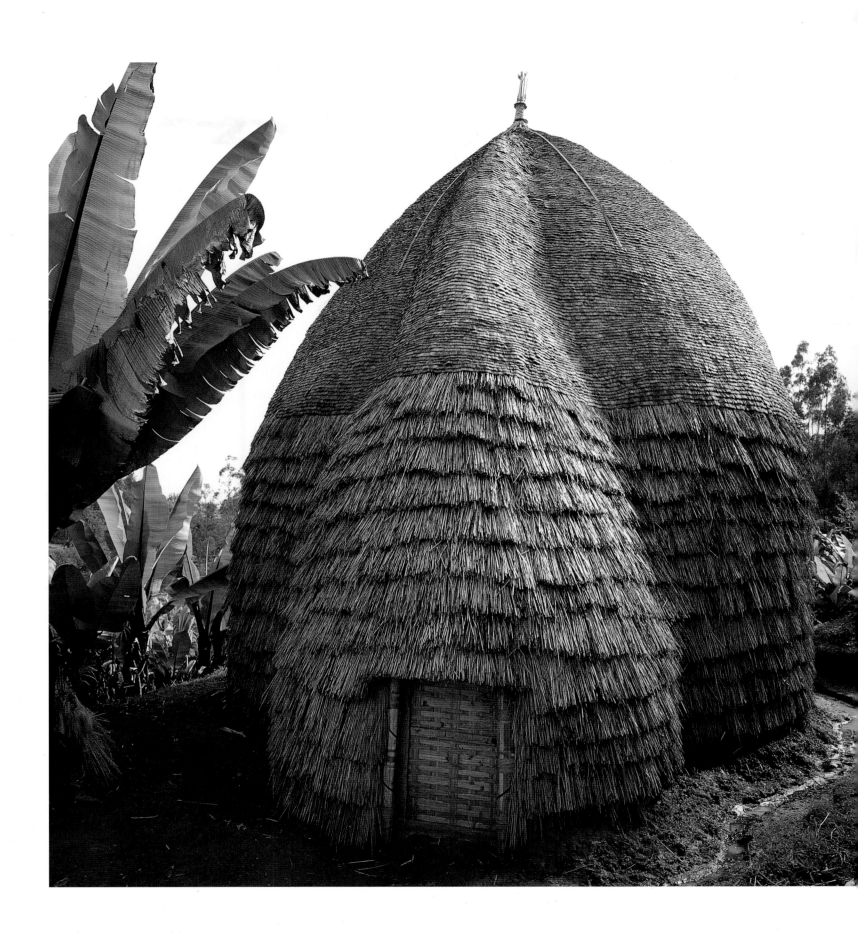

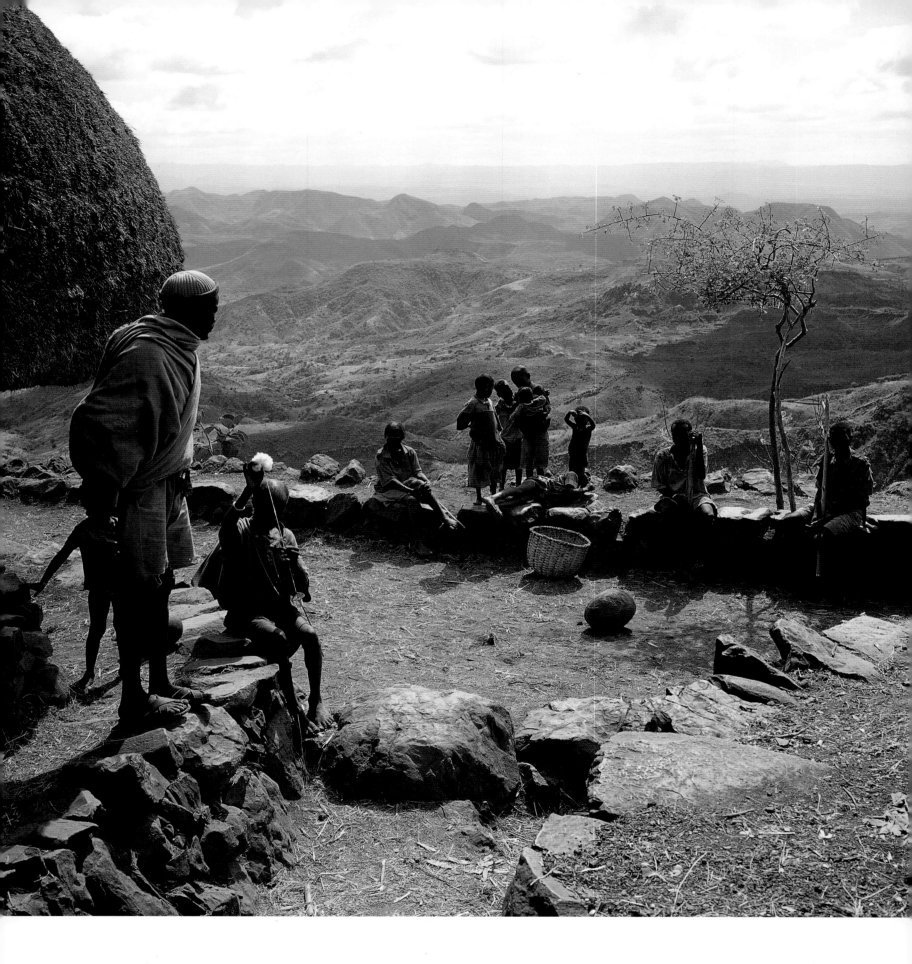

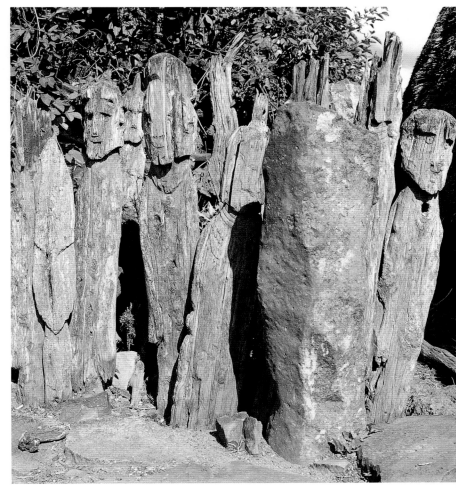

The Konso people, living in the hilly country of southwest Ethiopia, farm the stony land by terracing it with great skill. Many families still live in fortified villages that are about 500 to 600 years old. The central meeting place in each village (left), called **mora**, *features a large wooden structure with a high conical roof where boys from the age of twelve years sleep on wooden platforms. The Konso worship the sky God,* **waq**, *and place carved wooden effigies (above and right) at prominent places to honor their illustrious ancestors.*

and a horde of camp followers to wait on officers and troops alike. Under Indian regulations, a British battalion was entitled to 1,200 mules for baggage and 600 camp followers, inclusive of muleteers. Napier reduced this number to 187 mules and 100 followers, who combined the roles of muleteer with that of stretcher-bearer. Napier's decision was unpopular with many but made a vast improvement in the problem of rationing because the Hindu camp followers would not eat meat. The introduction of bullock carts also had a big impact, for a cart carried many times the load of a mule.

Elephants used to draw heavy artillery caused great excitement with the locals, who followed them everywhere. Once, Napier mounted one to impress Ras Kassai, the friendly ruler of Tigre Province, when the two met at

Hawzen. Kassai, who allied himself to the British and later became Emperor Yohannes IV, rode a white mule while a servant ran alongside shading him from the sun with a large crimson umbrella. He was only about thirty-five years old at the time, but constant conflict had aged him well beyond his years. He wore a silk flowered shirt beneath his traditional white cotton shawl with a crimson border and fringe. His hair was arranged in braids drawn back from the forehead and tied by a ribbon at the back of the neck.

The British expeditionary force was made up of 10,800 fighting men and 14,500 followers. As the assault troops numbering 5,300 men approached Magdala, Theodore continued his bouts of heavy drinking. During one of them, he attempted to commit suicide but was

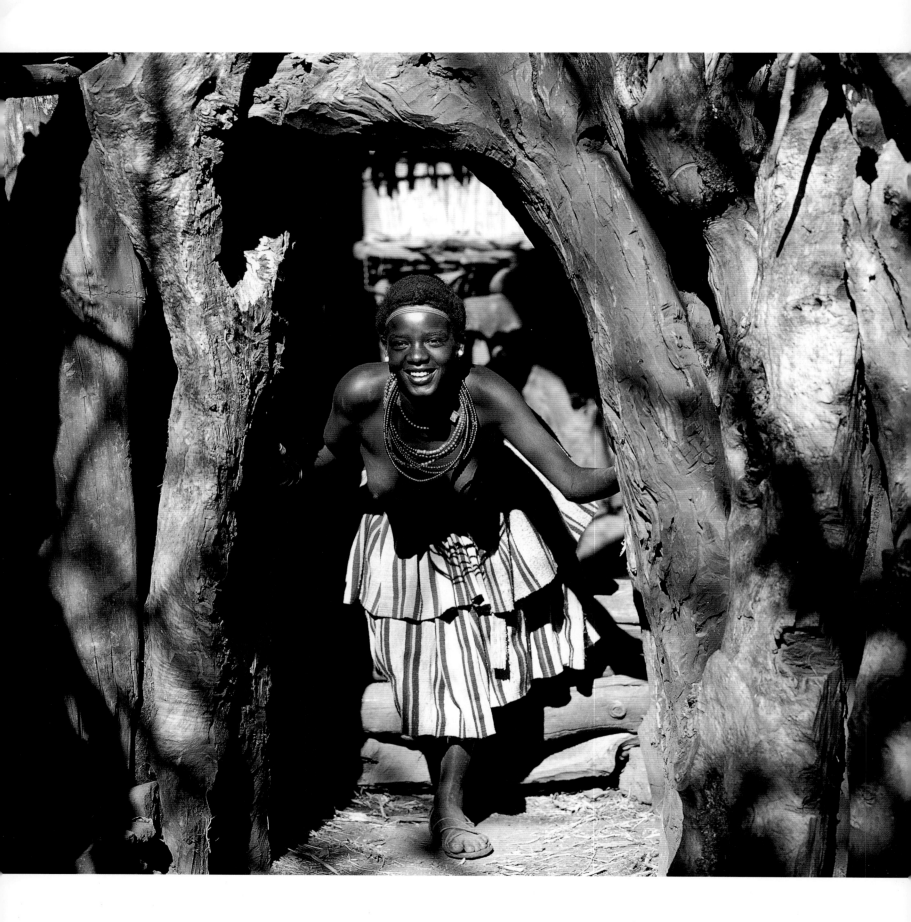

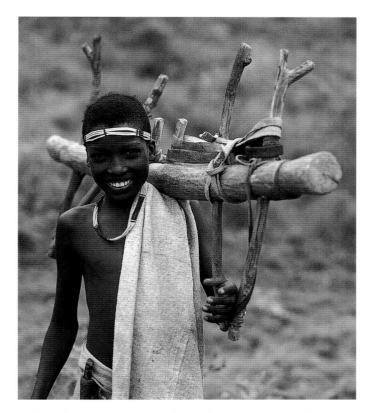

A Konso boy carries a wooden yoke used by pairs of oxen to till the land.

their forces for the final assault on the mountain fortress, Theodore shot himself with an inlaid silver revolver that Queen Victoria had sent him in more cordial times. The expeditionary force promptly withdrew, costing the British taxpayer a staggering £9 million.

As European imperialism gathered momentum in the latter part of the nineteenth century, a Muslim army led by a fanatic named Khalifa, who had proclaimed himself the messiah, or Mahdi, attacked Ethiopia from the Sudan. The then-emperor of Ethiopia, Yohannes, fought bravely but was mortally wounded on the battlefield just as victory was within his grasp. After learning of their leader's death, his army fled in disarray.

In 1895, the country was again attacked, this time by Italian forces from Eritrea bent on expanding their

stopped by an aide. On another occasion, he ordered most of his Oromo prisoners to be put to death. The battle for Magdala turned out to be a very one-sided affair because Theodore's army had been severely weakened by desertion. Nevertheless, those who stood by their leader were utterly fearless. In a reckless attack on the British, 700 of them were killed and 1,200 wounded. Theodore then realized the hopelessness of his military position and released the hostages unharmed. British casualties were extraordinarily light; twenty men wounded, of whom two later died. As the British commanders maneuvered

OPPOSITE: *The Konso have a great affinity for wood and stone: large trunks or branches surround every homestead, and special care is taken to select the most pleasing shapes for entrances.*

RIGHT: *Konso weavers make a thick cloth called* buluko *from local cotton using crude wooden looms. After weaving, the cloth is flayed by women to flatten the warp and weft.*

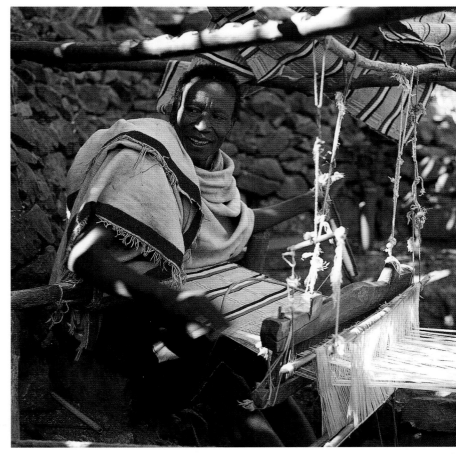

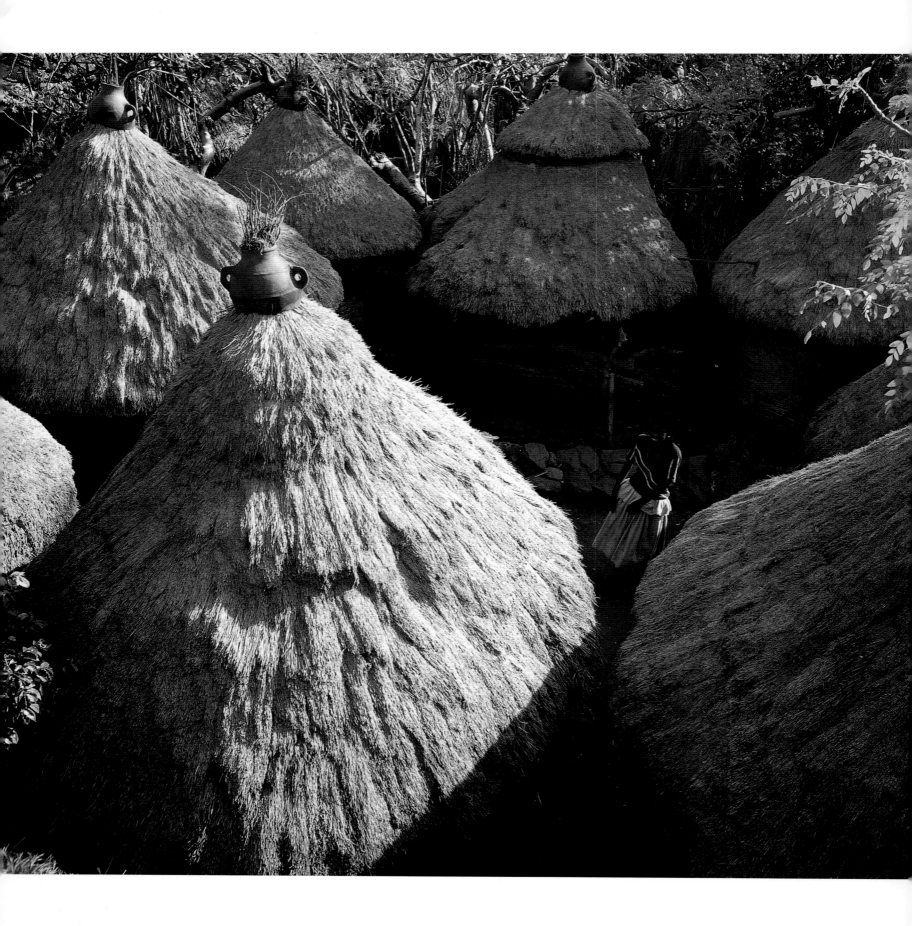

country's African empire. Several European imperial powers were sympathetic to Italy, but France had its own agenda and readily supplied arms to Emperor Menelik II through the French port at Djibouti. The Italian commander, General Baratieri, never for a moment thought he could lose a battle, though his forces were outnumbered eight to one. The world powers were aghast when Emperor Menelik's feudal army routed the well-equipped Italian forces at the Battle of Adowa on March 1, 1896. One sanguine warlord explained: "Wars are won by brave men hurling themselves in hot blood against the enemy." How right he was: it was an epic victory by any standard and still stands out as the most decisive battle ever won by African troops on African soil against an outside aggressor. From an invasion force of 17,700 men, of whom 10,600 were Italian and the rest native troops, more than 6,000 were killed, nearly 1,500 wounded, and between 3,000 and 4,000 taken prisoner. The battlefield was a scene of frightful carnage. The Italian death toll alone was put at 4,133 officers and men. Had Menelik pursued the remnants to the coast, the whole of Eritrea would have fallen into his hands. His decision not

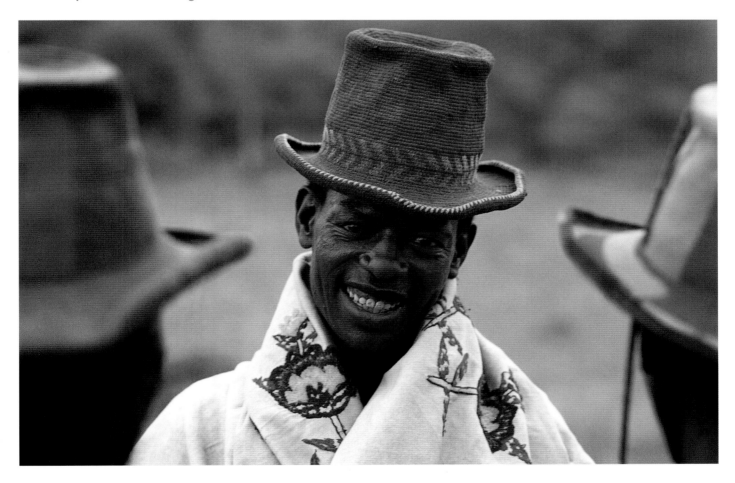

ABOVE: *Like Dorze men, the Konso are expert weavers, and their handiwork includes these "top hats."*

OPPOSITE: *The high thatched roofs of Konso homes are topped with earthenware pots to keep out the rain. Cultivated around the walled compounds are trees of the Moringa species, whose leaves are cooked and eaten as a vegetable.*

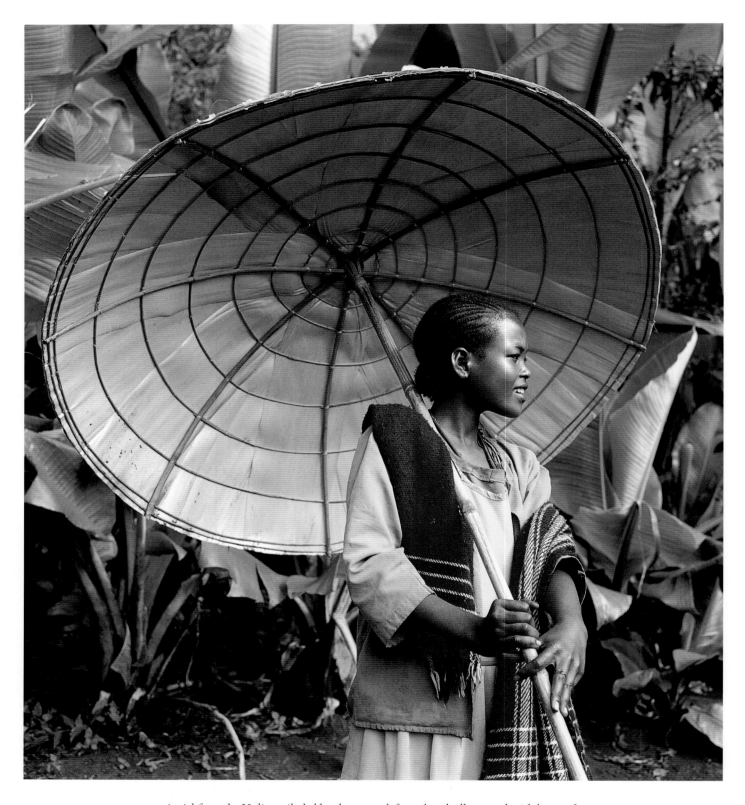

A girl from the Kediyo tribe holds a large wood-framed umbrella covered with leaves of ensete, the false banana plant. Widely cultivated in southern Ethiopia, ensete roots and stems, rich in carbohydrates, are either cooked as a porridge or made into a bread.

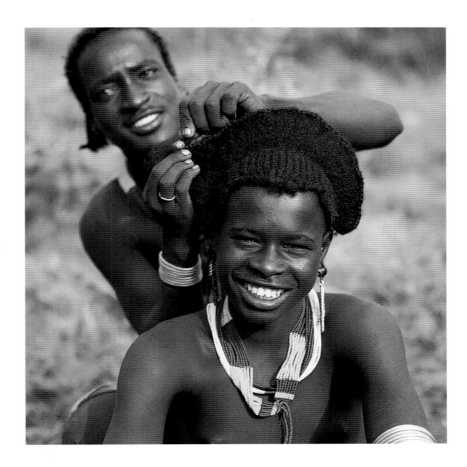

The Hamar of southwest Ethiopia live in the Hamar Mountains and the semi-arid thorn scrub country adjacent to the seasonal lake Chew Bahir (the name means "salt lake), formerly known as Lake Stefanie. Semi-nomadic pastoralists, the Hamar focus all their attention on livestock, their most important economic and cultural asset. The young men braid their hair stylishly and adorn themselves with beads and brass.

to do so proved a mistake for which later generations suffered.

For forty years Italy smarted under this defeat until the Fascist dictator, Mussolini, vowed revenge. He cunningly engineered a flimsy excuse to attack Ethiopia while the League of Nations, of which Ethiopia was a member state, sat on the fence and watched events unfurl. Lamentably, a minority of influential European powers sided secretly with Italy because they were upset that Ethiopia had not taken sufficient measures to abolish domestic slavery. It was a remarkably perverse interpretation of human rights. Laws had already been promulgated in

Ethiopia to abolish the practice, but time was needed to release thousands from bondage and for the church to change its age-old practice of using serfs to till its large land holdings. War delayed, rather than hastened, that process.

In 1935, Italy invaded the ancient empire from Eritrea and within a year Emperor Haile Selassie had been forced into exile. The victorious Italian army marched into Addis Abeba on May 5, 1936 having outclassed and outgunned the imperial army. Ethiopian troops fought bravely in difficult terrain until demoralized by the Italian airforce, which inflicted heavy casualties by spraying them with deadly mustard gas from the air. There was no

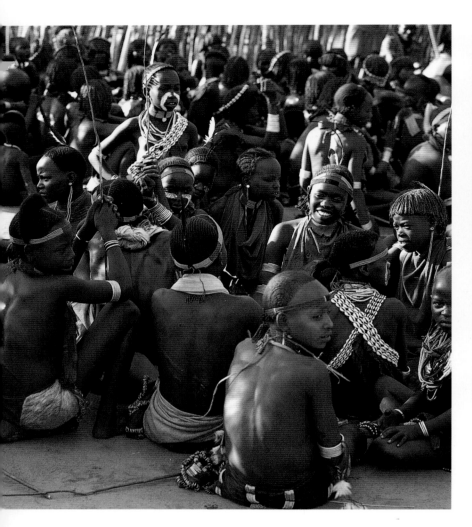
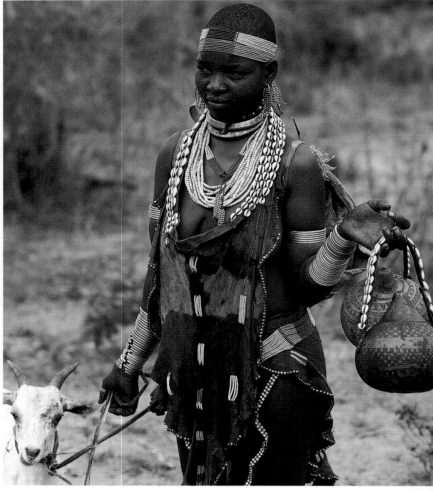

People travel great distances on foot to attend the largest market in Hamar country at Dimeka. Goats, chickens, vegetables, fruit, spices, butter, eggs, tobacco, and ochre are sold or exchanged for other produce at the market, which is both a commercial and social event.

international outcry. Throughout the occupation, leaders of the Ethiopian resistance movement kept alive their steely determination to reject the status of a subject people. The excesses of the invaders merely stiffened that resolve.

The outbreak of World War II interfered with Mussolini's grandiose plans to create another Roman Empire. Once the Fascist dictator sided with Hitler his fate was sealed. The Allied forces immediately embarked on a campaign to destroy his colonial army and retake Ethiopia. The country was liberated in 1942 and Emperor Haile Selassie

was restored to the throne. The one benefit Ethiopia received from this disgraceful adventurism was a superb road network of 2,000 miles of all-weather trunk roads with 8,354 bridges and viaducts, which 60,000 Italian technicians and laborers built in only twenty-four months. Without this remarkable engineering achievement, the escarpments of the Great Rift Valley would not have been tamed so soon.

Like Eritrea and Djibouti, Ethiopia is nowadays a republic. Until his assassination in 1975, Emperor Haile

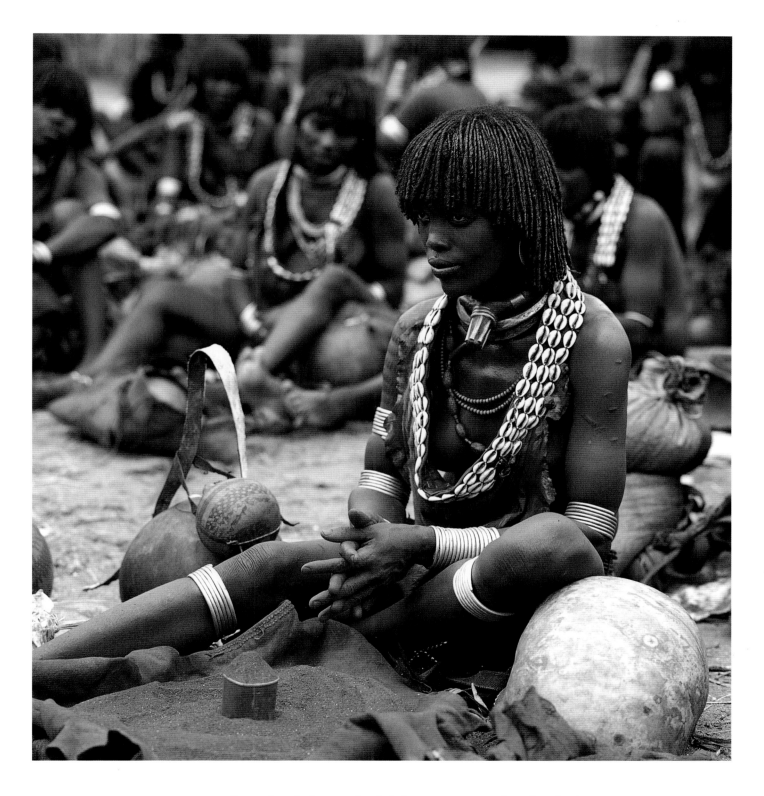

A woman sells gourds and ochre—used in body decoration—at Dimeka. The style of her necklace denotes that she is her husband's first wife. Cowrie shells are popular adornments among the Hamar, although the sea is 500 miles away from Hamar country. The shells were probably first brought to the region by ivory traders.

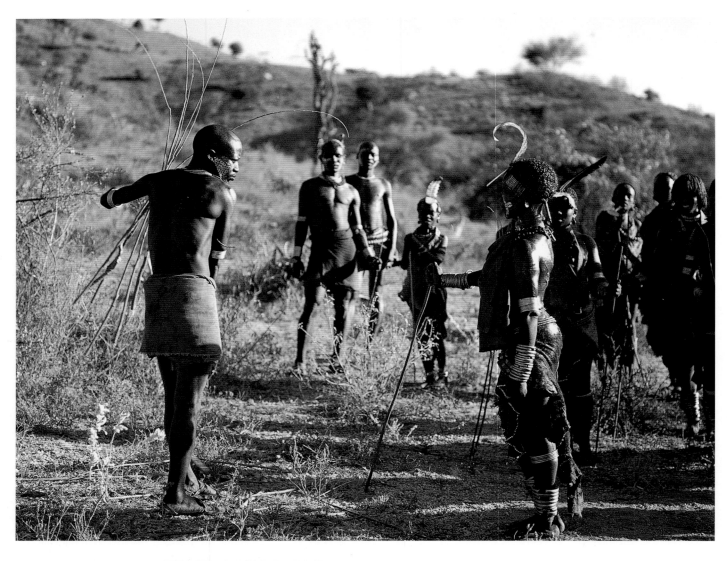

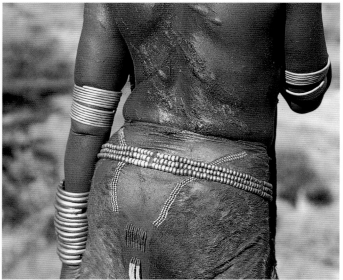

The Hamar embrace an age-grade system that includes several rites of passage for young men. At the most important ritual, the Jumping of the Bull ceremony, a youth becomes a man and is allowed to marry.

ABOVE AND LEFT: During the ceremony, the initiate's female relatives beg to be whipped by his chosen helpers as a token of their love for him. They do not flinch or show any pain. A girl with arms and legs heavy with iron ornaments shows bloody welts on her back.

OPPOSITE: Toward the climax of the ceremony, women and girls dance around the family's herds, blowing trumpets and leaping into the air, their ringlets flying.

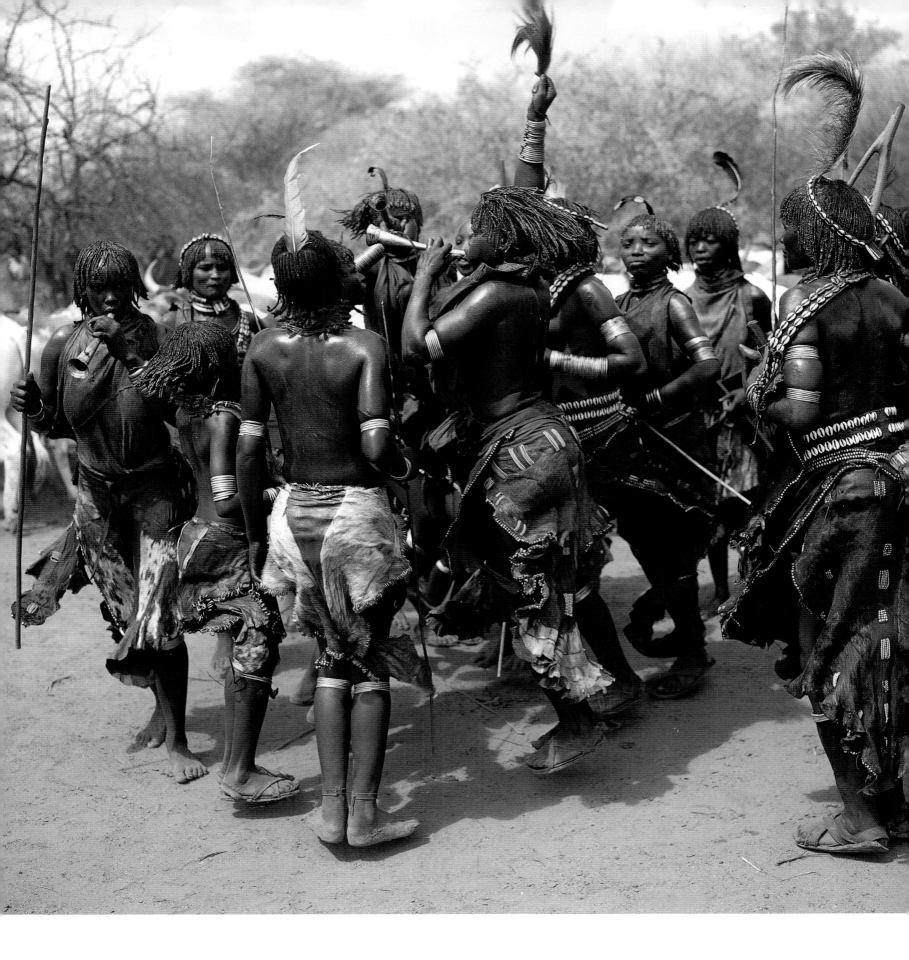

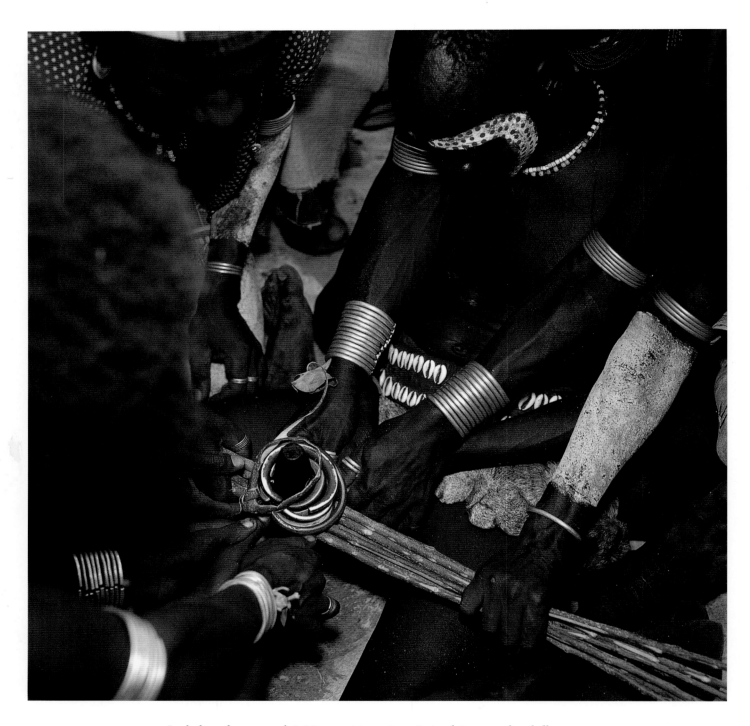

In the late afternoon, each initiate participates in a rite involving a wooden phallus, metal bracelets worn by women, and the pliable sticks used to whip them. The ritual mimics the act of copulation and symbolizes the "rebirth" of the young man as an initiate. Shortly afterward, the family's bulls are assembled and lined up side by side. The initiate, by now naked and with his hair frizzed up, rushes toward the line of ten or more beasts held by the elders. He leaps onto the first ox, then runs along the backs of the rest. He must repeat the feat twice in each direction. A single fall is tolerated but any young man who fails to complete the ordeal suffers considerable dishonor.

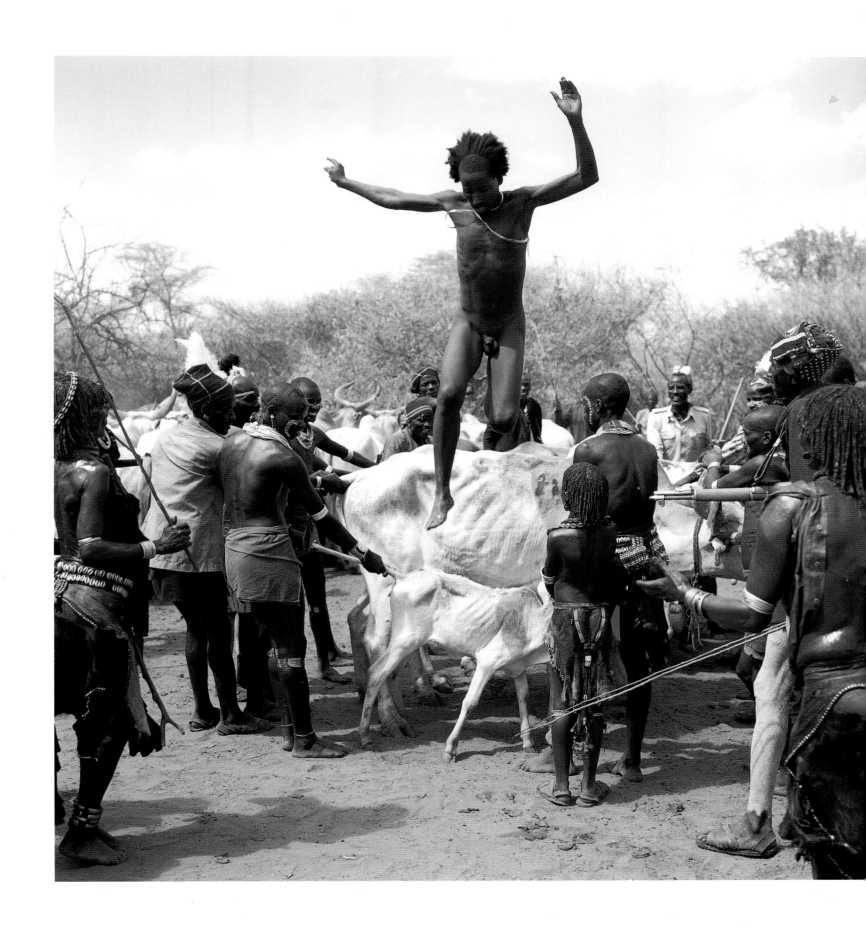

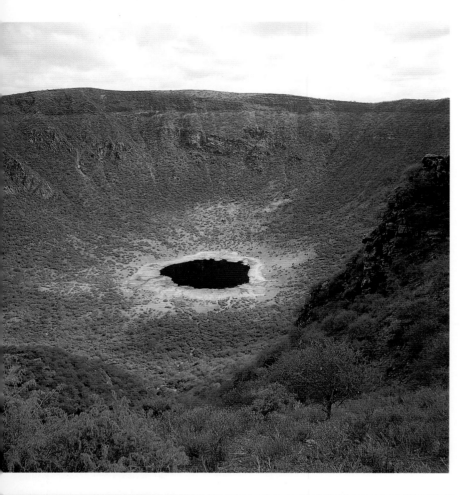

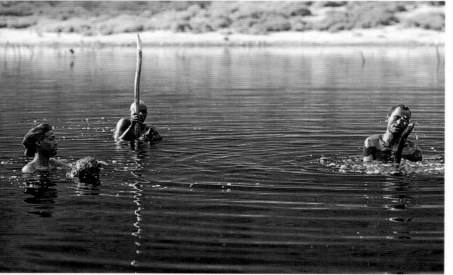

Borana tribesmen harvest salt for their livestock in a dark lake at the bottom of the deep crater of Chew Bet in southern Ethiopia. They use long poles to pry clods of salt-enriched inky ooze from the lakebed, occasionally submerging themselves to gather it in their arms.

Selassie—King of Kings, Elect of God, and Conquering Lion of Judah—was the last ruler of an empire whose lineage, thanks to his wife, could be traced back to Solomon with reasonable certainty. He and his immediate predecessor, Menelik II, were largely responsible for bringing a feudal empire into the modern world. Haile Selassie was imperfect in his insistence on centralized power and for making appointments based solely on personal loyalty rather than on ability. But he had contributed too much to his country to deserve the fate that befell him, aged 83, at the hands of Mengistu Haile Mariam, a disgruntled army major with Marxist leanings. Mengistu helped to overthrow the monarchy in 1974 and, later, as head of the provisional military administrative council known as the Derg (an Amharic word for committee), unleashed a "Red Terror Campaign" to crush all opposition. His rule came to an end in 1991 when he fled to Zimbabwe after his army suffered a series of defeats at the hands of the advancing rebel forces of the Ethiopian People's Revolutionary Democratic Front (EPRDF), which had the support of the peasantry. The Ethiopian Orthodox Church had always played a dominant role in the culture and politics of Ethiopia and stiffened the resolve of the people to get rid of him. The EPRDF chairman, Meles Zanawi, became head of a new government and was reelected prime minister after a general election in 2000.

Although Ethiopia is one of the poorest nations in the world, the people are dignified and intensely proud. They are proud of their age-old independence, proud of their unique written language, and proud that they are one of the oldest Christian nations in the world. Moreover, they take great pride in the achievements of their ancestors, who stood resolute as Africa's last independent empire against the fierce onslaught of the Mahdi, against nineteenth-century European imperialism, and against twentieth-century Fascism.

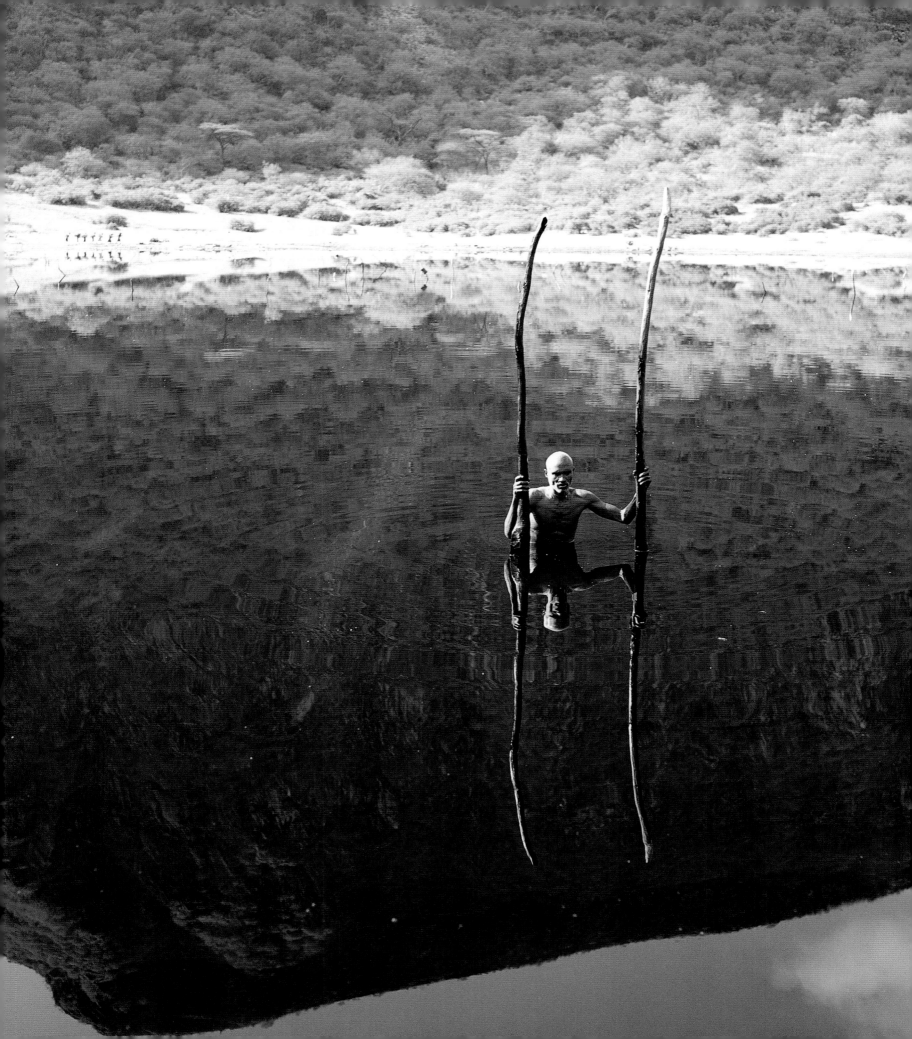

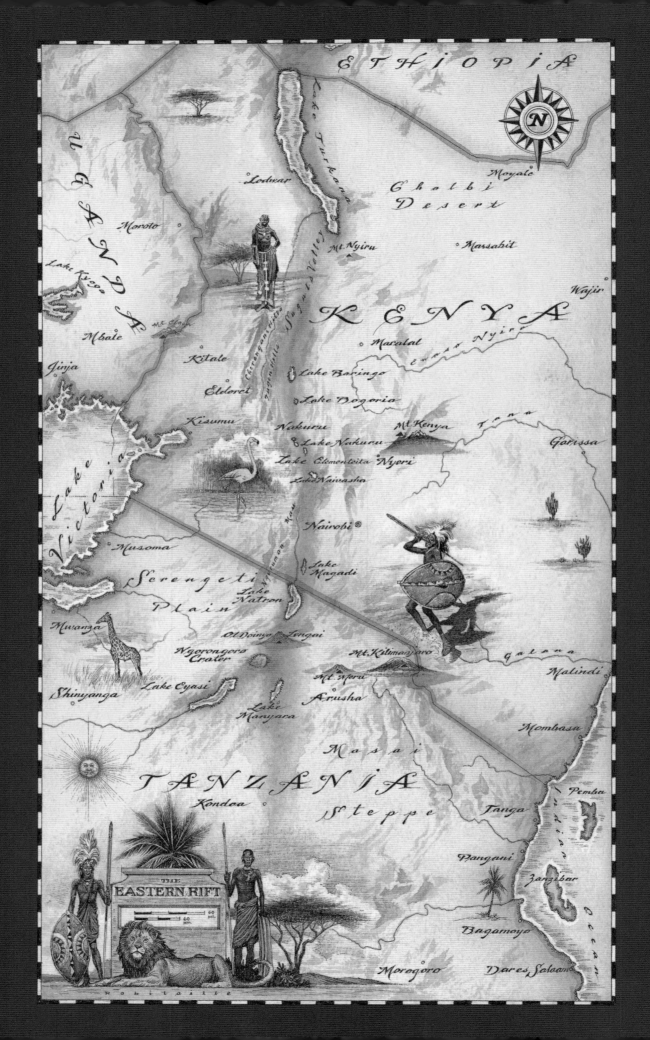

The Eastern Rift

including the Gregory Rift

Africa's Great Rift Valley reveals itself with breathtaking beauty in central Kenya and the far north of Tanzania, where it is called the Gregory Rift Valley. It divides Kenya from north to south in a series of fault lines that give spectacular shape to the landscape. In places, the Rift's dramatic sheer-sided walls drop abruptly more than 2,000 feet to a broad valley, the domain of nomadic pastoralists. Settled communities of other tribes till the well-watered, fertile volcanic soil on the shoulders of the Rift. From time immemorial, pastoralism has been the predominant occupation of the people living in the low-lying, arid regions of East Africa. Nomads know only too well that the contrast between lush pasture of the wet season and a searing dust bowl of the dry season often spells the difference between feast and famine, life and death.

In the Lake Turkana basin of northern Kenya extensive lava fields and punishing heat, coupled with high winds that erode and exhaust the poor soil, make the region one of East Africa's most inhospitable. The Turkana inhabitants are well scattered and lead a Spartan nomadic lifestyle, tending camels, sheep, and goats. A warlike people, they live west and south of the lake that bears their name and along the barren southeast shoreline, which resembles a desolate lunar landscape. Cattle are the Turkana's most prized possessions, but they find suitable pasture only in the isolated mountain ranges at the boundaries of Turkanaland, where armed conflicts with hostile neighbors often break out over water and grazing rights.

East of the lake are the proud Gabbra, who roam the desert wastes on either side of the Kenya–Ethiopia border with large herds of camels, their principal wealth.

Though the Turkana and the Gabbra live next to one another, they rarely fraternize and have little in common except a similar way of life adapted to the harsh conditions of their forbidding land. They speak different languages and have distinctive cultures and traditions. The Turkana, generally tall and very dark-skinned, are the largest ethnic group of Ateger-speaking people, an eastern cluster of seven tribes originating close to the Nile. The Gabbra are a section of the Oromo people who spread from southeast Ethiopia throughout the Ethiopian Empire and south into Kenya after the sixteenth century. Their complexions are dark brown and their features are more Caucasoid than those of the Turkana. Their arrival

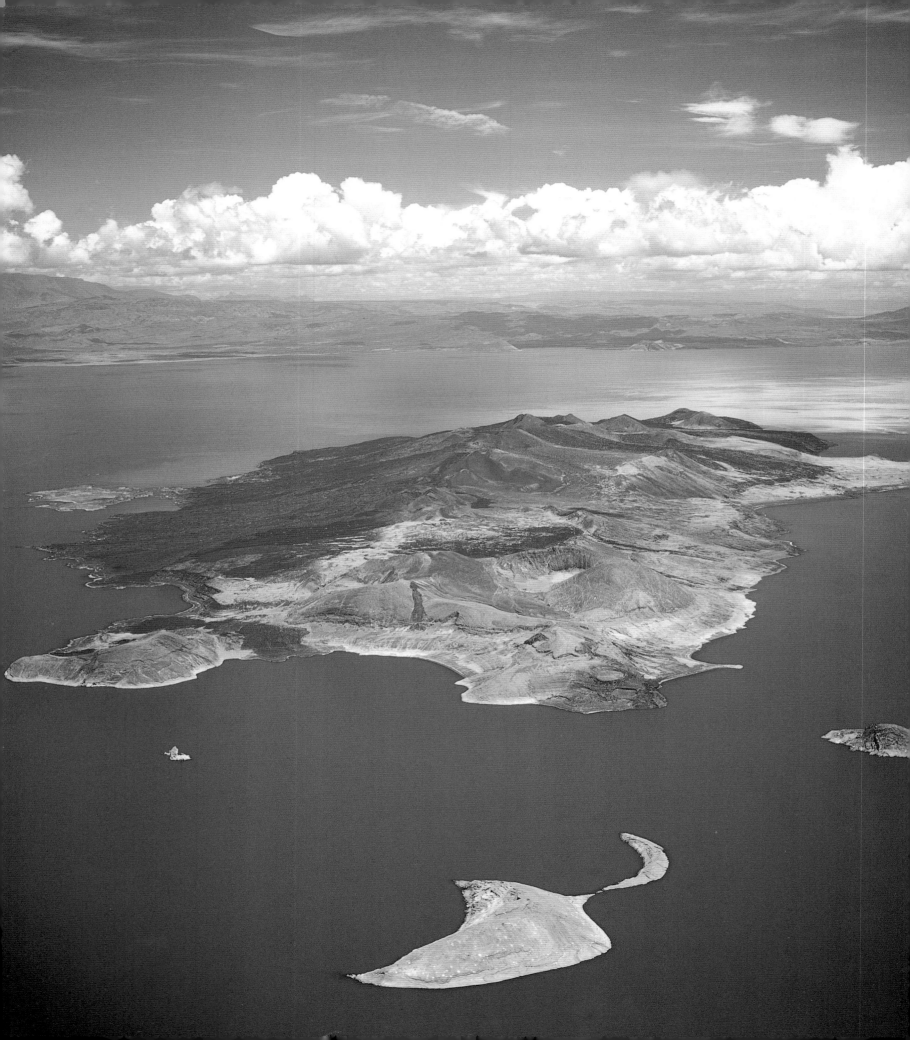

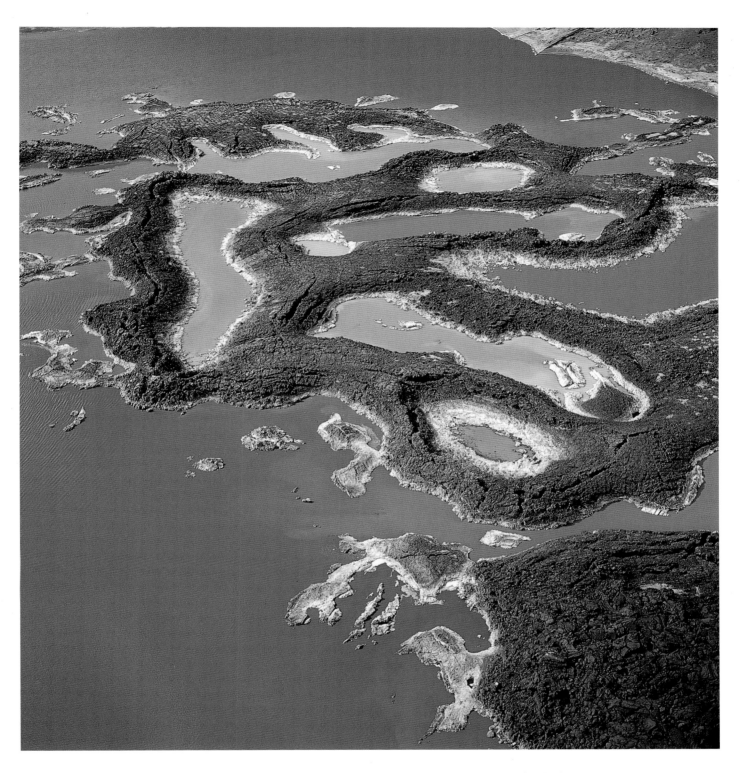

Lake Turkana, often referred to as the Jade Sea, takes its color from algae with a high chlorophyll concentration that develop in the lake's alkaline waters. At the southern end of the lake, South Island (left), a volcanic spine of cones and craters, rises from deep water. Gale force winds blow incessantly from the southeast in this region of the lake.

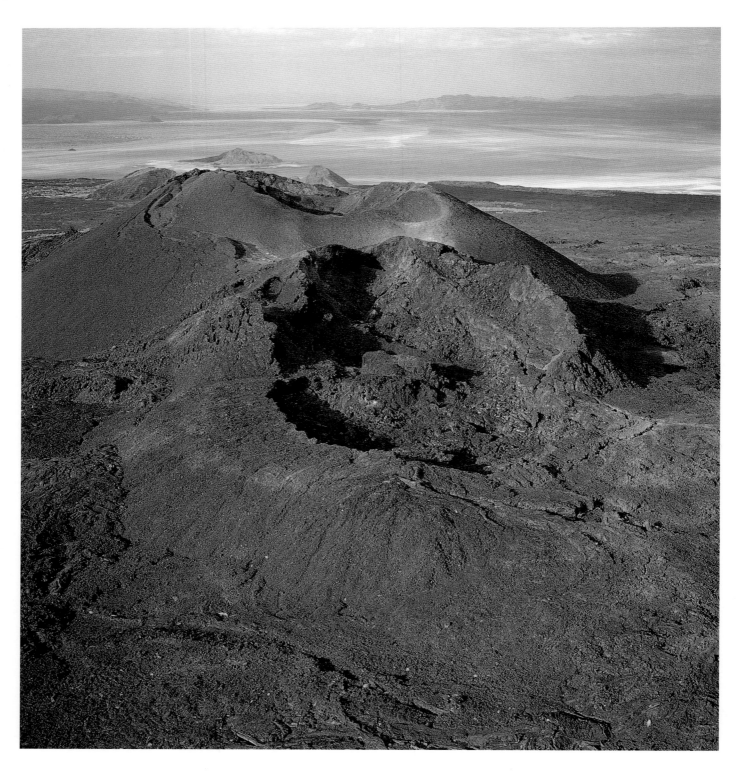

Lake Turkana's tortured landscape has been shaped by massive volcanism over millions of years. Andrew's Volcano (above) and Teleki's Volcano were active there until about 1895. The basaltic lava flows from Teleki's Volcano (right)—named after Count Teleki, an Austrian explorer who was the first to report it erupting—still look remarkably fresh.

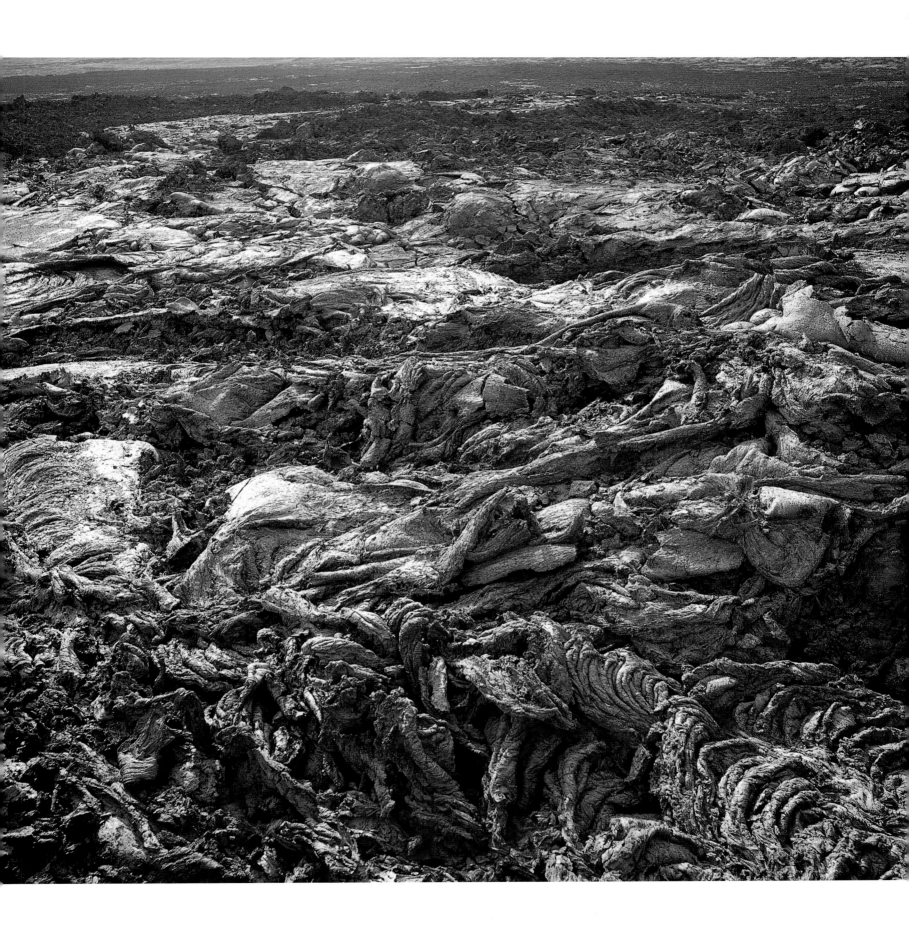

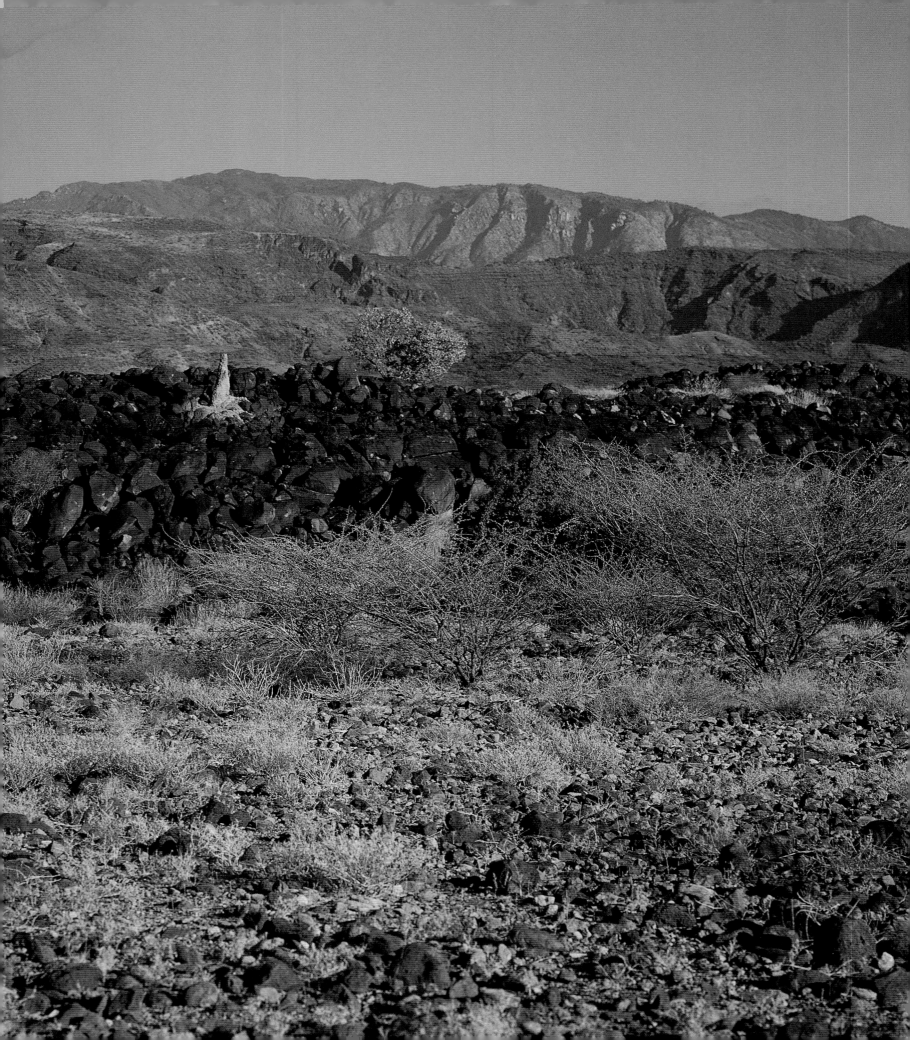

in Kenya predates the Turkana expansion to the east of Lake Turkana by more than a century.

The asymmetrical trough of the Rift Valley in Kenya rises from a low point of 1,197 feet above sea level at Lake Turkana to almost 6,200 feet at Lake Naivasha, the highest lake of the Rift system. Then, moving south, it falls away quite rapidly to 1,977 feet at Lake Magadi before rising steadily again toward the Ngorongoro highlands in northern Tanzania. Before the creation of the Rift Valley, only a few lakes filled the depressions of a featureless plateau. Now, more than thirty nestle in the trough of the Rift system. One or two of these lakes are deep; others are shallow and ephemeral. The majority are alkaline, though a few are fresh. Each is different and each supports life forms that occur nowhere else. Significant changes in climatic conditions and major earth movements have caused the lakes to rise and fall in long natural cycles. Short-term changes also occur but do not affect the over-all trends. In the past five million years, Lake Turkana, a true desert lake, has varied from up to five times its present size to little more than a swamp. Though now the largest lake of the Eastern Rift system and Africa's fifth largest, Turkana's level fluctuates more than any other lake of natural origin in the world because it has only one permanent source, the Omo River. The Omo rises in the distant highlands of Ethiopia and provides more than 90 percent of the lake's annual inflow.

A failure of the rains in Ethiopia has a dramatic effect on the lake's level because surface water evaporates about ten feet a year, a result of intense heat and the desiccating

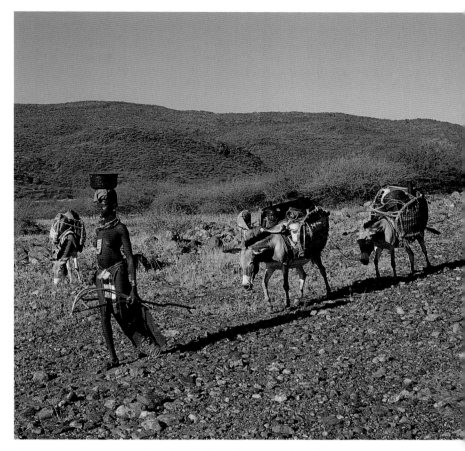

effect of incessant wind. Lake Turkana lies in a closed basin, and the presence of sodium carbonate has left its slimy waters disagreeable to taste. Yet the influence of the Omo River has produced a predominantly freshwater fish fauna.

As a mega-lake in ancient times, Turkana must have had an outflow to the White Nile, for its rocks contain the remains of at least seven species of mollusks and eight of fish common to the Nile system. Today, Lake Turkana abounds with Nile perch and the population of Nile crocodiles may still be the largest in the world, despite dwindling numbers due to human interference. When

Ridges of volcanic rock of varying hues rise from the oven-hot wastes of the Suguta Valley toward Mount Nyiru, an eastern boundary of the Rift. The chimney of a termite mound at left center displays the pale soil beneath the lava. The nomadic Turkana live in this inhospitable land, moving frequently in search of grazing. They breed donkeys to carry their few possessions and children too young to walk.

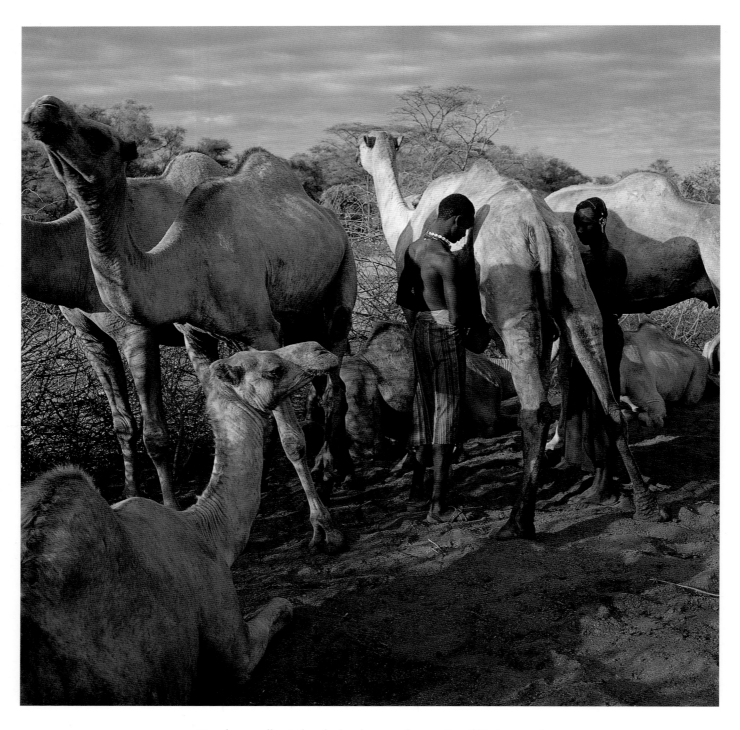

ABOVE: *Camels are well suited to the dry thorn scrub vegetation of Turkana territory, and camel milk forms an important part of the nomads' diet. During times of abundant grazing, stock owners may milk their animals five times a day.*

OPPOSITE: *The fish in Lake Turkana also provide families living near the lake with a valuable source of protein. Fishing the shallow waters with traditional wicker baskets has gradually given way to the indiscriminate use of small mesh nets, which has reduced the lake's breeding stocks of tilapia.*

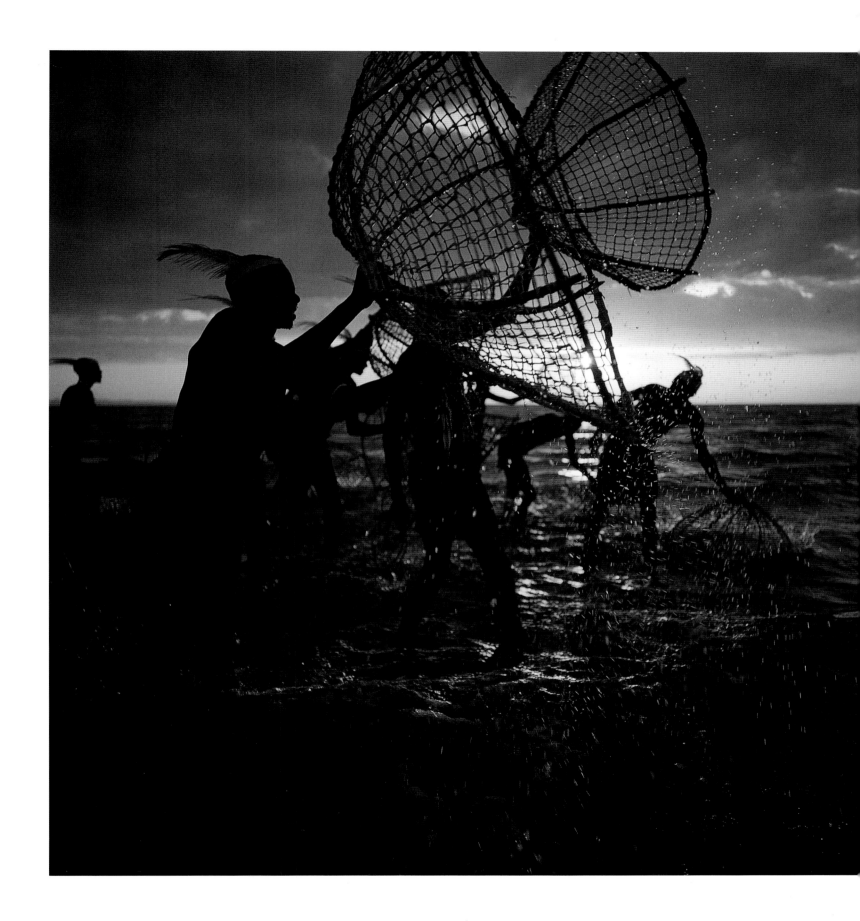

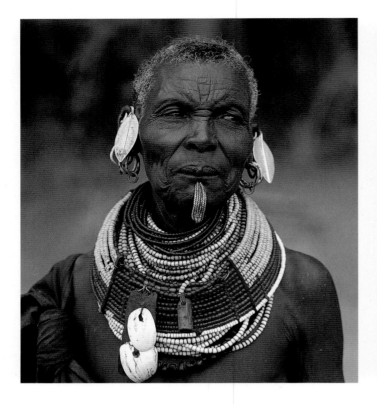

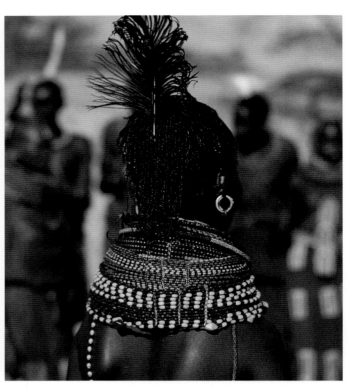

A Turkana woman of northern Kenya wears a brass ornament fixed in a hole below her lower lip. Her ear rings and beaded collar denote her married status.

Turkana girls sometimes wear so many strings of colored glass beads that their necks stretch and the muscles weaken.

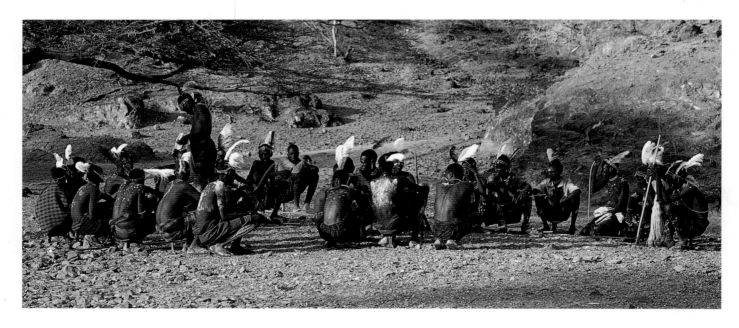

With their white ostrich feather headdresses waving in the breeze, a group of Turkana men meet under the shade of an acacia tree. Men customarily sit on a small wooden stool, which doubles as a pillow at night.

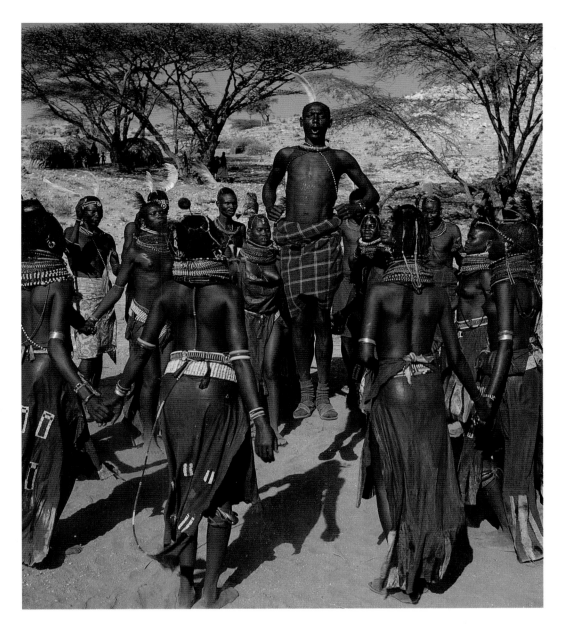

Turkana men and women dance to the rhythm of bells, handclaps, and singing. Beaded leather skirts are held in place by broad belts adorned with ostrich-shell discs.

the lake was roughly 220 feet above its present level 10,000 years ago, the most likely connecting route between the lake and the river was the low-level divide between the Omo River plains and the Lotagipi swamp, an alluvial flood plain to the west of the lake.

Standing amid the barren, windswept lands of stunted vegetation in the Turkana Basin makes it difficult to imagine that the place was at one time covered in tropical forest, as the fossil records prove. Over the millennia, climatic changes gradually reduced the forest canopy, giving rise to scattered woodlands and open grassy plains teeming with game. Some of the arboreal apes adapted to these unfamiliar conditions rather than face possible extinction. As we have learned, more than four

million years ago one species learned the art of walking upright, and so began the long evolutionary path toward humanity. During a crucial period in human evolution, frequent volcanic eruptions layered the country with ash and the expansion and contraction of rivers and lakes deposited sediments over the exposed layers. Fortunately for the paleoanthropologists of today, tectonic faulting has uplifted some exceptionally rich fossil beds of the animals and people living along the lakeshore in those ancient times. Constant weathering of the strata by wind and rain helps to reveal new finds each year.

The records of human evolution in the Turkana Basin are unrivaled, although many gaps still remain to be filled. Some experts now believe that the cradle of humankind was the eastern branch of Africa's Great Rift Valley because more fossil evidence has been found there than elsewhere in Africa. The Rift trough may have been an important route for human dispersal, just as it is today a migratory route for European birds wintering each year in the Southern Hemisphere. The distribution of indigenous African species such as the Yellow-throated sandgrouse follows the course of the Rift system all the way from Eritrea to northern Zambia.

The first definitive account of Lake Turkana's existence came from Count Samuel Teleki von Szek, a count of the Holy Roman Empire who was born in Transylvania (now in Romania). With Count Teleki was Lieutenant Ludwig von Höhnel, of the Austrian Navy. They recruited close to 400 men and purchased stores weighing eighteen tons for their two-year journey from the East African coast, opposite Zanzibar, to the uncharted lake. It was the only expedition of its era that was privately financed by the explorer himself. Teleki was an astute leader, able to deal with hostile tribesmen, deceitful porters, a harsh country, and serious shortages of rations. In March 1888, he and his men finally reached the southern end of the lake where the daunting environment filled them with apprehension:

The mountain district between us and the lake was, in fact, a veritable hell, consisting of a series of parallel heights, running from north to south, which we had to cut across in a northwesterly direction. The slopes of these mountains were steep precipices, most of them quite insurmountable, and those that were not [were] strewn with blackish-brown blocks of rock or loose sharp-edged scoriae. The narrow valleys were encumbered with stones and debris, or with deep loose sand in which our feet sunk, making progress difficult. And when the sun rose higher, its rays were reflected from the smooth brownish-black surface of the rock, causing an almost intolerable glare, whilst the burning wind from the south whirled the sand in our faces, and almost blew the loads off the heads of the men.

At that time, Lake Turkana was known to the local Samburu tribesmen as *empaso narok*, the Black Lake, but Teleki named it Lake Rudolf after his influential friend, Crown Prince Rudolf of Austria. In a move to eradicate the vestiges of colonialism, the lake's name was changed again in 1975 to Turkana, after the people who live along its shores.

Nothing much has changed at Lake Turkana in a hundred years except that an active volcano, which von Höhnel named Teleki's Volcano, is now dormant. The explorers stood on a massive 3,000-foot-high volcanic ridge at the southern end of Lake Turkana where the dying and quiescent phases of Kenya's most recent volcanic activity can be seen in stark surroundings. This feature, known as The Barrier, separates Lake Turkana from the Suguta Valley, which was once a southerly extension of

the mega-lake. Its shallow waters have long since dried up, leaving a small seasonal lake of high alkalinity at its northern extremity.

The Barrier was formed by lava extruded from one huge volcano. Though the volcano subsequently collapsed to form a caldera, later subsidence and tilting of the land caused more eruptions from parasitic cones, one being Teleki's Volcano, which has erupted several times in recent geological time. There are five recognizable flows varying in color from chocolate brown to dark gray. The last recorded eruption took place in 1895 when lava almost reached the base of Nabuyatom, a perfectly symmetrical cone that juts into the jade waters of Lake Turkana's southern shoreline. This extrusion, gunmetal in color, still looks remarkably fresh. The lava fields are filled with whorled and twisted boulders and jagged spikes and giant blisters of thin rock, making movement on foot extremely hazardous.

Until 1935, an element of mystery surrounded Teleki's Volcano. A young English traveler, Henry Cavendish, who in 1897 became the first European to travel down the west side of Lake Turkana, could find no trace of the volcano at the southern end of the lake, "its place being taken by an absolutely flat plain of lava." Though he was looking for it in the wrong place, he was also confused by the locals, who explained that six months prior to his visit the level of the lake had risen. As water gushed into the volcano, they said, an explosion occurred that extinguished the fire. Cavendish believed this unlikely tale. Thirty-eight years elapsed before the colonial administrator of the Turkana Province, A. M. Champion, put the record straight. The volcano was exactly where von Höhnel had plotted it on his painstaking maps. It does, however, give the appearance of having been ripped apart by a massive explosion.

Before Cavendish and his companion, Lieutenant H. Andrew, left the area, they ventured into the Suguta Valley, where they saw a smoldering cone on the southern slopes of The Barrier and named it Andrew's Volcano. Like Teleki's Volcano, it is now dormant, with a few steam jets being the only sign of latent activity.

The Suguta Valley is the hottest, windiest, and most unpleasant spot in East Africa. Nothing prepares the visitor for the surprising surge to 130 degrees F in midday temperatures or the huge dust clouds of fine volcanic material that develop in the strong dry-season winds. An unusual feature of the valley, the Suguta River, gushes from hot springs a short distance from Kapedo, north of Lake Baringo and then plunges down an impressive waterfall before coursing into the tortured terrain of the valley, only to dissipate in bleak sandy wastes. Although the river appears alluring to the unsuspecting, it is so saline that even livestock shun drinking its tepid waters. Despite the harshness of this wilderness, which can drive visitors to extremes, Turkana herdsmen eke out a living from the sparse vegetation, proving that man is the most resilient and adaptable species on Earth.

The small administrative center of Kapedo marks a southern boundary of the lands of the Turkana and the start of Pokot country. The two tribes have been bitter enemies for generations and continually rustle each other's herds, which invariably leads to loss of life. There is no end to the bad blood between the groups.

The Pokot are an example of a people whose whole lifestyle has been influenced by the climatic and topographical diversity of the Rift Valley. The more affluent section of the tribe lives in the Cherangani Hills, above the western wall of this sector of the Rift. They farm the fertile soil intensively, and their neat round

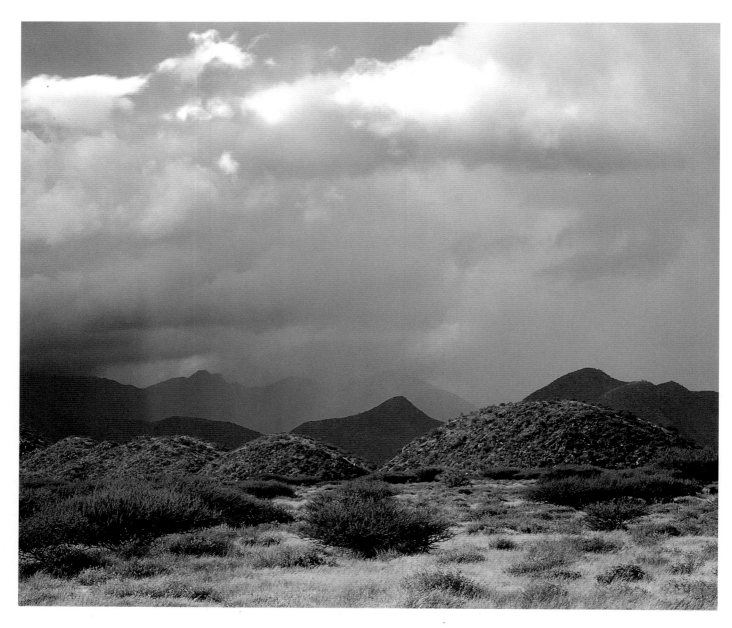

A rare torrential rainstorm lashes the foothills of Mount Nyiru, a scenic region of semi-arid thorn scrub vegetation.

houses with grass thatch reflect their settled existence. These Pokot have abandoned traditional forms of dress, their wealth and their diet are no longer dependent on livestock, and they are literate because government and mission-sponsored schools are only a short walk from their homes. The other section of the tribe lives in the Rift trough where the climate is hotter and drier, and the vegetation changes abruptly to acacia thorn scrub growing in poor, rock-strewn soil. The people there are largely semi-nomadic pastoralists, although some families plant maize and millet in places where soil and water are suitable for cultivation. They have less opportunities for schooling due to their lifestyle, and they dress much as their forebears did: some of the young men still sport the traditional blue

Of volcanic origin, Mount Kulal stands along the eastern margins of the Rift and is divided into two sections by the spectacular, narrow, and very deep El Kajarta Gorge.

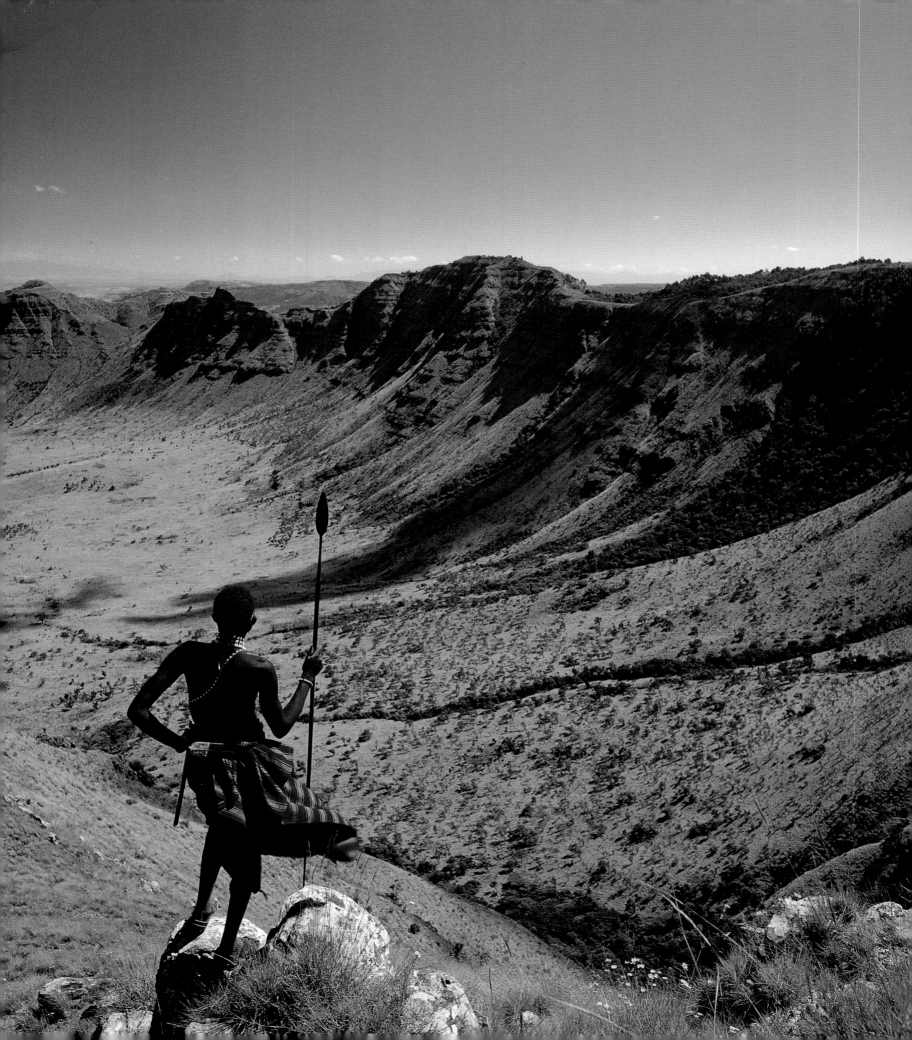

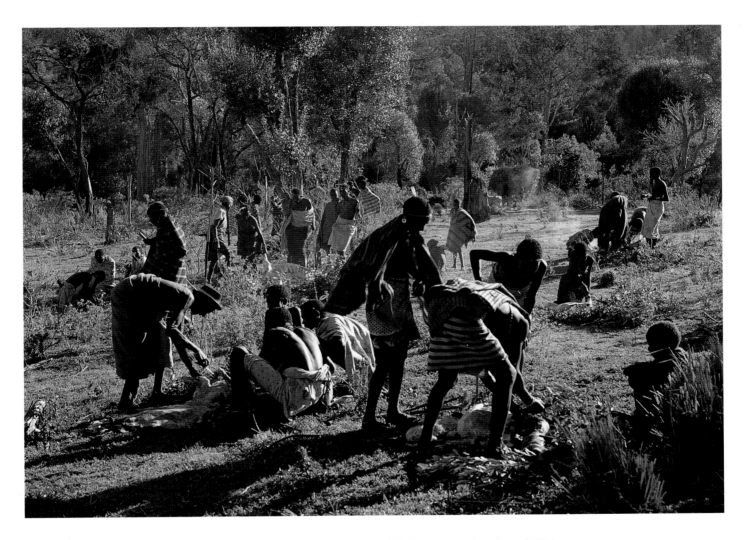

OPPOSITE: *A Samburu warrior overlooks one of the finest views from the wall of the Eastern Rift at Poro, near Maralal, where the top of the escarpment rises to 8,000 feet. From there, the land drops precipitously 3,000 feet into a stark valley, inhabited only in wet weather when abundant forage for livestock attracts herdsmen from various pastoral communities.*

ABOVE: *Samburu warriors participate in several age-grade ceremonies to mark a change in their status. On each occasion, cattle are slaughtered for a feast.*

clay hairstyles and women and girls often wear goatskin skirts in preference to cloth.

The southeast boundary of land belonging to the pastoral Pokot lands abuts Lake Baringo, which lies in a shallow basin between the Laikipia escarpment and the Tugen Hills. It is one of only two freshwater lakes of the Gregory Rift. Since neither lake has a visible outlet, their waters are fresh because of substantial subsurface seepage: Rift lakes that lose water by surface evaporation alone are always alkaline. Lake Baringo was once the center of a thriving fishing industry with its own processing factory. In the past thirty years, however, the waters have become increasingly turgid due largely to erosion and bad agricultural practices in the lake's catchment area. The accumulation of suspended sediment has caused poor breeding and stunted growth of the indigenous perchlike tilapia fish, forcing the factory to close. With the gradual silting up of the lake basin the long-term existence of the lake itself is now in question: it could become seasonal in years to come.

Cartographers 150 years ago showed Lake Baringo as the principal source of the White Nile. That fantasy was not debunked until 1883 when Joseph Thomson, a twenty-one-year-old Scottish explorer, became the first European to cross Maasailand. For two decades after Thomson's pioneering journey, the southern end of the lake was an important staging and supply base for caravans heading to Uganda on foot. Travelers were always relieved to reach there because the extremely friendly attitude and remarkable honesty of the people was so refreshing after the trials of crossing Maasailand. Members of the small Il Chamus tribe still live along the shores and on the main islands of the lake as they have always done, practicing agriculture, animal husbandry, and fishing. Their forefathers devised an ingenious method of irrigating the rich loam at the southern end of the lake, which gave rise to a modern irrigation system. (Joseph Thomson mistakenly called these people Njemps, a misnomer that was perpetuated by the British colonial administration and remains in use today.)

One hundred miles south of Lake Baringo lies Lake Naivasha, the other freshwater lake of the Gregory Rift. In prehistoric times, it was substantially larger than it is today and had an outlet that passed through a narrow gorge now known as Hell's Gate, a small but beautiful national park. Guarding the entrance to the gorge are enormous rock buttresses, which were scoured by the copious volumes of water flowing through it in the Pleistocene pluvials. In what was the middle of the ancient river stands an imposing volcanic plug called Fischer's Tower or Fischer's Column after the German explorer, Dr. Gustav Fischer. Fischer had financial backing from the Geographical Society of Hamburg when he set out from Zanzibar in 1883 to explore the lake. But he fell foul of truculent Maasai warriors at Lake Naivasha, who forced him to turn back. Despite Fischer's disappointment, his journey was hailed as a success back home for he had not only mapped out a large tract of hitherto unknown country but also gathered a wide array of natural history specimens of major importance. His outstanding collection of bird skins included thirty-six species new to science. No less than seventeen species bear the name *fischeri* today.

A curious sidelight of Fischer's journey is that had he been allowed to travel farther, the boundaries between English and German colonial possessions in East Africa might have been settled quite differently because demarcation was influenced by the successful exploits of each country's

OPPOSITE: *A Samburu herdsman tends his family's flocks of fat-tailed sheep and goats.*

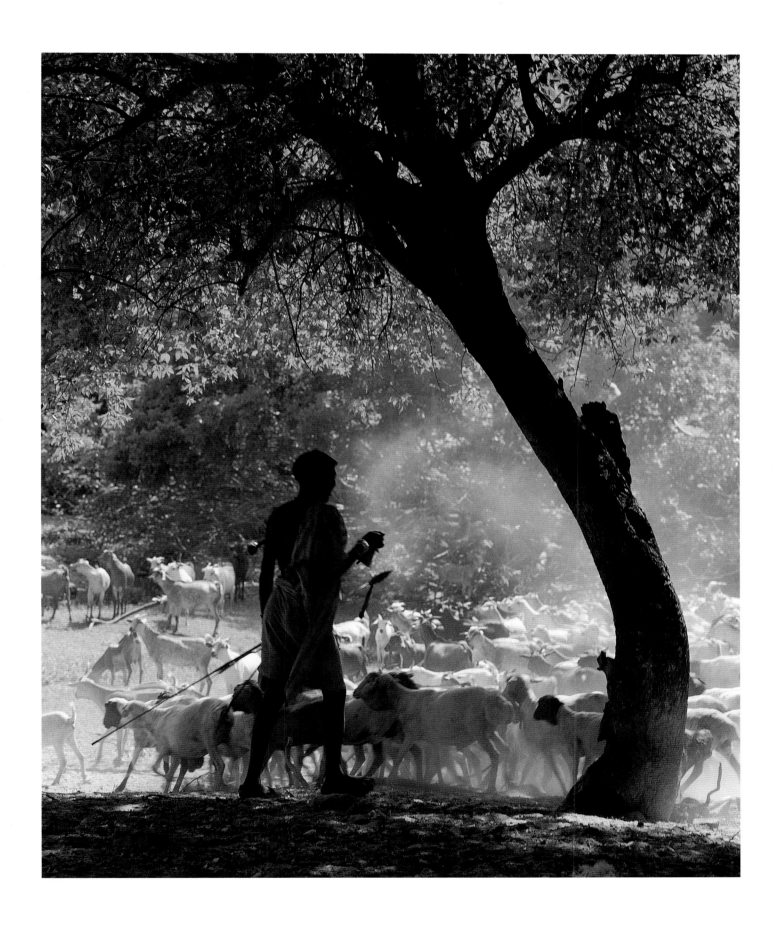

explorers. Only three months separated Fischer's rebuff by the Maasai at Naivasha and Joseph Thomson's successful passage through the same place. Unwittingly, Thomson's remarkable journey through Maasailand to the eastern shores of Lake Victoria was to reinforce England's claim to a large tract of land that is now part of Kenya.

Under the terms of a 1971 international treaty to protect wetlands, Lake Naivasha was declared a Ramsar site in 1995. This classification aims at promoting conservation and the sustainable use of wetlands that fill a unique ecological niche in their region. Wetland management has become an important aspect of global natural resource protection. Lake Naivasha is one of Africa's foremost ornithological treasures, hosting some 400 species, but over-exploitation of the lake forms a growing problem because Kenya's expanding horticultural industry is centered around it. Huge volumes of water

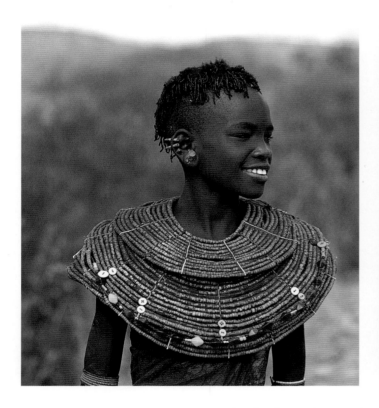
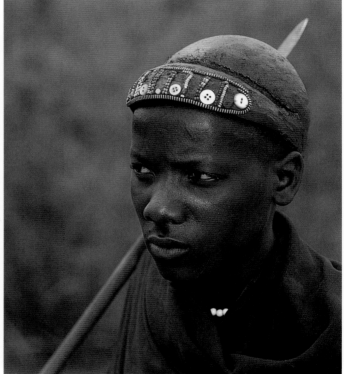

In contrast with Pokot farmers living in the Cherangani Hills, their cousins in the trough of the Rift Valley are semi-nomadic pastoralists who live a more traditional life.

ABOVE LEFT: *A young girl wears a broad necklace made from the stems of sedge grass. Her ears are pierced in four places, ready to insert the large brass ear rings that she will acquire after marriage.*

ABOVE RIGHT: *The unusual clay hairstyle of this young man, decorated with beads and buttons—a familiar contemporary addition to traditional adornment—reveals that he was recently circumcised.*

OPPOSITE: *A cluster of houses of the Marakwet people clings to a ledge of the rocky Tot Escarpment, east of the Cherangani Hills of Kenya. Across the Kerio Valley are the Tugen Hills, a huge fault block in the middle of the Gregory Rift.*

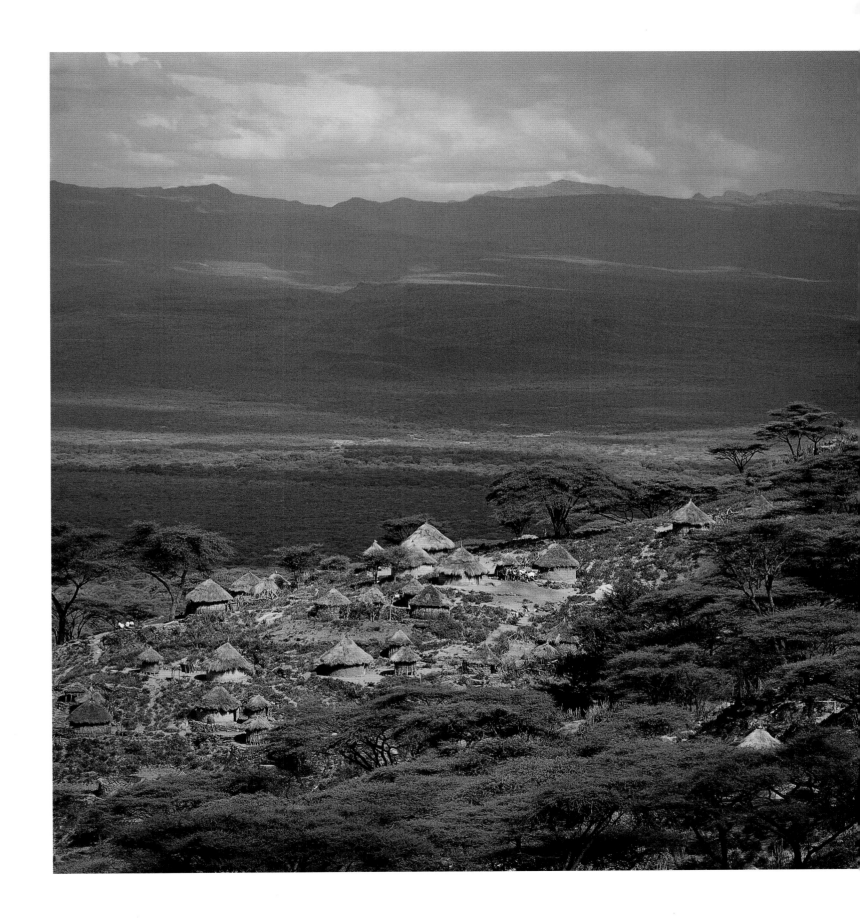

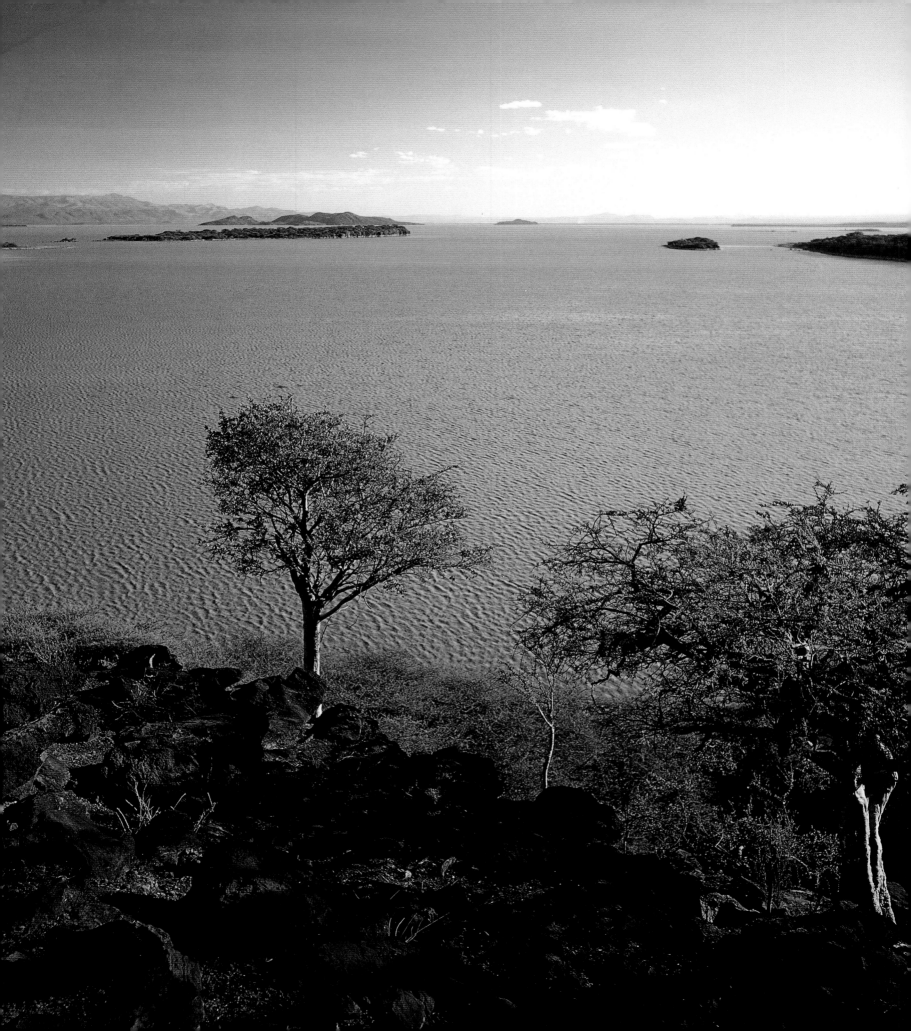

OPPOSITE AND ABOVE: *Lake Baringo, one of only two freshwater lakes of the Eastern Rift, lies in a shallow basin surrounded by hills where poor agricultural practices have led to bad soil erosion. In consequence, the lake's waters are red with suspended solids. The Il Chamus live near the shores of this lake, and on the islands. Related to the maa-speaking Samburu, they make a unique raft from the light wood of the Ambatch tree that grows in swampy ground around the lake.*

are pumped out of the lake each day to irrigate the thirsty volcanic soil. At the same time, nearby townships divert part of the lake's natural inflow to supplement their water supplies. In the 1880s, many lakes in Africa were affected by prolonged drought, and Lake Naivasha almost dried up. If the average extraction from the lake for the past twenty years had been the same for fifty years, scientists calculate that it would have dried up on two other occasions.

The landscape surrounding Lake Naivasha, dotted with the unmistakable shapes of volcanoes and calderas, reveals its ancient history today in the intense pressure of the steam jets at Olkaria, situated on a volcanic ridge close to Hell's Gate. Steam also issues from the slopes of Eburru and the inner wall of Longonot crater, two dormant volcanoes lying to the north and south of Lake Naivasha. The vents are small in comparison to Olkaria's, which let out a muffled roar. Steam at 250 degrees to 300 degrees C from the most powerful vents is harnessed for geothermal power 3,000 feet or more below the earth's surface. The Olkaria field produces 15 percent of Kenya's electricity and should last another 30 years.

As a rule, fumaroles, geysers, and hot springs are taken as a sign of declining volcanic activity, but

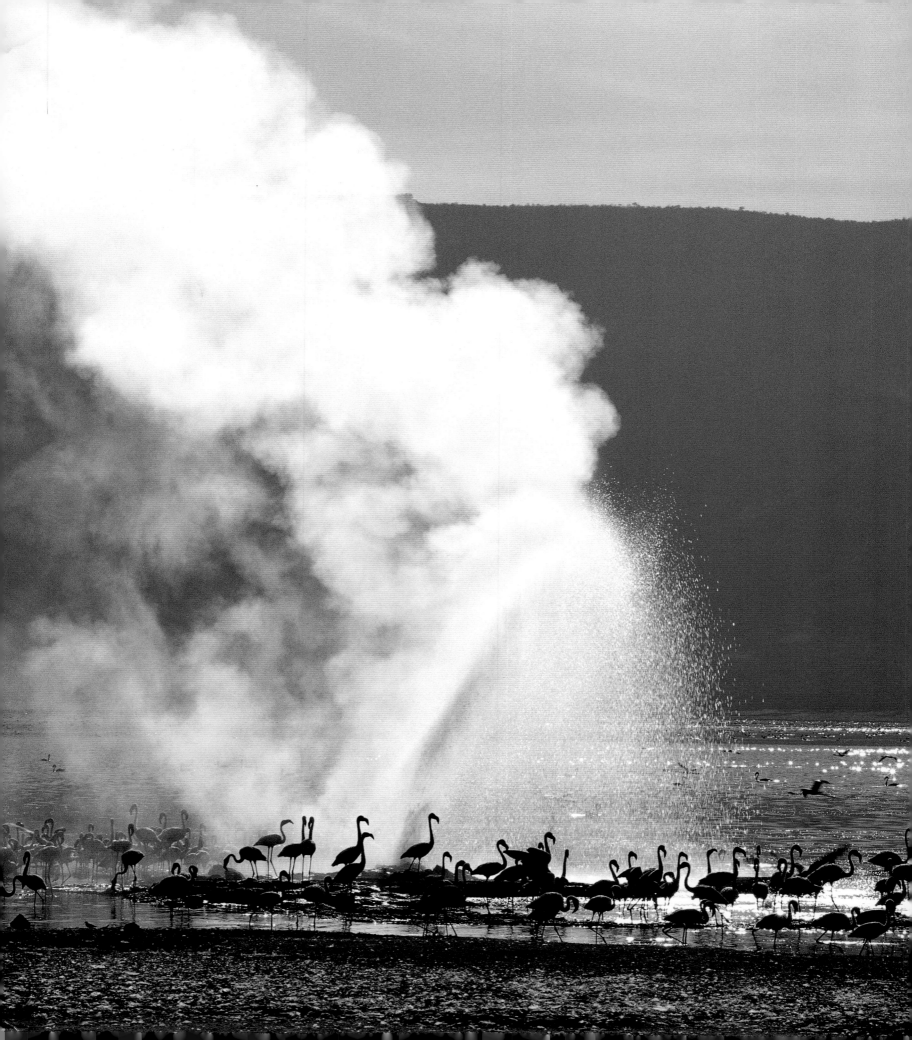

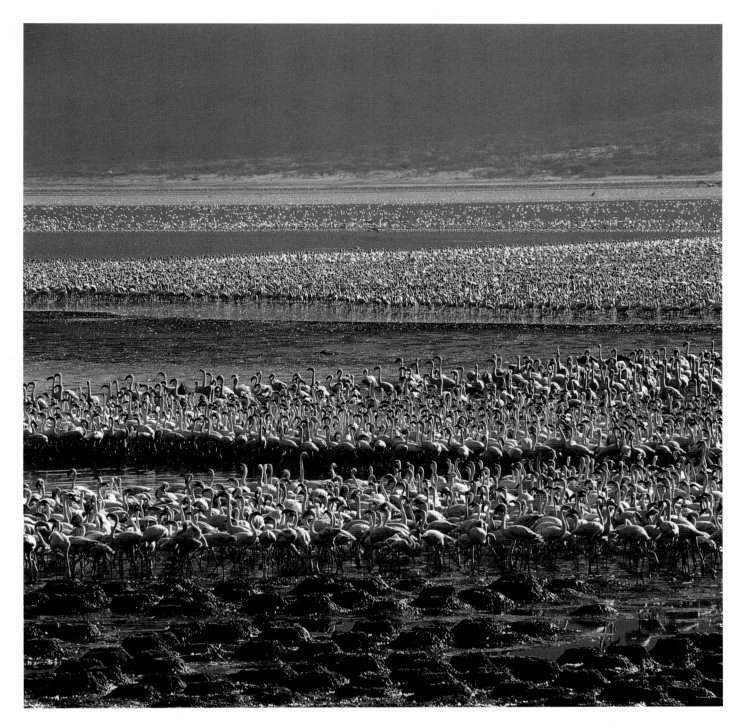

OPPOSITE AND ABOVE: *Thousands of lesser flamingoes congregate at Lake Bogoria amid geysers and hot springs. The long, narrow lake nestles in the foothills of the Siracho Escarpment, which rises abruptly from its eastern shoreline. The lake's warm alkaline waters provide the ideal breeding ground for the blue green algae,* Spirulina platensis, *on which flamingoes feed.*

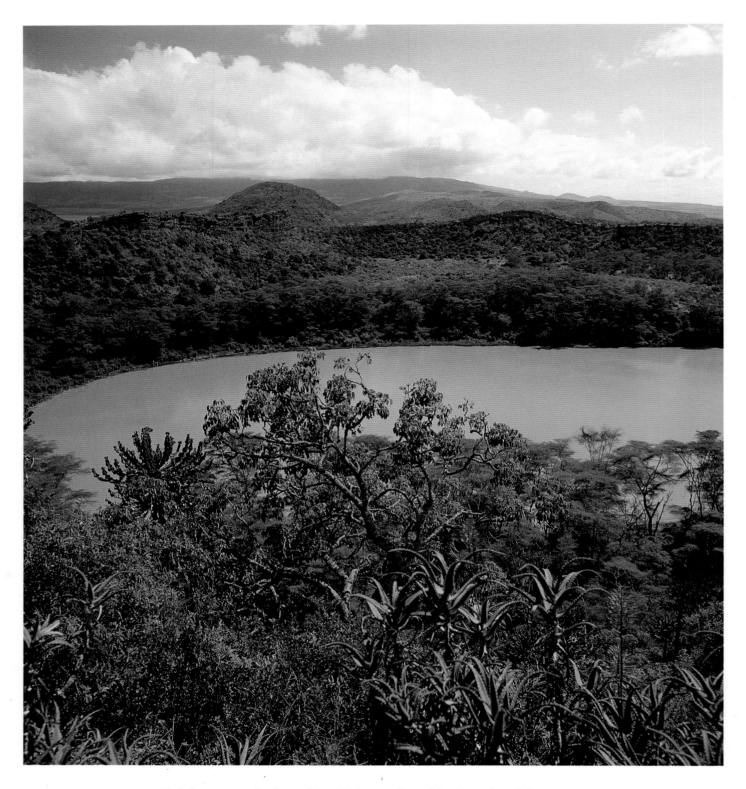

Red aloes grow on the slopes of Sonachi Crater, a beautiful extinct volcano lying two miles west of Lake Naivasha. Lesser flamingoes are attracted to the algae in the green tinged alkaline waters of its crater lake.

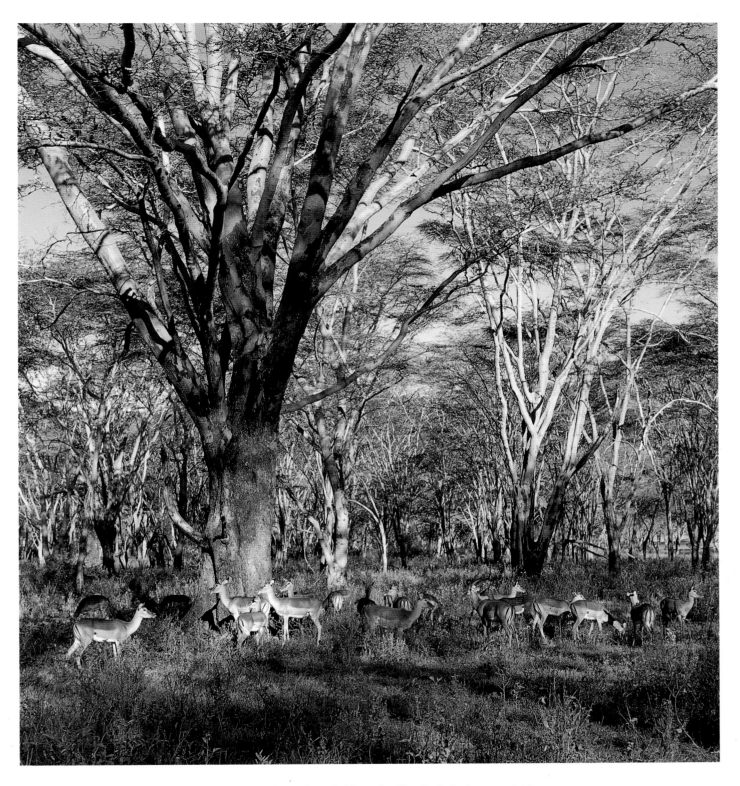

A herd of graceful impala antelopes feed beneath yellow-barked "fever trees" (Acacia xanthophloea) near Lake Nakuru. Nineteenth-century European explorers gave the tree its nickname because it flourishes in places of high groundwater, which attracts mosquitoes. The link between malaria and mosquitoes was not recognized until 1880.

tectonic conditions in the bowels of the earth are never certain. While volcanism in this middle section of the Gregory Rift has been in a long dormant phase, which could last another few thousand or even million years, it is still capable of changing the geography of the region dramatically. Latent activity is also evident at Lake Bogoria, where numerous hot springs and geysers contribute to the lake's alkalinity.

Lake Bogoria, the northernmost of three small alkaline, or soda lakes lies between Baringo and Naivasha. It nestles at the foot of the Laikipia escarpment in a place of wild beauty. Here, the eastern scarp drops down precipitously to the long, narrow lake before the land rises gradually from the Rift floor in a series of steps to the Tugen Hills. The poor rock-strewn soil has sparse vegetative cover but supports dry acacia bush land. (The leaves of acacia trees

ABOVE: *Lake Naivasha, the highest lake of the Great Rift Valley, has the reputation as an ornithologist's paradise for the white pelicans and myriad other birds found there.*

OPPOSITE: *Lake Elementeita, a shallow, ephemeral lake, lies in the trough of the Gregory Rift. Beyond the lake to the left, a hill feature is called The Fallen Warrior for its profile. Eburu, a dormant volcano rising in the distance, is referred to by the Maasai as Ol doinyo Epuru, the steam or smoke mountain, because steam jets issue from its slopes.*

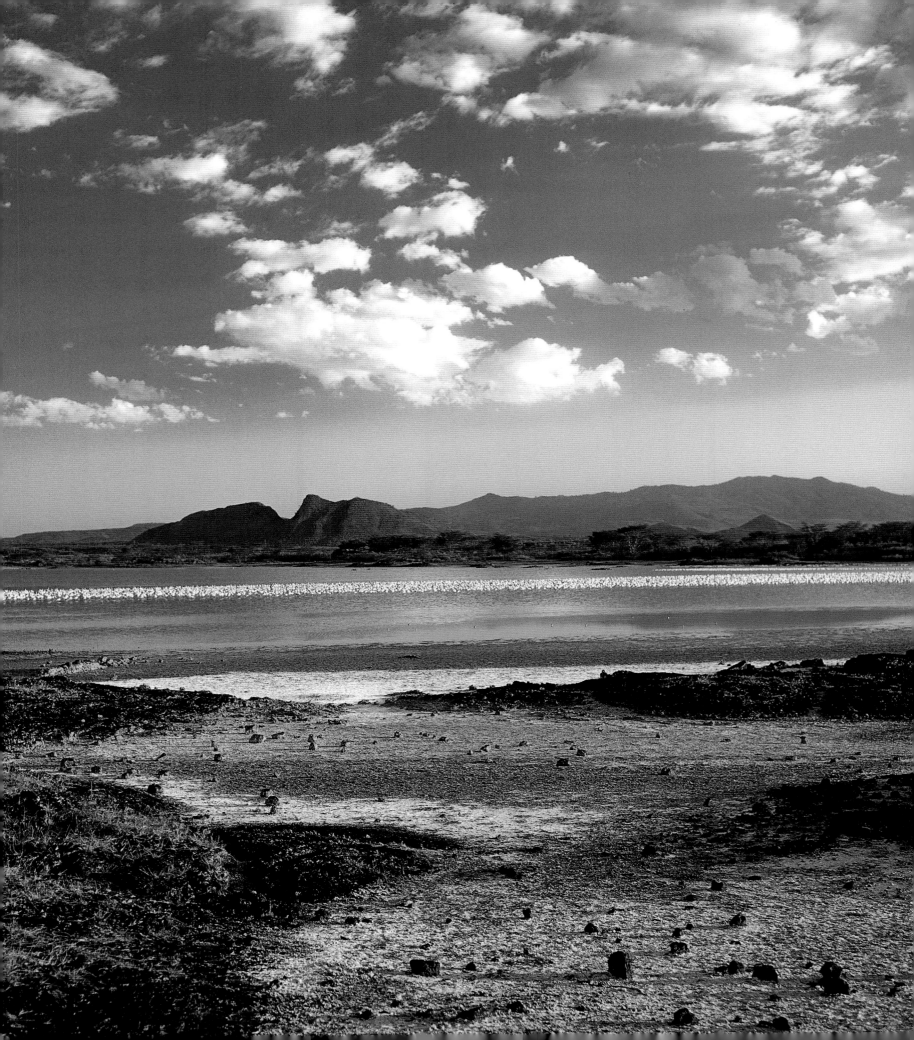

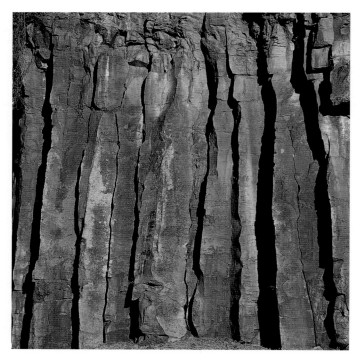

ABOVE AND OPPOSITE: *A lone Coke's hartebeest stands dwarfed by the huge fluted escarpments that dominate the volcanic landscape at Hell's Gate, south of Lake Naivasha. When the level of the lake was much higher in the Pleistocene epoch, these escarpments bounded a fast-flowing outlet. Eagles and vultures nest every year in the cliffs.*

present the smallest surface for moisture evaporation of any indigenous species, and their spreading, flat-topped canopy make them ideally suited to the hot, arid conditions that prevail over much of subSaharan Africa.)

Lake Bogoria was once known as Lake Hannington, after the first bishop of East Equatorial Africa. He camped there in 1885 on his way to Uganda, where he was murdered on the orders of the ruthless Bugandan King Mwanga. Like Lake Turkana, the waters of Lake Bogoria are jade because the microscopic blue-green algae, *Spirulina platensis*, multiply prolifically in its warm shallows. For several months each year a broad band of pink fringes the shores of Lake Bogoria as upward of a million lesser flamingoes with their long, bright red legs jostle to feed on the algae.

At times, the flamingoes at Lake Nakuru can be even more spectacular than at Bogoria. The renowned

American ornithologist, Roger Tory Peterson, described the lake—Kenya's first Ramsar site—as "the world's most fabulous bird spectacle." A quarter of the world's lesser flamingo population may be seen there on its mineral-stained shores. Its size fluctuates widely from one year to the next, and at no time this century has its depth exceeded twelve feet. In antiquity the lake was 600 feet deep, but it has dried up on at least five occasions since the 1930s and only recovered again after heavy rain. Ringing Lake Nakuru are beautiful stands of the graceful yellow-barked *Acacia xanthophloea*. Early travelers and explorers called these acacia "Fever Trees" in the belief that the trees themselves were the cause of malarial fever because they grew in swampy areas rife with mosquitoes.

The Gregory Rift appears at its most majestic south of Lake Naivasha where the valley trough narrows to just fifteen miles across. In this scenic area, the Rift's western wall forms the Mau Escarpment, whose upland was covered for hundreds of years with the largest indigenous forest in East Africa. In the past three decades, however, about 30 percent of the land has been cleared for cultivation despite its importance as a vital water catchment for western Kenya and the Lake Victoria basin. The nature of the forest shows the affect on climate and vegetation of mountain ranges along the margins of the Rift. Moist air from Lake Victoria rises over the western slopes of the Mau range, precipitating heavy rain that has encouraged the growth of broad-leaved evergreens, semi-deciduous trees, and a great diversity of other plant life. The eastern slopes of the range, on the leeward side, are in rain shadow and consequently drier. The vegetation there is quite different, with cedar and olive trees predominant.

Man has lived in harmony with nature on the Mau range for thousands of years; first as Stone Age man in caves, and

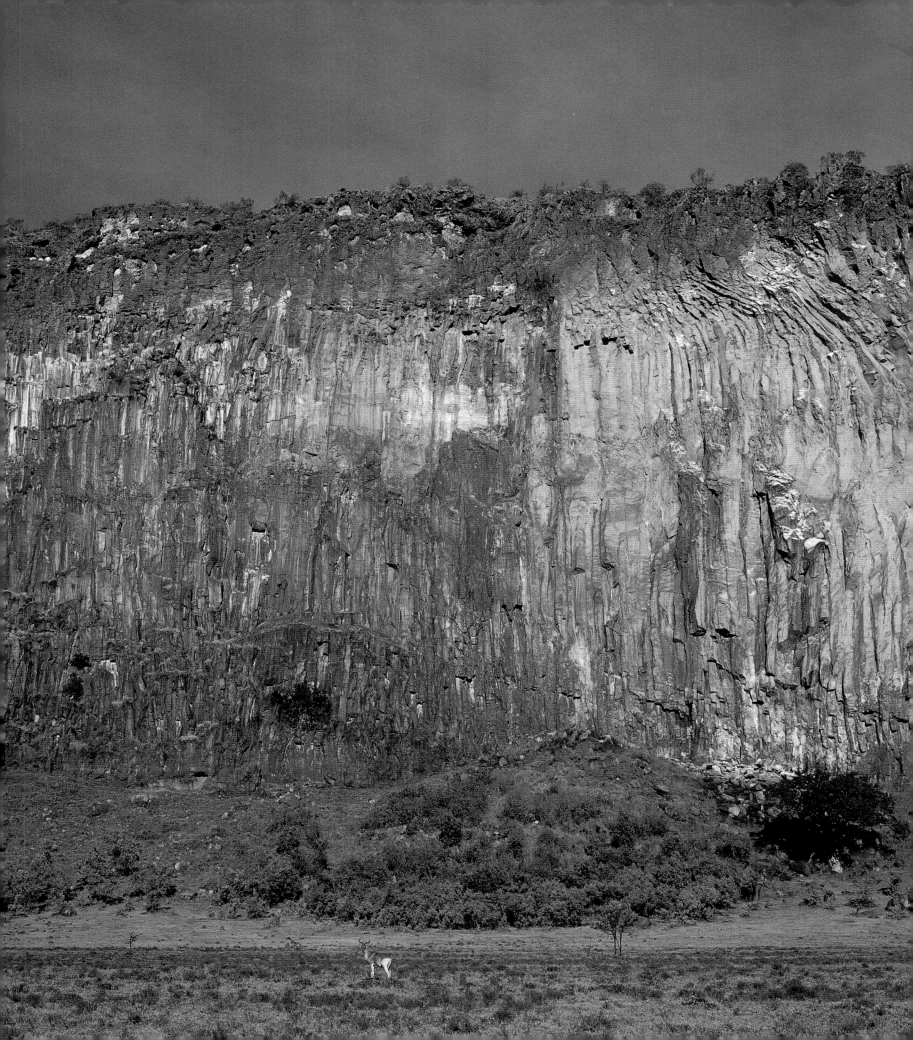

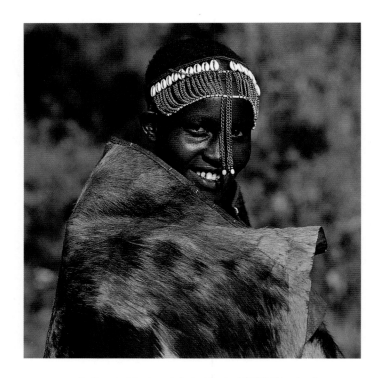

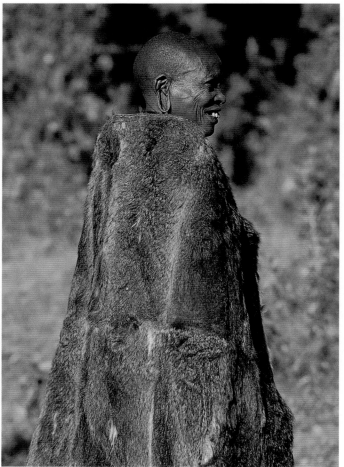

thereafter as hunter-gatherers in basic shelters. The Ogiek, a community of hunter-gatherers, still follow the traditions of their ancestors in the Mau forests although their way of life is now under threat due to over-exploitation of the forest's resources by outsiders. In hunting, the Ogiek use packs of dogs to bring wild animals to bay. A head of household may own as many as six dogs, which he will train to obey instantly a series of whistle calls, each with a precise meaning. Honey forms an important part of the Ogiek diet and also serves as a commodity to barter or sell. Some families harvest as many as 300 cylindrically shaped hives scattered over a wide area.

While some Ogiek groups have retained their own language, an early form of Kalenjin, their powerful neighbors, the Maasai and Kipsigis, have influenced the language and customs of other groups. For a long time the Ogiek lived under the protection of the pastoral Maasai, who are members of East Africa's most famous and at one time most powerful tribe. Until the turn of the twentieth century, the Maasai were masters of a vast savanna that stretched east—west from the East African coast to Kilgoris, not far from Lake Victoria; and north—south from the Laikipia and Uasin Gishu districts to central Tanzania. They had a very well deserved reputation for bravery and a less-deserved reputation for being extremely bloodthirsty. Intruders and neighbors

The Ogiek people, a small community of hunter-gatherers, make a living off the wild resources of the Mau Forest, high above the western wall of the Rift. Their way of life has remained largely unchanged for centuries. They gather forest honey for consumption and for sale from beehives that they make by hollowing out logs and covering them in cedar bark (opposite). A family may own as many as 300 hives scattered over a wide area, harvesting them at eight-month intervals.

ABOVE: *A young Ogiek girl's decorated headband marks her recent circumcision.*

LEFT: *Her mother keeps warm in a cape made from the skins of the diminutive rock hyrax.*

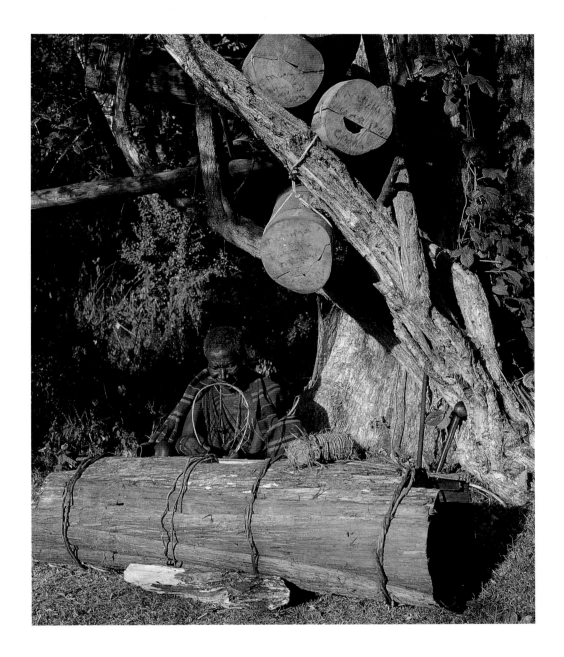

alike feared them as much for their bellicose appearance as for their efficient war machine, which was based on a warrior age-grade system. Highly mobile and well controlled by the Laibons, the ritual leaders of the tribe, the Il Murran, or warriors, were awesome in their panoply of war. Their only clothing was a small loin-cloth draped loosely around the waist, but magnificent headdresses adorned their long plaited hair, which was liberally coated with animal fat mixed with red ochre.

The young braves who killed a lion with a spear would wear its mane like a tall busby; other warriors wore round their faces an imposing oval headdress edged with black ostrich plumes, which was intended to frighten the enemy. Their weapons included double-bladed spears, short swords, and knobkerries of hardwood or rhino horn. Their long oval-shaped shields were made of buffalo hide and painted with the heraldic devices of the section to which they belonged.

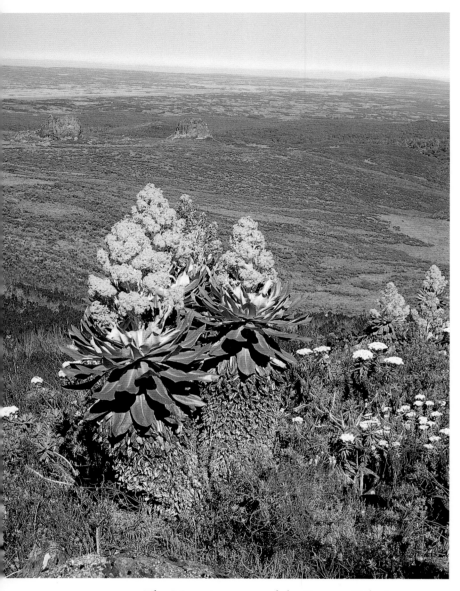

The Maasai are part of the Eastern Nilotic linguistic group, which began to disperse from the vicinity of the Nile in southern Sudan three thousand years ago. By 500 AD, the forebears of the Maasai had split from a cluster of people speaking Ateger to interact and intermarry with eastern Cushites close to southwest Ethiopia, assimilating many of their traits. Later, this division migrated slowly down the eastern branch of the Rift, encountering diverse peoples whom they displaced or absorbed before splitting several times again.

From this complex cultural blend of Nilotes and Cushites emerged the Maasai, who arrived in central Kenya about four centuries ago. Over the next two to three hundred years, they consolidated their hold over a huge territory covering some 80,000 square miles as they perfected the art of nomadic herding in an unforgiving climate. They refused to practice agriculture, which they held in contempt. This uncompromising stance meant that no one could call himself a Maasai unless he possessed cattle, and no true Maasai was permitted to till the soil. A Maasai myth relates how God gave them all the cattle on earth, and many of them still believe that rustling stock from a neighboring tribe is merely a matter of taking back animals that are rightfully theirs.

Maasai power in the Rift Valley was broken during the last quarter of the nineteenth century when rinderpest, a highly infectious disease of cattle, followed an outbreak of pleuropneumonia to decimate their herds. Coinciding with this disaster was a smallpox epidemic that spread from the Horn of Africa and killed more than half the tribe. The Maasai had no cure for these foreign diseases, although they have an outstanding knowledge of herbal medicines for humans and animals. The survivors were in a pitiful state by the time the major European powers sat in conference at Berlin in 1884, and carved eastern and central Africa into spheres of influence by drawing straight lines on a map.

The otherwise straight line dividing modern-day Kenya and Tanzania (a contraction of the former countries of Tanganyika and Zanzibar) has a kink in it resulting from Queen Victoria giving Mount Kilimanjaro, Africa's highest mountain, to her nephew, Kaiser Wilhelm of Germany. This nepotism on a grand scale divided Maasailand between the two imperial powers (England to the north, Germany to the south) with no concern for the

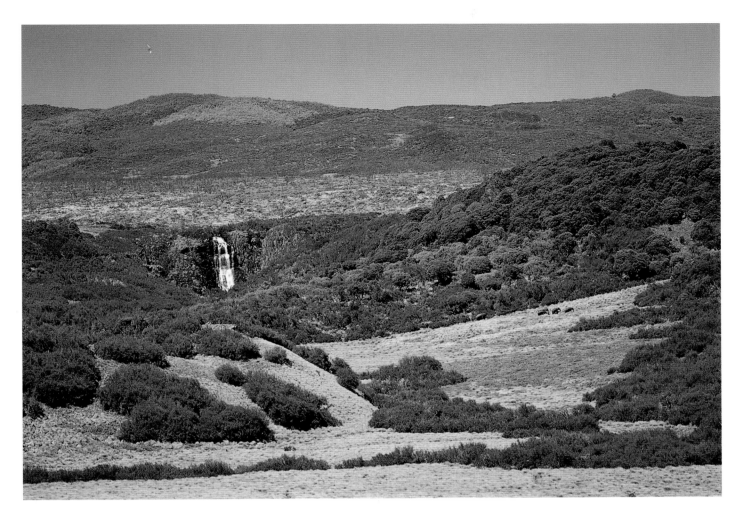

The Aberdare Mountains in the central portion of the Eastern Rift support a variety of high-altitude vegetation that grows unusually large.

ABOVE: On the slope at right center a small herd of elephants feeds on coarse moorland grass. Elephants are an evolutionary success story in Africa, thriving equally on hot arid plains and in cold mountainous regions and feeding on a wide range of vegetation.

OPPOSITE: The striking tree senecio or giant groundsel (Senecio johnstonii ssp. battiscombei) flourishes above 10,000 feet and flowers only about every ten years.

RIGHT: The lobelia, another plant displaying afro-montane gigantism, can attain a height of twelve feet.

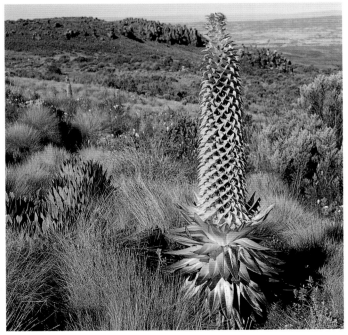

rights of the people who lived there. At the beginning of the twentieth century when imperial exploitation was at its zenith, the Maasai in Kenya lost large tracts of land to European settlement. More recent developments have tempted them to sell most of their dry weather pasture to wealthy outsiders who now till the land. This has left the Maasai vulnerable to severe drought, bringing increased pressure on a traditional society to change its

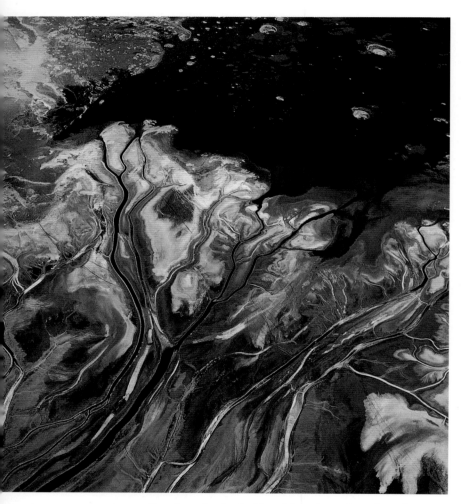

ABOVE: *Seen from the air, the Uaso Nyiro River flows from the Mau Escarpment into the northern reaches of Lake Natron through a soda-encrusted delta.*

OPPOSITE: *A hardy* Commiphora *tree thrives beside Lake Magadi in an especially hot region of southern Kenya. The pink-tinged mineral encrustations, which are mined for a variety of commercial uses, are continuously replenished by the action of underground springs. Just visible in the distance is the Nguruman Escarpment.*

ways. Change, however, comes slowly in Maasailand, and throughout the twentieth century, the people have clung to their age-old customs despite many attempts to bring them into the mainstream of modern society.

The Maasai deserve recognition for their stand against slavery and for their attitude toward most wild animals, except those that threaten their herds. The Maasai tolerance for wild animals stems from an aversion to eating game meat and birds, which comes, perhaps, from their Cushitic forebears. It is no coincidence that East Africa's finest game areas are in Maasailand. As for slavery, Maasai society never condoned traffic in human beings, so slave-raiding outsiders avoided their territory. Until the practice was finally stamped out, Kenya was left relatively untouched by the scars of the trade.

After the English and German penetration of East Africa, England built a railroad from Mombasa to Uganda right through Maasailand. Its coming was predicted by Mbatian, the most respected and revered of all Maasai Laibons both past and present, who foresaw an iron snake that would belch forth fire across the land. This was a startling vision of the railroad, which was built in the late 1890s, five years after his death.

The Eastern Rift was a major obstacle in the way of the railroad's construction. Engineers grappled with the technical problems of laying lines up an incline of 2,000 feet in 27 miles to the summit of the Kikuyu Escarpment, then down a precipitous 1,500 feet to the valley floor. A temporary railhead terminus and construction workers camp was established where a small river, the Enkare Nairobi (a descriptive Maasai name meaning the cold water river), issued from the forest onto the Athi plains. From those humble beginnings, Nairobi grew to become Kenya's capital city.

The railway survey party wisely avoided an area of complex faulting south of Nairobi where a series of parallel ridges running north–south cut the extensive

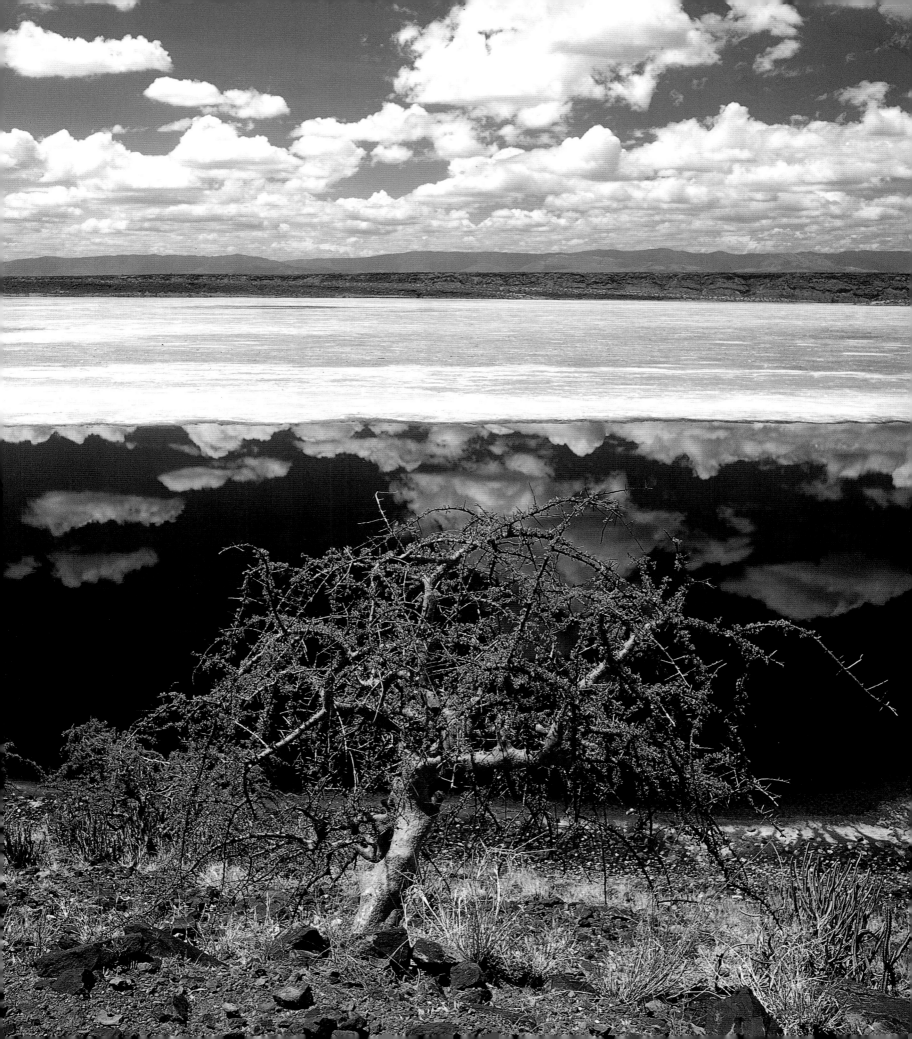

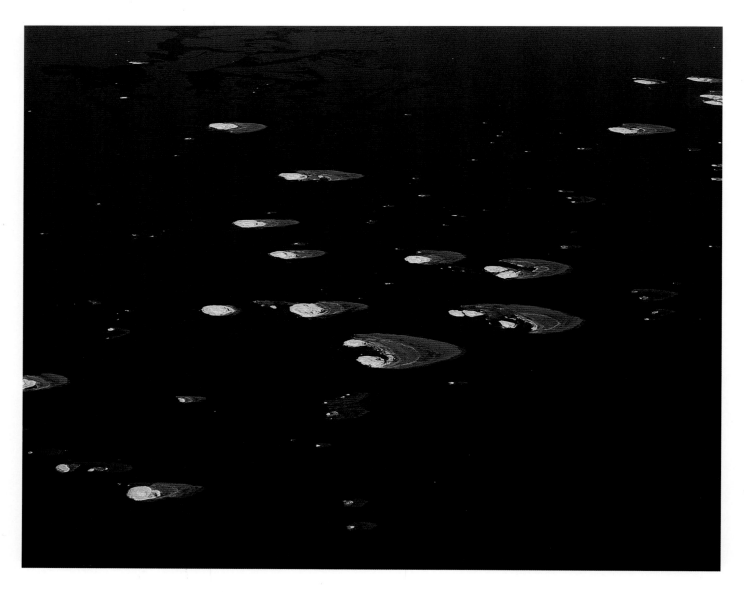

Lake Natron in northern Tanzania is one of the most alkaline lakes of the Rift system. As its waters evaporate in the intense heat, sodium sesquicarbonate, known as trona or natron, solidifies to resemble giant coral heads. Visible beyond the lake are the active volcano Ol doinyo Lengai and a scarp of the Eastern Rift.

lava flows into a grid. This contorted country drops in steps to Lake Magadi, which is set in a torrid, low-lying basin of the Rift floor with lava debris strewn everywhere. Until a water pipeline was laid, the Maasai grazed their livestock at Magadi in wet weather only because a permanent source of freshwater was non-existent. (The name Magadi derives from the Maasai word *emakat,*

meaning soda. Maasai elders customarily chew coarse tobacco with a small lump of Magadi soda to enhance the tobacco's flavor.)

Within the last four to five thousand years, Lake Magadi was forty feet deeper than it is today. Stunted *tilapia nilotica* fish fossils have been found in rock sediments at a high

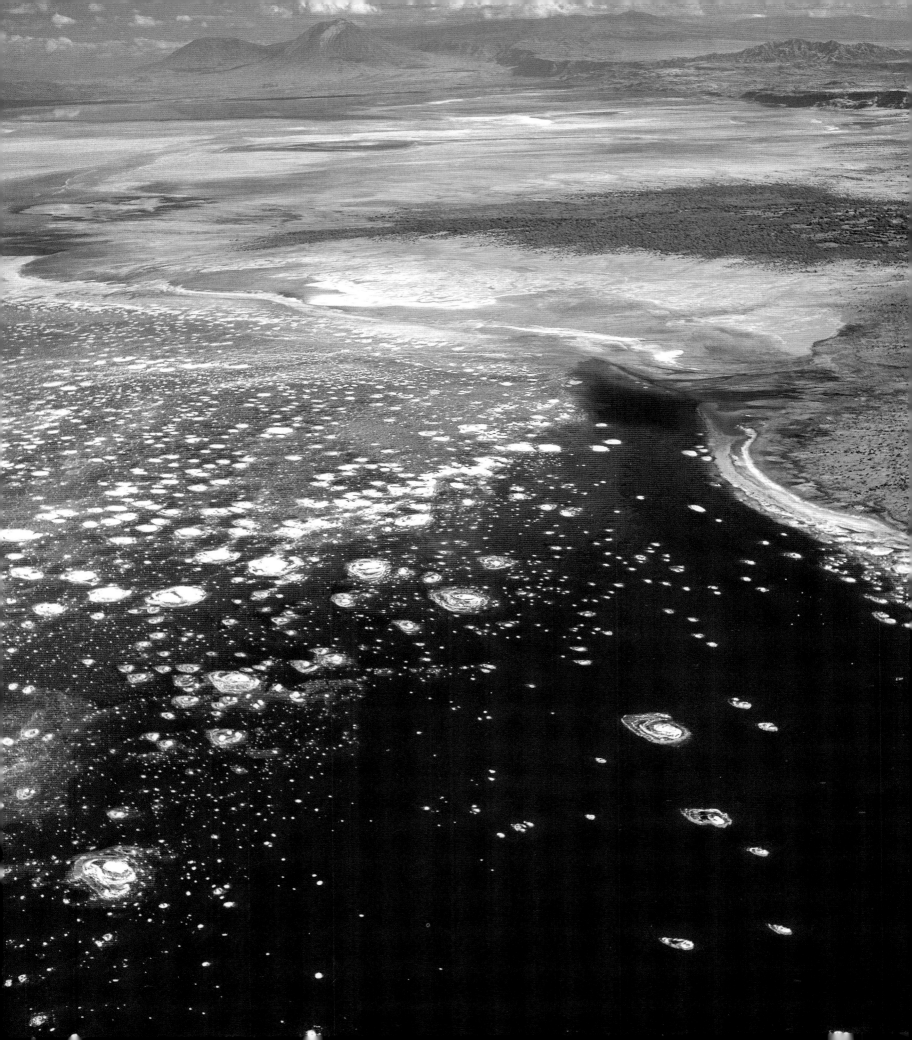

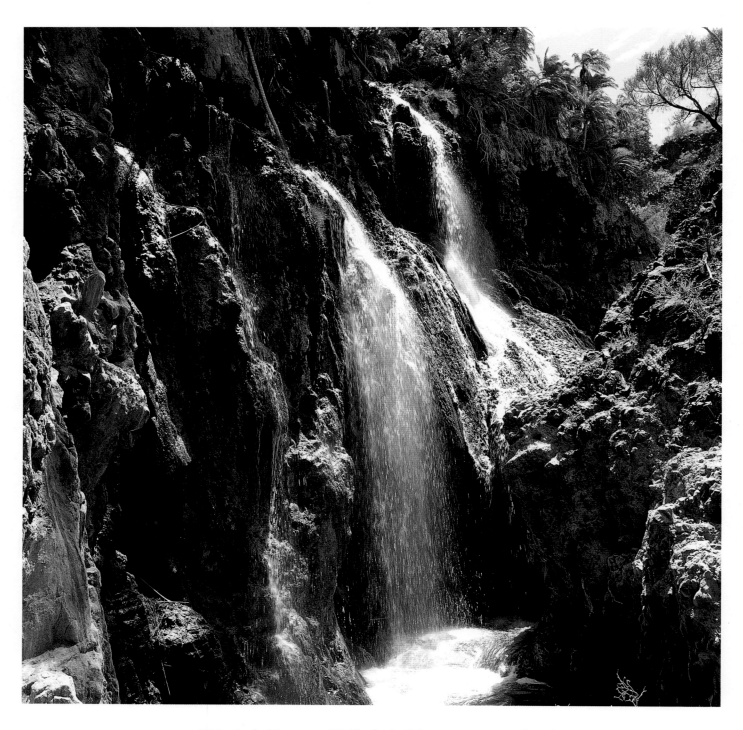

ABOVE: *Rising in the Ngorongoro Highlands, the Enkare Sero River provides welcome water for the Maasai living at the southern end of Lake Natron. Although the river's water becomes mildly saline after cascading over lava rocks into the Rift, it nevertheless serves Maasai herds of cattle, sheep, and goats.*

OPPOSITE: *In the late afternoon, Maasai herdsmen drive their cattle home over the dusty volcanic soil at the base of the western wall of the Gregory Rift, which dominates the landscape in this remote corner of northern Tanzania.*

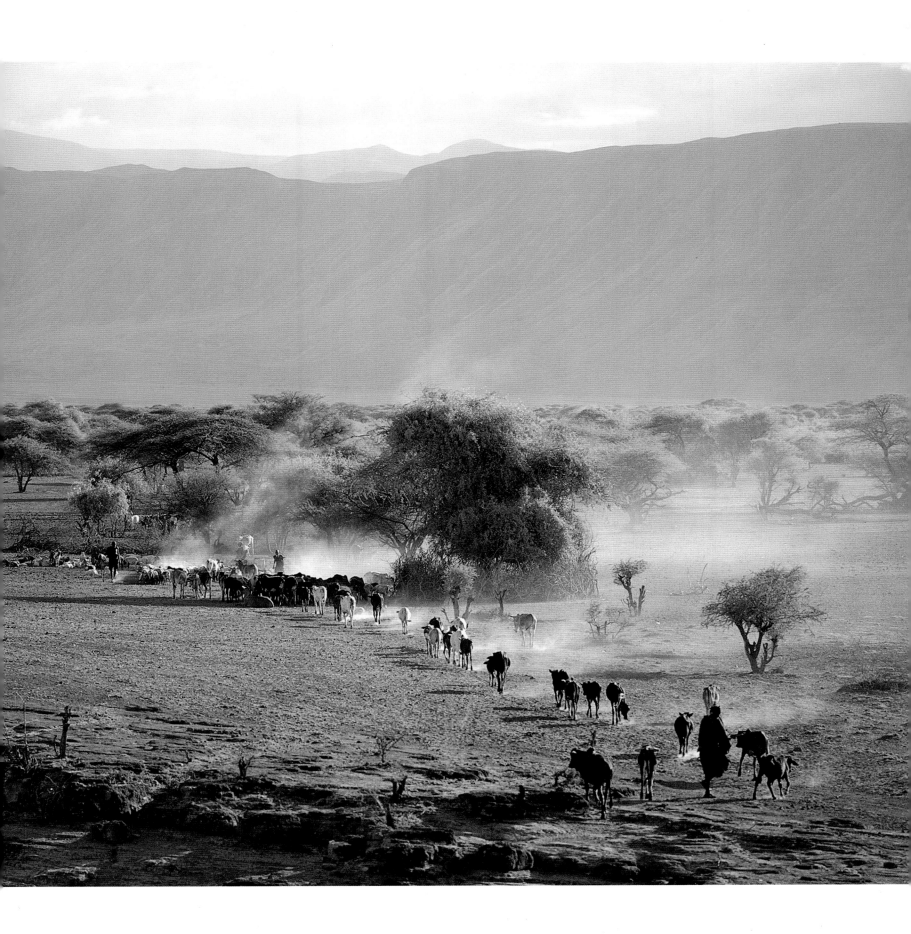

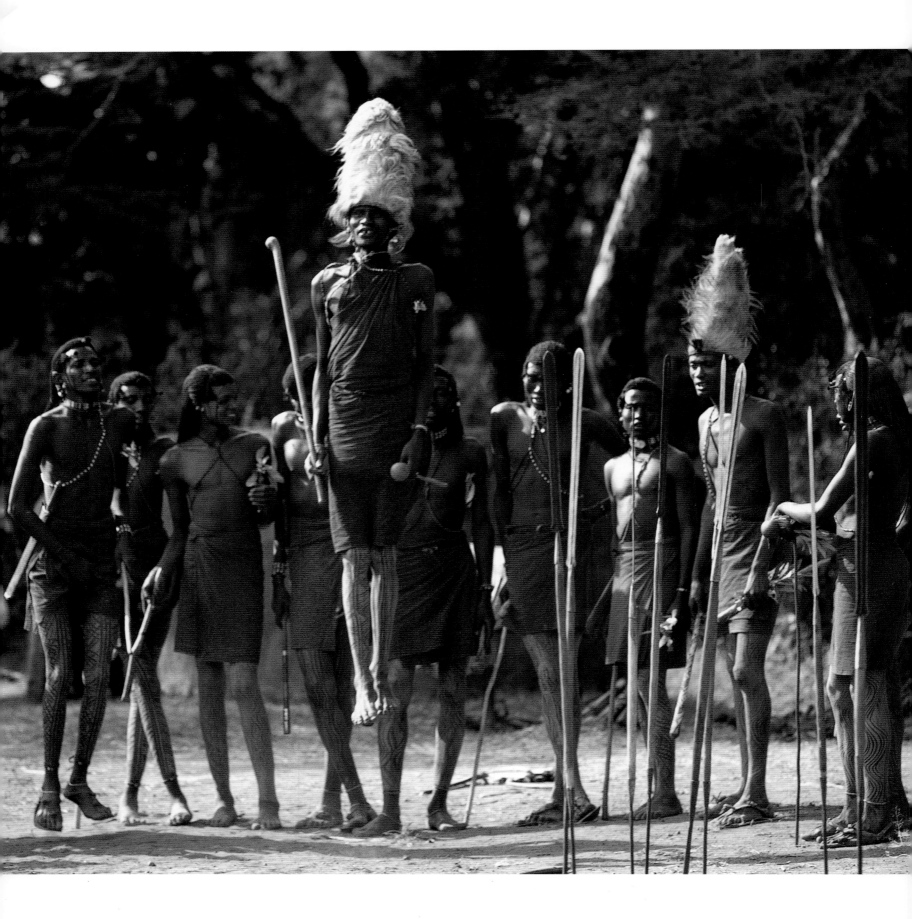

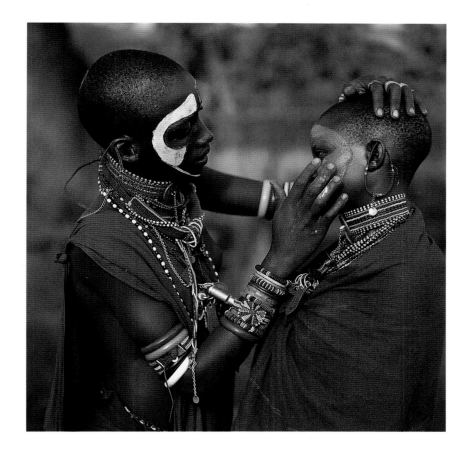

In the nineteenth century, the Maasai were the most feared tribe in East Africa because their age-grade system produced a highly effective fighting force. Belligerent warriors controlled the vast savannas of the Rift trough where their large herds of cattle grazed.

OPPOSITE: *Watched by his friends, a warrior wearing a lion's mane headdress leaps high in the air by flexing his ankles with his knees kept straight.*

ABOVE: *Adorned in all their finery, young girls decorate their faces before joining a dance.*

level, suggesting that the water was only mildly alkaline back in time. The alkalinity of closed basin lakes occurs when salts leached from lava rocks by weathering are concentrated by evaporation over a prolonged period. Today, Lake Magadi acts as a huge evaporating pan consisting of small alkaline lagoons interspersed by stretches of almost pure trona (a mixture of crystalline sodium sesquicarbonate and sodium chloride). It hardly deserves the description of a lake although it is unquestionably one of the natural wonders of the world because its resources are infinite. Trona is turned very simply into soda ash and

used as an ingredient in glassmaking. Although it has been mined there for seventy-five years, the trona deposits have actually increased because hot alkaline springs along the lake margins contribute an estimated 4,300 tons of additional soda a day to existing reserves. Pelicans are attracted to this unusual habitat by a diminutive fish of the cichlid family, *Oreochromis alcalicus grahami*, which has adapted to living in spring-fed pools with temperatures too hot for humans to touch. After scientists introduced this unique species to Lake Nakuru in 1960 in an attempt to control mosquito larvae, pelicans were drawn there too.

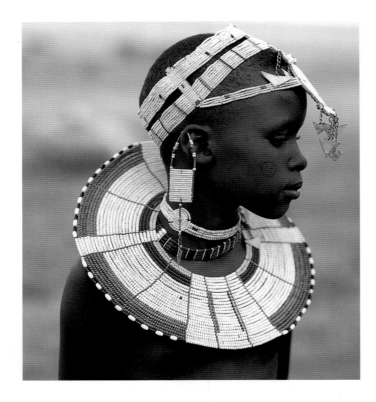

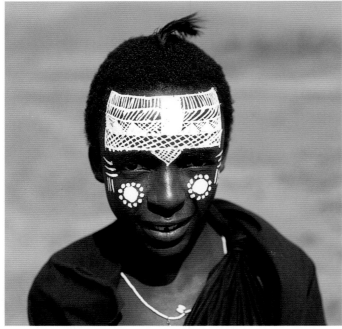

TOP: *A Maasai girl of northern Tanzania wears jewelry made by herself. The extensive use of white glass beads and the circular scar on her cheek mark her as a Kisongo Maasai, the largest clan of the tribe.*

ABOVE: *Black clothing and the intricate white patterns on the face of this Kisongo Maasai youth signify his recent circumcision.*

A short distance south of Lake Magadi, across the border in Tanzania, stands Lake Natron, another largely dry, shallow soda lake. There, layers of sodium carbonate and sodium sesquicarbonate cover a bed of black mud, making it stiflingly hot. Natron is the world's most important breeding ground of the lesser flamingo. On shimmering mud flats that are beyond the reach of man and predator, hundreds of thousands of birds group in dense colonies each year, building their truncated cone-shaped nests out of mud to a height of twelve inches above the ground. During nesting their wings molt and the birds in each colony remain flightless for three weeks. As with Lake Magadi, hot alkaline springs feed Lake Natron, turning its shallow lagoons into brilliant hues of orange, pink, and deep burgundy red. Seen from the air when the waters evaporate, twirls of trona begin to appear like giant coral heads above the surface of the lake.

Resplendent beyond the southern end of Lake Natron is Ol doinyo Lengai, the Maasai's Mountain of God, which remains the only active volcano in this sector of the Rift. It rises 7,000 feet above the plains of this remote region and has the unmistakable shape of a steep volcanic cone grooved by deep gullies. The last major explosive eruption took place in 1966, when dense clouds of volcanic material were ejected high in the air, leaving the volcano mantled in white dust. Approached from the northeast in July of that year, the cone resembled Japan's Mount Fuji in winter from a distance of fifteen miles. Uniquely, the volcano is the only one in the world still discharging rare carbonatite lavas. Although black on first emerging from the bowels of the earth, on exposure to air carbonatite becomes white within a month and resembles washing soda. After rain, a thick layer of ash can turn into a calcium-rich hardpan as tough as cement, which tree roots cannot

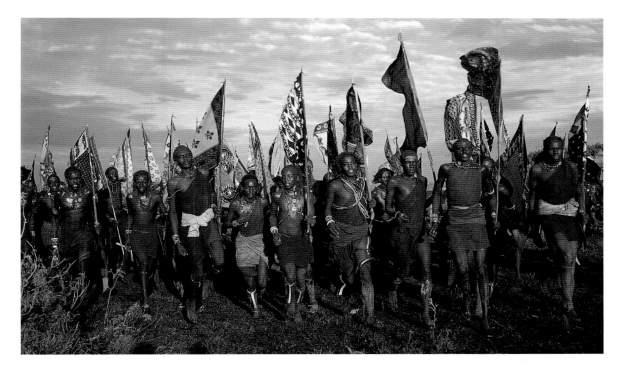

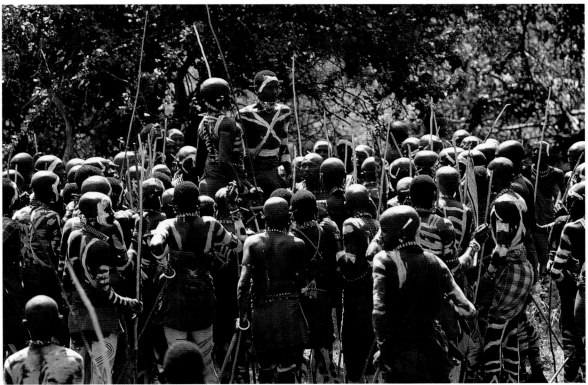

An age-group of Maasai warriors becomes junior elders, in an important ceremony called Eunoto, celebrated with much dancing and other rites. They daub themselves with white clay after their mothers shave off their ochred locks. At the conclusion of the ritual, they will settle down and marry.

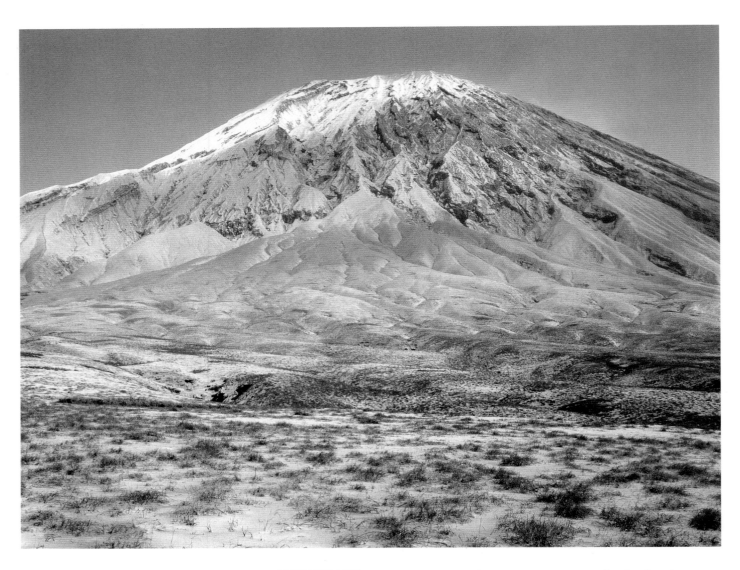

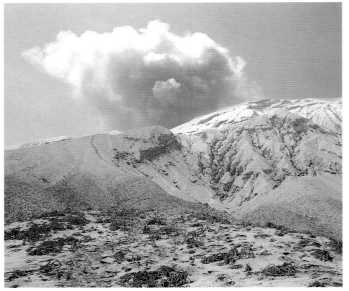

Ol doinyo Lengai, the Maasai's "Mountain of God," the only active volcano in the eastern branch of the Great Rift Valley, still discharges rare carbonatite lavas, which turn white on exposure to air.

ABOVE AND LEFT: The last major eruption took place in 1966, mantling the volcano's flanks with fine ash.

OPPOSITE: Smoking vents and molten lava, seen from the air in the 9,400-foot-high crater, suggest that another explosive eruption might take place within a few years.

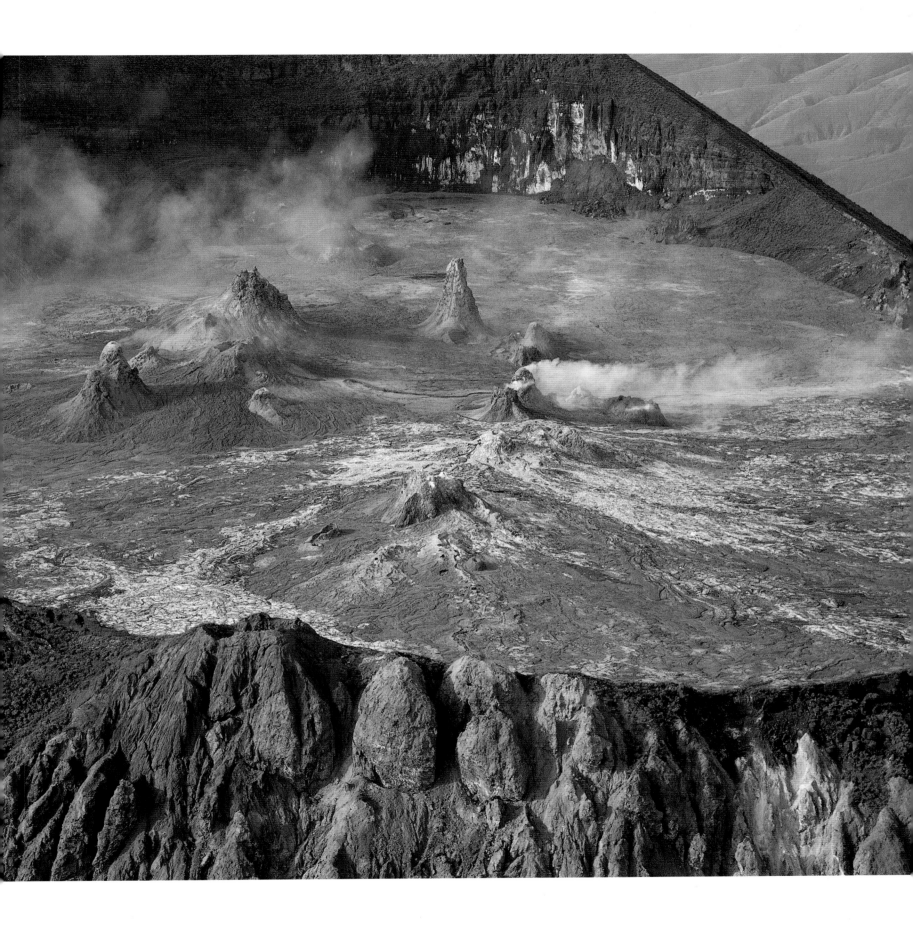

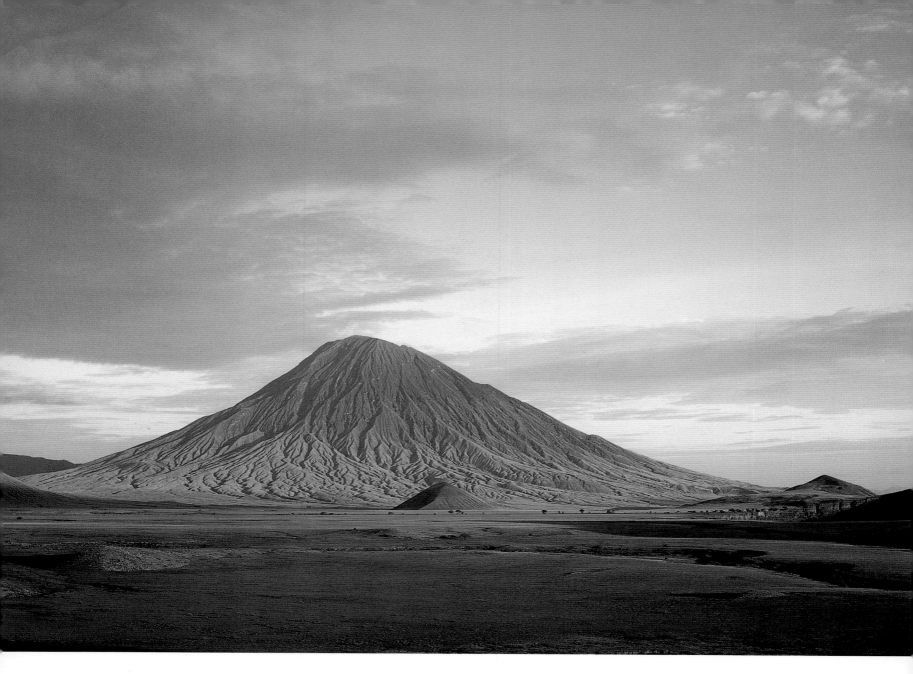

Ol doinyo Lengai shows the unmistakable shape of a volcanic cone. Its steep, deeply eroded sides and loose volcanic ash make the climb to the top an exhausting experience.

penetrate. This peculiarity accounts for the great treeless plains in the Serengeti National Park, which lie to the west in the direction of the prevailing wind. At the start of the rains in April and May nearly a million wildebeest gather on these plains to calve before starting out on their annual migration for Kenya's Maasai Mara Game Reserve in one of the most outstanding wildlife spectacles in the world.

Small-scale eruptions of lava within the summit crater of Ol doinyo Lengai have occurred regularly since early 1983. With molten material welling to the crater rim once more, vulcanologists anticipate that another major explosive eruption might happen quite soon. Fifteen million years ago, the entire region was a volcanic cauldron, with widespread eruptions and tectonic movements shaping the land. A quiescent phase ensued until four to five million

years ago, when volcanoes with evocative Maasai names such as Shombole, Gelai, Kitumbeine and Kerimasi again burst into life. Though all these cones are now dormant, they are visual reminders of a violent past.

The Ngorongoro highlands rise above the western wall of the Rift and were created by another cluster of volcanoes that blocked the passage of the Rift. The oldest ones—Oldeani, Sadiman, and Lemagrut—date from more than two million years ago, but others erupted in recent geological time. The best known feature of the highlands, the magnificent Ngorongoro Crater, took shape about two and a half million years ago when a 15,000-foot-high volcano exploded. Its dome then crumpled inward to form the largest caldera in East Africa, with walls only half the original height. Its natural amphitheater of 102 square miles hosts a wonderland of wildlife in a setting of unparalleled beauty. Ngorongoro Crater was declared a World Heritage Site in 1978. With the contiguous Serengeti National Park, the 3,200-square-mile Ngorongoro Conservation Area supports the greatest concentration of wildlife left on earth today.

The Ngorongoro Conservation Area was established in 1959 to encourage a partnership between man and nature. Eight years earlier, the crater was designated an eastern extension of the Serengeti National Park, but the legislation proved unfair to the Maasai whose home it has always been. The Maasai were bemused by the sudden interest in protecting wildlife when white men had shown a complete disregard of it, indeed had hunted it down with enthusiasm, for decades.

The first European to visit Ngorongoro Crater was a German explorer by the name of Dr. Oscar Baumann, who camped in the crater in 1892 and promptly shot three rhinos before moving on to the Serengeti. His glowing descriptions of the place prompted two brothers named Siedentopf to lease part of the crater from the

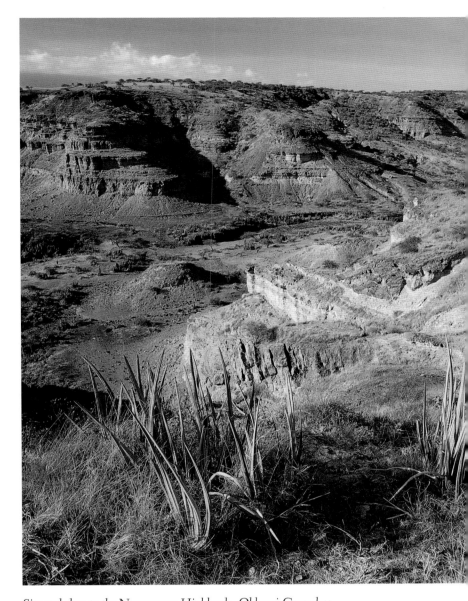

Situated close to the Ngorongoro Highlands, Olduvai Gorge has revealed one of the world's most remarkable fossil records of human origins. Named oldupai *by the Maasai after the wild sisal plant,* Sansevieria *(in the foreground), Olduvai displays a unique evolutionary trail spanning two million years. A fast-flowing river cut the gorge 500,000 years ago, and a million years previously a large lake visited regularly by our human ancestors covered the entire area.*

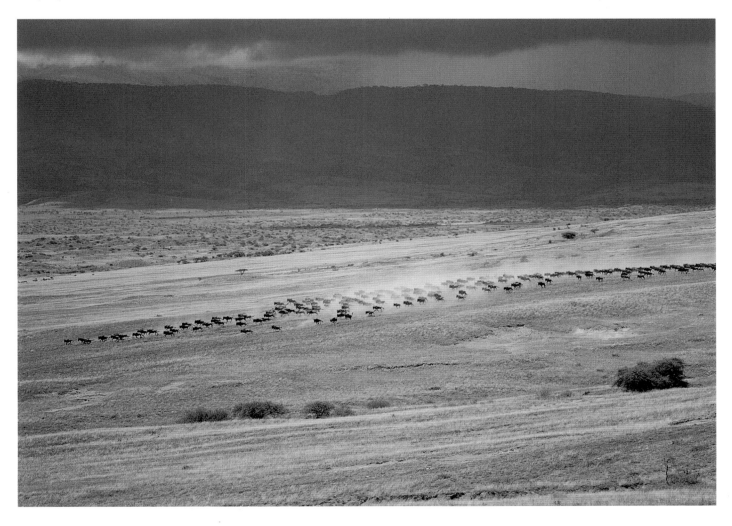

OPPOSITE: *Maasai graze their cattle in lush pasture at the foothills of the Ngorongoro Highlands.*

RIGHT AND BELOW: *A lion chases a wildebeest calf and stampedes a herd on the plains beyond Ngorongoro that stretch westward to the Serengeti National Park. When the wildebeest gather here before their annual migration to the Maasai–Mara, the grassland nourishes as many as four million wild animals.*

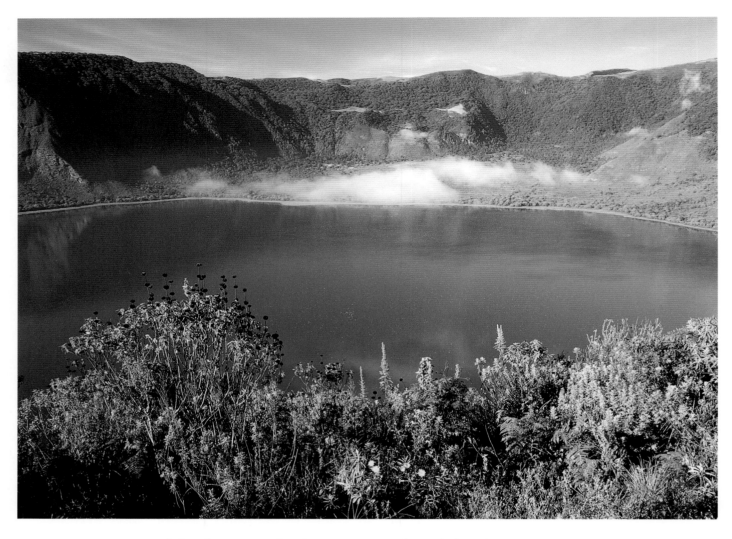

The lava from ten major long dormant or extinct volcanoes built up the Ngorongoro Crater Highlands over a period of twelve million years. A lake (above) fills the crater bottom of Empaakai, one of the tallest volcanoes.

colonial administration of German East Africa, which was to become first Tanganyika and then in 1964, Tanzania. By 1908, they possessed 1,200 head of cattle, and had bred ostriches and tamed zebras for farm work. The brothers regularly organized shooting parties to entertain their German settler friends. And to combat what they perceived as a menace, they tried to drive the wildebeest herds out of the crater by employing long lines of beaters and by stretching ropes draped with pieces of colored cloth across parts of it. But to no avail: the animals won out when

the ranches were abandoned during World War I and never reoccupied again. The ruins of Adolf Siedentopf's farmhouse can be seen in the crater to this day.

The paleoanthropological sites at Olduvai Gorge, made famous by Louis and Mary Leakey, are within the Ngorongoro Conservation Area. Olduvai Gorge lies just beyond the Rift Valley in the rain shadow of the Ngorongoro highlands, making it the driest part of the whole region. Its almost vertical cliffs, in places 295 feet

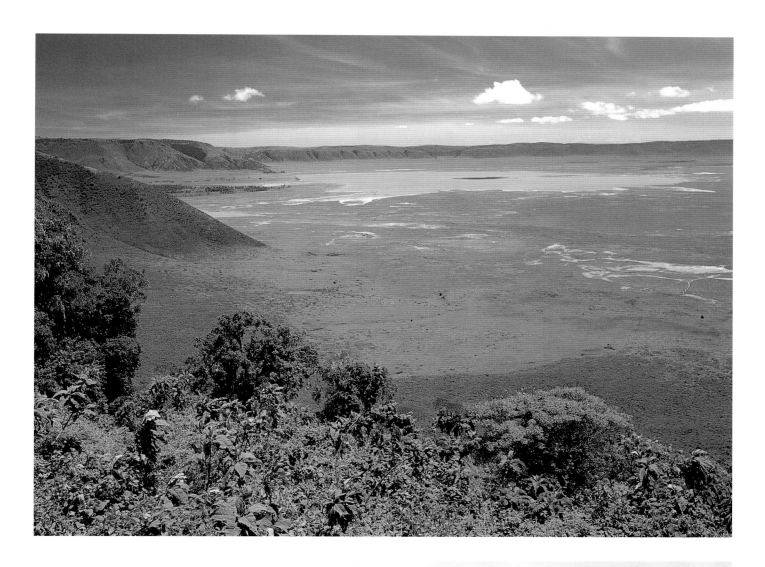

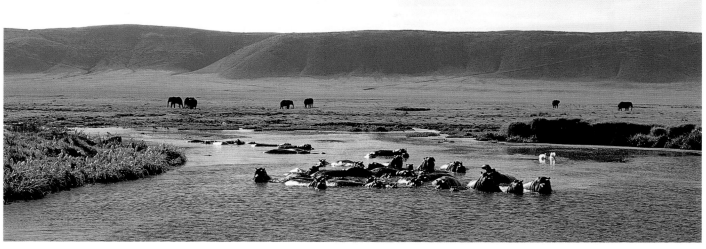

The 102-square-mile crater floor of Ngorongoro Crater, the largest unbroken,
unflooded caldera in the world, is the haunt of a wonderful wildlife spectacle.

ABOVE: *In clear dawn light, a chain of dormant volcanoes stretches 100 miles to the east of Empaakai. First in line is Kerimasi, then Kitumbeine, and finally Kilimanjaro, Africa's highest snow-capped mountain, whose 19,340-foot-high cone-shaped peak is called Kibo. Kilimanjaro's most extensive eruption took place just 36,000 years ago.*

OPPOSITE: *Swirling mist often shrouds the forested rim of Ngorongoro Crater.*

OVERLEAF: *A false arm of the Rift Valley runs southeast from the Ngorongoro Highlands to Lake Eyasi, a shallow alkaline lake that can vary in size considerably from one year to the next. Here, a Datoga pastoralist drives his herd across the partly dry lake basin.*

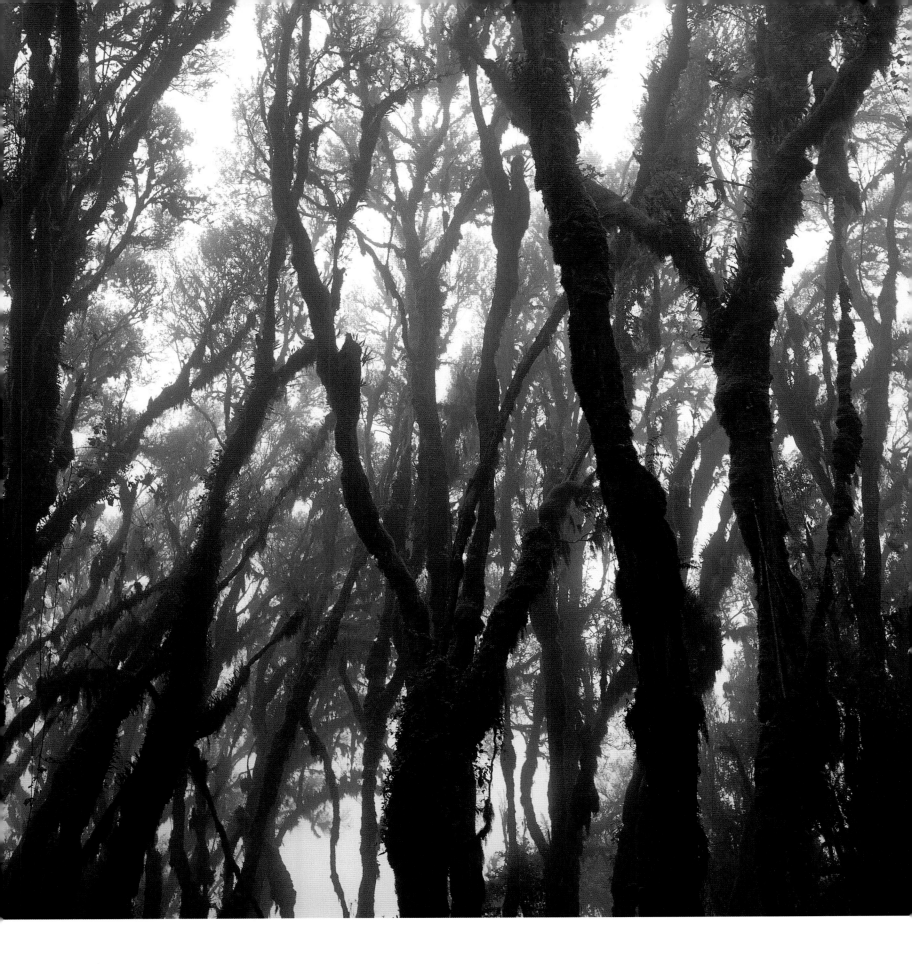

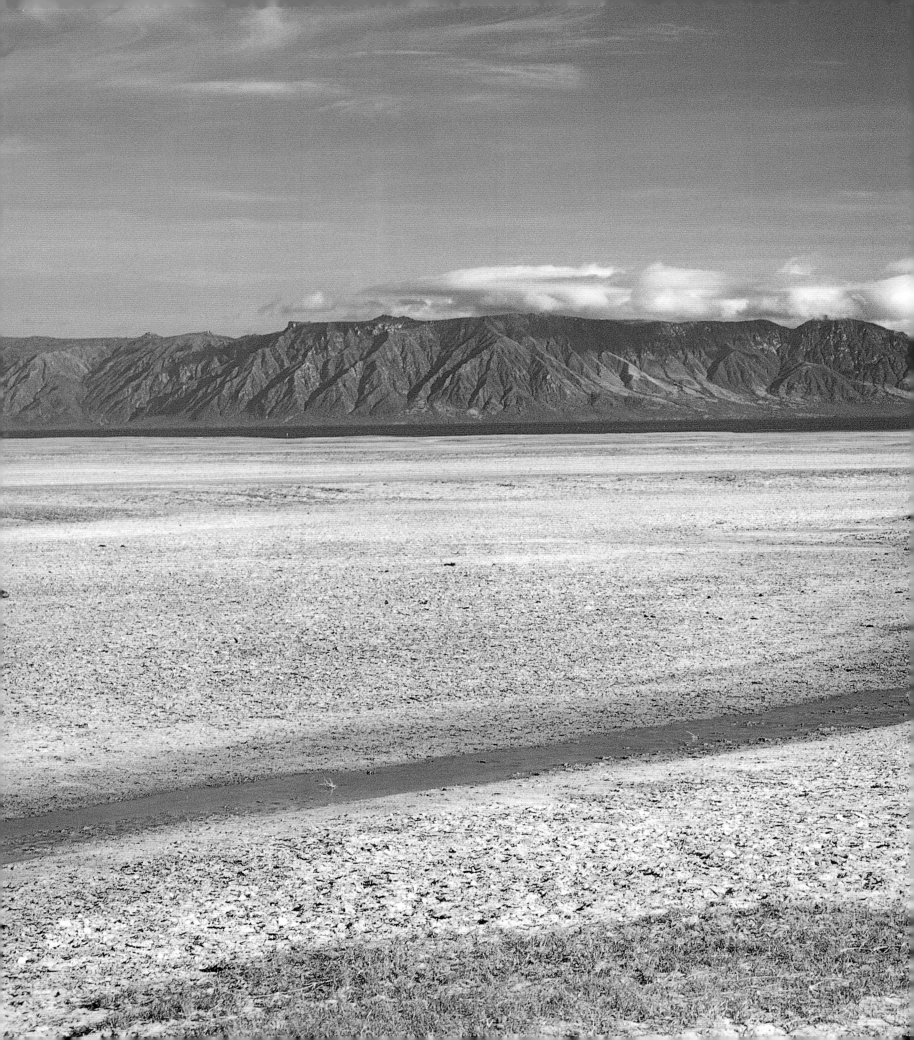

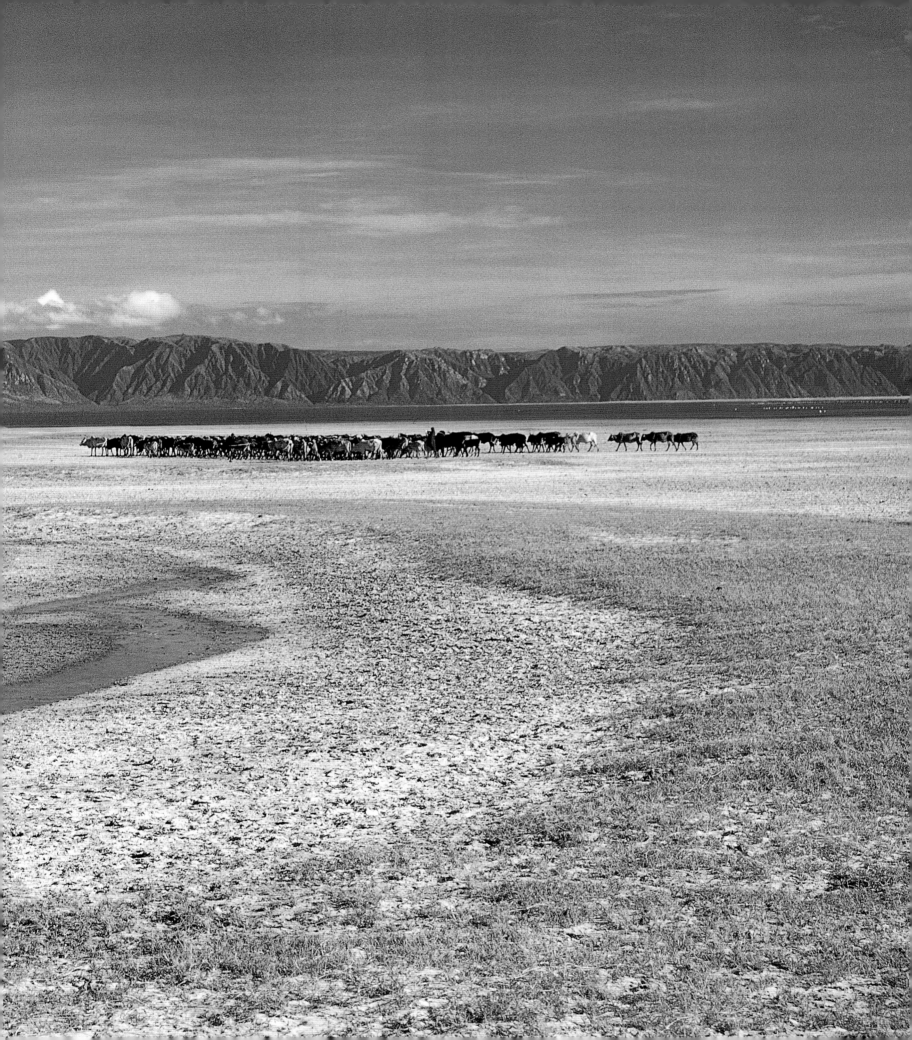

Lichen-stained boulders and Euphorbia trees add form and color to Lake Eyasi's impressive western scarp.

deep, were cut by a fast-flowing river less than half a million years ago, but no trace of permanent water lingers there today. The cliffs reveal successive strata of starkly differing hues made up of layer upon layer of volcanic ash and river sediments. The earliest exposed deposits—just under two million years old—have been found where an ancient lake occupied a shallow basin at the time tectonic movements were shaping the Rift anew.

Fifty years of painstaking work at Olduvai Gorge by Dr. Louis Leakey and his wife, Mary, has produced a treasure-trove of fossils, dating from about 2 million to 15,000 years ago. The remains of more than 50 hominids have been exposed at sites where streams from the highlands brought fresh water down to the lake. The crude stone tools found there are ascribed to the Oldowan culture, and include some of the oldest implements yet discovered. An impressive array of animal fossils, including wild pigs the size of hippos and baboons the size of gorillas, are representative of the region's ancient biodiversity. All in all, Olduvai Gorge has revealed a

most remarkable record of human evolution and offered insights into why many species of the animal kingdom became extinct while others survived by adapting to a new environment.

The lines of the Eastern Rift diffuse at Lake Manyara, which lies south of the Gregory Rift. The main trough follows a zigzag course south before disappearing altogether at Dodoma, where an old crystalline block called a craton prevented the Rift from propagating further. It reappears again near the southern highlands of Tanzania before joining the Western Rift. An important branch of the Eastern Rift with an impressive 984-foot high western wall encloses a shallow alkaline lake called

Small groups of hunter-gatherers, the Hadzabe, live in the basin of Lake Eyasi. Dressed in a baboon skin, a proud Hadza hunter (above) returns to camp with the haunch of an impala antelope. He killed the antelope with a metal-tipped arrow that had been dipped in a fast-acting vegetable poison extracted from the desert rose (Adenium obesum). The hunter's first task on reaching camp is to replace the arrows that he lost in the day's hunt (right). Here, he fledges a shaft with guinea fowl feathers using the impala's sinews.

Eyasi, before ending abruptly in granite uplands. It would have been connected to the main Rift near Lake Natron if it had not been blocked at its northeast corner by the volcanic outpourings of craters lying along a twenty-million-year-old fault line.

The Hadzabe, a thousand-strong community of hunter-gatherers, have lived in the Lake Eyasi basin for centuries, moving their camps with the timeless cycle of rain. They are one of only four or five societies in the world that still earn a living primarily from wild resources. Their origins remain a mystery because experts cannot link their language, which has four click consonants, to another phylum. Their near neighbors, the Sandawe, also speak with click sounds but their language is quite different. Moreover, the Sandawe have racial affinities to the central

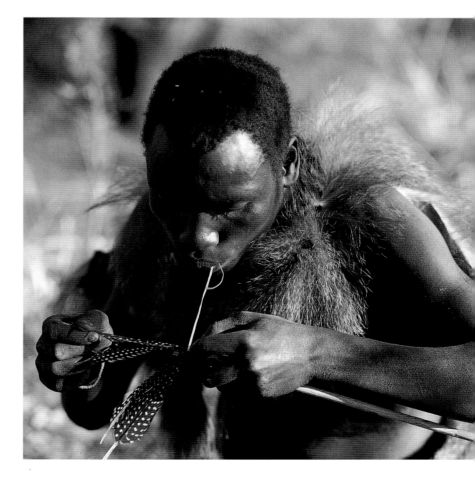

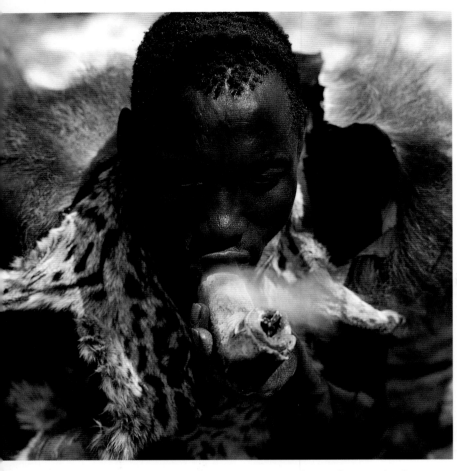

A Hadza hunter wearing a genet cat skin smokes cannabis from a crude stone pipe sheathed in leather.

privileged look at the consummate survival skills evolved by human ancestors many thousand years ago. The hunters have an uncanny ability to track animals over difficult terrain; a sixth sense of how an animal will react in any given situation; and faultless tactical coordination on the chase.

The Hadzabe survived the Bantu diaspora of the sixteenth century by retreating to Lake Eyasi, which lay in a bad tsetse fly belt. Because the Hadzabe owned no livestock, the flies did not endanger the people's livelihood. In recent times, tsetse eradication programs aimed at eliminating trypanosomiasis and sleeping sickness in the region have been ongoing, and their success has been a very mixed blessing for the Hadzabe. Now, Iraqw peasant farmers from the Ngorongoro highlands have invaded the area and cleared marginal land for subsistence agriculture. Disturbed by the wanton destruction of their wild resources, the Hadzabe are powerless to stop it. Land clearances, charcoal burning, and encroachment by outsiders bring the area closer to desertification, threatening the traditional Hadzabe way of life. Nevertheless, every society has to adapt to change or face extinction. But it would be tragic if the Hadzabe disappear because land rights are denied them on the grounds that they had no proper claim to their ancestral land because they neither tilled it nor established permanent settlements on it. In the semiarid basin of Lake Eyasi, the Hadzabe probably get more out of the natural environment on a sustainable basis than do other farmers, who destroy the natural vegetation and erode the friable soil in many ways. That outsiders should be given this land on the basis that it was "unused" before they appeared on the scene constitutes a manifest injustice.

Khoisan-speaking peoples of South Africa, which the Hadzabe do not possess.

The Hadzabe hunt expertly with five-foot-long bows and two types of wooden-shafted arrows. The arrows used to kill birds and small game are simply sharpened to a point, but those selected for large antelopes or big game are tipped with metal barbs and dipped in a fast-acting vegetable poison. Hunters obtain the poison by boiling the roots of the colorful desert rose (*Adenium obesum*), which grows defiantly in poor soil. Anyone able to accompany a Hadza hunting party gets a

With its swollen trunk and stunted arms, the baobab tree (Adansonia digitata) is common near Lake Manyara in northern Tanzania. Mature trees are perhaps a thousand years old. Bats and bushbabies pollinate its large white flowers, which open at night. The pith around its seeds is rich in vitamin C, and makes a refreshing drink.

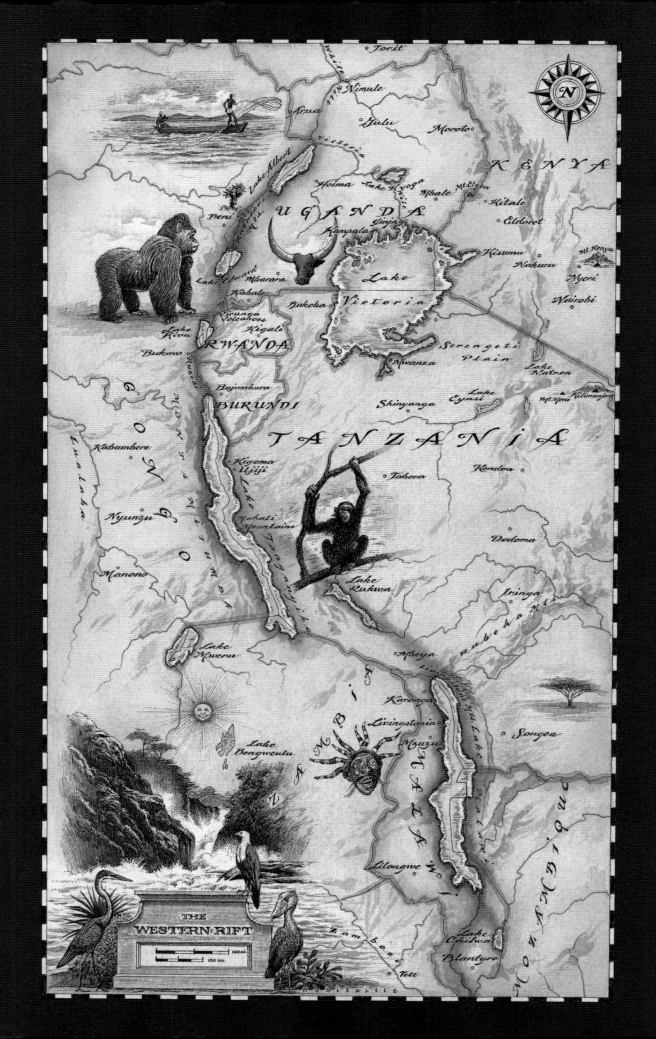

THE
WESTERN RIFT

THREE

The Western Rift

including the Albertine & Nyasa Rifts

The western branch of Africa's Great Rift Valley system extends 600 miles along a north–south axis from an area of irregular faulting on the White Nile north of Lake Albert to Lake Rukwa in southern Tanzania. It has no obvious link to the Eastern Rift at its northern extremity. However, a series of buried fault lines called the Aswa faults extend southeast along the Victoria Nile to Lake Kyoga, then pass to the north of Mount Elgon, an immense volcanic cone. The two Rifts converge in the southern highlands of Tanzania. Then, as a single entity known as the Nyasa Rift, they continue another 400 miles south through Lake Malawi and the Shire Valley. The fault lines become indiscernible near the Zambezi River, but geologists can still trace them into Mozambique.

The formation of the Western Rift followed the same tectonic processes of uplift and faulting as the Abyssinian Rift—with one important difference. The outpouring of volcanic materials was on a much smaller scale than in Ethiopia and elsewhere. The resultant lack of alkalinity in the substrata has lead to huge freshwater lakes of outstanding beauty nestling in the gentle curve of the valley trough. They include Lakes Albert, Edward, Kivu, Tanganyika, and Malawi. These lakes and numerous other smaller ones make up the Great Lakes region in the heart of Africa.

A striking aspect of rift margins is their impressive escarpments. Perched high above the Western Rift in Western Uganda stands the dramatic Rwenzori massif. Its majestic snow-capped peaks rise to a height of 16,763 feet and were first mentioned by the celebrated ancient Greek geographer Ptolemy almost 1,900 years ago.

The Rwenzori Mountains had their beginnings tens of millions of years ago when the earth's crust was weakened by movement. During the formation of the Great Rift Valley, Precambrian crystalline rocks were gradually thrust upward and tilted at a weak point to create the largest tilt-block massif of non-volcanic origin in Africa. The Rwenzori peaks stand like brooding sentinels between the humid tropical rainforests of the eastern Democratic Republic of Congo (often called Congo DRC) and the lake basin climate of Lake Victoria. Their height brings very high rainfall and almost constant cloud cover, with drenching mists. In these damp conditions, where the climate varies from summer in daytime and winter at night, the vegetation is both prolific and unique: forests of huge tree-heathers, grotesque and primeval, grow to

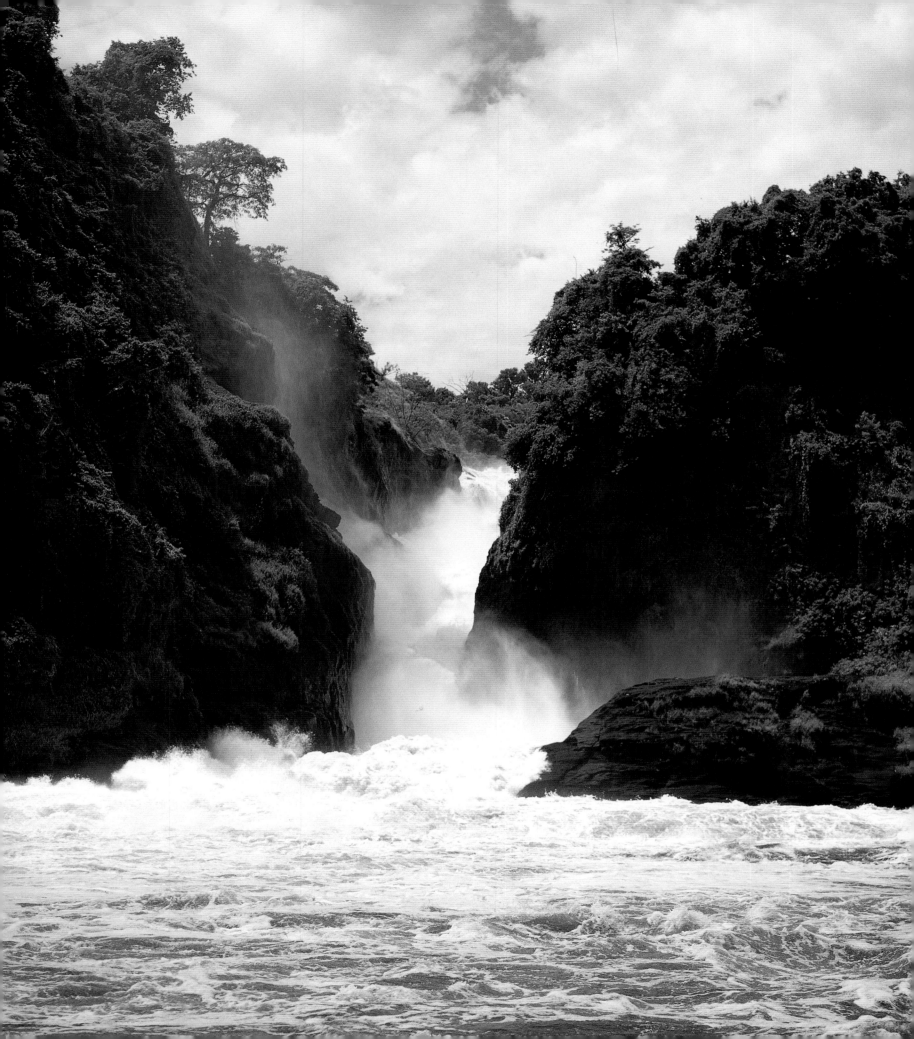

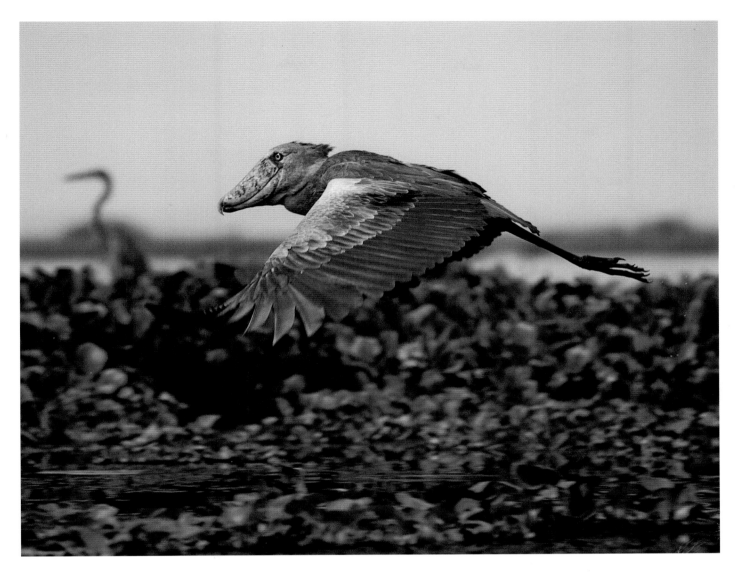

OPPOSITE: *The Victoria Nile flows out of Lake Victoria into Lake Albert, and from there into the mighty White Nile. Twenty miles east of Lake Albert, its colossal volume of water squeezes through a cleft in the rocks little more than twenty feet wide before dropping 400 feet in a series of three great cascades called Murchison Falls.*

ABOVE: *The rare shoebill, or whale-headed stork (Balaeniceps rex), lives in papyrus swamps and river marshes, especially in the vicinity of Lake Albert and the Nile.*

RIGHT: *Large groups of hippos wallow all day in Uganda's rivers and lakes, leaving their secure refuges only at night to graze. A single hippo can ingest up to 120 pounds of grass in five hours.*

Huge thunderclouds build up early over Lake Albert, promising storms and rough seas later in the day.

heights of 30 to 50 feet in perennial bogs; giant groundsels and lobelias flourish above 10,000 feet in a remarkable display of afro-alpine plant gigantism.

Neither Ptolemy nor his successors could have guessed that a permanent mantle of snow and ice existed only thirty miles from the equator. The many deep moraine-blocked valleys and the widespread evidence of ice sculpturing reveal that the glaciers were vast 15,000 years ago in comparison to their size today. The renowned journalist and African explorer, Henry Morton Stanley, sighted the snowcaps on May 27, 1888, thus solving a centuries-old geographic riddle. While the mountains may not be the source of the Nile, they provide the highest and most permanent water catchment of the entire river.

The mountains remained unmapped and largely unexplored until 1906 when the Duke of Abruzzi led an expedition to climb all the peaks. His team included the accomplished Italian mountain photographer, Vittorio Sella, who produced an outstanding portfolio. A study of his pictures highlights the continuing retreat of the glaciers. Global warming will likely reduce or even destroy the remainder in the next few hundred years.

The eastern foothills of the Rwenzori Mountains are pockmarked with numerous explosion craters only seven thousand years old—a recent event in geological time. The Bunyuruguru Field of some thirty craters lies in the fertile land of the Toro people, about twenty miles south of Fort Portal. A testament to the violence of these dramatic

Derelict lake steamer The Robert Coryndon *lies rusting at Butiaba on the eastern shore of Lake Albert. The 850-ton vessel entered service in 1930, and was regarded as the most luxurious of all passenger boats, operating an elegant service to Pakwach on the Nile and to Kasenye in the Congo. After months of heavy rain in 1963–64, Lake Albert rose to unprecedented levels, and Butiaba port was submerged.* The Robert Coryndon *capsized and was finally abandoned in 1965.*

ABOVE: *Shallow alkaline lakes have formed in many of the volcanic explosion craters that pockmark the country between Lake Edward and Lake George in Uganda's Queen Elizabeth National Park.*

OPPOSITE: *Situated at this park's southern extremity is Ishasha, renowned for its tree-climbing lions. The lions favor wild fig trees to observe their quarry on the plains while resting during the sultry heat of day.*

events can be found further south in the vicinity of Lakes Edward and George, where poisonous volcanic gases and dense ash clouds combined to destroy the aquatic fauna, notably crocodiles and Nile perch. Innumerable blowholes were punched through the Earth's crust, and debris remains visible around several of their rims. Over the centuries, small alkaline lakes formed in the deeper craters. An intensely saline one at Katwe has been the center of a flourishing salt industry for at least a century. Volcanism is presently quiescent, but the region remains seismically active: a violent earthquake in 1966 killed 157 people and injured some 1,300 in the northern Rwenzori region. Tremors were felt 600 miles away.

Before the final stages in the uprising of the Rwenzori range a quarter of a million years ago, the Semliki River flowed south into Lake Edward, which together with Lakes George and Albert formed one great lake. Nowadays the river flows north along the trough of the Western Rift into Lake Albert, and then into the Nile. Lake Albert, the northernmost of Uganda's Rift lakes, lies in one of the hottest parts of the country almost 1,000 feet lower than Lake Edward. Measuring 100 miles long and

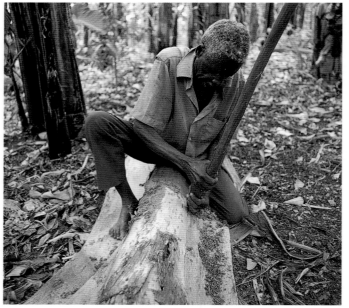

The Baganda and other Bantu-speaking peoples of Uganda still prepare traditional bark cloth, principally for use as shrouds. After the hard outer bark of the fig tree, Ficus natalensis, has been scraped off (left), the softer inner layer is folded several times and pounded with ridged wooden mallets (opposite) to increase the surface area by reducing its thickness. After several hours work, the material is left to dry in the sun. Its brown color comes from tannin in the wood. Banana leaves are tied around the trunks of stripped trees (above) to promote regeneration of the bark. Uganda is one of the few countries in Africa where bark cloth is still made.

on average 22 miles wide, it is a relatively shallow body of water with a maximum depth of 190 feet.

Despite the importance of the Great Rift Valley to human evolution, the Western Rift has been largely neglected in the hunt for evidence of early man because its prolific vegetation concealed the ancient sediments, and political instability in the area made research impossible. Only recently have archaeologists investigated the Semliki River valley. At the small town of Katanda, thousands of exciting artifacts have been found in sediments that date back 90,000 years to a time when *Homo sapiens* was just appearing on the scene. Among the objects found are finely carved bone harpoons and knives of remarkable sophistication. Equally exciting but slightly younger finds have been made recently in a cave at the southern tip of South Africa. Until these discoveries, carving skills had been attributed to human development almost 50,000 years later.

Today, the Semliki Valley shelters scattered communities of Batwa pygmies, who migrated from the immense Ituri rainforest of Congo DRC many years ago. Short in stature, the Batwa are sturdily built and perfectly adapted to a Spartan way of life. They eke out a living as hunter-gatherers, often entering the Semliki Forest, where many Central and West African animal species reach the eastern limits of their range, and whose bird life is unrivaled for its extraordinary variety. Still, a few communities now rely on income from tourism, which has adversely affected their culture. The Batwa are of mixed ancestry, being on average six inches taller than their Bambuti pygmy cousins who still live deep inside the Congo rainforests.

Most people who inhabit the Western Rift are Bantu speakers. They include the Banyoro living on the east side of Lake Albert, whose ancestors established Uganda's greatest ancient kingdom. At the kingdom's peak in the seventeenth century, the king of Bunyoro controlled

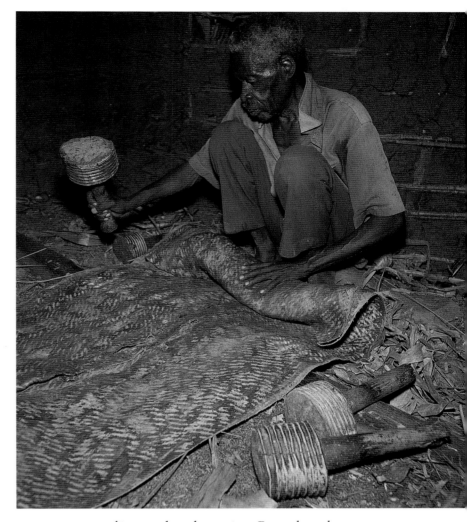

a vast area extending south and west into Rwanda and Congo (DRC). The kingdom, however, had been in decline for a century by the time the first Europeans arrived there 150 years ago. Revolts in outlying areas had culminated in autonomy for the Baganda people of the Buganda kingdom, who became a powerful threat. Nearby Toro and Ankole groups were also asserting their independence. But the Banyoro were still the most respected and powerful peoples of the Great Lakes region, halting the southward push by Arabs up the Nile. One reason for the kingdom's regional supremacy was its control of two essential commodities—iron and salt. For centuries, salt had been recognized as essential to healthy livestock. The women of Bunyoro worked the salt mines on the shores of

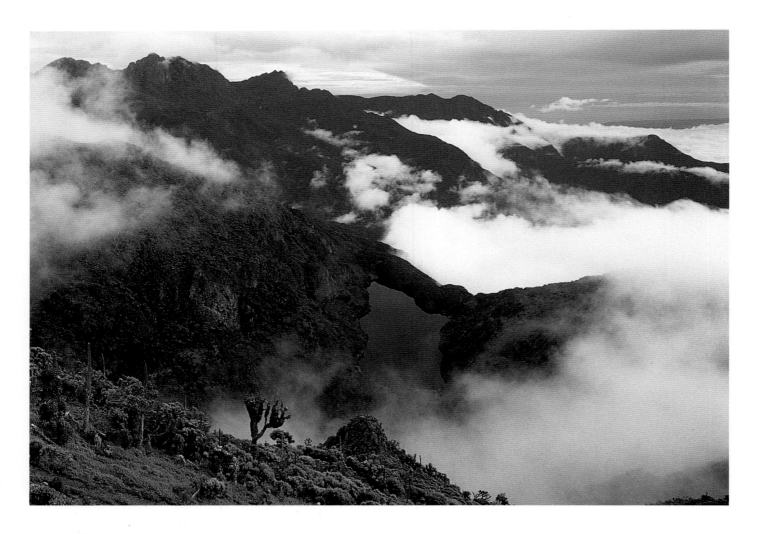

Lake Albert at Kibero with considerable ingenuity. The men smelted iron from local ore, were expert smiths, and also learned the art of making cloth from the bark of certain types of wild fig trees.

Bunyoro society was by tradition centralized and hierarchical, with a hereditary ruler who was held sacred by his subjects. He had an official queen but also kept a large harem. His people were great cattle owners until most of their livestock was lost in wars and to disease, especially trypanosomiasis spread by the tsetse fly. The majority of people are now farmers, growing maize, millet, sweet potatoes, cassava, beans and plantains for food, and

ABOVE: *The western slopes of the Rwenzori Mountains with Lac Noir in the foreground form part of the Parc National des Virungas in Congo DRC. Humid air blowing off the vast tropical rainforests of the Congo mixes with the cool mountain air to precipitate very heavy rain on the lower slopes. Many places record in excess of 500 inches a year.*

OPPOSITE: *Altitude, high rainfall, and almost constant cloud-cover with drenching mists nourish a prolific and unique plant life in the Rwenzoris. A stand of tree-heathers* (Philippia trimera) *covered with moss conjures up a primeval scene in boggy ground at 12,000 feet.*

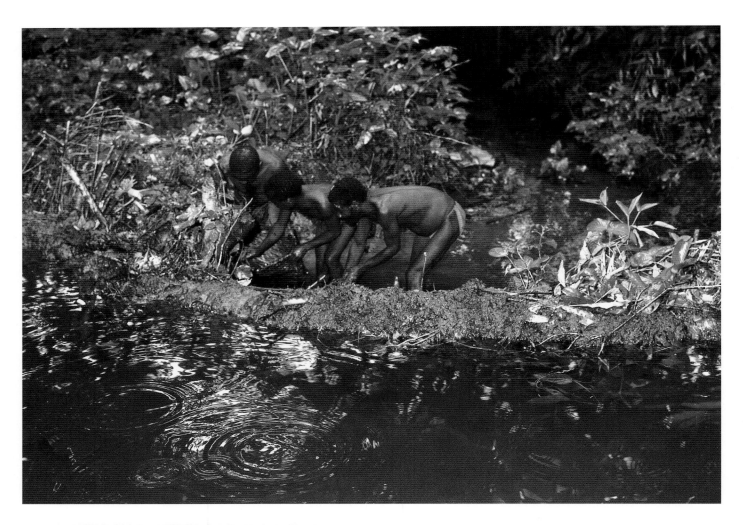

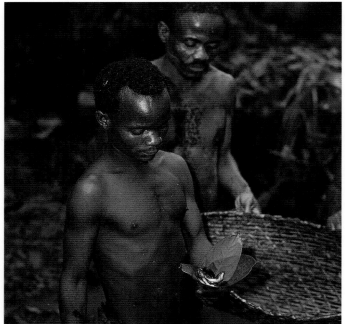

ABOVE AND LEFT: *Small scattered communities of Batwa pygmies hunt and fish in the Semliki Forest of western Uganda, an extension of the vast Ituri rainforest of Congo DRC. Rarely more than five feet tall, the Batwa catch fish by damming a stream and placing bamboo-stem drainpipes in its base. The fishermen trap tiny fish swept through the drainpipes in woven baskets.*

OPPOSITE: *An old Batwa pygmy smokes cannabis using a traditional bamboo pipe.*

OVERLEAF: *Five volcanoes of the Virunga cluster overlook freshwater Lake Mutanda in southwest Uganda.*

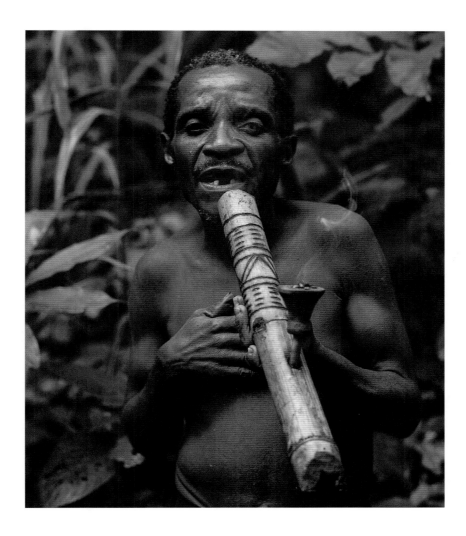

cotton and tobacco as cash crops. Fishing supports the communities living along the shores of Lake Albert.

Early European contact with the Banyoro first came from John Hanning Speke and James Grant, fresh from exploring Lake Victoria as a source of the Nile. Both men were officers of the Indian Army and firm friends. Speke had a passion for hunting to the exclusion of other pursuits; the more animals he killed, the better his satisfaction. The unassuming Grant was a talented artist and botanist, and an equally good shot. Kamurasi, the Banyoro ruler, mistrusted both of them because they arrived separately in his kingdom from Buganda, the country of his archenemy, and they were escorted by Bugandan troops. Further alarming Kamurasi was that the king of Buganda, determined

to maintain a monopoly on European trade goods, had ordered his men to spread lurid accounts of white men being cannibals. Kamurasi, who had never seen a European, naturally believed the tales. He put the travelers into an uncomfortable campsite from where they could neither mix with his subjects nor escape. Speke was systemically robbed of all his valuables before Kamurasi tired of his presence and allowed him to go.

Next came Samuel Baker, a wealthy English big game hunter-cum-traveler with a bent for exploration. With him was the fair-skinned Florence, who hailed from Transylvania in Hungary. At the age of seventeen, she had been captured by Turks and put on sale in an Ottoman slave market. Baker, who had lost his first wife to typhus

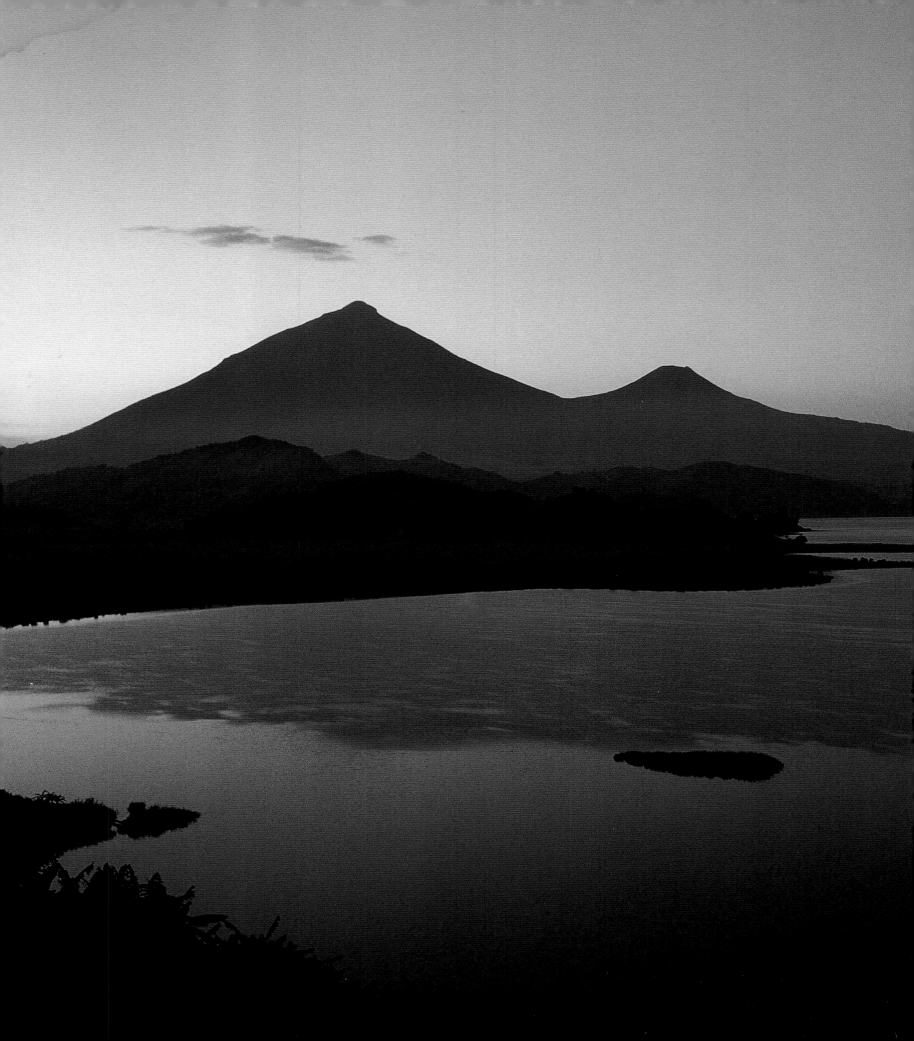

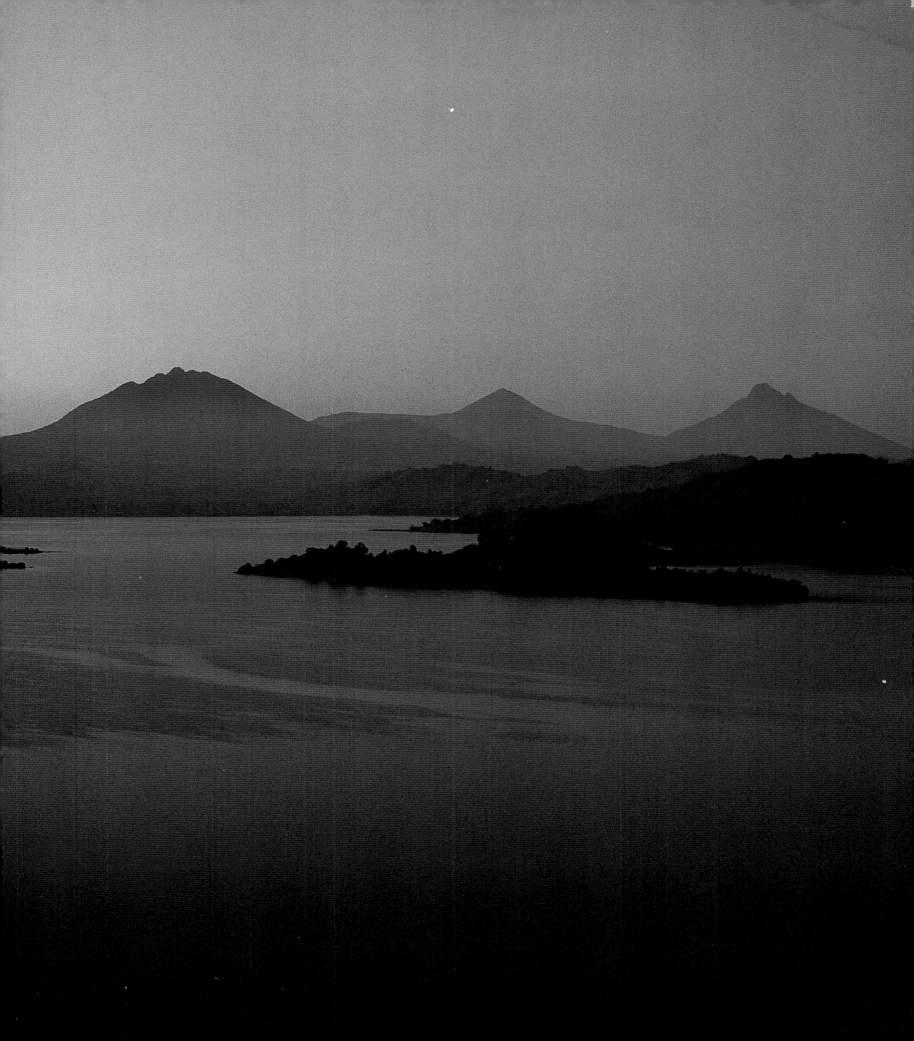

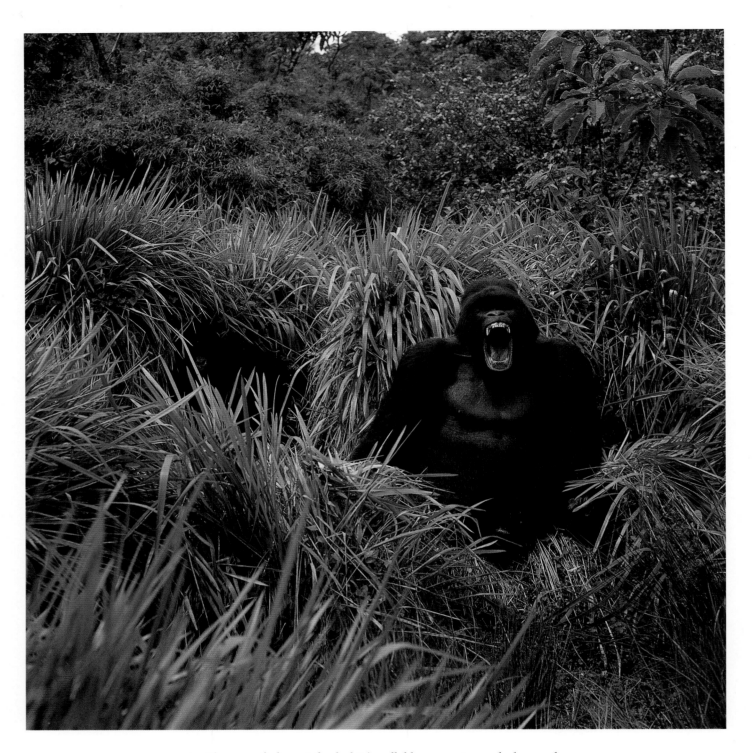

ABOVE: *The yawn of a large "silverback" (so called because mature males have a silver-haired back) suggests aggression, but gorillas are relatively docile. Uganda's Bwindi Impenetrable Forest and the slopes of the Virunga Volcanoes are the only natural habitat of the mountain gorilla, the world's rarest and most endangered primate.*

OPPOSITE: *A young gorilla's vacant expression is a singular trait of these great apes. At far right, mother and child rest on a leafy bed.*

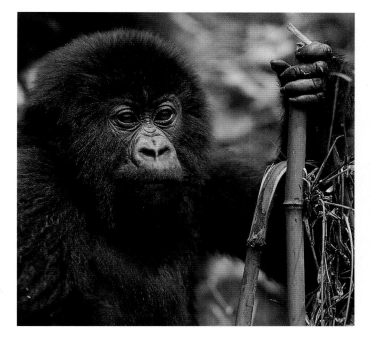
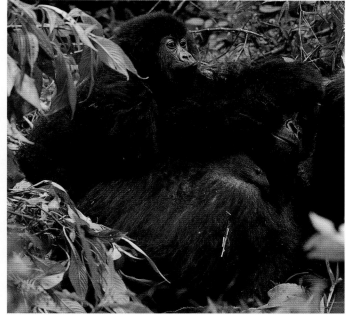

fever five years earlier, spotted her in the market and bought her on the spur of the moment. He set her up as his common-law wife but quickly realized that he could not take a timid young girl with this background to England; so he decided to travel to Africa instead. There, Florence's strength of character and sense of humor blossomed. She proved to be fearless, reliable, and devoted to the man who saved her from a fate worse than death and later married her.

Kamurasi was suspicious of the couple because his spies had warned him of Baker's association with slavers in southern Sudan. His people had suffered badly at the hands of the so-called traders, who had professed to be Speke's best friends, then promptly attacked a village killing 300 men, women, and children. Kamurasi was also uneasy about Baker's strange motives for coming to Bunyoro. He could not believe that anyone would travel so far in search of a river or a lake. Kamurasi was also annoyed at his visitor's discourteous behavior. Baker had no rapport with Africans and probably threatened the African chief with dire consequences if he did not get his way.

Like Speke before him, Baker was forced to hand over many of his valuables before Kamurasi would allow him to go. Enduring great hardship, he carried on to Lake Albert, and established it as a source of the Nile, which brought him fame back home. He returned to Bunyoro in 1872 after an absence of eight years, as Sir Samuel Baker, the governor-general of the Egyptian province of Equatoria in southern Sudan. His title, status, and a large well-armed escort of Egyptian soldiers increased his belligerent disposition.

Although Kamurasi was dead by this time and his young son, Kabarega, had acceded to the throne, Baker received an unfriendly welcome because he was in the company of people with similar looks to slavers who were creating havoc in the kingdom's northern domain. Baker failed to address these concerns, and when Kabarega refused to sign a document acknowledging Egyptian sovereignty over his kingdom, Baker announced its annexation anyway.

Baker's unflattering, one-sided account of Banyoro intransigence resulted in the kingdom being severely punished by the fledgling British administration in 1893.

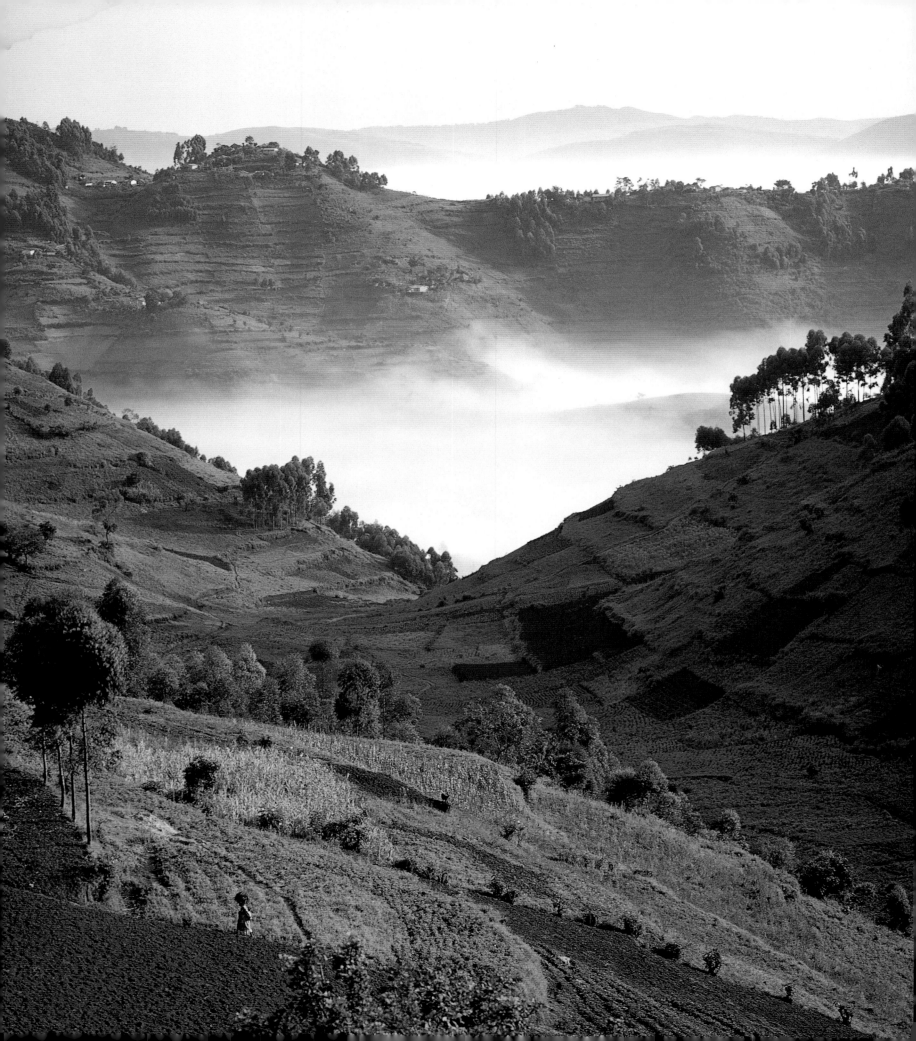

It therefore entered the twentieth century a conquered territory, depopulated by wars and famine, with its leader banished to the Seychelles for having the audacity to resist foreign rule. A large chunk of Bunyoro was then transferred to the Buganda kingdom in a deliberate act to punish transgressors and reward those tribes loyal to the Crown. Today, almost 40 percent of all Banyoro live in the so-called Lost Counties within the borders of the old Buganda kingdom.

At the southwest limits of the ancient Bunyoro kingdom an exceptionally fertile land of volcanic soil supports one of the densest peasant populations in the world. The landscape of neatly terraced hillsides in southwest Uganda and Rwanda has led some people to call it the Switzerland of Africa. The forest-clad Virunga volcanoes tower high above the rich farmlands and form a splendid backdrop. This forty-mile-long chain of six volcanoes straddles an east-west line of crustal weakness across the breadth of the Western Rift close to the common borders of Congo DRC, Rwanda, and Uganda. The tallest volcano, Karisimbi, rises to a height of 14,788 feet and is Africa's sixth highest mountain. Two highly active volcanoes with parasitic cones stand to the west of this chain in Congo DRC. Nyamulagira has erupted periodically during the last century and Nyiragongo blew spectacularly in 1977 destroying its 285-foot-deep crater lake. A tidal wave of lava then hurtled down its slopes killing fifty peasant farmers. Other smaller eruptions have followed through a series of parasitic vents that burst into activity in the 1980s.

The rare and beautiful montane forest ecosystem of the Virunga chain is protected by legislation in three countries, but the enforcement of those laws leaves much to be desired. The vegetation includes bamboo forests and *hagenia—hypericum* woodlands to an altitude of 10,500 feet. Higher up the mountains, giant heather, giant groundsels, lobelias, and everlasting flowers grow in semi-permanent mist. These forests are the natural habitat of one of nature's rarest large mammals, the mountain gorilla.

Entering the twenty-first century, this unique sub-species, with its low aptitude for dispersal and colonization, totters on the threshold of extinction. Not a single specimen has ever survived in captivity. It has suffered from a disastrous reduction of its range because humans are exerting tremendous pressure on the limits of available land. A sea of people surrounds the animals' forest island fortress. Rwanda has on two occasions in the past fifty years given up part of its Parc National des Volcans in response to an ever-rising population, of which 86 percent lives in poverty—the highest percentage in the world.

Serious ecological damage was also inflicted on the Congo's Parc National des Virungas during the humanitarian tragedy of the 1990s when three-quarters of a million Hutu refugees camped on lava wastes near the volcanoes. To build shelters and maintain cooking fires, the people resorted to nearby woodlands because international aid agencies had failed to provide wooden or metal poles or badly needed fuel. Although the park has World Heritage site status, this inexcusable lapse resulted in more than half the bamboo stands on Mount Mikeno being cut down and an estimated 900 tons of firewood removed from the forests each day.

The ongoing trouble in Congo DRC has not helped to secure the park's uncertain future. No one knows the real extent of the long-term damage or the incidence of poaching in an area where primates are hunted for food. Today, the mountain gorillas' best secure haven is the

OPPOSITE: *Mist hugs the bottom of a valley in southwest Uganda, where terraced hill slopes are cultivated to feed one of the highest human population densities in Africa.*

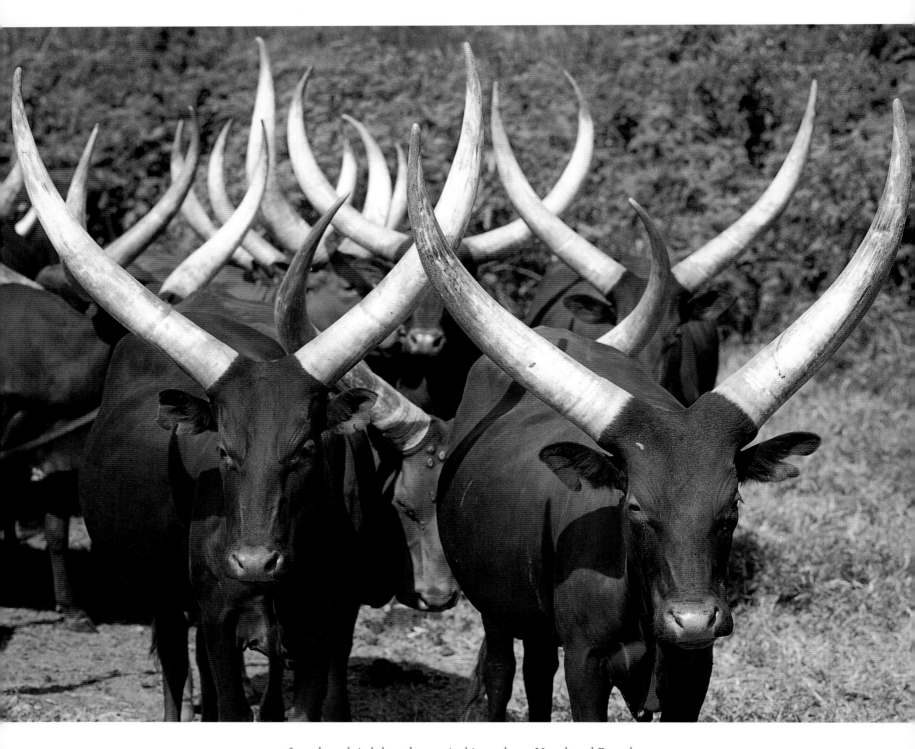

ABOVE: Long-horned Ankole cattle are prized in southwest Uganda and Rwanda.

OPPOSITE: The Banyarwanda-speaking peoples use an unusual bell-shaped wooden pot, called ekyanzi, for storing fresh milk. Every member of a family has one, but the milk of two cows may not normally be mixed in the same pot for fear that one of the cows may cease its lactation prematurely. A further taboo prevents married women from milking livestock.

Bwindi Impenetrable Forest in Uganda, which itself has considerable importance because of its antiquity. At least 25,000 years old, it is one of the few forests in East Africa where lowland and montane vegetation can be found in one continuous belt.

The American Museum of Natural History's famous naturalist and taxidermist, Carl Akeley, looked upon the Virunga volcanoes as "the most beautiful spot in the world." He set about persuading King Albert of Belgium, whose country then controlled Congo DRC, to establish a national park there to protect the mountain gorilla. His efforts were rewarded when the Albert National Park was established in 1925. (This was just twenty-three years after Captain Oscar von Beringe of the German Army discovered the new subspecies on Mount Sabinyo. Hitherto, only the smaller, eastern lowland gorilla had been known to science.) Akeley made it his life's work to preserve Africa's wildlife in bronze and in specimens set in realistic diorama habitats at the museum. A highlight of this wonderful New York City museum to this day is the family group of mountain gorillas that Akeley collected between 1921 and 1925. He died and was buried on the slopes of Mount Mikeno only a year after the creation of the national park. That a modicum of protection still exists for this rare great ape pays tribute to the foresight of a remarkable man.

Akeley also took the first motion pictures of gorillas in the wild, and in filming a sequence of the benign behavior of a gorilla group, he was able to prove that the apes were not the vicious and horrible creatures people in the West had been brought up to believe. The misconception had arisen after 1861 when the publishers of *Explorations and Adventure in Equatorial Africa* by Paul du Chaillu insisted that the book be rewritten to thrill the public. So the author claimed that every gorilla he saw stood on its hind legs beating its chest and uttering blood-curdling roars

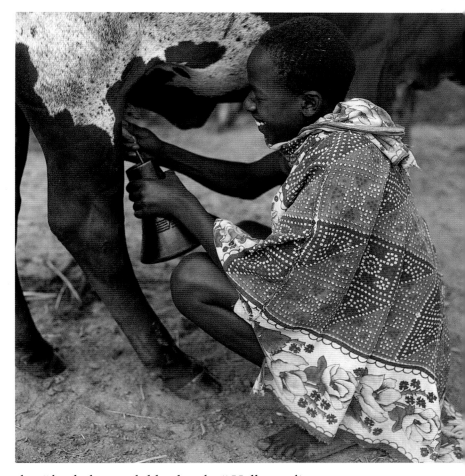

that "shook the woods like thunder." Hollywood's moviemakers dramatized this falsehood in the film *King Kong* and others until the temperament of the gorilla was totally misunderstood.

Over many thousands of years a gradual building up of the Virunga Volcanoes with successive outpourings of lava created a gigantic barrier across the Western Rift. In the process, river systems were adjusted and lakes formed. Lake Kivu, the highest lake in the trough of the Western Rift, owes it origin to this barrier. Kivu's beautiful setting between Rwanda and Congo DRC has led visitors to compare the site to a Norwegian fjord. But danger lurks beneath its waters because an earthquake could release the vast quantities of methane gas trapped under the lakebed.

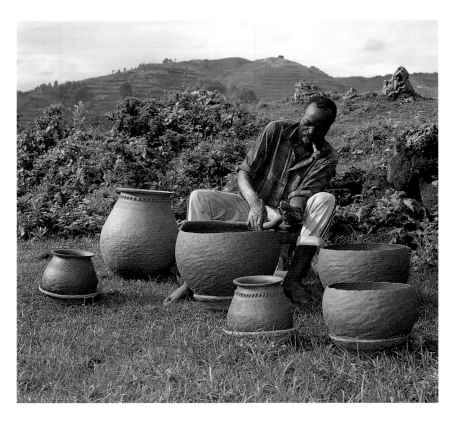

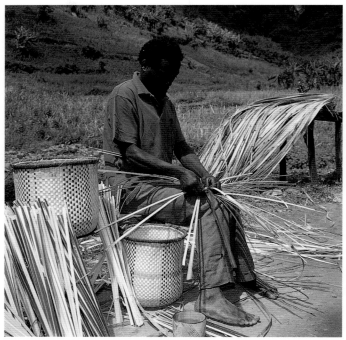

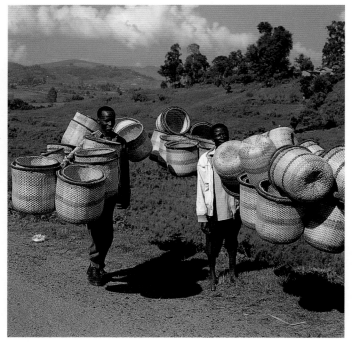

Craft skills such as pottery and basket making are the sole preserve of men in southwest Uganda. A potter (above) fashions an array of cooking pots by the coil method, shaping them by eye alone Men also weave split bamboo baskets and carry them to market, where women will buy them to carry farm produce balanced on their heads.

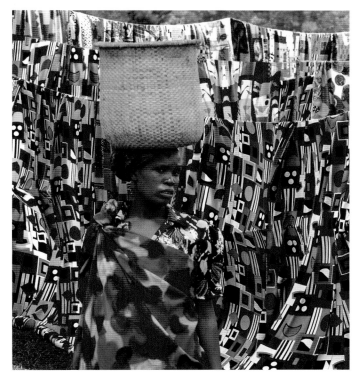

ABOVE: *Women in southwest Uganda love vivid wraps, so the materials on sale at Kisoro market reflect their tastes in fashion.*

BELOW: *A woman sells raffia from the prickly raffia palm, whose leaf fibers are used in basketry and weaving.*

Prior to volcanism, the run-off from the mountainous region flowed north into Lake Edward and from there to the Nile. Today, the drainage pattern is reversed: outflow from Lake Kivu runs south through a series of deep gorges of the turbulent Ruzizi River, which drops more than 2,200 feet in 70 miles before spilling into Lake Tanganyika.

Lake Tanganyika, an immense inland sea set in a long, low, deep trough of the Western Rift, is the biggest lake of Africa's Great Rift Valley system. Its 410-mile-length distinguishes it as the longest freshwater lake in the world, and its depth ranks second after Lake Baikal in eastern Siberia. Since Lake Tanganyika lies 2,515 feet above sea level and has a depth of 4,710 feet, the floor of the Rift on the lake bottom is an astonishing 2,195 feet below sea level. Nowhere else in the Rift Valley is deeper.

Although Lake Tanganyika has less than half the surface area of Lake Victoria—the world's second largest lake—it holds seven times more water because of its colossal depth. Remarkably, the water temperature remains surprisingly constant from surface to lakebed, with a change of only 3 degrees C. This constancy, implying a complete absence of water circulation, leaves the deep waters of the lake permanently deoxygenated, undisturbed, and, in fact, biologically dead. No life exists below 650 feet. In contrast, the lake's upper layers are oxygenated, crystal clear, and support abundant life. That so many cichlid fish species have evolved there emphasizes the lake's isolation over a lengthy period of geological time. Four-mile-deep sediments suggest that it existed in some form or another for twenty million years, although its present shape dates back only three to six million years.

Lake Tanganyika demarcates Congo DRC and Tanzania and also marks another dividing line between the flora of east and west Africa because clouds born of rainforest moisture from the Congo basin bring with them more humid conditions to the lake environs. On the

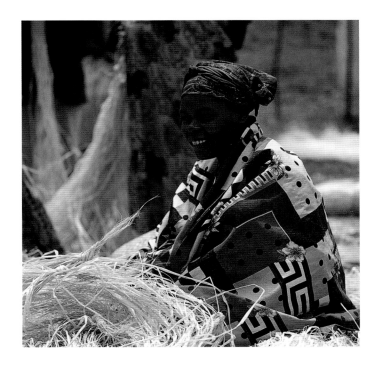

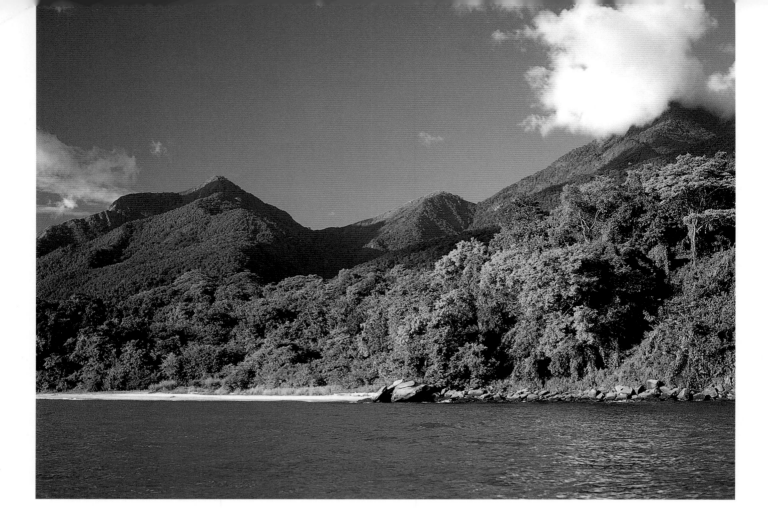

magnificent escarpments that rise sheer from the western lakeshore, the vegetation resembles that of West Africa. On the east side of the lake, the remote Mahale Mountains are clad in warm, wet lowland forests between the mountains and the lakeshore. That habitat was given national park status in 1980 because of its population of chimpanzees. The Mahale chimps are less arboreal than chimps elsewhere, which can probably be explained by the availability of food. Up to 700 live there in family groups, making it the largest concentration anywhere in the world, and a prime site for the ongoing research that brings chimpanzees ever closer to humanity.

Also on the eastern shores of Lake Tanganyika is Ujiji, a small market town established by Arab merchants from Oman in the 1830s as a clearing house for ivory and slaves. Some years later, the town rose to prominence as a staging post for the trickle of nineteenth-century Victorian adventurers who came in search of the mysterious and elusive source of the Nile. Their descriptions of the lake region helped geographers to recognize the existence of an extensive trough-like valley, which was identified later as the Western Branch of the Rift.

In 1858, the remarkable English soldier, explorer, linguist, and author Richard Burton and his assistant,

The remote Mahale Mountains, located on a bulge along the eastern shores of Lake Tanganyika, rise spectacularly to 8,069 feet. The mountain slopes are covered with rainforest, where many trees show a closer affinity to West African species than to those of East Africa. Protected as a national park since 1980, the mountains are home to one of the most important wild chimpanzee populations left in Africa.

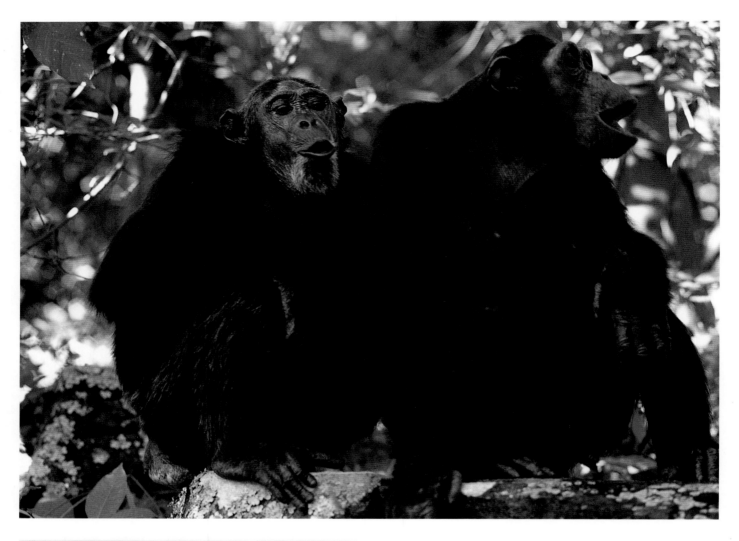

About 700 chimpanzees live in the Mahale Mountains where the wild fruits and seeds they feed on are abundant.

ABOVE: Chimps communicate by facial expressions, gestures, and a large repertoire of vocal noises. At top, two females purse their lips to let out a distinctive "whoo, whoo, whoo" call that gets faster and louder until it breaks into a short scream.

LEFT: Adult chimps spend long hours each day removing fleas from one another.

RIGHT: Young chimps are born with pale faces, hands, and feet and a strong clinging reflex.

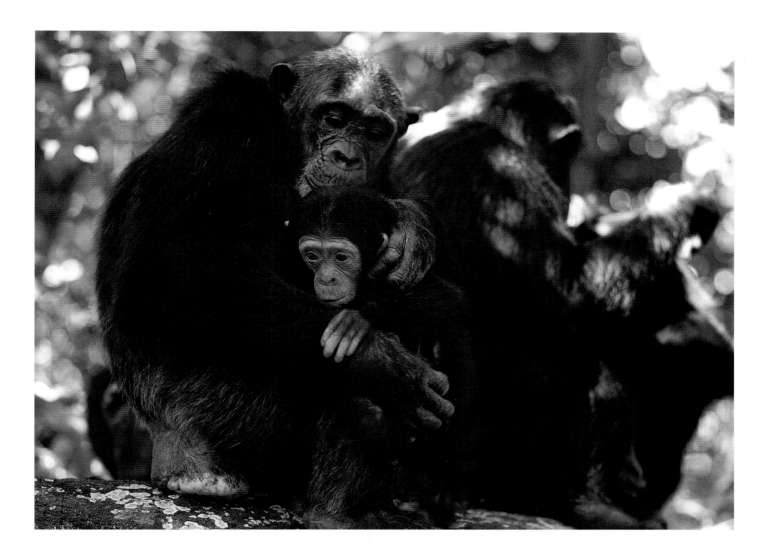

John Speke, were the first Europeans to reach Ujiji. Being first, they claimed the "discovery" of Lake Tanganyika. Men have a great desire to go where no man has trod before, but Burton's claim of a discovery rings hollow when local tribesmen and foreigners of Arab descent had lived beside the lake for years. Burton had earlier written that, "To be first in such matters is everything, to be second is nothing."

Burton had served in the Indian Army for seven years before making a name for himself by reaching Mecca, Islam's holiest shrine, disguised as an Arab. His first journey to Africa was to the walled city of Harar, now in Ethiopia, where the emir was reputed to put infidels to death. But

Burton entered the place openly as an Englishman, the first to do so, and was greeted cordially. His next challenge almost cost him his life. He had planned a long expedition into the African interior from the port of Berbera, opposite Aden, and invited three other Indian Army officers to join him. One of those officers was Speke. Before leaving base camp, hordes of Somali warriors launched a ferocious night attack against them in the mistaken belief that they were British spies investigating the slave trade. Burton and Speke were injured and one of their companions was killed.

After recuperation and service in the Crimea, the two returned to Africa again toward the end of 1856.

Burton had been appointed by the Royal Geographical Society to head an expedition to explore a slug-shaped inland sea that had appeared on missionary maps. He invited Speke to join him although the two men had little in common and Burton harbored misgivings about Speke's courage after the Berbera debacle. Nevertheless, their pioneering journey to central Africa turned out a remarkable feat. The two explorers had to surmount enormous obstacles to reach Lake Tanganyika, not the least of which was frequent illness. Both of them almost died on more than one occasion. In those early days of African travel, no one had come close to recognizing the connection between malarial fever and the mosquito. Theories ranged from bad fumes emitted from marshy ground (the word "malaria" originates from the Italian *mala aria* meaning bad air), to overexertion and sweating, to impure water and to sleeping in damp clothes. The introduction in about 1854 of quinine (a decoction from the bark of the South American cinchona tree) as a treatment for "African fever" was a breakthrough in the fight against malaria and saved many lives, yet no one knew why. Quinine has been effective in Africa for nearly 150 years.

Burton was a brilliant scholar and linguist whose ethnological descriptions of tribal customs of the period are without equal. He described the people living in the vicinity of Ujiji as belonging to a sturdy race with dark skins and plain features. Many were disfigured by smallpox. They had larger builds and were darker than the Wanyamwezi, who lived at Tabora. Both sexes were extensively tattooed with lines, circles, and rays of little cuts drawn down the back and across the stomach and arms. Their skins were always well oiled with animal fat. Hairstyles varied but generally displayed tufts of hair shaped in circles, crescents, crests, or lines on an otherwise cleanly shaved head. The tufts were often coated with white chalk. Women wore bark cloth, which was brought from Burundi and Uganda. The finery of both men and women included brass bracelets, armlets, anklets, and necklaces of white and blue beads. They also wore small pink shells of freshwater mollusks strung on stout fiber, and ornaments made of hippo teeth tied tight round the neck.

One of Burton's important expeditionary objectives was to find a north-flowing river along the shores of Lake Tanganyika, but in this he failed. Just short of the Ruzizi River, the crews of his two dugout canoes took fright and refused to go any farther, but not before the locals had made it clear to him that the river definitely flowed into the lake. Burton was unconvinced. He and Speke left on their return journey to the coast without proving or disproving a connection to the Nile.

On arrival at Tabora, Burton decided to rest and recoup his strength while agreeing with Speke that his time could be profitably spent investigating Arab reports of a much larger lake to their north. Although the two men had got on each other's nerves and were pleased to separate for a while, Burton may have expected his companion to abandon the attempt halfway. He had a fairly low opinion of Speke's competence and derided him for his lack of language skills. So Speke's reappearance six weeks later after a trouble-free trip to the southern end of a vast lake must have taken him aback. Burton's surprise soon turned to astonishment and then to anger when Speke announced that his lake—the Victoria Nyanza— was unquestionably the source of the Nile. Burton was still quietly confident that Lake Tanganyika would prove to be its source, but insisted that no claims could be made without tangible evidence. Since lack of supplies, time, and money prevented them exploring further afield, and settling the argument on the spot, they returned to the

coast with their personal differences rankling. Still, they had a firm understanding that the controversy would not be raised again until they were both safely back in England.

Speke had no compunction in breaking this gentleman's agreement. He landed in England two weeks before Burton and grabbed the headlines by impetuously announcing his findings. It was a dastardly act, yet strangely condoned by the President of the Royal Geographical Society. The truth was that Britain had strategic concerns for finding the source of the Nile ahead of other European nations, so her officials were willing to dispense with etiquette in their haste to succeed at any cost. As expedition leader, Burton's fury was hardly surprising. While he licked his wounds and set about demolishing Speke's unfounded claims, Speke was appointed to lead another expedition to the lake region. He chose as his companion an unassuming army officer with whom he had hunted in India. He was confident that Captain James Grant would not try to steal the limelight from him, but as a precaution, Speke undertook all the important research himself. Perhaps this flaw in his character, this selfish clamor for fame whatever the cost, was the result of an underlying lack of self-confidence, though outwardly he was an arrogant man.

Speke's diary, a litany of calamities, raises serious doubts about his leadership qualities and judgment of men. In his desire to prove his theory empirically, Speke often lost control of his headstrong porters, who were difficult to control at the best of times. He thus left important decisions to the rank and file. At other times he bribed his way through difficult situations when a firmer hand would have been best. Only his dogged determination got him through.

At the conclusion of his journey, Speke was quick to reiterate his claims on the source of the Nile, yet they were still unproven and open to dispute. For a start, he had not kept sufficiently close to the western shores of Lake Victoria to confirm whether or not a large river entered or left the lake from that side. More importantly, he had failed to follow Lake Victoria's outflow from the place he named "Ripon Falls" to Gondokoro on the White Nile. So he could not be sure of a direct link. That his hunch was subsequently proved correct was no defense for his unscientific approach.

Geographers back home were unimpressed by Speke's unsubstantiated claims. His backers at the Royal Geographical Society were also having second thoughts. The committee was infuriated by his impudent refusal to publish his findings in their learned journal ahead of his own book in case the article affected its sales. With no sign of the controversy over the Nile ending, Burton and Speke agreed to a public debate at Bath under the auspices of the British Association. Less than twenty-four hours before the appointed day, Speke was dead, the victim of a shooting accident on his family estate. Tragic though his untimely death was, it saved him from being humiliated publicly for his rash conclusions based on intuitive guesswork. The definitive answer to the Nile question was settled after Speke's death.

The most famous of Ujiji's distinguished nineteenth-century visitors was Dr. David Livingstone, a humble Scot who was born in poverty. At the age of ten he worked in a cotton mill, where, in his spare time, he taught himself Greek and Latin. As he grew up, he decided to become a missionary doctor and serve in China, but the Opium Wars prevented that. Instead, he went to South Africa and spent twelve years (1840–52) undertaking missionary work in Bechuanaland, now Botswana. It was then that his interest in geography blossomed, first as a means to open the interior to Christianity and trade, then later to

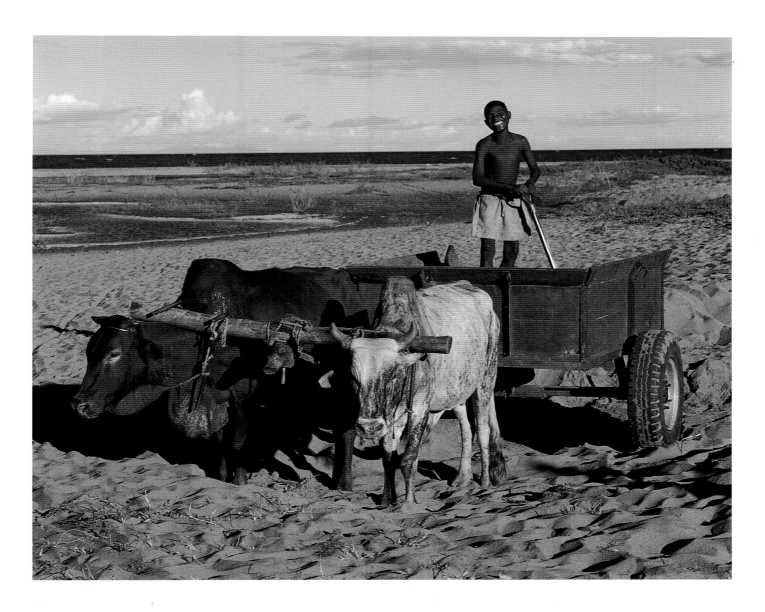

satisfy his growing obsession with solving geographic riddles and exploring the unknown.

Livingstone was a loner who never wanted to settle down. Even his marriage to Mary, a missionary's daughter, failed to change his lifestyle. The union was a loveless affair, and when his young family got in the way of his travels, he packed them off home, to all intents and purposes abandoning them. Mary was deeply hurt by her husband's uncaring attitude as she struggled single-handed to raise their children. After enduring years of separation and misery, she died of malaria during a brief visit to her husband on the Zambezi.

Livingstone had planned to explore the Zambezi River to see if it could be used for legitimate trade into the

OPPOSITE: *Rough seas pound Karonga Beach near the northwest corner of Lake Malawi. The Livingstone Mountains rise steeply at the far side of the lake.*

ABOVE: *Ox-drawn carts are familiar rural sights in Malawi. Here a boy collects building sand from Karonga Beach.*

ABOVE AND OPPOSITE: *Forming a dramatic eastern boundary to the Rift, the Livingstone Mountains drop almost perpendicularly more than 4,000 feet into the northeast corner of Lake Malawi. Trees grow sparsely on the rugged slopes but wild flowers are abundant. The scarp continues below water level for another 2,200 feet, making this the deepest part of the lake.*

Upper Zambezi, but the Kebrabasa Gorge, with its dangerous rapids, proved an impassable obstacle. Looking for other opportunities, he was attracted by the Shire River, the more so because it had not been fully explored by the Portuguese, whose settlements on the Zambezi had spanned 300 years. Since the Portuguese had been aware of the existence of a large lake at the mouth of the Shire River way back in 1616, Livingstone's eventual sighting was hardly the discovery with which he was credited.

Nevertheless, he was the first to explore it. He named it Nyasa after the local Bantu word for a lake. Both Tanzania and Mozambique have sovereignty over different eastern sectors of the lake and call it Lake Nyasa to this day.

Nyasaland became the name of the country surrounding the lake, but the narrow, land-locked state in the heart of central Africa was changed to Malawi when her citizens gained independence from Britain in 1964. The lake of

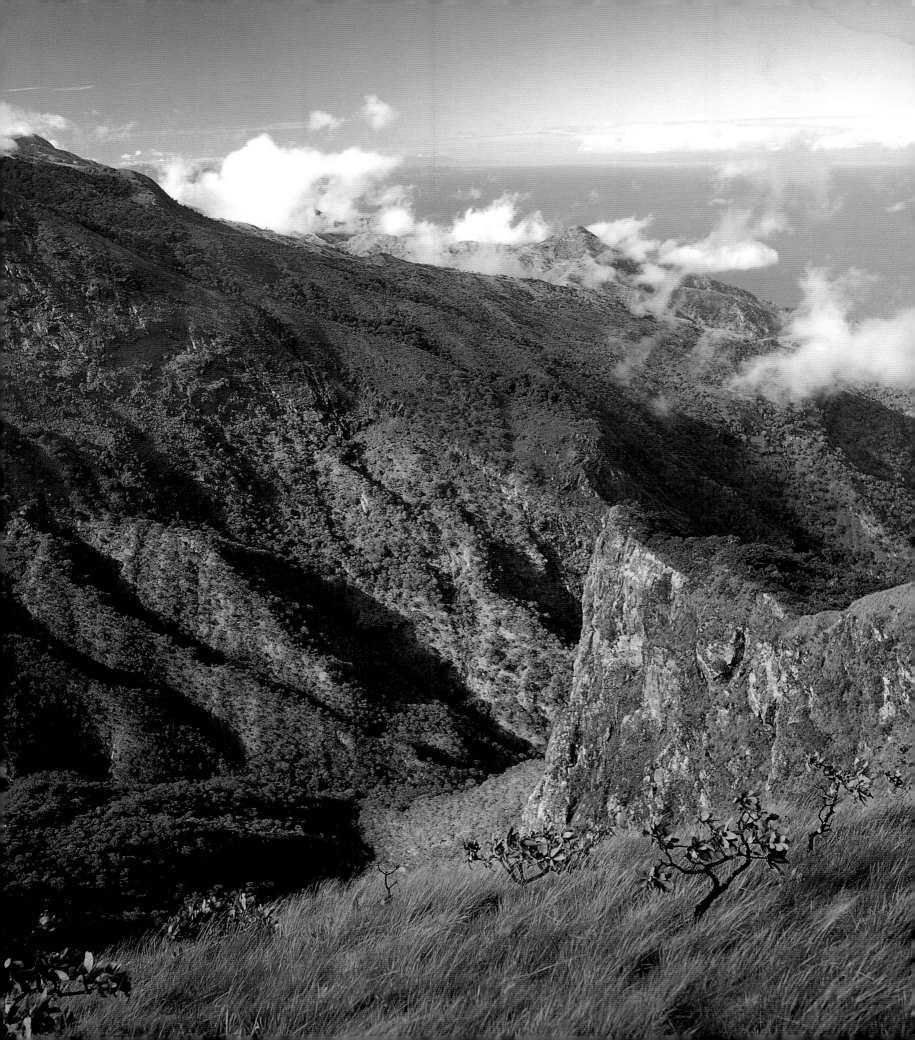

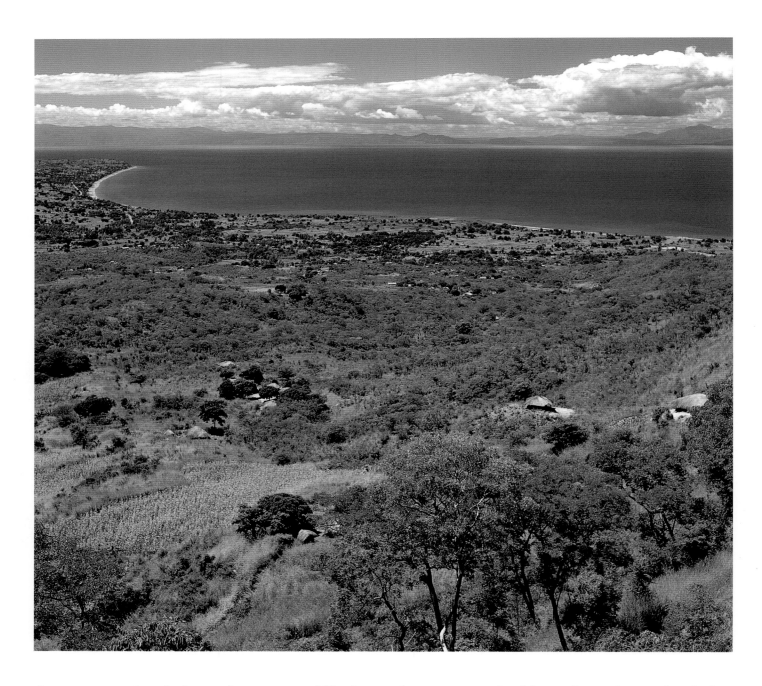

the same name, 363 miles long and covering one fifth of the country, is the epitome of a Rift Valley lake—long, narrow, and very deep. Only Lake Tanganyika is bigger. In the northeast, the magnificent Livingstone Mountains drop precipitously to the lakeshore and continue beneath the water line for another 2,200 feet.

Like other Rift lakes, the size of Lake Malawi has varied over the ages. In antiquity, it was hundreds of feet above its present level, but millions of years of gradual tilting, faulting, and subsidence removed a retaining wall, and the lake level dropped. Since then, it has varied in long natural cycles: many homes have been submerged during the past twenty years as the lake's level has risen.

No other lake in the world has a more diverse fish fauna than Lake Malawi. There are almost 600 species

In 1894, the Free Church of Scotland established a mission at Khondowe and renamed the place Livingstonia in memory of Dr. David Livingstone, the great missionary-explorer, who died in 1873. The view of Lake Malawi at left is from the road built by the pioneering missionaries: its twenty-two hairpin bends wind up the steep western scarp of the Nyasa Rift to reach the mission, 4,000 feet above the lake. The original post office (below) was built of local brick with a clock tower added in 1905. It houses one of the oldest clocks in Africa with a face that lights up at night. The construction of the mission church (right) began more than a century ago and took twenty-five years to complete.

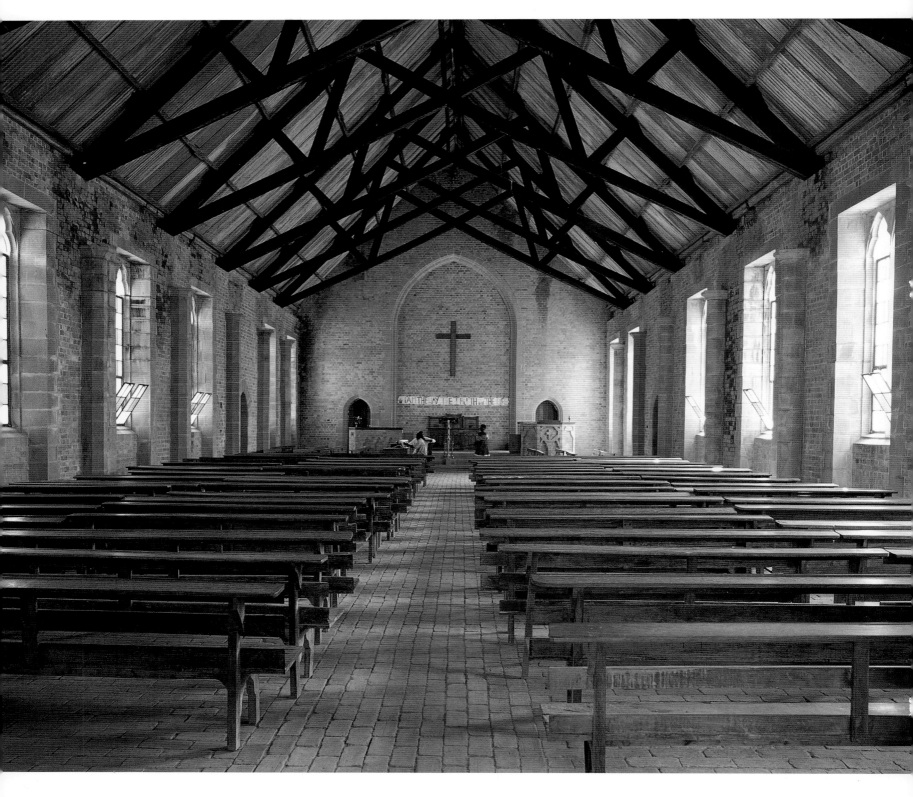

The austere mission church at Livingstonia, still in use today, features a magnificent
stained-glass window (opposite) depicting David Livingstone beside Lake Malawi with
Gusi and Chuma, his two loyal servants.

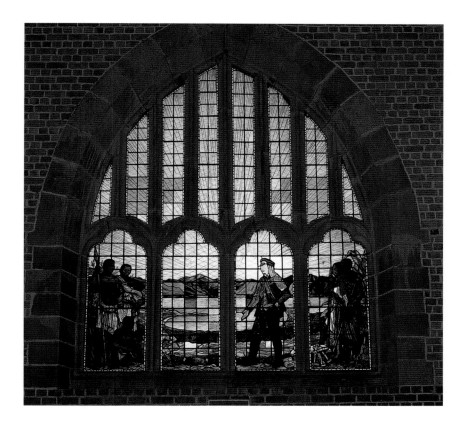

from ten families, the majority of them being endemic cichlids. The shallow waters in the southern sector of the lake and nearby Lake Malombe have the greatest fish concentrations, and the best fishing grounds. Fishermen paddle dugout canoes laboriously fashioned from hardwood by adz and fire as they have done for centuries. The fish landed each year from all Malawi's lakes and rivers amounts to 70,000 tons, satisfactorily providing about 70 percent of the population's protein requirement. Faced with a growing population, however, Malawi will no longer be able to rely on its natural water resources, and fish farming offers the best solution: more than 2,300 small fishponds have been constructed in recent years as part of an integrated farming approach.

The sole outlet of Lake Malawi is the Shire River, which flows south through Lake Malombe and past Lake Chilwa before winding down the Shire Valley over a series of rapids to join the Zambezi River in Mozambique. Throughout the 250-mile-long river valley, the floor of the Rift provides light, fertile soil, ideal for cultivating cotton, sugar cane, and tobacco. Just south of the country's largest sugar estate an extensive flood plain of the Shire River plays host to a spectacular avian display in its maze of islets, channels, and reed beds. Seasonally, it is also a prolific fishing ground.

In a marshland of the area, David Livingstone once watched "hundreds of elephants moving like gray galleons across the boggy waste," but no one alive today can remember when the last elephant was seen there. Its name, Elephant Marsh, recalls the wildlife that once inhabited this magnificent wetland wilderness. Provisional plans that exist to drain the marsh for agriculture would be environmentally tragic, but cannot be ruled out because Malawi's population has almost tripled in 35 years and the people need more fertile land.

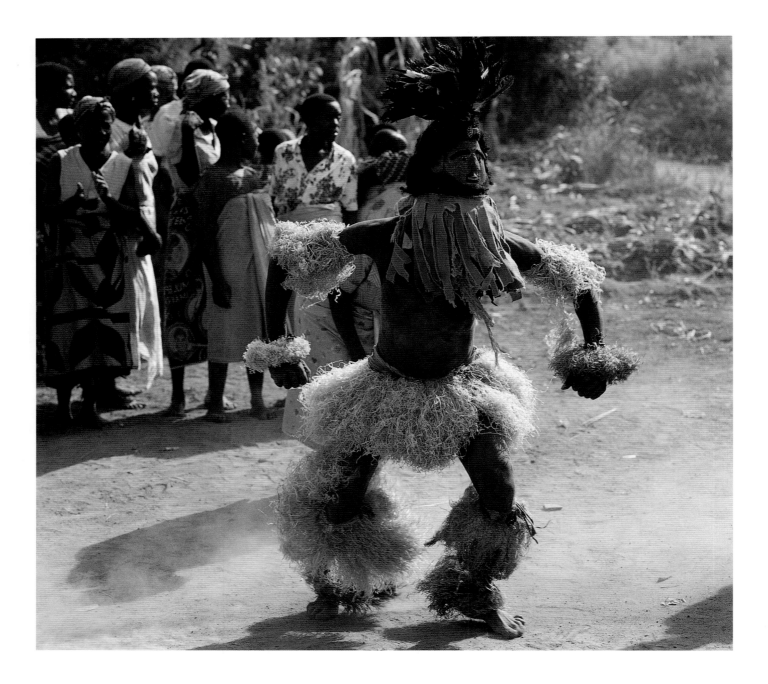

By the time Livingstone sailed up the Shire River for the first time in 1858, he had ceased to be a missionary in the true sense of the word. He was no longer employed by the London Missionary Society, nor was his journey purely ecclesiastical. He exhorted others to spread the word of God while he turned his attention increasingly to exploration. Livingstone may never have been suited to an evangelistic calling anyway. He had been curiously indifferent to his ordination in London, and he had disagreed with his colleagues in southern Africa over their rigid observance of the Sabbath. He also found their prudish revulsion of nudity in Africa to be absurd. Though he remained a devout Christian to the end of his days, always traveling with a bible and trusting the Almighty to guide him safely, he found his true calling as an itinerant explorer and meticulous amateur cartographer.

More than anything else, this satisfied his restless spirit and inquiring mind.

Livingstone made three trips to Lake Malawi despite the personal danger caused by the presence of slave traders. At home in England, the best-selling book on his exploits in southern Africa had made him a respected household name. His voice was heard, therefore, speaking out strongly against the barbaric trafficking in human beings, which had robbed the interior of Africa of its youth. Untold suffering was inflicted on the peoples of central Africa long after the West African trade had been stamped out. Slaving was not confined to Arabs or Swahilis from the coast. Yao tribesmen living at the southern end of Lake Malawi enthusiastically captured and sold their neighbors. Only practicing Muslims were relatively unaffected by the scourge, so conversion to Islam became a matter of life and death. Yao villages began to resemble coastal settlements: mosques were erected, and the people built rectangular homes quite different from their traditional round huts. The slavers were very much at home there, enjoying mangoes and coconuts in season.

The Yao prospered under foreign influence, and some of their traditions, male circumcision, for example, changed to follow Muslim practice. Still, no one was safe when the demand for slaves exceeded the supply. (A poignant reminder of the brutality still exists in the two-door design of the Yao home: when slavers knocked at the front door, the occupants fled into the bush through a rear door.) Given the opportunity, almost everyone in the region sold people into slavery because the trade was so profitable. C. P. Rigby, the British Consul at Zanzibar

OPPOSITE, RIGHT, AND OVERLEAF: *The Chewa people, Malawi's largest tribal group, live on the west side of Lake Malawi. Despite years of missionary influence, they still cling to old beliefs and rituals, and when people die, masked dancers appear at their funerals to welcome the deceased to the spirit world.*

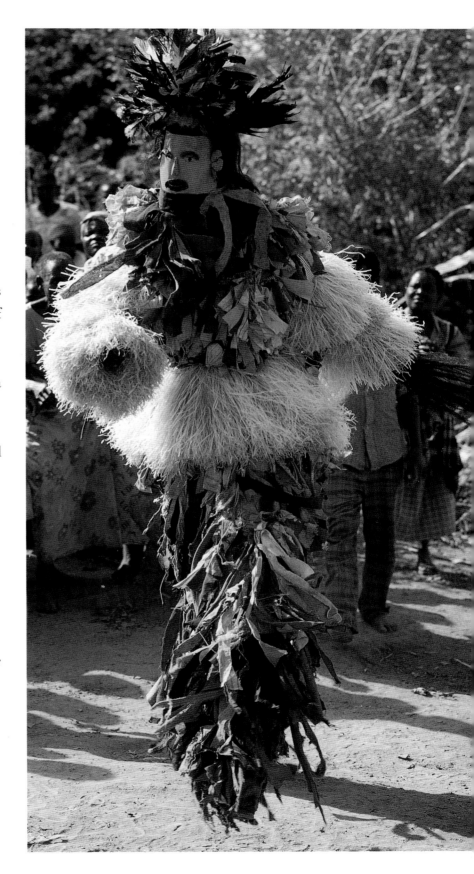

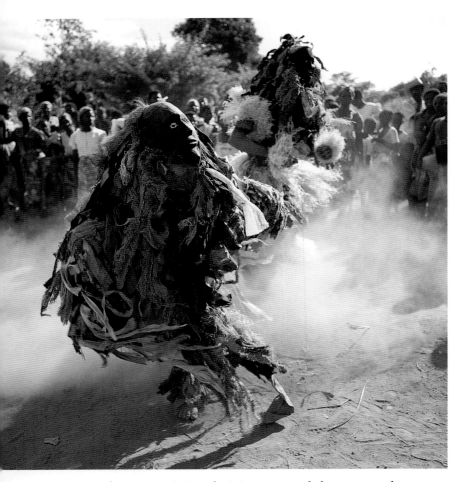

about 200 AD, the first waves of Bantu invaders began to arrive. Evidence of smelting dates from this time. A Bantu group called the Banda reached there around 900 AD and, over the centuries, assimilated the Akafula to breed a race of short, stocky people. Hundreds of years later, their descendants intermarried with the Phiri people to form the Chewa tribe. The Phiri are also Bantu and came from Katanga in southern Congo: they are now the dominant section of the Chewa, Malawi's largest tribe. Their vernacular, Chichewa, is a national language along with English.

In matrilineal Chewa society, descent, succession, and inheritance are traced through the mother but authority remains in the hands of men. Chewa women give the impression that men are in charge of tribal affairs, but they consider themselves the custodians of real power by controlling reproduction and by bringing up their children. They claim to tolerate their husbands' idiosyncrasies simply because they cannot procreate without them. Of course, men have a very different interpretation of who is in charge. They hold the secrets of afterlife, which revolves around the Spirit World—a fascinating aspect of Chewa culture that has survived missionary attack.

The spirits maintain the well being of Chewa society and impart moral codes. They teach people the correct way to behave in life on earth. For the Chewa, death simply means a journey of rebirth into the Spirit World: a funeral rite eases the transition. The terrestrial representatives of this other world are the grotesquely masked dancers of the tribe, known as Gule Wamkulu, who appear at funerals and the commemorations that follow three months and a year after death. As they gyrate in turn to the pulsating rhythm of five drummers, the Gule Wamkulu give comfort and encouragement to the bereaved while welcoming the dead person to forge new relationships in

between 1858 and 1861, estimated that 19,000 slaves from Central Africa passed through the Zanzibar slave market each year. The total extent of the human tragedy remains unknown because only a very small percentage of the people captured ever reached the coast alive.

During his initial survey of Lake Malawi, Livingstone met large numbers of people living peacefully on the fertile plains between the western lakeshore and the Rift escarpment. Shortly afterward, slaving led to a catastrophic decline in the population. One hundred and fifty years on, the region has once again become densely settled. The earliest inhabitants were Batwa pygmies, known as the Akafula, who had spread from the vast equatorial rainforests of central Congo into a land teeming with wild animals and with abundant fish in the lake. By

the Spirit World. One year after the funeral, when the transition is complete, sexual and other taboos are lifted on the bereaved and the widow or widower is permitted to remarry.

The masks of the Gule Wamkulu are sacred and kept in a hiding place called *dambwe*, which is usually within a grove of trees or part of a graveyard. Only males who have been initiated may visit the *dambwe* (initiation takes place at the age of thirteen or fourteen). Women must never see the masks except when they are worn on ceremonial occasions. The masks come in many extravagant forms, all with themes, messages, and their own individual songs. Some remind people that ritual customs must be followed in order to maintain a flourishing community; others inspire self-control because loose behavior can lead to death; and others remind people that laziness breeds poverty.

David Livingstone passed close to Lake Malawi for the last time in 1866, still trying to unravel the mysteries of the Nile. Despite the journeys of Burton, Speke, Grant, and Baker, it remained unclear whether the Nile entered and left Lakes Albert and Victoria in the north. Undeterred by ill health, Livingstone never wavered nor turned back. He worked ceaselessly to produce accurate maps and plot the drainage patterns of the region's principal rivers and lakes. As his own party of faithful followers and indifferent porters was steadily reduced to a handful of stalwarts, he often teamed up with Arab traders for escort through hostile lands. His determination to discover the Nile's sources at any cost, even in seeking the assistance of the very people whose slaving activities he so vehemently opposed, was to prove a big mistake. Slavers followed in his pioneering footsteps to hitherto unexplored regions and rapidly expanded the trade he had set out to destroy. What is more, his close association with them lost him the

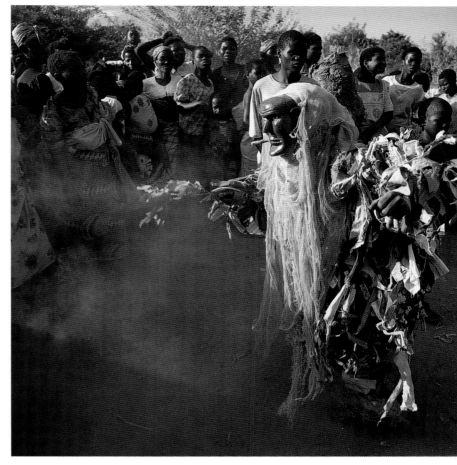

trust of the local people, which kept him from reaching some of the places he might otherwise have explored.

When Livingstone staggered into Ujiji a second time on October 23, 1871, he was at his wits' end. With most of his supplies and medicines stolen, he had been unable to shake off the serious illnesses that had dogged him for months. Apart from ill health, he was profoundly depressed by the massacre of hundreds of innocent villagers at the important trading center of Nyangwe, where his escort of slave traders had participated in acts of unspeakable barbarity. In Europe, the furore over Livingstone's eyewitness account eventually became a turning point that finally forced the sultan of Zanzibar to issue a decree abolishing slavery. The international pressure exerted on the sultan was an outstanding tribute to Livingstone's compassion, strong sense of justice, and steely

Though poverty persists in Malawi, most people are extremely house-proud and often decorate the walls of their homes with traditional designs. Here, a family shells maize cobs on their veranda.

resolve: his name will be forever linked with goodness in central Africa.

On November 10, 1871, while Livingstone was resting at Ujiji, an incredible stroke of luck brought about the most memorable meeting in the annals of African exploration. Livingstone heartily disliked the village, and had never felt comfortable there, describing it as "this den of the worst kind of slave traders." The animosity was mutual. The plunderers secretly tore up all his letters and put many obstacles in his way. Still, exhausted, sick, and alone, he was forced to stay.

And, then, on that fateful day, Livingstone's servant, Susi, "came running at the top of his speed and gasped out, 'An Englishman! I see him!' and off he darted to meet him. The American flag at the head of the caravan told me of the nationality of the stranger. Bales of goods, baths of tin, huge kettles, cooking pots, tents, etc. made me think, 'this must be a luxurious traveler, and not one at his wits' end like me.'"

With the immortal words, "Dr. Livingstone, I presume," Henry Morton Stanley strode up to greet Livingstone. The encounter was as extraordinary as it was timely, for it probably saved Livingstone's life.

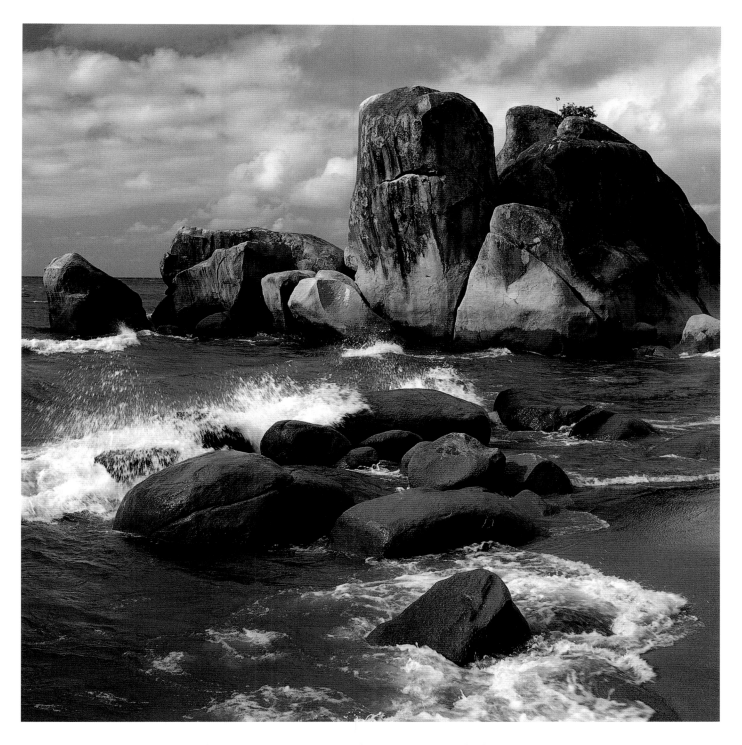

Huge rocks smoothed by many centuries of wave action jut into the clear waters of Lake Malawi. Africa's third largest body of water, and ninth largest in the world, Lake Malawi supports an exceptionally rich fish fauna.

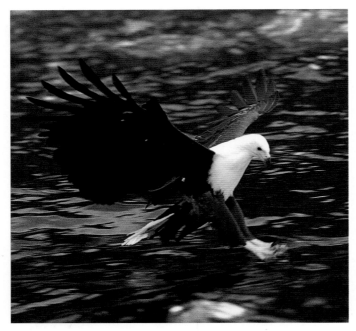

Henry Morton Stanley was an adventurer and some-time journalist, who had traveled widely. In 1867 he went to work for the *New York Herald*. Two years later, the publisher of the paper sent him to Africa to find Livingstone, whose exploits in Africa had been widely reported in America and whose stand against slavery had found considerable sympathy, especially in the urban northeast. Little had been heard of him for five years, however. Traveling by way of Egypt, where he reported on the opening of the Suez Canal, Stanley reached Zanzibar only in January 1871. Ten months later, making his way across country ravaged by warfare and sickness, he marched his little caravan into Ujiji.

Stanley's arrival provided Livingstone with a sympathetic means of reporting the atrocities he had

ABOVE: *A fish eagle, talons outstretched, swoops on its prey in the Shire River. Though territorial, these magnificent African eagles are numerous at the south end of Lake Malawi because small cichlid fish proliferate in the shallow waters.*

RIGHT: *A woman shades her child as she inspects a rich fish haul drying in the hot sun.*

OPPOSITE: *A fisherman in a dugout canoe casts his net on the Shire River. Traditional methods of fishing are still widespread in Malawi.*

witnessed while catching up on world affairs and enjoying stimulating conversation after five lonely years. Here were two strangers with quite different philosophies: the one, a devout Christian gentleman bent on discovering the true source of the Nile; the other, a tough, thirty-year-old, self-made man in search of a journalistic scoop. They immediately struck up a rapport, which gave Livingstone a new lease on life and Stanley, a radical change of outlook. The men enjoyed each other's company, as Stanley was quick to point out: "For four months and four days I lived with him in the same house, or in the same boat, or in the same tent, and I never found fault in him. I am a man of quick temper, and often without sufficient cause, I daresay, have broken ties of friendship; but with Livingstone I never had cause for resentment, but each day's life with him added to my admiration."

Their harmonious relations were not that surprising. They had both come from humble backgrounds and made good in their different fields. They were both determined and obstinate men, yet lacked a loving home on which to anchor their lives. Although thirty-two years in age

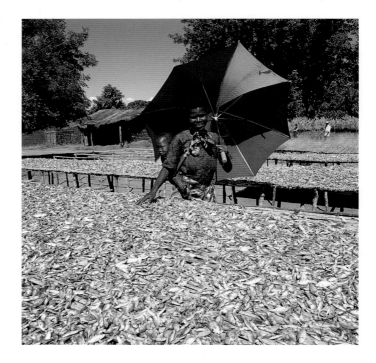

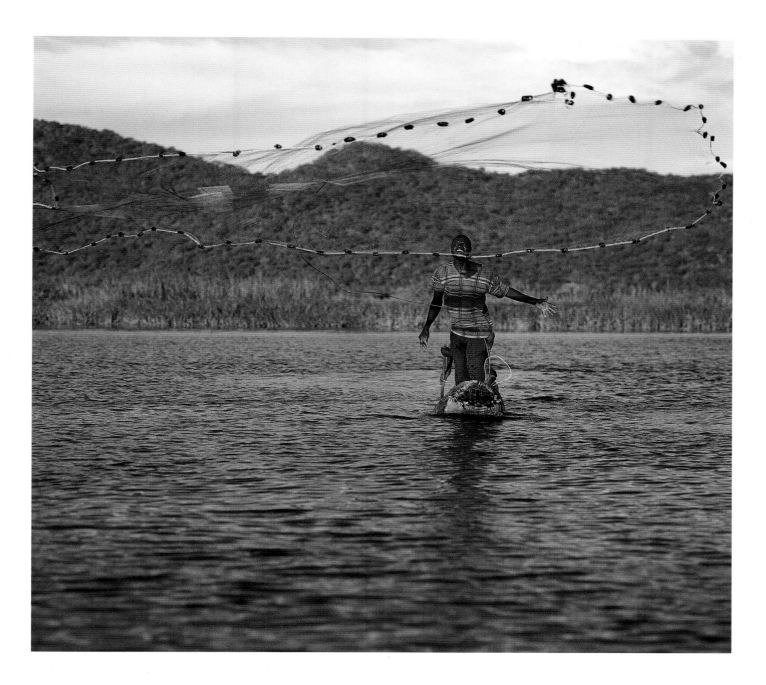

separated them, Livingstone had all the attributes Stanley most admired in a man and became the fatherlike figure Stanley had always missed. Stanley had all the qualities Livingstone wished for in a son, replacing to some extent his estranged firstborn who had died in the American Civil War.

Together, Stanley and Livingstone explored the northern end of Lake Tanganyika to settle the long-running debate on the direction of the Ruzizi River. Having found it flowing into the lake, Livingstone should have abandoned his theory of a Nile connection; instead, he reasoned that the lake had to have an outlet to the Nile elsewhere.

After Stanley's departure from Africa some seven months later, Livingstone was alone again, forlorn, and near the end of his life. He clutched at many geographic

straws after learning of four "fountains" issuing close to each other near the copper mining district of Katanga. With no one to challenge his theories and with constant bouts of debilitating malaria affecting his judgment, he was sure that at least one of them would prove to be the Nile's source. Livingstone went a step further by drafting dispatches to announce the discoveries that he was yet to make. In spite of this clouded ending, his contribution to African geography was exceptional. His most outstanding achievement, however, was to rid east and central Africa of the slave trade.

When David Livingstone died in 1873, Stanley determined to return to Africa to complete the geographical riddle of the Nile. Short, stocky, and objectionable to some, Stanley was thorough, determined, and effective. He was an able administrator and strict disciplinarian whose tremendous energy, courage, and physical endurance got him to places that others failed to reach. He had more critics than the other explorers of his day because of class prejudice. The English establishment resented the exploits of the brash Yankee who had been born a bastard and began life in a Welsh workhouse. English newspaper editors were also piqued that the *New York Herald* had gained a stunning scoop on their national hero. Several committee members of the Royal Geographical Society were upset that Stanley had found Livingstone at all because it upstaged their own initiative. Other erudite members openly questioned whether Stanley had really seen the great man. How could he have possibly found his way, they wondered, when the man was not an explorer, not a geographer, and decidedly not a gentleman? But Queen Victoria turned the tables on them by giving Stanley an audience at Balmoral castle and shaming the president of the Royal Geographical Society into awarding him the society's coveted Gold Medal for his outstanding achievement. Stanley later became a British citizen again and was knighted in 1899.

There is no doubt that Henry Morton Stanley was the most accomplished of all the Victorian explorers who trekked to the Western Rift. His no-nonsense approach enabled him to make journeys in half the time taken by his fellow travelers, with much less anguish. He circumnavigated Lakes Victoria and Tanganyika. He disproved one of Livingstone's Nile theories by tracing the Luabala River to its confluence with the Congo River. Then, fighting his way through thirty-two separate armed clashes while sailing down the Congo River to the Atlantic Ocean, he demonstrated that it had no connection to the watershed of the Nile. As head of a relief expedition to rescue Emin Pasha, the governor of the Equatorial Province of Egyptian Sudan, Stanley crossed the 200,000-square-mile Ituri rainforest—the first outsider to do so—in a beastly journey lasting six months. Finally, he solved the mystery of the Mountains of the Moon, identifying them as the Rwenzori Mountains.

By a process of elimination, Stanley helped geographers to establish the true sources of the Nile. However, few in the English establishment really liked or trusted him in spite of his knighthood. A vociferous minority went further to accuse him of using excessive force to achieve his goals, but his methods were not extreme by the standards of his day. Nevertheless, he remained a controversial figure to the very end of his life because of his association with King Leopold of Belgium, whose forced labor policy in the Congo caused the death of many thousands. Stanley had not been involved in either proposing or implementing this abhorrent policy, but his link with the king greatly damaged his reputation in England. At his death in 1904, although he was given a memorial service in Westminster Abbey, the Dean of Westminster refused him burial there.

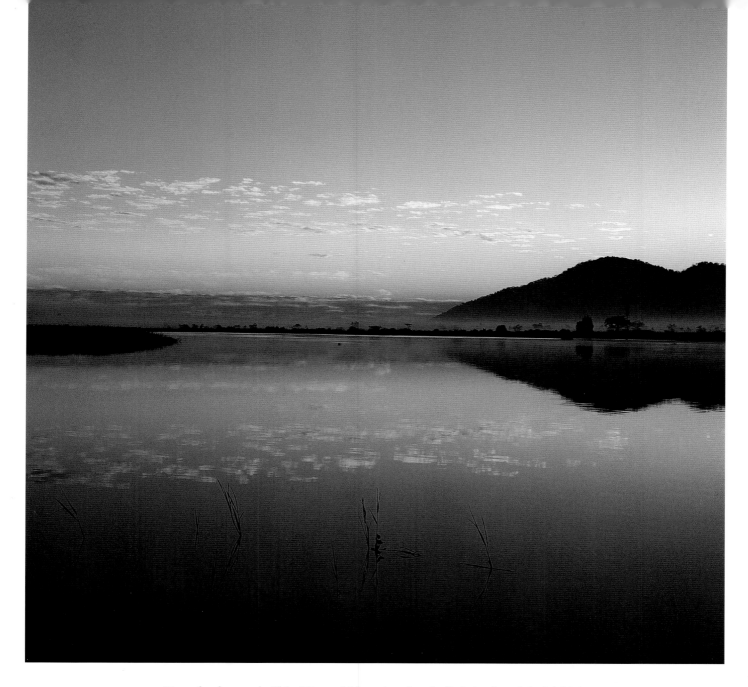

Dawn breaks over the Shire River, which receives the only discharge from Lake Malawi at its southern end. The Shire follows the trough of the Rift through Elephant Marsh before joining the Zambezi River in Mozambique.

More than half a century later, the Congo, where Henry Morton Stanley had spent so much time, gained independence from Belgium. Stanley had traced the Congo's principal river and had aided in its existence as a free state. In the independence celebrations, the country's first Prime Minister, Patrice Lumumba, went out of his way to praise Stanley, who "gave us peace, human dignity, improved our living standards, developed our intelligence, made our spirits evolve. . . ." It was a very unusual tribute for the premier of a newly independent African state and demonstrated that the Congolese appreciated Stanley more than did England's gentry.

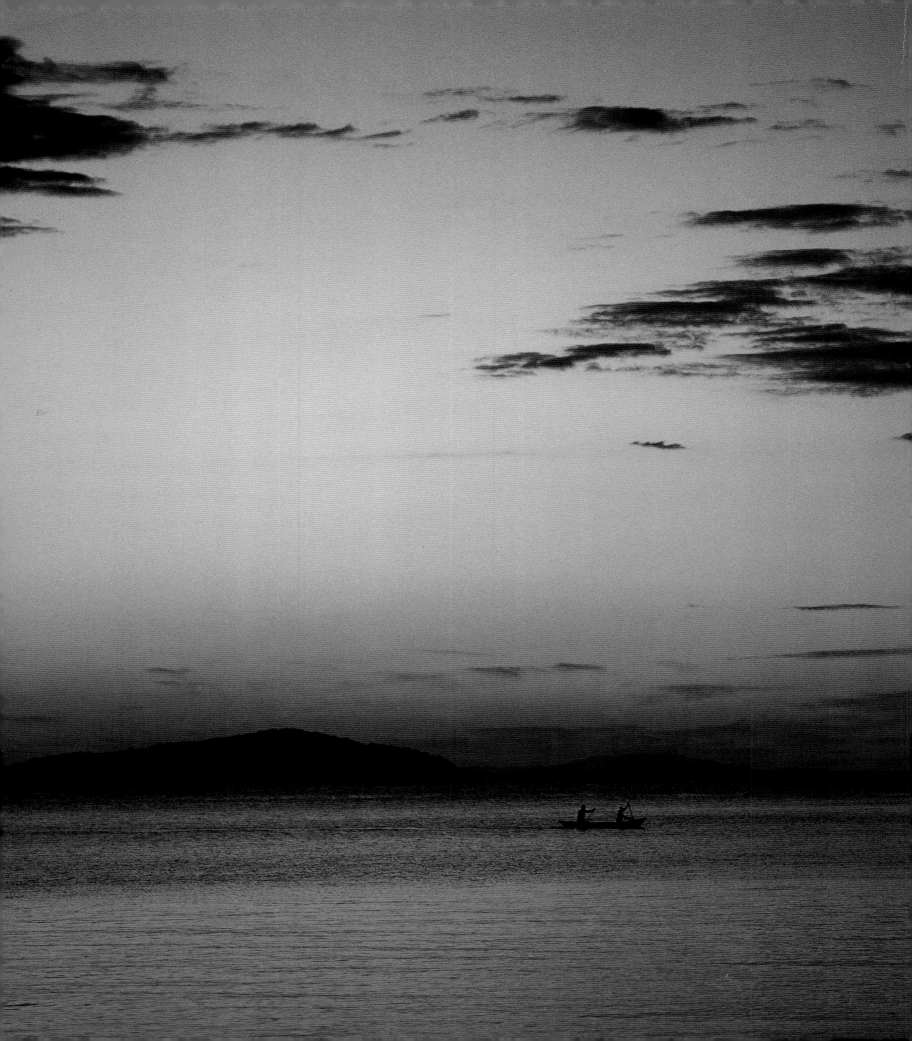

No End to Change

A nineteenth-century German explorer wrote, "The art of travel, like every other art, is only acquired by practice." In his era most travelers equipped themselves in England, where long colonial experience and an intimate knowledge of field sports had led to the development of specialist outfitters who were best able to meet their particular needs. Even so, those who ventured into Africa's "dark" interior were singular men. After recruiting trustworthy porters, they had to overcome the hazards of hostile tribesmen, dangerous wild animals, a variety of unfamiliar diseases, and recurring shortages of supplies. Their selection of the right barter goods at the right price was vital to rationing their caravans through unknown lands. Richard Burton, for example, went through seventy loads of cloth, beads, and brass wire on his way from Zanzibar to Lake Tanganyika in just over a year.

By comparison, the problems today's travelers encounter are relatively minor as long as they have ready cash. In any case, they rarely venture into the unknown—there being little of that left. They might still face challenges, however, from endemic diseases such as malaria, which kills a million Africans each year.

My travels crisscrossing the Rift in search of information and photographs for this and other books have been an experience of extremes. A few years ago I was in a light aircraft flying 200 feet above Lake Assal in Djibouti when the pilot made a tight turn to permit me to photograph a camel caravan on the salt flats. As we turned in the stifling air, I glanced at the instrument panel and realized that we were flying 300 feet *below* sea level. Only a few days earlier, 225 miles away in Ethiopia as the crow flies, I had shivered in the afternoon sun at 11,000 feet while photographing a troop of gelada baboons on the windswept western scarps of the Rift.

I have followed in the footsteps of Burton, Speke, Livingstone, Baker, and Stanley to the Western Rift, but traveling in a very different manner and at a very different pace. While many of the places described by these famous explorers have changed out of all recognition in the past 150 years, others have remained largely the same. The scenery in the Great Lakes region and some other parts of the Rift is as spectacular today as it has always been.

OPPOSITE: *Two fishermen paddle home as the blood-red glow of the dying sun reflects in Malawi's vast inland sea.*

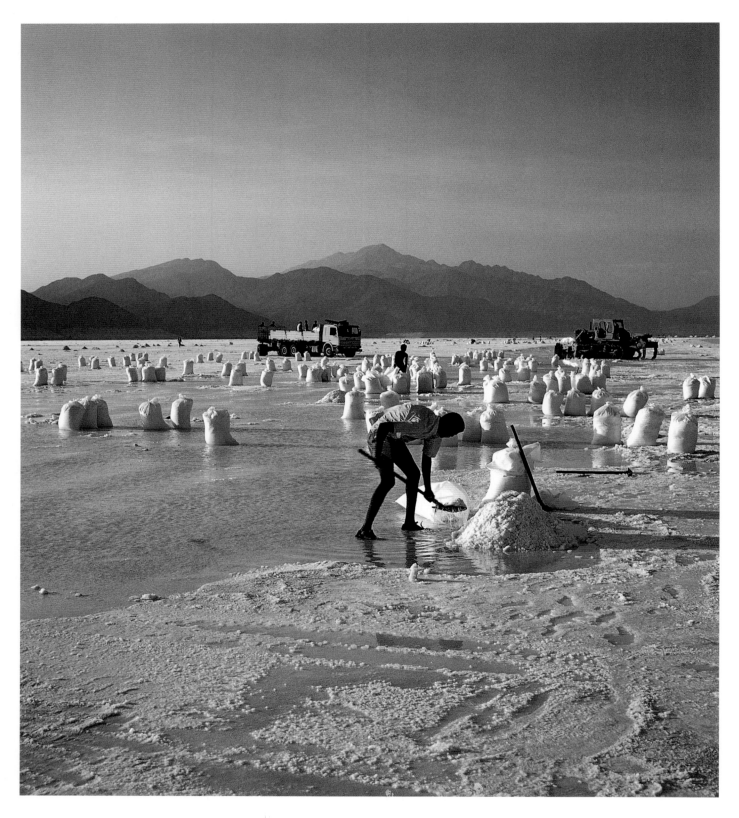

*Modern methods of harvesting are used at Lake Assal in Djibouti to satisfy an
ever-growing demand for salt in Ethiopia.*

My longest safari in the Rift was 6,850 miles, traveling around Ethiopia in 1998. The government-run hotels there can be superbly indifferent to the comfort of their guests but the local people invariably extend a wonderfully warm welcome. They are extraordinarily generous even though they have little themselves. Sweet tea is offered more than any other beverage, sometimes black but usually with milk, and sometimes spiced with cinnamon, cloves, or ginger. In much of Ethiopia, one finds that "tea," an expensive luxury, is more often than not made from coffee husks to which salt is sometimes added in preference to sugar.

In times of plenty, pastoral communities in many parts of the Rift offer visitors milk from cows, camels, or goats. Usually fresh but sometimes curdled like yogurt, milk is stored in gourds and handmade wooden, leather, or woven vessels shaped like gourds. Containers come in all shapes and sizes and are often beautifully decorated, even inlaid with metal. The impressive variety of styles exemplifies the numerous tribal traditions and cultural diversity of the peoples who have worked out different ways of living according to their geographic and climatic circumstances.

I have seen innumerable changes, both good and bad, while living in close proximity to Africa's Great Rift Valley for the past forty-five years. Although a huge increase in the population of most African countries has taken place, the remote and more inhospitable parts of the Rift remain relatively untouched by the hand of man, leaving the harsh landscape pristine. Still, many tribesmen in these areas make best use of twentieth-century technology in at least one respect. Almost every young man has an AK-47 assault rifle slung over his shoulder and is an expert shot. Without the protection of modern weapons, he knows that his family's herds are at the mercy of stock in possession of equally up-to-date

The Turkwell Gorge hydroelectric plant in northwest Kenya was commissioned in the 1990s to alleviate a serious power shortage. Extreme drought in 1999 and 2000, however, still left Kenya short of electricity, in addition to other deprivations.

firearms. Despite this illegal arsenal, I have rarely felt unsafe; an individual without livestock is not a prime target, although it helps, of course, to be accompanied by a respected local person and to be sensible in one's approach. In a tight spot, a good sense of humor dispels tension quicker than does anything else.

Regrettably, some regions of the Rift Valley remain too dangerous to visit under present circumstances. For many years insurgency has plagued the eastern sector of the Democratic Republic of the Congo, turning the country into one of the biggest battlefields in Africa's history. Ethnic

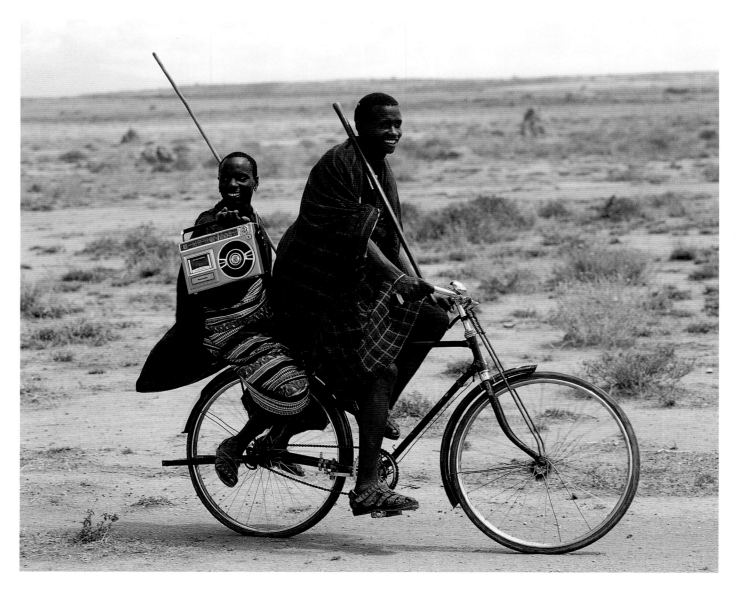

*Dressed traditionally and carrying familiar wooden staff, two young Maasai men give
hints that the lifestyle of the tribe's younger generation is gradually changing in Tanzania.*

animosities and a lust for riches continue to fuel conflict in a region endowed with vast untapped natural wealth. Four years ago, the trouble spilled over into western Uganda, resulting in the closure of the magnificent Rwenzori Mountains National Park.

Past and present tribal hatred in Burundi and Rwanda has left these central African countries in a very troubled state. In Rwanda, the Hutu majority perpetrated an appalling genocide on the Tutsi minority in 1994 when more than half a million people died. The strange thing about this terrible expression of fear and hatred is that ethnic differences between the two groups are minimal. They speak the same language, they have many common customs, and they may have been part of exactly the same wave of Bantu

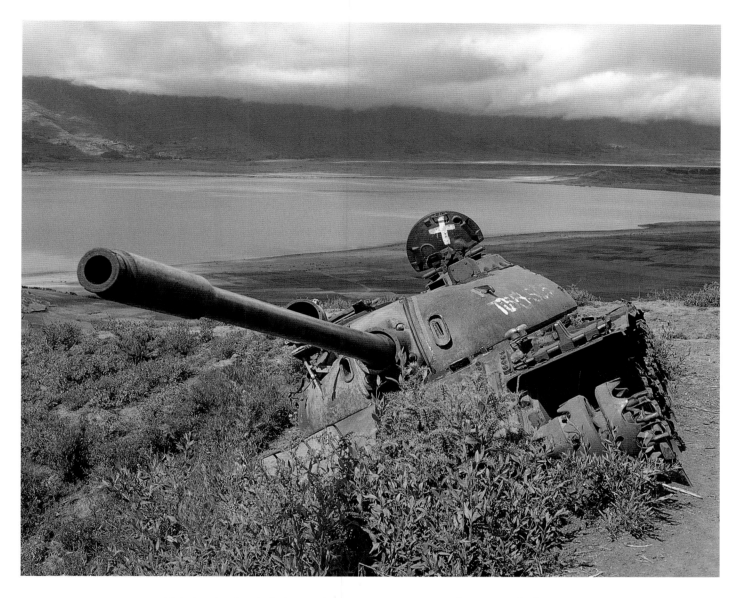

Africa's regional and ethnic wars divert scarce resources away from urgent development projects that could uplift the living standards of the people. Defeated forces of the former Ethiopian dictator, Mengistu Haile Mariam, left behind this wrecked Russian-made tank near Lake Ashange, northern Ethiopia.

immigrants to the region centuries ago. For generations they lived together amicably, although they diverged in lifestyle, the Hutu becoming cultivators and the Tutsi pastoralists. Eventually, herding came to be regarded as a noble pursuit, and cattle were recognized as the most important symbol of status and wealth. This led to Tutsi hegemony over the Hutu, and may partly explain the awful brutality.

Northern Ethiopia and parts of Eritrea have also been a recent war zone. If the fragile peace deal brokered by the international community breaks down, fighting could flare up again. Neither country can afford to start another war but generations of bad blood have led to serious mistrust.

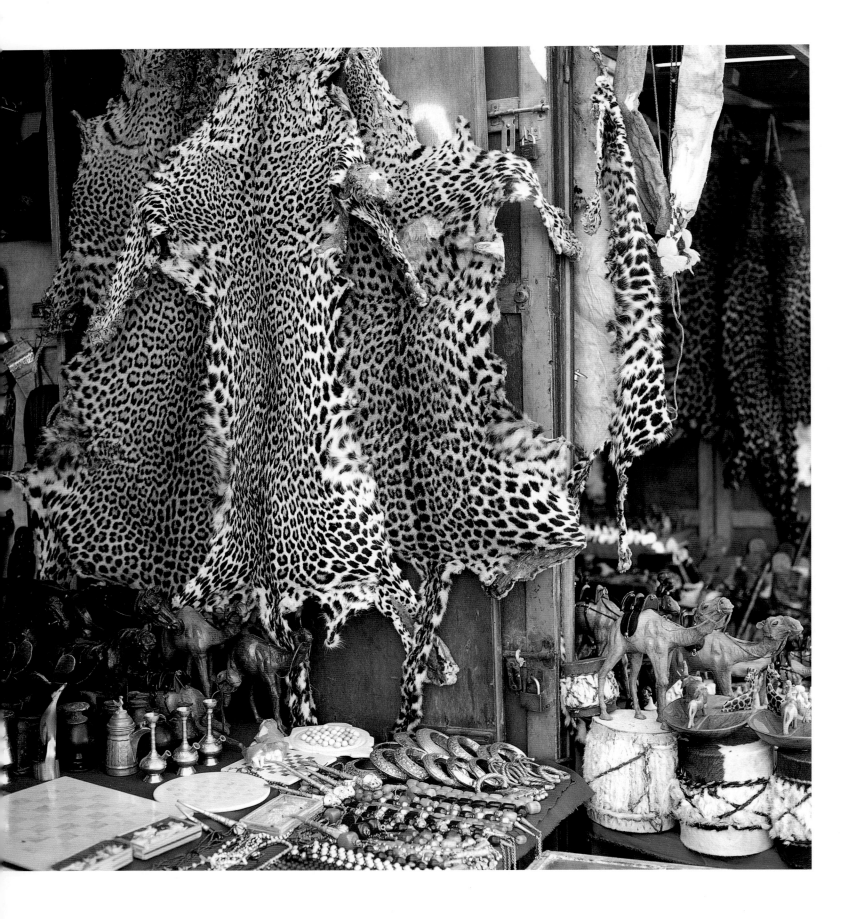

OPPOSITE: *Despite a worldwide ban on trade in leopard skins, they are openly on sale in curio stalls catering to tourists at Djibouti-ville.*

ABOVE: *Ancient baobab trees are cut down in southern Tanzania to make way for the cultivation of marginal areas. The indiscriminate clearance of wild places will continue for as long as population increases exert pressure on limited fertile land.*

Addis Abeba, the capital city of Ethiopia, reflects the common hodgepodge of old and new in Africa's cities.

The African continent faces huge social, economic, political, and environmental challenges as it enters a new millennium. These challenges, however, can be met if the friends of Africa encourage a new brand of leadership to flourish. State feudalism and personality cults must be made to give way to the pressures of the times. Corrupt politicians and government officials have to stop taking advantage of their positions. Political parties have to choose to be more broadly based without overtly tribal overtones. In the Rift, as elsewhere in Africa, as in the larger world, the ruthless exploitation of natural resources and destruction of natural habitats has to stop. And, different people must come together proudly in nations, to work for the common good, to eradicate poverty and disease. As we have seen in the Great Rift Valley, change is constant. We must choose to change for the better.

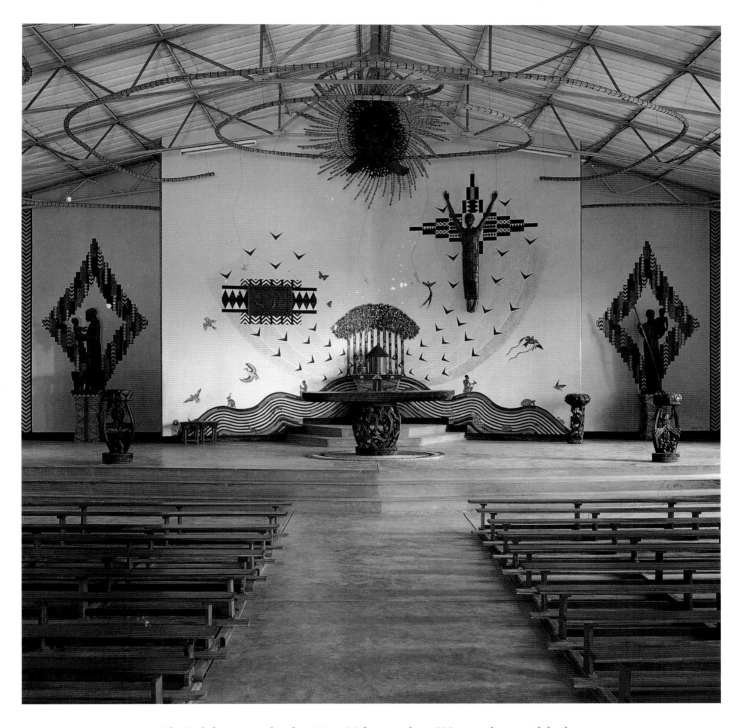

The Catholic mission church at Mua, Malawi, combines Western religion with local art in a visually exciting way.

ACKNOWLEDGMENTS

I have received much kind help during my research and travels over the past five years. Foremost has been the very generous assistance extended to me by Professor Celia Nyamweru on the geology of the Great Rift Valley, Dr. Meave Leakey on the evolution of humankind, and Mrs. Susan Southwick with advice on an early draft of my manuscript. I owe them a great debt of gratitude.

I have been given information, hospitality, encouragement and support from many quarters, not least from the many inhabitants of the Rift Valley whom I had the pleasure of meeting on my journeys. My special thanks go to Dr. Chris and George Magin in Djibouti; Halewijn Scheurmann, Lale Biwa, and Biruk Kassa in Ethiopia; Alan Binks, Joanne Csete, Murray Surtees, Dr. Olivier Hanotte, Mike Towon, Vicky Chignall, and Lis Wackman in East Africa; Frank and Maria Johnston, Chris and Pam Badger, Everlasting Nyirenda, Sally Foster-Brown, Fr. Claude Boucher, and Roger Gardner in Malawi. One of my most memorable trips to Lake Tanganyika would not have been possible without the generosity of my late cousin, Trevor Hoy.

Maps are a most important part of any geograpical book and I was fortunate when Chris Robitaille agreed to draw them for my book. He has a wonderful, old-world style. The selection of photographs from the many thousands I took on my journeys in the Rift was an ordeal in itself. I am greatly indebted to my friends Barney Wan and Sally Perry for their patient and knowledgeable appraisal of my material, and in making the difficult task of picture editing more enjoyable.

I am also grateful to my editor, Robert Morton, and the staff at Abrams for their contribution to the production of this book. Bob's friendly help and advice throughout the project have been invaluable.

POSTSCRIPT

Just as my book was going to press, evolutionary thinking was thrown into confusion by the discovery in northern Kenya of a second genus of early human that walked the earth 3.6 million years ago. Until Meave Leakey and her daughter, Louise, discovered *Kenyanthropus platyops*, scientists believed that present-day *Homo sapiens* had a single common ancestor, *Australopithecus afarensis*. Now they can no longer be certain. *Kenyanthropus* had a much flatter face than Lucy as well as small molar teeth, leading scientists to believe that it fed on a mixture of fruit, berries, and grubs, as well as small mammals and birds. This remarkable find and others that might follow over time would make the evolutionary tree bushier than previously imagined, raising important questions about exactly who were humankind's earliest ancestors.

OVERLEAF: *Two men in a dugout canoe paddle across Lake Bunyonyi, southwest Uganda, at twilight.*

SELECT BIBLIOGRAPHY

Adams, William M., Andrew S. Goudie, and Antony R. Orme, eds. *The Physical Geography of Africa.* Oxford: Oxford University Press, 1996.

Baker, B. H. *An Outline Geology of the Kenyan Rift Valley.* Nairobi: Government Printer, 1965.

Baker, Samuel. *The Albert Nyanza—Great Basin of the Nile.* London: Macmillan, 1866.

Beattie, John. *Bunyoro: An African Kingdom.* New York: Holt, Rinehart & Winston, 1960.

Bierman, John. *Dark Safari.* London: Hodder & Stoughton, 1991.

Burton, Richard. *The Lake Regions of Central Africa.* London: Longmans, Green, 1860.

Brown, Leslie. *Africa.* London: Random House, 1965.

Carter, Judy. *Malawi.* London: Macmillan, 1987.

Coupland, Reginald. *Livingstone's Last Journey.* London: Collins, 1945.

Davidson, Basil. *The Story of Africa.* London: Mitchell Beazley, 1984.

Debenhan, Frank. *The Way to Ilala.* London: Longmans, 1955.

Dennis, L. G. *The Lake Steamers of East Africa.* Egham: Runnymede Malthouse Press, 1996.

Diamond, Jared. *Guns, Germs & Steel.* London: Jonathan Cape, 1997.

Dixey, F. *The Nyasaland Section of the Great Rift Valley.* JRGS, London: Journal of the Royal Geographical Society, 1926.

Gregory, J. W. *The Great Rift Valley.* London: John Murray, 1896.

Gregory, J. W. *The Rift Valleys & Geology of East Africa.* London: Seeley Service & Co., 1921.

Hancock, Graham. *The Sign and the Seal.* London: William Heinemann, 1992.

Hozier, Captain J. M. *British Expedition to Ethiopia.* London: Macmillan, 1869.

Huxley, Elspeth. *Livingstone and His African Journeys.* London: Saturday Review Press, 1974.

Kingdom, Jonathan. *Island Africa.* London: Collins, 1990.

Livingstone, David and Charles. *Narrative of an Expedition to the Zambesi and Its Tributaries.* London: John Murray, 1865.

Makin, W. J. *War Over Ethiopia.* London: Jarrolds, 1935.

Mathew, David. *Ethiopia.* London: Eyre & Spottiswoode, 1947.

McLynn, Frank. *Hearts of Darkness.* London: Hutchinson, 1992.

Meyer, Dr. Hans. *The First Ascent of Kilimanjaro.* London: George Philip, 1891.

Mohr, Paul A. *The Geology of Ethiopia.* Addis Ababa: University College of Addis Ababa Press, 1961.

Moorehead, Alan. *The Blue Nile.* London: Hamish Hamilton, 1962.

Newman, James. L. *The Peopling of Africa.* New Haven: Yale University Press, 1995.

Nyamweru, Celia. *Rift & Volcanoes: A Study of the East African Rift System.* Nairobi: Nelson Africa, 1980.

Packenhan, Thomas. *The Scramble for Africa.* London: Weidenfeld & Nicolson, 1991.

Quammen, David. *The Song of the Dodo.* London: Hutchinson, 1996.

Quaranta, Baron Ferdinando. *Ethiopia.* London: P.S. King & Son, 1939.

Reader, John. *Africa.* London: Hamish Hamilton, 1997.

Roscoe, John. *The Soul of Central Africa.* London: Cassell, 1922.

Sandford, Christine. *Ethiopia Under Haile Selassie.* London: J. M. Dent, 1946.

Sellassie, Sergew Hable. *Ancient and Medieval Ethiopian History to 1270.* Addis Abeba: 1972.

Speke, John Hanning. *What Led to the Discovery of the Source of the Nile.* Edinburgh: William Blackwood 1854.

Speke, John Hanning. *Journal of the Discovery of the Source of the Nile.* Edinburgh: William Blackwood, 1863.

Stanley, Henry, M. *How I Found Livingstone in Central Africa.* London: Sampson Low, 1872.

Stringer, Chris and Robin McKie. *African Exodus.* London: Pimlico, 1996.

Tattersall, David. *Land of the Lakes.* Blantyre: Blantyre Periodicals, 1982.

Thesiger, Wilfred. *The Life of My Choice.* London: Collins, 1987.

UNESCO Upper Mantle Committee. *Geology: The East African Rift System and Its Relation to Others.* Nairobi: University College Nairobi, 1965.

Waller, Horace. *Livingstone's Last Journals 1864 to His Death.* London: John Murray, 1874.

Yeoman, Guy. *Africa's Mountains of the Moon.* London: Elm Tree Books, 1989.

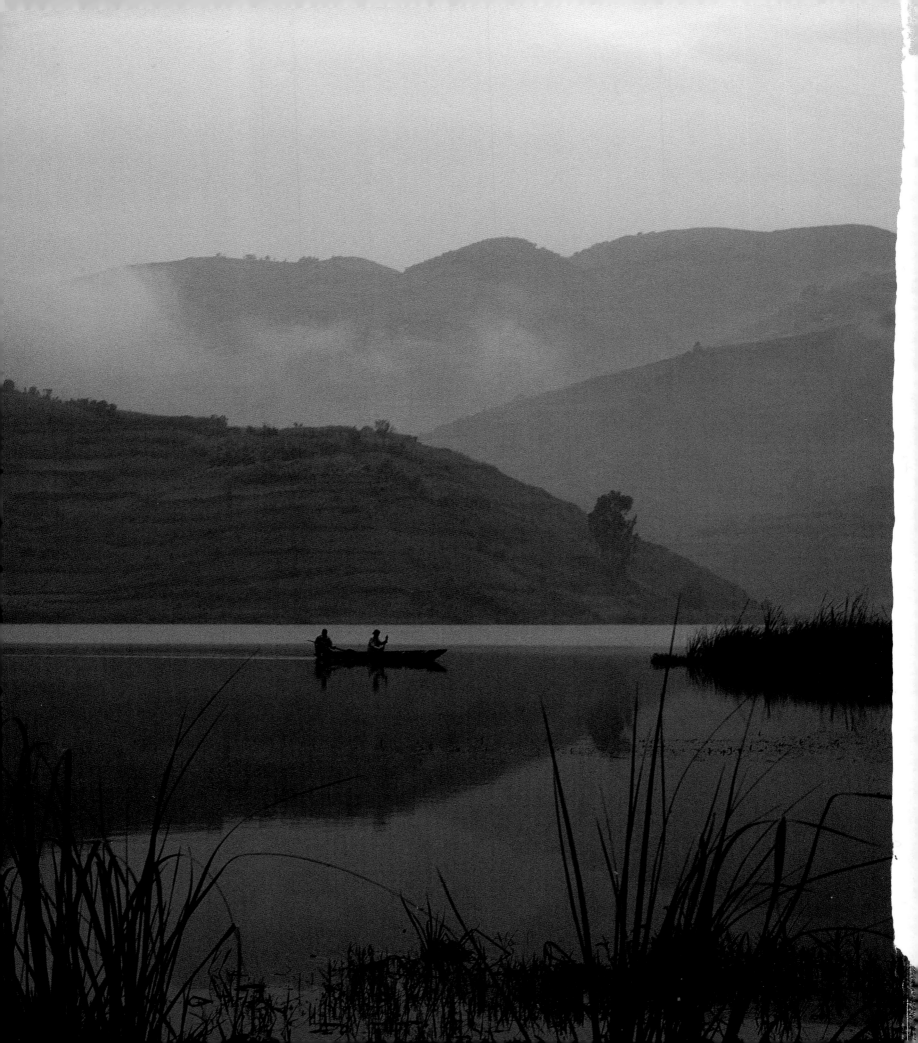